From
CLAY *to* BRONZE

From
CLAY *to* BRONZE

A Studio Guide to Figurative Sculpture

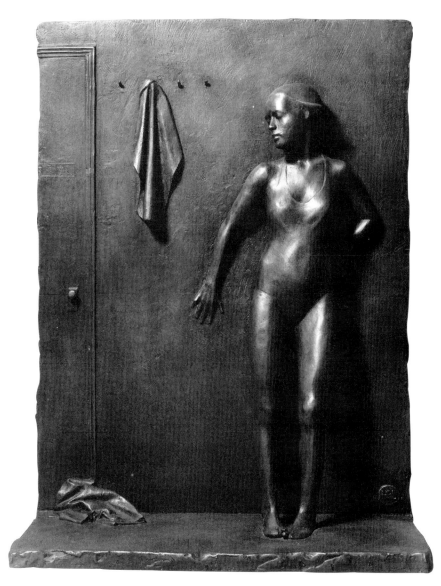

by Tuck Langland

WATSON-GUPTILL PUBLICATIONS
New York

Notes on the Art
On the cover: *Dawn*, Tuck Langland, 1998. Bronze, 22" (56 cm) high. Photo by Mel Schockner Photography.
On page 3: *Swimmer: Alone*, Tuck Langland, 1980. Bronze with green patina, 18 × 14 × 6" (46 × 36 × 15 cm) deep.
On page 5: *Water Nymph*, Tuck Langland, 1997. Bronze, 25" (64 cm) high. Photo by Mel Schockner Photography.

Acknowledgements
The author wishes to thank the many people who gave advice, showed techniques, helped with photos, and generally supported this lengthy endeavor. First, my wife Janice, who put up with papers all over the office for a year and gave constant support in ways too numerous to list. Mel Schockner graciously read the chapter on photography and gave valuable advice, and Andrea Greitzer of Indiana University South Bend did a great job printing photographs. Harry and Karly Spell of Art Casting of Illinois advised me on shell casting, SAV Molds helped with mold seams, and Hiram Ball of Ball Consulting was a gold mine of information on plasters and superplasters. My brother, John Langland, of the National Institute of Standards, gave needed information on metric screws, and John Kinkade and the Columbine Gallery of Loveland and Santa Fe were generous with their time and artists. George Lundeen and Blair Buswell kindly supplied photos of their enlarging processes, and Tallix Foundry graciously allowed me free rein to wander and photograph. My studio assistant, Cara Lawson-Ball, went way beyond the usual call of duty to help. And of course the cooperative staff at Watson-Guptill, particularly editor Julie Mazur, was indispensable.

Senior Editor: Candace Raney
Editor: Julie Mazur
Designer: Judy Morgan
Production Manager: Hector Campbell

Copyright © 1999 by Tuck Langland
First published in 1999 by Watson-Guptill Publications,
a division of VNU Business Media, Inc.
770 Broadway, New York, NY 10003
www.watsonguptill.com

Every effort has been made to trace all copyright holders and obtain permission for the materials used in this book. The author, editor, and publisher sincerely apologize for any inadvertent errors or omissions and will be happy to correct them in future editions.

Library of Congress Cataloging-in-Publication Data

Langland, Tuck.
 From clay to bronze : a studio guide to figurative sculpture /
 Tuck Langland.
 p. cm.
 Includes bibliographical references and index.
 ISBN 0-8230-0638-7
 1. Bronze sculpture—Technique. I. Title.
NB1230.L36 1999 99-22169
731.4'56—dc21 CIP

Printed in the United States of America

First printing, 1999

3 4 5 6 7 8 9 / 07 06 05 04 03 02

To Janice, Susan, and Tori

CONTENTS

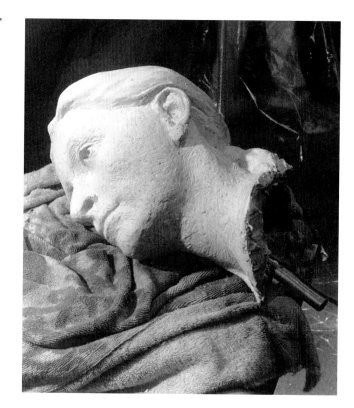

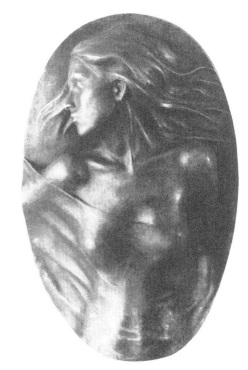

PREFACE

How do you learn to become a sculptor? It's such a complicated field, with so many terms, so much technique, and so many mysteries taking place in the foundries. And then there is the business side, with the pricing and numbering of editions. It can be overwhelming for someone just starting out.

One way to learn is by taking classes. Colleges and universities offer courses in sculpture, but be warned—most emphasize the avant-garde and do not teach classical figure and portrait modeling. If that's what you want, those classes won't be of much use. Keep an eye out for more comprehensive classes, and ask questions. You can learn a lot if you find the right class. There are also one-week courses held in places like the Scottsdale Artists School in Arizona and the Loveland Academy of Fine Arts in Colorado. These schools, and others like them, offer short programs of intense instruction in various aspects of sculpture (and usually painting and drawing as well). Courses often last for a week, and can be very rewarding. There are no degrees or grades, just work and learning. Look in various sculpture and art magazines, such as those listed at the back of this book, for listings of such classes.

And then there are books. *From Clay to Bronze* takes its place on a broad shelf of books on sculpture—some very fine, others less so. These go back to the famous books on modeling by Edouard Lanteri from around the turn of the century, and carry on with *Sculpture Inside and Out* by the great Malvina Hoffman. (If you ever see a copy of Ms. Hoffman's book in a used bookstore, buy it! You'll be so glad you did.) For a list of other recommended books, please refer to pages 233–234.

The aim of this particular book is to guide you through the steps involved in making a figurative bronze sculpture, from choosing a type of clay to having your own gallery opening with cheap white wine. I have attempted to explain most of the many confusing terms sculptors like to toss around, and to steer you through the mass of products and materials on the market. The book will guide you step-by-step to completion of a work, including casting it in bronze or, if that's too daunting, to dealing with and talking intelligently to a foundry. And it will branch off here and there with various alternative processes and materials.

In nearly every case, I have listed multiple ways of doing something, since almost every sculptor has individual tricks and techniques to get the job done. If you read about a process here and then find someone doing it differently elsewhere, well then you have two ways of doing it. The emphasis here is on a variety of ways of working, on an ever-expanding list of products for the job, and on an ever-expanding list of ways to use them.

In the end, taking classes and reading books are only preludes to the real learning, which can only come from making sculpture. Just like learning to play the piano, it's all about practice. Arnold Palmer, the great golfer, once said, "The more I practice, the luckier I get." There are many ways to start being a sculptor, of course, and it's also true that a real sculptor never stops learning. So keep this book handy in the studio. Let it get covered with plaster and grime. Use it as a reference, and then make notes in the margins of what works for you and what doesn't. If you want it to stay pretty, buy two copies. But make sure one of them gets dirty.

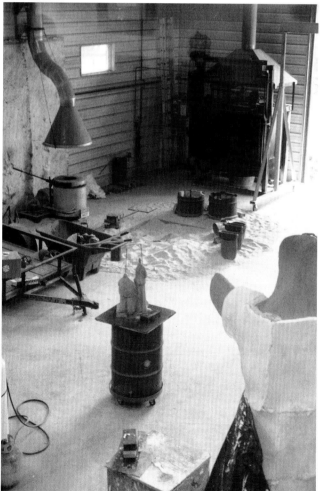

A commercial bronze foundry.

INTRODUCTION
A Brief History of Bronze Casting

Naturally, the earliest use of cast metals by humans is lost in the mists of the distant past, but we can conjecture that it went something like this: early hunter-gatherers were sitting by a fire, and a nugget of copper fell into the coals. In the intense heat, the copper melted and ran out on the ground in a glowing stream. Once cool, this shiny, heavy material had become very hard and had taken on a new shape.

It's likely that early people saw this happen again and again, and maybe they began to look for and collect nuggets just so they could throw them into the fire to watch the glowing streams trickle forth. Then someone had an idea and formed a shape in the sand, and let the metal run into it, making perhaps a spear point. There had to have been a first time for this, and from that moment came all the metal casting of the centuries right up to today.

Then, sometime between 4,000 and 3,000 B.C., a small miracle happened. There is no evidence to show where or exactly when this miracle occurred, or how it came about, but someone discovered—again, probably by accident—that if a little bit of a different shiny metal, tin, were allowed to melt into the shimmering molten copper, the mixture was harder than either of them on their own. With this discovery, the Bronze Age began.

Soon people moved from open-face molds scooped out of the sand to closed molds of fired clay, which could be used over and over. In the Shetland Islands, way to the north of Scotland, there is a "House of the Smith," where an early bronze caster lived and worked. A mold for an ax head remains, made of fired clay in two halves. Since it was a simple, flat shape, this mold must have been used again and again by the bronze caster, who lived about 2,700 years ago. Likewise, the ancient bronze ceremonial vessels of China's Chou Dynasty, which dated from 1122 to 256 B.C., were cast in molds of fired clay. Again, these were molds that, once created, could be used over and over to create many vessels.

But a human figure is too complex for a simple two-piece mold, and so eventually someone imagined what it would be like to cover a wax figure with clay and then fire it to simultaneously remove the wax and harden the clay, thus eliminating the need to pull a mold off the pattern. It is to this mysterious person, and his or her fertile imagination, that we owe almost all of modern bronze sculpture.

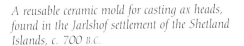

A reusable ceramic mold for casting ax heads, found in the Jarlshof settlement of the Shetland Islands, c. 700 B.C.

The earliest lost wax castings date from the early dynasties of Egypt, nearly 7,000 years ago. Clay would have been thinned down with water into a smooth slip, perhaps mixed with a little fine sand, and then painted onto the wax figure and allowed to air dry. Layer after layer of the clay would have been applied, each layer mixed to be a little thicker, until a large mass of clay had been created, called an *investment*. Wax rods would have been attached to the outside of the figure to allow the melted wax to run out and hot metal to flow in. The clay investment would then have been fired, slowly so as to avoid cracking, and when it was hot the metal would have been poured in.

We can tell quite a bit about this method by looking at similar methods still used in West Africa today, as well as those used by traditional bronze casters in India. They use an investment mixture of fine clay, fine sand, and powdered charcoal, which is then mixed with water in varying proportions to be applied as either a creamy, smooth first coat, or thick and sticky later coats. Some casters add fiber of some kind, such as rice husk or goat hair. Some even use a little manure for bonding strength.

A particularly interesting variant on this method is practiced in West Africa, where pure copper is cast. Pure metals are difficult to cast because they tend to react to oxygen in the atmosphere, becoming sluggish and not flowing well. Adding tin to copper to create bronze is a little like adding detergent to water—it changes the character of the liquid.

Metalworkers in Nigeria cast pure copper successfully by using a very clever method. They create and fire the

investment as usual and then, knowing the weight of the wax they used, they can easily calculate how much copper they will need. They then create a pottery bowl that is placed over the open end of a fired investment and sealed on with clay. Inside this bowl they have put the needed copper and some charcoal. Then this whole closed system is heated again, with the mold upside down and the copper in the bowl at the bottom. As it becomes hotter and hotter, the charcoal burns, using up the oxygen inside the mold and leaving an oxygen-free atmosphere in which the copper melts. When the system is completely hot and the copper is believed to be melted, the whole affair is turned over, allowing the copper to run into the mold with perfect results.

Another major breakthrough in sculpture casting occurred around 2,500 years ago in Greece, with the invention of hollow casting. Before this, all castings had been solid and thus limited in size. But the Greeks figured out how to create hollow sculptures, and could begin working larger, even life-sized. They did this with a simple technique that involved creating an armature, or supporting framework, and then covering it with fireproof investment material. The core was made to look exactly like the desired sculpture, but just a little smaller. Over this core were painted several layers of melted wax until a thickness of about ¼ inch was reached.

At this point the artist would have had a wax sculpture with a fireproof core. The surface of the wax was then worked and refined, with details added in wax. Finally, wax tubes would have been attached to the outside to allow the melted wax to run out and hot metal to run in. The sculpture would have been covered in investment material, fired, and then the hot metal would have been poured in.

When the famous Riace bronzes, which dated from about 450 B.C., were discovered in 1972 off the southern tip of Italy, the fireproof cores were still inside, where they had been for over twenty-four centuries on the bottom of the sea. Also inside were the iron bars of the original armatures, over which the cores were first fashioned. By examining these, we can form a very accurate idea of just how early bronzes were made.

This same process was used throughout the Roman period and on through the Renaissance and Baroque periods, up until the nineteenth century. The sixteenth-century Italian sculptor Benvenuto Cellini wrote a very dramatic account of casting his *Perseus*, in which he describes making the core but keeping it just a little smaller than the desired finished work. Cellini writes of the frenzy that transpired when, just as it came time to pour the metal, he became sick with fever, a huge storm blew in, and his entire foundry caught fire! With his fever raging, the storm howling, and the roof blazing, Cellini tossed all the kitchen pots into the melting metal and then poured this mixture into the mold on which he had been working for years. It all hung in the balance: it was all or nothing. His joy is contagious as he describes the nearly perfect casting that resulted. (There was, he writes, a flaw in the big toe that was easily repaired.)

Note that throughout all of this development, there was no casting of waxes from molds, and thus no editions. Each sculpture was a unique creation, a one-off, and if the casting failed, all was lost. But with the Industrial Revolution came two new influences on bronze casting. One was the rapidly improving technology of the casting art, and the second was the rise of a middle class able to afford bronzes, and the subsequently greater number of sculptures needed to satisfy this new market. It was the French who answered this need, and

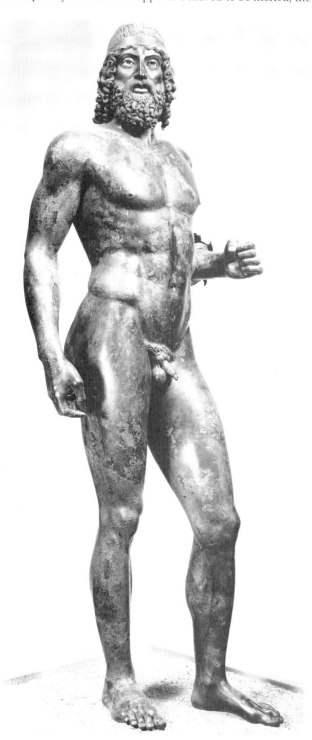

Warrior: Statue A, from the sea off Riace (Italy), Greek, c. 460–450 B.C. Bronze, approx. 6' 6" (2 m) high. Museo Archeologico Nazionale, Reggio Calabria, Italy.

they did so in two ways. One was the French Sand method, and the second was the use of gelatin and piece molds.

French Sand casting involves making a plaster original in parts so that each part can be pressed into specially mixed bonded sand to create a heatproof mold. One plaster original can be used over and over to cast a large number of multiples. And a single artisan can work on one simple part—say, an arm—and cast hundreds of them, each of which will be identical and will fit perfectly with other parts cast by other artisans.

But the French Sand method led to a new problem: how to join the bronze parts. Welding had not yet been developed, so instead a process called *pinning* was used. Each bronze part was created with a small raised *flange*, or rim, around the joint. Two parts were fit together with a sort of socket, and held by drilling holes through both parts and driving in bronze pins. The raised flanges were then hammered down into the seam to fill it and make the flanges invisible. This technique produced strong invisible joints, and was used throughout the industry. When you look at nineteenth-century bronzes today, you can often see a very fine seam or hairline crack where the joint has opened due to bumping when moving. This is always a sign of an original cast for nineteenth-century work.

The other advance in bronze casting was the use of flexible and piece molds to create multiple waxes. With the refinement of plaster of Paris, very accurate and fine *piece molds* could be made in as many pieces as necessary, all the pieces supported by a further *mother mold* around the outside. With this type of mold, waxes could be cast of even very intricate sculptures. These waxes could be produced by the hundreds, and then invested with plaster mixed with brick dust or other refractory. Usually the fine lines of the seams between pieces of the mold were eliminated in the wax, but French sculptor Auguste Rodin often left them where they could be seen in the bronze.

There was another kind of mold often used for smaller, more intricate works on which the numerous seam lines created by piece molds would detract: a *flexible mold* made of gelatin. To make a gelatin mold, a plaster original was prepared, then fastened down to a board and a plaster outer shell created, leaving about 1 inch of space between it and the sculpture all around. Cows' feet were boiled to create a rich gelatinous mixture, which when hot was as runny as water. This was then poured into the cavity surrounding the sculpture. By the next morning, when the gelatin had cooled and set, the outer mold was opened and the gelatin cut into two pieces with a special knife that created a perfect key.

Once a gelatin mold was made, wax could be painted into it to form a perfect wax sculpture, which could then be covered with investment material, fired, and so on. But how did the artisan paint hot wax into a mold made of gelatin, which melts at the slightest heat? The answer is, very carefully. The wax was first adjusted to the lowest possible temperature. Then a swipe of wax was quickly laid in, left to cool, another swipe added to build thickness, and so on.

It was generally thought that one gelatin mold would yield about ten waxes before losing too much detail, and a good wax person could create about ten waxes in one day.

Then, at the end of the day, the mold was cut up, melted back into liquid gelatin, and poured into the master mold. By the next morning the gelatin had set and cooled and was ready to be cut open, thereby allowing ten more waxes to be made, and so on indefinitely.

It should be noted that in the nineteenth century a large edition, or number of pieces made from the same mold, was a sign that the sculpture had great value, rather than the other way around as today. The thinking was simply that if a piece was a good one it would sell more castings, and so the number sold was the surest indication of quality. This is much the way we view books and movies today, automatically assuming that those on the best-seller lists are the better books.

Commercial foundries continued casting throughout the nineteenth and twentieth centuries to the present day. But in the first decades after World War II, there arose a new interest among sculptors in doing castings themselves. Across the country, college and university art departments began to experiment with bronze casting, primarily as a way to beat the high cost of commercial foundries, but also out of love for the process. Beginning in 1960, the University of Kansas under the direction of sculptor Eldon Teft began a series of bronze-casting conferences that would be held every two years, bringing together sculptors and founders from across the country. It was the first time many of these struggling artists had had a chance to find out what others were doing, and the number of homemade bronze foundries mushroomed.

It was at about this time that some artists grew curious about a new way of casting used in industry, called *ceramic shell*. Their experiments with this radically different way of making an investment were shared at the conferences in Kansas, and the idea spread. In the wake of this excitement a new kind of commercial sculpture foundry appeared, no longer looking back to old-world, traditional techniques, but started and run by a new breed of caster coming from either the more experimental college foundries or industry. These foundries took to ceramic shell as the investment material of choice. They also introduced new synthetic rubber molding compounds to eliminate piece molds and gelatin molds, and began using a whole host of technologies borrowed from industry, such as TIG welders and air-powered tools. They also turned to new bronze alloys, particularly silicon bronze, as the metal of choice.

Today, the sculptor who wants to have work cast in metal is faced with a smorgasbord of opportunities. There are still traditional foundries that cast with nineteenth-century techniques—methods that work perfectly well. Many still use the French Sand method, particularly for very large works. There are also the new breed of foundries, which use ceramic shell and new alloys, and the college and university foundries, which use all kinds of methods. And of course there are many individual sculptors casting work in their own personal foundries, often using unique techniques and methods shared by few others. It is safe to say that there are literally hundreds of methods in use today, although almost all of them use wax castings and either ceramic shell or traditional, solid, plaster-based investments. Within those limits the variations are endless.

So, with that introduction, let's make sculpture.

GETTING STARTED

A lot of people seem to think that the only requirements for becoming a sculptor are a wooden board, some wire, a little soft clay, and a checkbook. If you have the money you can mush together just about any kind of small sculpture, have a professional bronze foundry cast it into bronze, and presto—you're a sculptor. Now for the real requirements.

First, you need a suitable place to work. It must be equipped with certain minimum items, but is better if equipped with more. You need to acquire a firm grasp of sculpture technique of the purely physical sort, as well as a grasp of human anatomy if you're going to make images of humans. And just as a doctor needs to know about medicine in general, you need to know about sculpture, and that means sculpture history.

A PLACE TO WORK

The two main ingredients for a good studio are space and light. As for space, a studio can be simple, elaborate, or anything in between. Many people do fine work in a spare bedroom, a basement, or part of the garage. Matisse even made sculptures in bed! But for most people, there should be enough room to move around, to store some things, and to be able to stand back a bit from the work. The floor should be one that can get messy, such as a basement or garage floor, or a nice floor covered with sheets of plywood or a heavy covering.

If you can find a space bigger than a spare room or basement corner, so much the better. Turning the entire garage into a studio is one option—let the car sit outside—or take a large space in the basement. Alternatively, many people borrow or rent space in unused industrial buildings. Such space is good psychologically because you "go to work" by leaving home, and are encouraged to stay working rather than run into the living room for a sit-down and snack (and maybe just a tiny bit of TV) every time you feel the slightest bit tired. Also, the ability to make some noise without disturbing others is an advantage.

Light, however, is actually more important than space. There are several kinds of light. The best is natural light, and the best natural light is overhead light, which means skylights.

If you are converting a garage or similar single or top-floor space into a studio, consider installing simple skylights. The old complaint about them leaking has been largely eliminated by new sophisticated designs, and they are easy to install.

The second-best type of light is good window light, the more the better. Naturally, windows on the opposite side from the predominant position of the sun (north in the Northern Hemisphere, south in the Southern) are best. Windows facing the sun are a problem when the sun shines in directly, but this can be cured in a couple of ways. One is to buy and use blinds, whether venetian or pull-down; another is to install those bumpy plastic diffusers for fluorescent lights right over the windows. These not only diffuse the light very nicely but create privacy as well. Finally, you can even spray the glass lightly with white spray paint.

You will also need artificial light for working at night and on dark days, and for areas natural light won't reach. And of course if natural light is impossible (in a basement, for example) you will need to depend entirely on artificial light. The best artificial light is a combination of fluorescent and incandescent light. Mount strong full-spectrum fluorescent bulbs on the ceiling for general background lighting. Don't skimp, but place them no farther apart than the tubes are long.

Next, you should have good floodlights to aim at your work. The easiest system is a track lighting system, available at any home building store. Mount the tracks so they illuminate the work from all sides, and buy enough fixtures—usually a minimum of four—to give good all-around light. Regular incandescent floods are fine, but halogen floods are better. They give a cleaner, whiter light and are more efficient, giving more light for energy used. The come as bulbs that screw into the same sockets as ordinary bulbs, cost very little more, and

are available wherever lighting supplies are sold. Don't buy spots as the beam is too narrow. Get floods.

Once you have your space and lighting settled, install some countertops along one wall to hold supplies, perhaps with boxes or cabinets underneath, and also to afford a work surface. Simple shelves attached to the walls above the counters will also provide lots of space for the many cans of liquids, boxes of brushes, and other materials that accumulate quickly.

If possible, try to keep one wall clear and paint it a nice white. This is a good surface to work against so you can look at your sculpture without fussy background clutter. You can also use it as a background when photographing your work.

A sink is very handy. Try to arrange plumbing and install a sink, even if it's a cheap one. Many building stores sell small water heaters that can be installed beneath a sink; if you buy one you'll be very glad you did. You may also wish to install a sink with a good plaster-proof trap (diagram on page 77).

I have known people who outfit a garage into a studio and forget to add heat. In the winter it's too cold to work, and freezing can ruin all sorts of things. I believe the studio should be as comfortable a place as possible, preferably with a good source of heat and an air conditioner if you live with hot summers. I like music when I work so I have a good sound system. A toilet, a coffeemaker, a small refrigerator—anything that will keep you in the studio instead of running into the house is a good idea.

EQUIPMENT AND SUPPLIES

Sculpture, unlike writing poetry, is equipment and supply intensive. They say a poor carpenter blames his tools, but a good carpenter only has great tools. Here too, the equipment, tools, and supplies you buy are directly related to the quality of work you create. Always buy the best you can afford and treasure them.

Please note that all measurements in this book have been given in English standard, which means inches, feet, and ounces. A conversion chart has been provided on page 229 for those working in metric-standard countries.

■ *Modeling stand:* The first piece of equipment you will need is a good modeling stand, and more than one if you can afford them. There are several on the market, so here's what to look for: some kind of up-and-down crank mechanism; three legs (not four as four will wobble); legs that reach well out so the stand is stable; and large, heavy-duty casters for easy rolling. One stand that meets these requirements is the one manufactured by the Loveland Academy of Fine Arts in Colorado. The stand is a bit costly but is wonderful, and will last all your life. Sculpture House makes a good crank-up stand, the "Excalibur," which has the advantage of folding up for easy carrying. The crank mechanism is cast iron and can break with heavy banging, so be careful. Sculpture House also makes the "Hercules," an extra heavy-duty stand that is excellent. (See the list of suppliers for contact information.)

If you find another stand, look for the quality of construction and of the cranking mechanism, if it has one. If the

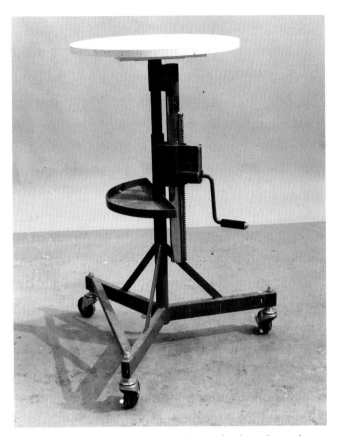

A modeling stand manufactured by the Loveland Academy of Fine Arts.

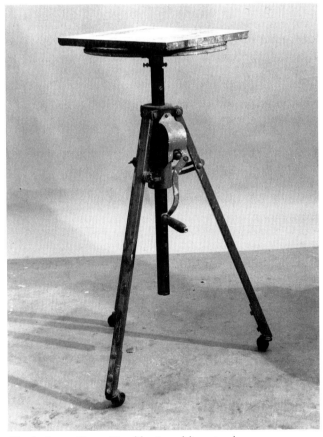

The Sculpture House "Excalibur" modeling stand.

mechanism is the kind that slides up and down and is held with a pin, be sure there are plenty of closely spaced holes for fine height adjustment.

If you have access to a welder (either the machine or a person), you can design and make your own stand. Crank-up mechanisms can usually be bought from trailer supply houses as they are used to crank up the hitches on heavy trailers.

■ *Saw:* You will need some way to cut wood, such as the boards you model on. The best option is a table saw. They are available in many sizes and will serve you all your life. A 10-inch table saw is a good size. Larger isn't necessary and smaller can be too light for some jobs.

A table saw can take up a lot of room, so if room is tight consider a 14-inch band saw. These are available from many sources and cut wood very well, as long as the cut is no more than 14 inches from one edge. Band saws are valuable even if you also have a table saw.

A third and easier option is a handheld circular saw, contractor style. Again, these saws are available at any hardware or builder store. The 7 ¼-inch size is the most common. To use it, lay a slab of 2-inch-thick Styrofoam on the floor and place the sheet of wood you wish to cut on top of it. Adjust the saw so the blade protrudes no more than 1 inch from the bottom of the board you are cutting, and cut away.

Yet another option is a saber or skill saw. These can be used with the Styrofoam as well, and can be fitted with blades to cut metal and even ceramic tile. These saws can also cut curves. And finally, if you're really on a budget, buy a simple handsaw. It's worked for hundreds of years—it'll work for you, too.

No matter what type of saw you use, it's the blade that does the cutting, so be sure to invest in the best blade you can afford. Carbide tipped is virtually a must. Get a good general-purpose blade—both for ripping and cross-cutting—and, if you can afford it, a smooth cut blade for cross-cutting only.

■ *Drill press:* If you're like me, you'll find that you turn on the drill press more than any other tool in your shop. They are easily available—every building store has a variety for sale—and many are quite inexpensive. Drill presses come in various sizes, with the bench model and floor model the most common. If you can afford it, the floor model will be the better buy in the long run. While you're shopping, be sure to buy a drill press vise, which you use to clamp pieces as you drill. It can save your fingers—really.

■ *Bench grinder:* A small bench grinder is very handy. A 6-inch model is fine, and you can replace one wheel with a wire brush for easy cleaning of tools and the like. Remember to *always* wear a full face shield when using the wire wheel as it shoots little spears out occasionally and you really don't want one in your eye. Hang a hook on the wall next to the bench grinder and hang the face shield on it so you won't lose it and be tempted to use the wire wheel without it "just this once." Also, whenever you are cleaning something against the wheel, *always* hold it so it drags against the downward turning brush and won't catch.

■ *Belt/disc sander:* Again, this tool is readily available and very handy. The disc part will measure either 9 or 12 inches across. The best belt size is 6 by 48 inches. The best discs have a peel-off self-stick back.

■ *Bench vise:* Don't forget this tool—it is nearly indispensable.

■ *Hand tools:* You will need the usual—hammer, pliers (slip joint, regular, and needle nose), a good wire cutter, scissors, a selection of screwdrivers, perhaps an electric screwdriver and a selection of bits, and a good electric drill. A hacksaw is handy as well. This might seem like a lot to buy at once, but you can start out with just a few pieces—I began my sculpture career with a handsaw and a hand drill. Buy tools as the need arises and you'll soon have a good collection.

■ *Wood:* You'll need wood for armature bases. The best strategy is to phone cabinetmakers in your area and ask if they have any sink cutouts. These are the pieces of plastic laminate-covered particleboard that are left over when a sink is installed in a counter. Many cabinetmakers have stacks of them and will either give them away or sell them for very little. If you can't find sink cutouts, buy some decent ¾-inch plywood.

■ *General armature supplies:* You need general armature supplies (see pages 28–29), and things like wire, nails, screws, and heavy staples. For screws, look into drywall screws as they can be run in quickly with an electric screwdriver and need no pilot holes. They can also be removed just as quickly, a fact you'll appreciate before long. Get an assortment of sizes and you'll love them.

■ *Clay:* See pages 18–24 for more information about clay.

With these supplies you can get started. Buy other things as the need arises.

KNOWLEDGE

Skill is the physical application of knowledge, so to build skill, we need first to gain knowledge.

Knowledge of Technique

In his book *David Smith by David Smith*, the sculptor David Smith wrote: "Technique is what belongs to others, technique is what others call it when you have become successful at it." Most of us are adept at countless techniques learned throughout our lives—tying a tie, driving on the freeway, using a telephone. These are all things that would baffle a person arriving fresh in our modern world. So it is with sculpture techniques. We learn them one by one as problems arise. This book will outline and detail a great many techniques, but none of them can be assimilated without repetition. And, just as we tie a tie with our own particular twist, so sculpture techniques will take on an individuality with every sculptor.

Nonetheless, a deliberate learning of certain, often difficult techniques is essential. Learning to weld, for example, won't just happen if you hang around a welding shop. You must find instruction, either from an instructor or from a book. You must try welding, try it a second time, analyze problems, and practice. Soon you will have learned sculpture techniques just as you learned the techniques of modern life.

Knowledge of Anatomy

It's a curious fact that, though we are humans, we know very little about what the human body actually looks like. We can recognize when something is wrong with a modeled figure, but we can't take clay and create one that is right—at least not without long study. Likewise, our ability to recognize and read human faces is extraordinary. We can remember someone we met briefly even a year before, yet we are quite unable to describe the faces of those close to us. We can read the smallest nuance of expression in a face, yet beginners invariably create clay heads with gross distortions.

When making sculpture we must tread a careful path, combining two aspects of knowing. We must learn to see as though the human form is utterly new to us, and we must also accumulate as much factual knowledge of anatomy and physiognomy as possible. *It is the application of observed particulars on a base of learned knowledge that is the foundation of the good figure sculptor.*

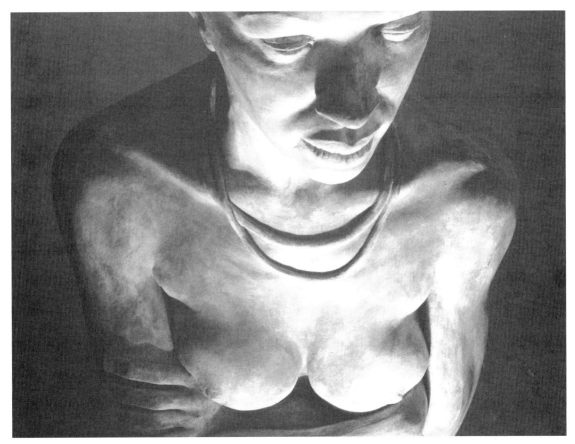

African Queen, *Tuck Langland, 1989. Life-sized plaster. An example of the endless variety of form found in the human body, ideal for creating exciting sculpture.*

We as sculptors must attack this complex and lifelong struggle from three directions. Firstly, we must work from the living model at every opportunity, observing afresh the forms of the wonderful machine we each inhabit. Secondly, we must study anatomy books to learn the inner workings of that wonderful machine, to learn to recognize, in the particular individual, those muscles and bones that, though unique in each of us, are common to us all. And thirdly, we must always remember that we are making sculpture, not taxidermy humans.

Knowledge of Art History

Humans have been making sculpture for something like 35,000 years, from the earliest Paleolithic fertility goddesses to the most current gallery installations. Virtually every problem you will encounter as a sculptor has been encountered before—and solved in one way or another. We can learn so much from the sculpture of the past; we don't need to reinvent the wheel. The very substance of human progress is our ability to learn from the past and thus to build on, rather than repeat, the efforts of previous generations.

Another great advantage to studying sculpture of the past is that time is the great filter. Those works that are less successful, which resonate less well with our deeper sensibilities, have been discarded, leaving only the works that have, to use the old cliché, passed the test of time. When looking at the current crop of works in the galleries one often struggles with the question, "Yes, but is it any good?" When looking at sculptures from the past as seen in the great museums and in books, that question has pretty well been answered for us.

A third reason to study art history is to get the broad view. When hiking we like to climb up on a high hill to survey the land before us. So it should be with art. Too often we view sculpture with tunnel vision, just seeing the tiny fraction of the world's sculpture that lies directly before us. Art history shows us how people from very different times and places have dealt with the fundamental problem of creating images of ourselves.

My advice is to look at as many books on sculpture as you can. Haunt libraries, buy the books you can't live without, travel to cities near you and visit the museums, and then travel farther as time and funds permit to see the major works of the human race face-to-face. As valuable as photographs are, they never truly substitute for seeing the real thing. All I'm asking is for people who love sculpture to let themselves love sculpture. Immerse yourself in it, and learn all you can. Read the biographies of artists, the reviews by critics, the analyses by art historians. And look at the pictures, look at sculptures, look a lot. More knowledge is better than less knowledge.

THE PROCESS

The process of creating a sculpture in bronze is very mystifying to most people. I have been asked the question hundreds of times: "How do you do that?" Some people wonder if I pour molten metal over the clay, or dip it into hot, liquid bronze. Others ask if I carve the works from solid blocks of bronze, and once I was asked if I put on heavy gloves and formed the metal while it was hot.

The process of bronze casting is, in fact, complicated, but it is easy to understand once a few quick principles are explained. The flowchart shown opposite and brief introduction below sketch these principles in broad strokes, providing context for the chapters that follow. (Please note that while this book offers several alternative methods for bronze casting, the particular process shown opposite and described below, called *lost wax casting*, is by far the most common method in use today.)

The initial clay piece is first covered with a rubber mold, creating a hollow version of the sculpture. Hot wax is then poured into this mold and poured out again, leaving a shell of wax, which, when removed from the mold, is a hollow wax version of the sculpture. The inside and outside of the wax is coated with a fireproof mold material called the *investment*. When dry, the investment is heated to melt out the wax, leaving a gap inside shaped exactly like the hollow wax. Melted bronze is then poured into the investment to fill this gap, and when cool the investment is broken off, leaving a hollow bronze reproduction of the original sculpture, right down to the fingerprints. This is then cleaned up, a process called *chasing*, and a *patina*, or chemically induced color, is applied. The bronze is mounted on a base, and is finished.

The flow chart also shows a detour you can take by sending your clay original to a professional foundry and letting the foundry do all the work. You can also have the foundry do only part of the work, while you do the rest yourself. But even if you use a foundry, it's a good idea to read this book carefully so you understand what happens as your piece makes that wonderful transition from clay to bronze.

And what if you don't want a bronze? This book will also offer several alternatives to bronze casting, many of which you can do in your home or studio. You'll find them in chapters 7 and 10.

From Clay to Bronze: Lost Wax Casting

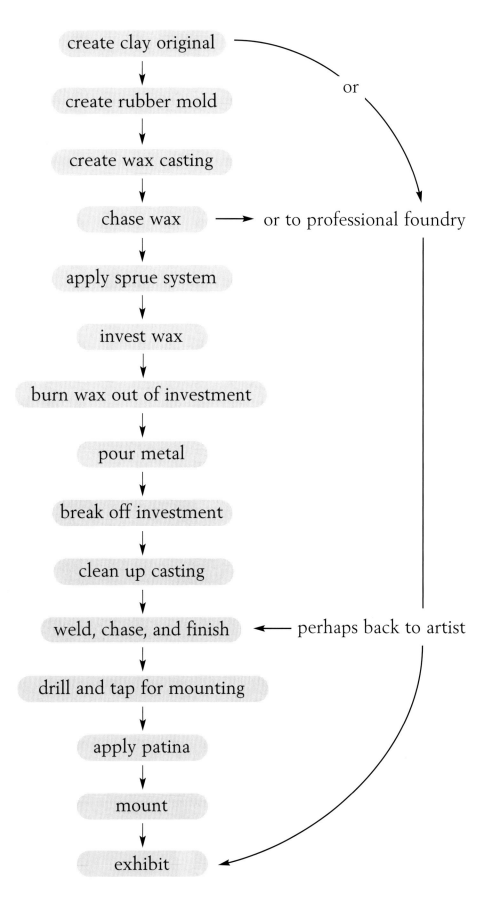

create clay original

↓

create rubber mold

↓

create wax casting

↓

chase wax → or to professional foundry

↓

apply sprue system

↓

invest wax

↓

burn wax out of investment

↓

pour metal

↓

break off investment

↓

clean up casting

↓

weld, chase, and finish ← perhaps back to artist

↓

drill and tap for mounting

↓

apply patina

↓

mount

↓

exhibit

or

MATERIALS FOR MODELING

All sculptural materials must meet at least two requirements: the material must be capable of being manipulated into a sculpture, and it must meet the permanency requirements of the intended work. Many sculptural materials are themselves hard and need not be changed when the sculptor is finished. Stone and wood can be carved, and steel and other metals can be cut, ground, bent, and welded into sculptures. Found objects fit into this category as well. On the other hand, many sculptures are created of materials that are soft and easy to manipulate, and are then converted to something hard. Clay, wax, plaster, and papier-mâché are examples of these. This chapter will deal with the most common of this second category: clay and wax.

CLAY

Clay occurs plentifully in nature all over the world, usually around streams and lakes, and is perhaps the oldest sculptural material known. There are clay sculptures still in existence that were made perhaps 20,000 years ago and were never fired, but are only dried out. A perfect example is the famous pair of bison in the caves at Tuc d'Audoubert in the Pyrenees in southern France. These bison were modeled with bare hands, and a stick was used to incise a few details. They were created from naturally found clay deep in a cave, and since they were completely protected throughout the centuries they are still in perfect condition, even though they are just dried clay.

Clay can be easily dug, worked, and then fired to become hard, waterproof, and permanent. Clay has been the main substance used by peoples around the globe for making utilitarian objects, primarily bowls, basins, cups, jars, and the like. It takes an infinite number of surface decorations and treatments, and though easily broken it is also easily replaced, so it is a very practical material indeed. This use of clay, of course, relies on the principle of a soft material that is transformed into a hard one through *firing*, or heating to red heat. But that is only one way to make a clay object permanent. Another way is through *casting*, which involves molding the object and then replacing the clay original with another

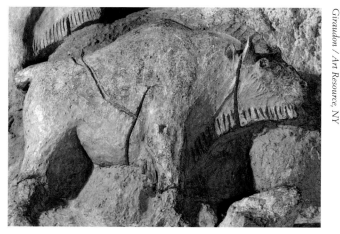

Bison from cave at Tuc d'Audoubert (Ariège, France), c. 12,000 B.C. Clay, approx. 2' (0.6 m) long. Musee des Antiquites Nationales, St. Germain-en-Laye, France.

material. This is the process used for the majority of sculptures created originally in clay, and will form the major emphasis of this book.

There are three major categories of clay used for sculpture: water clay (sometimes called pottery clay); oil clay (sometimes called plasticene, plastilene, or plastilina); and several self-hardening or very low-fire clays.

Water Clay

There is a truly limitless variety of clay found in nature, all of which is considered water clay. But although it is found in every corner of the world in great quantity, water clay from each location is a little different, and even differs within a single locale. Clay merchants mine clay, dry it, pulverize it, sift out rocks and other impurities, and then analyze the clay and blend it with other clays to create reasonably uniform products that are sold under a wide range of names.

So what exactly *is* clay? Chemically, it is four elements bonded together: oxygen, hydrogen, aluminum, and silicon. But in clay form they become aluminum oxide (alumina), silicon oxide (silica), and hydrogen oxide (water). The alumina and silica form hexagonal plates that slide easily over each other, making clay soft—but only when water is present to serve as a lubricant. As the water evaporates, the lubricant disappears, and the clay becomes hard. When clay is heated, the atoms forge an extremely strong bond that is highly resistant to heat, thus fired clay is very fireproof. In addition to alumina, silica, and water, clays in the natural world always contain a host of impurities that alter their structures and, more obviously, their colors. So of the many thousands of clays on the market, it is the impurities that form the differences.

Kinds of Water Clay

Most water clays fall into three general categories: earthenware, stoneware, and porcelain. Earthenware is fired at the lowest temperature of the three, and is also the softest. It is usually very creamy and *plastic*, which means sticky and stretchy, and is often colored a rusty red due to the presence of iron oxide. This is the kind of clay usually called terracotta. It is probably the best water clay for sculpture.

Stoneware is stronger and is fired at a much higher temperature. It is usually less plastic than earthenware and sometimes a little coarse. Its main advantage is the much harder product it forms when fired, making it good for pots. But for clay modeling it is generally considered a little less suitable than earthenware.

Porcelain is clay that has had all the impurities refined out of it, which is why it is pure white. While it can work reasonably well, it is usually not as plastic as earthenware, and generally a little less suitable for modeling. Its chief advantage is its beautiful white color after firing, and the effect that the white color has on transparent glazes, which blaze with life on good porcelain.

Additives to Water Clay

Water clays often contain additives to aid in firing, the most common of which are grog and sand. *Grog* is clay that has been fired and crushed to a powder. Grog and sand both come in a variety of grits, or coarseness, and can be added in varying proportions. The coarseness of grit is measured by the number of grains that, end to end, would measure 1 inch. Thus an 80-grit grog is relatively coarse, while a 200-grit grog is much finer.

Some clays contain very fine grog in small amounts, making it hardly noticeable. Others may contain coarse grog or sand in large amounts, making a very grainy, gritty clay. These types of clays are designed to be fired in thick sections and used on textured surfaces, and are usually not very suitable for fine modeling.

Obtaining Water Clay

Clays are almost always mixed, and special clays can be mixed for special purposes. Most earthenware is red, but some is gray, and the two can be mixed together for a very nice color. Ask your clay merchant to make a batch for you. Also, ask him or her to add perhaps 10 percent bentonite, an ingredient that adds stickiness. Most ceramic supply houses can devise a good formula using these ideas to mix clay for you.

Plasticity, or stickiness and stretchiness, is a very desirable characteristic in clay. Newly made clay is usually *short*, that is, somewhat crumbly, compared to old clay. This is because bacterial action increases the organic compounds in the clay that create plasticity. To increase the plasticity of new clay, people often age the clay by wrapping it securely in plastic and storing it in tightly covered plastic garbage cans for six months or so. Another way to increase plasticity is to feed the clay's bacteria by adding beer or vinegar to the water with which the clay is made.

Short of having clay made up specially, an easy place to get ready-made clay is any local ceramics shop. Use the Yellow Pages and look under "Ceramics" to find a shop in your area. Chances are there is one within reach, and it sells ready-made, moist clay in 25-pound blocks for a reasonable price. Try to visit the store and feel the various clays for sale to find one you like. Ask about any grog or sand content and be sure you like the feel of the clay in your fingers. You should also run a tool over the clay to see what kind of surface results.

Maintaining Water Clay

When you buy water clay it will usually come mixed and moist, sealed in plastic bags. This is perfect for working with immediately, and needs no further preparation. Many sculptors like to buy new, fresh clay for each major project, then throw it away when finished and buy new clay again. If the idea of throwing away all that clay doesn't appeal to you, you can recondition your old clay and use it forever. There are three major ways to recondition old, hard water clay. I will describe them in order of difficulty.

The easiest way to rework old clay, and the one involving the least equipment, is to use a cement floor. Let your old sculptures and clay dry out completely, then dump them on a slab floor and beat on them with a hammer until the clay is broken into lumps no larger than an egg. Now water the whole mass down well with a hose. It will take more water than you think, so get it good and wet. Cover it well with a large plastic sheet and wait a day, or even a few days. Remove the sheet and, using a floor scraper, chop the clay thoroughly with a downward chopping motion. It will now need more watering, covering, and waiting. Chop and water the clay every day or every couple days for about four or five times

and then, when chopping the clay, pick up lumps of it on the scraper and slam them down again, forcing the clay particles together. Finally, when it begins to feel like real clay, give it one more good chopping. Slam chunks of it down into garbage cans for storage, and you will have a reasonably nice batch of workable clay. It will help to pull chunks from the can and rework them in your hands as you are building up. This method involves virtually no equipment, doesn't actually take much working time, and produces a large quantity of sometimes lumpy but generally quite workable clay.

A second method for reconditioning old clay is by using a pug mill, a heavy mixing machine for clay. This is an expensive piece of equipment, but you may be able to use one in a local college or university pottery department. To use it, break up the dry clay and wet it down well, as just described, this time making it into a soft mush. This will take a couple days of soaking. You should also have on hand bags of dry powdered clay of the same type you are using. Then begin feeding the mush into the pug mill, adding dry powdered clay as you go and varying the proportions until what emerges from the pug mill is the approximate consistency you want. You may have to pass the clay through the mill two or three times before it's right. This method does involve an expensive piece of equipment and does take considerable time and work, but it will produce the most perfect and even batches of clay of any method.

The third method is especially useful when your clay has gotten contaminated with plaster, nails, and other bits of

nameless junk. For this method you break up the dry clay as usual, then fill about one-third of a clean garbage can with the clay and another third with water. After letting the clay soak for a few days, use a heavy propeller on a shaft in a powerful electric drill—or even a drill press on slow speed—to stir. You should, with some effort and persistence, create a nice creamy slip. This can then be strained, and you'll probably be amazed at the junk that was in there. Finally, get rid of the remaining water in the slip by spreading it out on a large concrete floor and leaving it for a couple days, with frequent scrapings and turning. Don't expect nice even drying as the edges will go dry while the middle is still a lake. But with enough work, and finally using the chopping and slamming techniques of the first method or running it through a pug mill, you can get beautiful, soft, junk-free clay. Another way to remove water in the slip is with plaster drying bats (see opposite). After the drying bats are made they must dry several days to lose their residual water, but once dry they will soak water from slip very efficiently.

Storing Water Clay

Metal or plastic garbage cans work well for storing water clay. Metal cans will often rust out on the bottom, so it's a good idea to line them with heavy plastic sheets before adding the clay. Plastic cans work well, but may split if too much clay is put into a large one. Also, be careful if chopping around in there with a floor scraper as you can easily go through the side of the can. If you're very lucky, you will find a plastic garbage can that slips nicely inside a metal one.

Cover the top of the clay with a plastic bag pressed down to form a tighter seal than just the lid, which often doesn't fit well. Resist the temptation to pour water in the can if the clay seems a little hard—the water will mostly just drain to the bottom and make mush. A better idea is to lay sodden towels across the top of the clay and then cover with plastic.

Working with Water Clay

There are two major concerns in working with water clay: adherence to the armature and maintaining moisture content. Water clay will slip off armatures much more readily than oil clay. That means your armature should have more solid areas, and in particular more horizontal surfaces, than are necessary for oil clay. Fill open centers with blocks of Styrofoam wrapped in plaster-soaked rags. You can also bolt in pieces of wood, and use butterflies (two short wood sticks bound into a cross with wire) freely. And don't forget the simple trick of building up from the base with clay. In a head, for example, on a simple head peg (see illustration, page 30) you can squeeze a column of clay right down the vertical pipe to the board. This will do wonders for keeping the head from sliding down the armature, and is particularly important for a large head, or one including heavy shoulders. This support need not be cast.

If clay does start to slip off your armature, there are some cures. One is to add support under the clay, either building up more clay from the base or using sticks and supports of any kind (which are removed before casting). Another good method is to

Chopping clay for reworking.

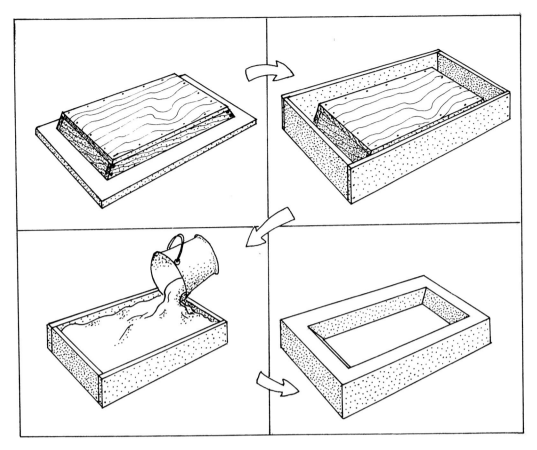

Making a plaster drying bat. Top, left to right: the wooden form, about 2 feet long and well greased with petroleum jelly; the form with walls. Bottom, left to right: pouring the plaster to fill the form; the completed bat.

dig some of the clay away to expose the armature, and then add elements such as pieces of wood, masses of plaster, or butterflies. Then replace the clay. In the case of a portrait head wiggling on the head armature, or tipping due to a weak armature, try driving steel rods from the top of the head right down through the bottom to come out parallel and lying close to the main pipe. Push the rods down far enough so they don't stick out the top of the head, then bind them to the pipe of the armature at the bottom with rubber straps (see illustration, page 22).

Another important trick when using water clay is to use the natural hardening that comes from drying. Rodin used to model as often as possible without using armatures at all. His trick for a head was to create a tall cone of clay on a board, let it dry out a day or two until it became nice and stiff, and then build on the cone with fresh soft clay (see illustration, page 26). This way he could actually slice the head off at the neck with a wire, hold it in his hands for study from all angles, and then reattach it with a wipe of a damp sponge. As you look at Rodin's figures in museums, note how many have large masses of clay that were essentially armatures. You can use the same trick by building the central core of your sculpture a day or two in advance and letting it harden before continuing. (This will be discussed in more detail on pages 26–27.)

Maintaining moisture content is another constant concern when using water clay. For most simple works, you can simply cover your sculpture tightly with a plastic garbage bag well tied-up at the end of each session. This will serve for many days. You will notice, though, that despite this the clay will begin to dry and harden. In most cases this is fine, as the hardness comes when you are moving into more detail and surface finish anyway. However, in a long project, or one with small parts that harden too soon, you will want to add moisture back again to replace that which was lost while you worked on the exposed clay. In almost all cases, you can simply spray water on the clay with a spray bottle. Just spray well before closing up for the night or occasionally while working, particularly on areas you're not working on at the moment.

If the clay begins to get really dry and you want to soften it considerably, wrap the piece with moistened rags before

TIP

The biggest *disadvantage* to water clay is that it dries out. The biggest *advantage* is that it dries out. Here's what I mean. When you use water clay you must always keep it moist and covered between sessions or it will dry, become hard, and crack. This is particularly problemmatic for small fussy work, like a small figure with thin limbs. These will dry and fall off if not maintained very carefully at just the right moisture level. But for work that is more massive and does not have thin projections, such as a portrait head, the ability of water clay to dry out becomes an advantage. Water clay is very fast for initial buildup. Then, as work progresses and time passes, the clay begins to dry and harden, allowing ever more refined detail and surface finishing.

A head armature with butterfly.

Using steel rods to stabilize a loose head.

covering with plastic. Depending on how wet the rags are, and how often you rewet them, you can take the clay from nearly rock hard all the way back to so soft it falls off the armature, and anywhere in between. If you're planning to wrap and leave a sculpture for a long time, double or even triple bag it. Using damp rags and well-wrapped plastic, a water clay sculpture can be kept moist and workable for years. If you use this method to keep a work going for months, you may find that you eventually get mildew and mold on the clay. A partly effective solution is to wet the rags in water with a little bleach in it, but then the sculpture gets a bleach smell.

Oil Clay

Plasticene, also called plastilene or plastilina, is clay in which the water has been replaced by an oil and wax mixture. The main reason for this is so the clay never dries or hardens. Oil-based clays cannot be fired—if they are placed in a kiln they will first melt into a puddle, then catch fire.

Obtaining Oil Clay

Oil clays are manufactured, and come from a number of sources. Here is a list of suppliers with the various clays they sell, and some comments about each to help you make a selec-

tion. See the list of suppliers at the back of the book for addresses, phone numbers, and, in some cases, web sites.

■ Chavant is the major manufacturer of oil clays in the country, and owns facilities in Europe and Japan as well. Their main products are the hard-styling clays used in the auto industry and other similar design applications, but they also have a very keen interest in sculpture and produce several fine sculpture clays. Le Beau Touché is their main sculpture clay, but they make others as well. Call or write for samples.

■ Classic Clay makes an excellent sculpture clay, also called Classic Clay. It comes in two colors (dark brown and pale tan) and each color comes in two consistencies (hard and soft). The hard version is best for warm climates like the south or southwest; the soft is better for the northern areas and the Midwest. There is also an extra-soft version of the pale tan color, which is for those who really like to slide clay around without worrying about refined or detailed surfaces, or for people who live in the Arctic. The dark brown color is something like brown sculpture wax, and gives a good feel for what the piece will look like in bronze. The pale tan is about the color of blond wood, and though it doesn't look much like bronze it is a little easier to see when modeling.

A great advantage to Classic Clay is its strength. It can be used with far less armature than other clays as it is very strong. Small figures can omit armatures in limbs with little trouble. It is ideal for quick models or maquettes simply formed in the fingers. And it is good for large works as slabs can be squeezed out and formed into cylinders, which can then become body parts without armatures.

■ Sculpture House sells Roma Plastilina, which has long been the most popular clay around. It is a gray-green clay that comes in four different consistencies: soft, medium, medium firm, and extra hard. There are two problems with this clay, however. One is that it has a tendency to crack and break apart after time. If you use it to make a piece and then leave that piece for a few months, you might find it cracked and falling apart when you return to work on it. Another problem is that the clay contains sulfur, which can inhibit the setting of certain flexible mold compounds. When taking a mold from Roma, it is usually necessary to coat the clay with shellac or lacquer, then coat further with a release agent—this extra step is not necessary with Chavant or Classic Clay. To remedy this problem, Sculpture House now offers a sulfur-free version called Prima, which is available in natural tan and only one consistency.

■ Van Aken International produces a line of plasticenes in various colors. These are fine, workable clays, similar to many others on the market but probably not, in the end, as specifically formulated for sculpture as Chavant or Classic Clay. Call or write for a list of distributors.

■ Many other manufacturers create oil-based clays, often for children and schools. Look in art catalogs, school supply catalogs, art supply stores, and other similar sources to find local suppliers. Again, feel the clay if at all possible before buying large quantities. It's best to buy a small amount, make a small sculpture, and then compare to other brands before choosing one type.

Some sculptors make their own oil clay, which can be done without too much effort. First, get a big metal pot of some kind, like a large canning kettle or an oil drum cut to about 18 inches high. Place this container on bricks and build a fire underneath it. Next, pour a mixture of equal parts Victory Brown wax (see list of suppliers) and regular new motor oil into the pot. Start with one slab of wax and 3 quarts (0.9 l) of oil. You can make bigger batches later. Heat the mixture until the wax is melted and is all liquid. Now start to pour in dry powdered pottery clay of whatever type or color you want, and keep adding and stirring the mess until it gains an oatmeal-like consistency. You can test the mixture by removing a little bit, letting it cool, and then working it in your fingers to test the feel.

When you feel the mix is right (soft and workable, but not mushy), and you have stirred it as thoroughly as possible, pour the whole sludge out onto a concrete floor to cool. Work the sludge in your hands, a bit at a time, to get rid of the graininess and form it into real clay. It will get better with use and age.

Working with Oil Clay

Oil clay doesn't gain or lose hardness with moisture, so the main concern when working with it is how to have clay soft enough for reasonably rapid buildup but then hard enough for good detail and finishing work. The usual solution is to choose a clay that is hard enough for finish work, and then use heat to soften it for buildup. The following is a list of various methods to warm oil clay.

One simple method is to use a disposable aluminum foil turkey-roasting pan from the grocery store and a gooseneck lamp with a heat-lamp bulb. Cut the clay into smallish chunks and spread them out on the tray, then shine the heat lamp on them, moving it up and down to adjust the temperature and turning the clay chunks frequently. This sometimes makes clay that is hot and smeary on one side and cool and hard on the other, but it is generally a quick, cheap, and efficient method for heating.

Another easy way to heat clay is with an ordinary heating pad from the drugstore. Wrap the clay in plastic (to keep the pad clean), then wrap the pad around the clay. Wrap the whole thing lightly in a blanket and plug in the heating pad. This method is cheap and efficient, and the clay is warmed evenly. (*Caution:* Keep checking the heat, as a contained heating pad can get dangerously hot.)

A third method is a simple light box. Make a wooden box with a hinged lid and put a light bulb inside. Place the clay inside the box and spread evenly on the bottom. It is necessary to watch the clay so it doesn't get too hot in any one spot, but with monitoring and frequent turning a nice warm batch of clay can be had.

Yet another way to heat clay is in the microwave. Put chunks in the microwave for short times at first and then try progressively longer times until you find what works. Be aware that a microwave will often heat the middle of the clay while the outside remains relatively cool. It can actually melt the middle into a scalding puddle of liquid clay, and if you pull a chunk from the microwave and mush into it with your hands, you can drive a thumb into the liquid center and get a nasty burn. Be sure to cut the clay into small pieces and turn them frequently when using the microwave, and then be careful when you actually handle them. Small quantities of oil clay can also be heated in a Crock-Pot.

TIP

Different clays respond differently to touch and tool, to styles of work, and to kinds of tools, and are variously suited to different kinds of surfaces, levels of detail, and so on. The clay you select becomes a very important factor in your sculpture. This can only be decided through trial and evaluation. It is a good idea to try several different clays on different pieces—some water clays of different kinds, and some oil clays—and narrow down your preferences until you find what you like. And you might well keep different kinds of clay in the studio for different kinds of sculpture. For example, portrait heads might be routinely done in water clay, with a good oil clay for the smaller figures.

The best way to heat clay is with a proper heater box. There are none on the market that I know of, but if you are serious about making a lot of sculpture with a good quantity of oil clay, you should invest in making your own. The box itself can be plywood or particleboard, and should be large enough to hold a couple hundred pounds of clay. Mine measures 4 feet wide by 3 feet high by 1 foot deep and will fit under a normal counter. Line the box with ¾-inch foam insulation secured with panel cement (such as Liquid Nails). The doors should be on the front for easy access, and should open and close easily, even with clay-covered sticky hands, so avoid fussy latches. (My doors latch with a large wooden tab that can be easily turned with one hand.) Inside, make shelves of open wire mesh or use plastic-covered, steel, open shelving, which is available from nearly all large home improvement stores. But don't just lay slabs of clay on these shelves as they will soften and ooze through. Buy cheap aluminum foil baking trays and set them on the shelves to hold the clay.

The heart of the heater box is the heating system itself. One type of system uses light bulbs—one or more, depending on the size. Mount the bulbs on the inside ceiling of the box so soft clay won't drip onto them, causing a fire. Another option is any kind of heating strip that doesn't get above ignition temperature, but is really just a warming strip. A third alternative is a heater with a blower mounted outside the box, set up to blow air into the box through an opening. (There must also be a second opening for air to exit the box.) The best system, however, uses a baseboard heater—the type used for supplemental room heat that operate on a liquid-filled radiator principle. These baseboards can't start a fire, but as they are usually four feet long and must be set horizontally, they can't be used in an old refrigerator.

Any heater you use must be controlled by a thermostat. Most house thermostats only go to 90°F (32°C), since no one wants to heat their home hotter than that, but you need a thermostat that will reach about 110°F (43°C), such as a thermostat for incubators or drying ovens. Again, scour the local industrial suppliers and ask for a line thermostat, 110°F

(43°C) or higher max temperature, open on rise. ("Open on rise" means that the thermostat shuts the heater *off* when the box gets too hot. An air conditioning or attic fan thermostat, on the other hand, is "close on rise," meaning that it turns the air conditioning or fan *on* when things get too hot.) For Classic Clay soft, the thermostat should be set to 105°F (41°C). For other clays, you will need to experiment for a while to find what's right for you. The idea is to have the heater box turned on twenty-four hours a day, all the time, so whenever you want to work there are masses of warm, soft clay all ready and evenly heated. As you work with a warm chunk, it will cool and harden in about five to ten minutes, and then you just swap it for a fresh one and keep going. Using oil clay with a good heater box is a real joy, and for me is the best way to model.

Self-hardening Clay

These clays come in two main varieties. One kind simply air dries to become quite hard and permanent; the other is fired in an ordinary kitchen oven to about 300°F (149°C). Some of these clays shrink on drying, while others can even be formed around a bottle and then harden without cracking.

To find self-hardening clays, begin with stores catering to hobbiests or educators, since these products are often intended for children. Another good source is general suppliers of art materials, such as The Compleat Sculptor, Inc. or Pearl (see list of suppliers). If there is an art supply store in your town and they don't stock these clays, ask them to look through their catalogs and order some for you.

The biggest advantage of self-hardening clays is that you can make all kinds of models that need no casting yet are hard enough to ship, display, use for presentations, and keep indefinitely. Some artists use these clays—which come in a wide range of colors—to create wonderful works that exploit the colors and freshness of the medium. Just because they are primarily designed for children doesn't mean that a creative person can't create fine works with them.

A disadvantage of these products is that they don't generally make works of high value, as least not comparable to the perceived value of bronze. But that consideration only applies to sales, not to the ultimate worth of the work of art. Another disadvantage is that they don't always last long in their original packaging. They should be used rather quickly or they go hard.

If you're interested in trying these clays, write or call a supplier for samples and put several through their paces. Follow the directions and then be willing to fool around a little to push the medium.

A heater box for warming oil clay, shown with doors open. Note the open work-shelves and the aluminum foil trays for clay.

WAX

Many sculptors prefer to model with modeling wax. It is soft like oil clay, yet strong and lightweight, needing less armature than clay. It is ideal for small maquettes and studies, which often need no armature at all. Wax will not dry out, so it is perfect for small pieces with a lot of fine detail. And many waxes have a very smooth and creamy feel, which is perfect for loose, free modeling. A disadvantage of wax, however, is that it can be slower to work with than clay, particularly water clay. Also, some people don't like the feel of wax.

Obtaining Wax

Modeling wax is any wax that has been modified to become more like clay, which usually means that it has been made softer than in its usual state. You can buy modeling wax from suppliers like The Compleat Sculptor, Inc., and many others (see list of suppliers). They will usually have samples of different waxes that you should try before buying a large quantity.

You can also make modeling wax by melting a regular wax, such as Victory Brown, other microcrystalline waxes, or even beeswax, and adding various additives to it. A common additive is petroleum jelly for softening; another is mineral oil or new motor oil. You might try glycerin or powdered rosin for stickiness, and paraffin to harden it.

The best way to make wax is to get a deep-fat fryer (see page 121) and a gram scale. Beginning with a small batch, weigh some wax, write down the weight, and then melt it in the fryer. Now weigh a quantity of petroleum jelly and add it, mixing it in well. (Begin with about ten percent of the amount of wax you used. You can increase the amount later if necessary.) Remove a small amount of the mixture and cool it well, then feel it to see how it works in your fingers. If you want to add other ingredients, weigh them before adding. When the wax feels right, do the math to figure the percentages of each additive and get your own personal formula. Then you can weigh out larger quantities using the same percentages, and make more wax.

Once the mixture is melted, pour it into aluminum foil turkey-roasting pans sprayed with WD-40, or into a plaster bat that you have cast for the purpose and which is damp but has no free water standing in it. (The bat shown on page 21 is perfect.) This will give you nice sheets of wax that can be easily torn into smaller pieces for modeling.

Working with Wax

Model with wax just as you would with oil clay, usually over an armature of some kind. To avoid using a metal armature, cast some rods of very stiff wax (ready-made sprue material is good for this) and use them to create an armature, then apply the softer wax over it. The advantage of this method is that since the piece is already in wax, you can invest it and cast into metal directly, skipping the intermediate rubber mold and wax cast. It also means, however, that you can only get one cast as your wax will be melted out of the investment and therefore ruined.

Direct sculpting with wax has the major advantages of not requiring an intermediate rubber mold and giving the greatest fidelity to your individual finger or tool marks. The disadvantages are that you get only one cast and it is difficult to cast works with a cross section much greater than 1 inch. Thus it is fine for casting small studies and maquettes, but larger works pose something of a problem.

But wait. There is a solution. If you create a larger wax piece, say 24 inches tall or so, with cross sections in the 4-inch-plus range, you can take it to a ceramic shell foundry and ask them to insert core pins and then "shell" the piece. (See page 145 for terminology and processes.) Once they have shelled it, ask them to "burn it clean," and then to pour a layer of wax inside to about 3/16 inch thick. They should then pour a refractory core. This process will give you a one-off hollow cast of even rather large, directly modeled wax sculptures. If there is an armature, it is often the case that the armature can be removed after the piece is burned out; an aluminum armature can be melted, and a steel one can often be shaken out.

There is also a third category of materials that work like clay but burn out like wax. Two examples are Castilene and a similar product made by Classic Clay called Sculpt-a-Wax, AB300 series (see list of suppliers). These look like clay and work similarly to clay, but can be burned out directly without an intermediate mold, assuming there are no thick cross sections.

TIP

In the final analysis, nearly every cast sculpture we see began as a clay or wax sculpture, so the selection, maintenance, and handling of clay or wax is of primary importance to this kind of sculpture. Take it seriously.

ARMATURES

Langland's Law: As goes the armature, so goes the sculpture.

The armature is the rigid framework that supports the clay. It can be generic, such as a head peg that can serve for almost any portrait head and can be used over and over, or specific, created for a particular sculpture and used only once. Armatures can be rigid and self-supporting, or can be themselves supported by an outside support, usually called a *back iron*. They can be very strong and unmoveable, as is usual when an armature is used for a large piece, or flexible and capable of change once the sculpture is underway, as would be more desirable in a model or maquette. The armature can also be absent, with support provided by the strength of the clay or wax itself.

Every sculpture seems to demand its own particular armature, and the sculptor who is able to create good armatures for specific works is the one who can get this sometimes meddlesome chore out of the way the quickest to move on to the real act of creation. But if the armature is poorly made or hastily thrown together, it can be a never-ending source of vexations and trouble, sticking out where it shouldn't, failing to support where needed, or just collapsing altogether. So often we want to get this part of the job out of the way but regret our haste later when correcting poor work, which takes ten times as long as it would have taken to do it right in the first place.

SCULPTING WITHOUT ARMATURES

With that prelude, let's look at ways to avoid armatures altogether. If you were making a portrait head and just began to lump clay on a board, chances are it would slump and sag and before long you'd have a no-neck portrait with its chin on the board. But Rodin had a way of making portrait heads without armatures that was very effective, using water clay and its ability to dry and harden. You can use this method for small heads with a stiff clay like Classic Clay or a wax, but larger heads will be a problem.

Rodin began by making a tall cone of clay on his board, with the top of the cone at about the middle of where he wanted the sculpture's head to be, and the bottom large enough to support the head. He let this cone dry and harden overnight, or perhaps for a couple days. Once it became leather hard, he built the head upon it. This gave him the ability to slice the head off the board with a wire at any point to examine it from all sides—particularly from below—and then reattach it with a wipe of a damp sponge.

Rodin would sometimes use the same basic method to make a figure. One of his studies for Balzac was modeled on a large cone of clay. Once this cone had begun to stiffen, he could lay huge rolls of clay on it for legs, then fashion a torso and plop it on, again letting it stiffen before fleshing it out fully. The cone remained and was cast as part of the final bronze.

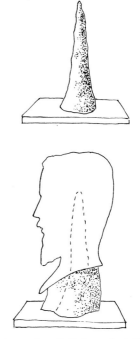

Avoiding an armature using Rodin's method. Top, a cone of clay allowed to stiffen; bottom, a head built on the stiffened cone.

A rearing horse made of water clay without an armature.

Naked Balzac, *Auguste Rodin, 1891. Plaster, 29 ¾"
(76 cm) high. Notice the clay support between the legs—Rodin
left this support intact in the final bronze casting.*

Another way to work water clay without an armature is to build a slab and roll it into a cylinder. Push the clay roughly into shape and allow it to harden somewhat. Clay can then be added and worked on the cylinder, which acts as an armature. To learn more about working in water clay without armatures, read the wonderful book *Modeling the Figure in Clay*, with sculpture by Bruno Lucchesi and text by Margit Malmstrom (Watson-Guptill Publications, 1996). The reason Mr. Lucchesi works without armatures is so the finished figure, which is hollow and without any metal inside, can be fired.

In the potteries of Stoke-on-Trent, England—home of Wedgwood, Royal Doulton, Spode, and most of the great names in English pottery—modelers create horses and other subjects in water clay without armatures so they can be cut into pieces for molding. The illustration above shows a rearing horse created without armature. The idea is to support the body of the horse, which is essentially a thick cylinder, on a column of clay, then add legs, head, and tail, each of which is supported as necessary with sticks or whatever will work. The sticks and supports are discarded when the piece is cut up for molding.

When using oil clay, the warmed clay may feel soft and saggy, but once cool it often has a lot of strength—this is particularly true for Classic Clay. Forms can be added to a core of hardened oil clay and small figures can be modeled very effectively without armatures. Limbs can be added by rolling out long snakes of clay, putting them in place, and then letting them cool to become quite strong. Soft warmed clay can be added later to flesh out the limbs.

ARMATURES

You can only go so far without an armature, and sooner or later one will be needed. You can buy ready-made armatures from various sculpture supply houses (see list of suppliers) or you can make your own to fit a particular job. In general, it's a good idea to have a generous supply of armature materials on hand so you can build what you need when you need it.

Materials

One of the best sources for armature materials is the plumbing department of your local hardware store. You will need the following materials:

■ *Pipe:* Black or galvanized pipe, with the many connecting fittings, provides a complete source of very strong, very adaptable, demountable, and reusable armature supports. Pipe comes in many diameters, with the size referring to its *inside* diameter, often called I.D., as opposed to its *outside* diameter, called O.D. Pipe walls are usually about ⅛-inch thick, so the O.D. is usually about ¼ inch larger than the I.D. For small figures, use ¼-inch pipe, while ½- and ¾-inch pipe is good for larger works. For very large works, such as life-size and larger, there are larger pipe sizes with matching fittings.

A precut short piece of pipe, threaded on both ends, is called a *nipple.* When buying nipples, there will be two numbers: the I.D. and the length, such as ¼ × 6 inches. A *close nipple* is one so short the threads on the two ends butt against each other. Longer pipe can be bought and most hardware stores will cut it to length and thread the ends as required.

■ *Fittings:* Pipes are connected with various fittings. These can be straight connectors, 45-degree elbows, 90-degree elbows, T-fittings, Y fittings, and four-way cross types. There are also fittings to change pipe sizes, such as *bushings,* or reducers, which are straight connectors that have one set of threads larger than the other (some with two female threads, others with one female and one male). There are also *floor flanges,* which are designed to attach a pipe upright to a board. See the illustration below for an array of pipe fittings suitable for armatures.

■ *Baseboard:* Perfect baseboards for heads and for figures up to half life-size are the cutouts from kitchen sinks. These are ¾-inch thick pieces of particleboard, coated with smooth plastic laminate. Call the staff of nearly any cabinet shop and they will usually be willing to give them away. They are made of strong, smooth, easy-to-clean Formica, and are just about the right size.

If you can't get a cutout, use a good grade of ¾-inch plywood. Don't use thin particleboard—it just isn't strong enough. For larger figures, double two boards on top of each other with plenty of glue and screws. For life-sized work, use two layers of strong plywood reinforced with two-by-fours underneath or, even better, steel angle iron bolted on. Don't skimp on the strength of the board. It is frustrating to be nearly finished with a figure and watch it sag out of shape as a weak board distorts. Don't underestimate the weight of wet clay.

■ *Armature wire:* Good armature wire is essential to a good armature, and the best is solid, soft aluminum, made especially for the purpose and sold in coils through sculpture supply houses and some art stores (see list of suppliers). It comes in diameters ranging from ⅛ to ½ inch, with ¼ inch being a good general-purpose wire.

There are also alternatives to this wire. Good ⅛-inch and even slightly larger wire can be found in stores like Radio Shack, where it is called *grounding wire.* It's used to ground your TV antenna, and comes in nice long coils. Though it's a

An array of plumbing parts. Top, two pipe flanges; center, left to right, four T-fittings; group of bushings, or reducers; ¼- × 6-inch nipple; straight coupler; close nipple; bottom right, elbow.

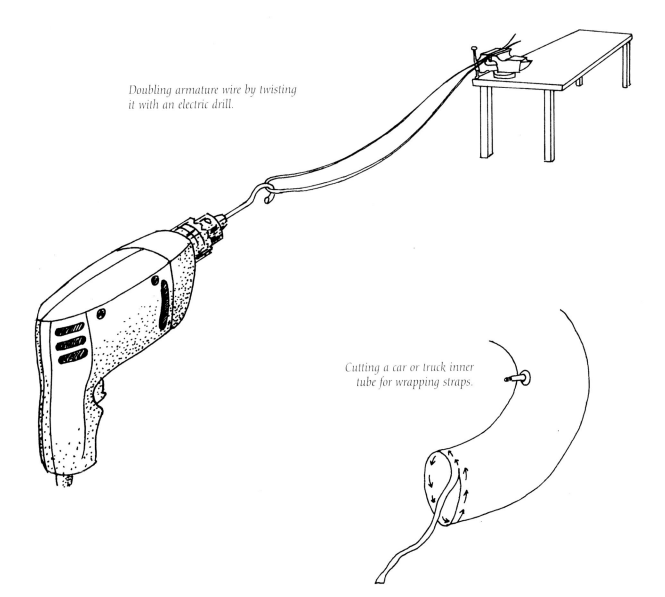

Doubling armature wire by twisting it with an electric drill.

Cutting a car or truck inner tube for wrapping straps.

little thin for any but small figures, the wire can be doubled by uncoiling it, clamping the two ends tightly in a vise, and then pulling the wire out in a long loop. Make a hook out of stout steel rod (or buy one from the hardware store), chuck it in your electric drill, and twist away as shown (see above). This not only doubles the wire, but also hardens it a little and provides a good clay-catching surface. Plastic-coated aluminum clothesline wire also works well with this method, but is a little less stiff than grounding wire.

Some large home supply stores have solid copper grounding wire in sizes very near ¼ inch. Another suitable wire is ¼-inch copper tubing, which is found in all hardware stores. Be very careful bending such tubing as it can kink easily and will drastically lose strength wherever that occurs. If you're clever, you can slip a ⅛-inch aluminum grounding wire *inside* a ¼-inch copper tube and you'll have a strong, kink-proof wire.

■ **Other materials:** Armatures can be made of almost anything, and often an armature will use many different materials. Wood is common, as is metal of varying kinds, from odd bars and rods to pieces of pipe and even scrap.

Fastening various materials together is a problem, but there is one way that is superior, I believe, to any other method: binding with rubber straps. The best source of rubber is old inner tubes. Most tire dealers will give away an old inner tube or two, and a couple of phone calls will usually locate a friendly one. Don't ignore bicycle dealers, as bicycle inner tubes are perfect. If you use a car or truck inner tube, cut around and around it, as shown above. With bicycle tubes, cut them the long way into strips. The strips should be between ¼ and ¾ inch wide, depending on how heavy a join you want to make. For very small things, buy a bag of heavy rubber bands and just snip them to get strips.

To join two pieces of an armature, lay the pieces side by side and then wrap rubber around them, s-t-r-e-t-c-h-ing the rubber hard as you wrap and wrapping it over itself so it stays. When you're nearly done, wrap one loop over your thumb and then push the free end under the loop to secure. This method will join anything to anything—it's very strong, it's demountable so you can change it easily, it's waterproof if you're using water clay, and it's free. Heck of a deal.

Making an Armature

Probably the easiest armature to make using pipe is called a *head peg*. This is simply a 12-inch length of ¾-inch pipe fitted in a ¾-inch floor flange, which is itself bolted to a baseboard. With the addition of some wires (see below), this armature will serve for modeling portrait heads over and over.

To fasten floor flanges to a baseboard, drill the board with a ¼-inch drill, then countersink up from the bottom so the head of the ¼-inch diameter *flat head stove bolts* (see illustration, page 186) will be flush. Many floor flanges will need a ¼-inch drill run quickly through their holes as they are often just a little undersized. (Be careful doing this! Clamp the flange securely in a vise and hold the drill tightly because the bit can catch.) When the bolts are through, put on washers and nuts and tighten.

To make a bust including shoulders, as shown in the illustration opposite, simply add a few armature wires to the head peg as necessary and run clay down to the board. Note the wood bound to the pipe to take up space and give the clay a better grip, and the butterflies attached by thin wire.

For very large figures, such as life-sized and above, you will need even more strength. To supply good reinforcement, attach long pieces of angle iron underneath the baseboard, drilling them so the bolts go through the angle iron first, then the baseboard, and then the flange. Naturally, as the size of the armature goes up, so does the size of everything else, including the diameter of the bolts. A good rule of thumb is make your support twice as strong as you think you'll need and you'll be about right.

Another way to make a secure back iron is to use two boards separated by lengths of two-by-fours on edge. The floor flange is attached to the bottom board, and the back iron pipe then rises through a hole in the top board, which is securely screwed down to the two-by-fours (see opposite).

A back iron in a floor flange, attached to a baseboard.

Reinforcing a back iron on the bottom side of the baseboard. (Two angle irons have been bolted on for strength.) Note that the flange bolts go through the angle irons and not just through the wood itself.

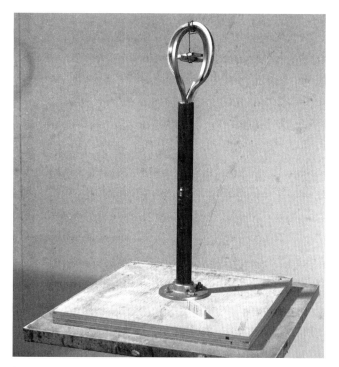

A head peg.

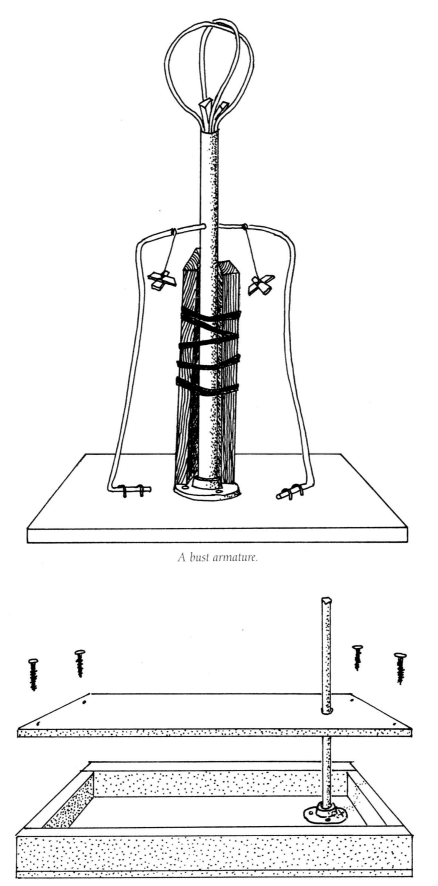

A bust armature.

The double board system for a strong base.

Securing the horizontal member

Now you need a horizontal pipe, also called a *horizontal member*, which will lead from the vertical back iron to support the actual armature. For a half life-size figure use a ¼-inch pipe. For smaller figures, use a ⅛-inch pipe. For very small figures that are 18 inches tall or less, a ⅛ by 6-inch nipple works well.

The best way to hold the horizontal member to the vertical pipe is with a T-fitting *one size* larger than your vertical pipe so it will slide over it. For example, use a ¾-inch T-fitting over a ½-inch pipe. Clamp the T-fitting in a drill press vise and drill several holes straight through, which can then be tapped for screws to lock it in place. For ¼-inch bolts, use a ⁷⁄₃₂-inch drill and a ¼-inch tap. For ⁵⁄₁₆-inch bolts, use a ¼-inch drill and a ⁵⁄₁₆-inch tap.

Since the side opening of the T-fitting will be very large (one size larger than your back iron), you will need to bring it down with *bushings*, which are reducers. Sometimes you can find a bushing that will come down a large step, say ½ inch to ⅛ inch. If you can't find one of those, buy several to come down in steps.

For larger figures, everything is proportionately larger; the middle illustration below, for example, shows a larger T-fitting. Notice that the bolts used to hold the horizontal member to the back iron do not rely on simply tapping and drilling the T-fitting, as the threads might strip out of the thin wall. Nuts were brazed on for greater strength. Notice also the bushing that drops from a large hole to a much smaller one.

There are two general ways to run this horizontal member from the vertical back iron. The most common is for the horizontal member to come straight out of the T-fitting, as shown in the illustrations below (left and center). A second method involves the Langland Special Fixture. For this system you need the horizontal pipe to be open on both ends, so you attach a second, smaller horizontal T-fitting to the first by means of a bushing and a close nipple, as shown below (right). Notice that the second T-fitting is placed so that the downward weight of the armature *tightens* the two T-fittings together rather than loosening them.

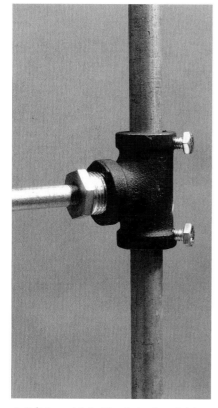

A T-fitting with locking bolts threaded in, plus reducing bushing and nipple.

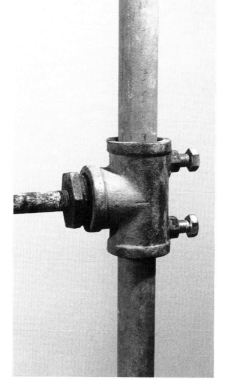

A heavier T-fitting, with nuts brazed on to increase thread strength.

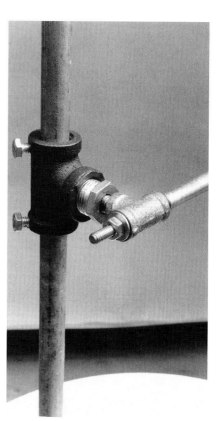

The T-fitting for a Langland Special Fixture. Note that when downward pressure is applied to the end of the nipple it will tighten, rather than loosen, the entire assembly.

Attaching the Armature

You must now securely attach the actual armature to the horizontal nipple, and this isn't exactly easy. I have described four methods below and on the next page; you may also invent others.

1. Screw a small floor flange onto the end of the horizontal nipple, using a bushing to come back up in size if necessary. Cut a short piece of steel strap and drill two holes to match two of the holes in the flange. Trap the armature wires between the strap and the flange and tighten with two bolts.

An alternative to the steel strap is to use a second flange.

2. A variant of method 1, above, is to first cut two bars of metal, such as ¼-inch thick brass, to a good length. Drill and thread the ends to take two screws, and then drill and thread the center of one bar using a pipe thread, so the bars can be screwed onto the horizontal nipple. Again, trap and clamp the armature wires.

3. Screw a small T-fitting on the end of the horizontal nipple, again using bushings to come up in size if necessary. Shove the two main armature wires through the T-fitting and secure with either wooden wedges driven in, or with screws threaded through holes drilled in the T-fitting.

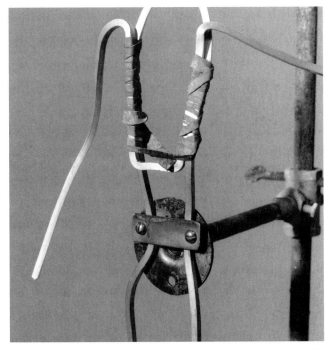

1. A figure armature joined to the horizontal nipple by means of a flange and a steel strap.

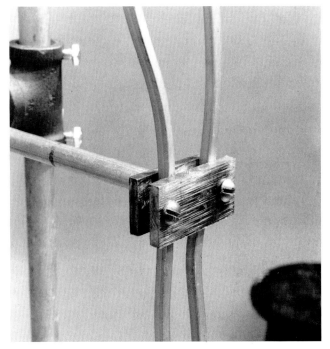

2. A figure armature joined to the horizontal nipple by means of two brass bars, drilled and tapped.

3. A figure armature joined to the horizontal nipple by means of a T-fitting and tapped bolts.

4. Finally, you can use the Langland Special Fixture. To make this fixture, get a bar of brass ½ by ½ inch and cut off a piece about 2 inches long. This is a good size for small figures. For larger figures, go up in size accordingly.

Drill five holes in the bar, as shown. First, drill one ⁷⁄₃₂-inch hole straight through the middle, threaded to ¼ inch. With the bar laid so this hole is horizontal, drill two *vertical* ⁹⁄₃₂-inch holes, one near each end. These holes will hold the armature wire, as shown. That odd size is just a bit larger than ¼ inch and assumes you will use ¼-inch wire. Keep the holes a little large or the wire will resist sliding through. Finally, drill a ⁷⁄₃₂-inch hole straight into each end of the bar, each tapped to ¼ inch to hold set screws that will secure the armature wire.

Using the sideways mount on the back iron, as shown on page 32, run a ¼-inch threaded rod through the horizontal nipple. (You might have to run a ¼-inch drill through the nipple first to clear it.) Then screw the end of this horizontal member into the Special Fixture. The other end should stick out beyond the fitting on the back iron—place a washer and nut on this end and tighten down to lock everything in place.

There are some advantages to this fixture. First, you can rotate the horizontal member, and thus the attitude of the entire armature, simply by loosening the back nut and then retightening it. But more importantly, you can remove the horizontal nipple from the figure with ease. Suppose you have finished the piece and are molding it. You make a mold over the front half of the piece, which steadies it and allows the piece to stand on its own. You could now easily remove the back iron completely, work the spot where it entered the figure, and mold the back half of the piece. And, of course, the fixture can be used over and over.

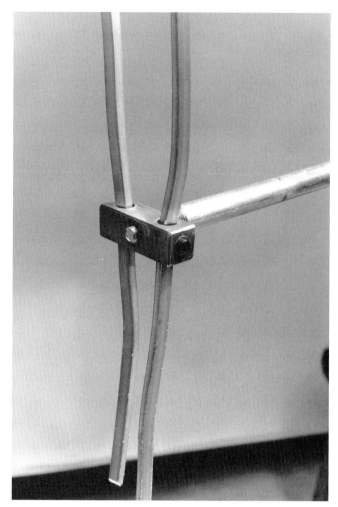

4. The Langland Special Fixture.

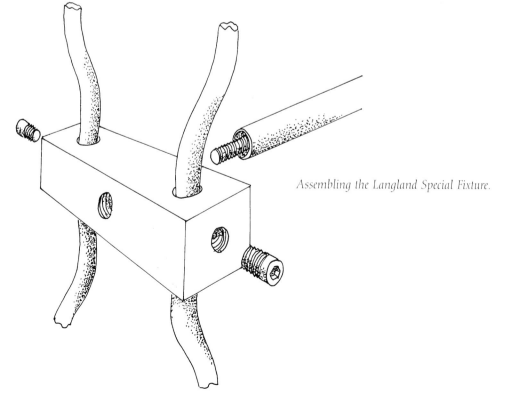

Assembling the Langland Special Fixture.

Making a Figure Armature

The human figure is a trunk with five extremities—two arms, two legs, and a head. Most figure armatures will be supported by a back iron, with the horizontal nipple entering somewhere about the small of the back. You need to have wires running from this fastening point out to each of the five extremities.

There is a tendency to join the upper chest, the two arms, and the neck all at the point where the body is very thin—the pit of the throat. It is easy to bunch these wires up and have them protruding as you work. The method described here, however, is designed to avoid this. Look at the illustration below and notice that the main figure is a single long wire running up one leg, over the *center* of the chest, and then back down the other leg. The arms are a single piece of wire that runs from one hand up to the shoulder, then down to lie parallel to the chest wire, over to the other side, up the opposite shoulder, and then down the opposite arm. The head wire is a third wire that runs down and is attached to one of the chest wires.

This method accomplishes two major things. First, it joins the chest, arm, and neck wires down in the thick part of the chest, leaving only a single neck wire at the pit of the throat. Second, it makes the two arms, though made of the same wire, quite securely fastened and independent, so if you move one arm you don't automatically twist the other arm around.

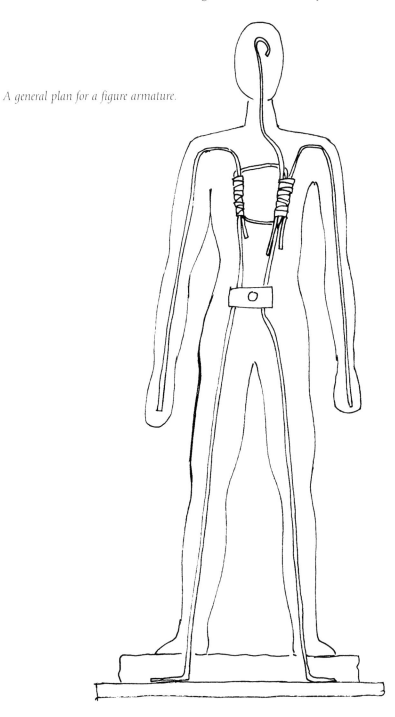

A general plan for a figure armature.

To create a figure armature, first draw out a generic figure at the size you want. I do it with chalk on the floor, but you can also use paper or any number of materials. Note that the groin should be halfway between the top of the head and the bottom of the feet.

With the figure drawn on the floor, draw the armature lines inside it. These will be the guides to which you cut and bend your armature wires. Cut all the wires to length and bend them so they lie on your drawn plan, then bind the wires together with rubber straps. In the armature shown, I simply bought heavy rubber bands from the office supply store—one snip and I have a fine rubber strap. Remember to s-t-r-e-t-c-h the rubber as you wrap.

When you have completed the armature, pass its two long leg wires through whatever attaching device you are using on the horizontal nipple and clamp tightly to the back iron. The illustration below shows a completed and attached figure armature for a small figure, 24 inches tall. For a larger figure, everything is increased in size and filler would be used (see page 37).

Making a Hand Armature

A hand armature is composed of three pieces of wire connected to the wrist piece. Using thin wire—⅛-inch aluminum grounding wire is perfect—cut one piece to form the thumb and little finger. Cut a second piece to form the forefinger and ring finger, and a third for the middle finger, which should extend out into the wrist. Join the pieces by wrapping them with rubber straps made from heavy rubber bands. For a life-sized hand, simply trace around your own hand and draw in the wires. Scale down for smaller hands.

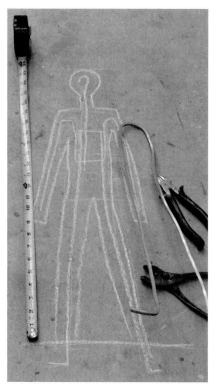
The plan drawn in chalk on the floor.

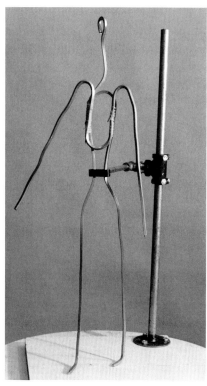
The completed figure armature, attached to the horizontal nipple.

A hand armature.

TIP Note that the ends of the leg wires in the figure armature do not represent the feet. The armature is designed to have a 1-inch thick platform of clay built on the wooden base, and the wires extend through that to the board and bend over. This holds them in place, but they can be moved. It also gives a good base to model if you wish, or can be left out of the casting. And it makes it easy to make slight adjustments in the height of the figure by adding or removing clay.

Demountable Armatures

It's sometimes handy to be able to take a figure apart while modeling, not only for ease of casting later, but for ease of modeling. For example, being able to remove the head from a large figure and place it on a modeling stand can help you avoid straining to reach over the figure while working. And hands, if they can be removed and held in any position, can be worked much more easily than if you're forced to your knees to work their undersides.

Probably the easiest way to make a demountable armature is to use square section tubing that telescopes, allowing you to slide one piece into the next. Such tubing can be bought from steel suppliers in various sizes, running from about ½ inch up to 1 inch, which should cover most things. Brass tubing in very small sizes can also be found in hobby shops. It's a simple matter to include a chunk of the larger size tubing as, say, the neck in a figure, and then slip a piece of the smaller tubing into it, to which are attached the various wires for the head. When modeling, you can then do detail work by cutting the clay around the neck, lifting the head off, and moving it to a separate board. Mount a piece of the larger tube to the board beforehand, to serve as a head peg and hold the removed head.

Likewise hands, arms, or any other body part that would be handy when separated, can be made demountable. The illustration to the right shows a demountable hand armature in place. Here, square section brass tubing from the hobby shop has been bound on the arm, and the hand member slides into it. This would eventually be covered with clay, of course, and cut where it was meant to separate.

Besides allowing you to detach parts of the armature, demountable armatures also allow you to change the length of a limb. If you're not really sure just how long a forearm should be, for example, you can use two telescoping tubes and change the length easily once the piece is underway—the clay will hold them in place. And of course demountable pieces are also very handy when it comes to casting, as we shall see.

Large Armatures

When working large, the armature becomes even more important. First, it has to carry a great deal more weight. Second, it becomes even harder to change if you get it wrong. So large armatures require special care.

In general, you proceed as for smaller armatures, but you measure everything very precisely. This should not be a problem as you will already have made a small maquette of your sculpture and should know exactly where everything has to be. It is a good idea to make a small model of the armature out of soft wire, one at the same scale as your maquette. Look at it from all sides to be sure it fits inside the maquette's form and will support clay in large masses. Now you enlarge the armature, rather than the sculpture. This way, you will be able to enlarge precisely rather than having to imagine the armature from just the maquette.

Use heavy pipe, either joined with pipe fittings or welded together, as the primary structure. Whenever possible, don't

A demountable hand armature attached to an arm. The hand armature can easily slide out of the square section tube into which it has been inserted.

stand a large figure on one or even two upright pipes—it will wave and wobble back and forth. Use three pipes for stability, even if one of them falls outside the form and you have to remove it when casting.

If doing a life-size or larger figure and you want a back iron, make sure the back iron is strong enough in itself not to deflect significantly downwards with the weight of the clay. Most importantly, be sure it is anchored to the baseboard securely enough so it won't either bend the baseboard or pull loose completely. One way is to use angle irons beneath your main board, as described and shown on page 30. Another is by using two boards and four two-by-fours, as shown on page 31.

After the initial extra strength of a large armature, the next most important trick is to use as much *filler* as possible to reduce the amount of clay being used. The filler will not only help you cut down on weight and clay, but will also give the clay a better surface to grip. Filler should be used to bulk the armature out everywhere you can, so the clay is in fact a rather thin skin instead of huge thick masses which stand a good chance of falling off eventually. Many materials can be used to bulk up an armature. Typical ones are:

■ wood, bound on with rubber straps or drilled and screwed in place
■ rags, soaked in plaster and formed against the armature, then wrapped with more strips of plaster-soaked cloth to secure
■ foam, sprayed from a can directly onto the armature, where it will stick tight and can then be formed with a rasp (Note: It can be hard to get foam to stick directly to the armature, so if you use this method, first tie a plastic bag around each armature element, then fill the bag with foam. Once the foam has set, peel off the bag and rasp the foam to shape.)
■ aluminum foil, crinkled tightly around armature members and then bulked out with more crinkled foil. (This is particularly effective with Classic Clay, which is then melted and

brushed on the foil for a solid base on which to model.)
■ large blocks of Styrofoam, fitted carefully and held in place with Liquid Nails glue. (Buy the denser blue or pink Styrofoam, not the crumbly white stuff, or you will get those little white balls everywhere.) The blocks can then be carved down to rough shape and covered with plaster-soaked rags. Smear more plaster over this surface to thicken and stiffen, always keeping it back from the final form to leave room for clay.
■ anything else you can think of

Any of these filler materials will help greatly in holding clay in place as well as cutting down weight to avoid possible sagging of the entire armature. The following illustrations show how sculptor Blair Buswell used foam filler on a large armature to create an 8-foot figure sculpture.

For further discussion of large armatures, see Chapter 6.

Right: Blair Buswell's 8' (2.4 m) steel armature.

Below left: Blair first covered the armature with foam to take up bulk and provide a grip for the clay.

Below right: Blair's next step was to create a nude clay figure over the armature to get sound anatomy.

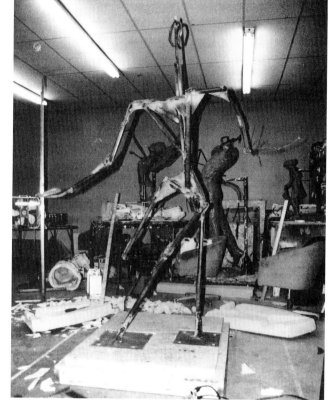

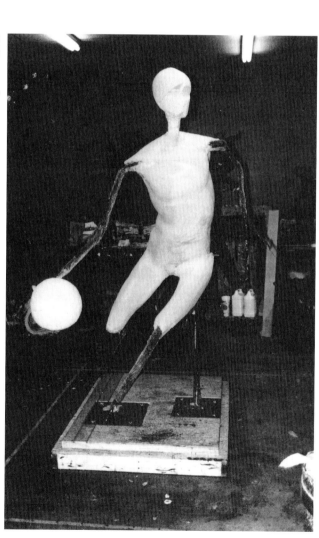

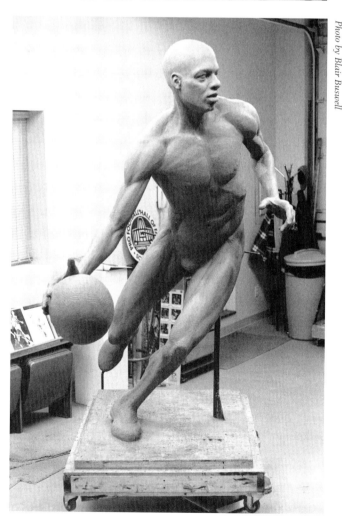

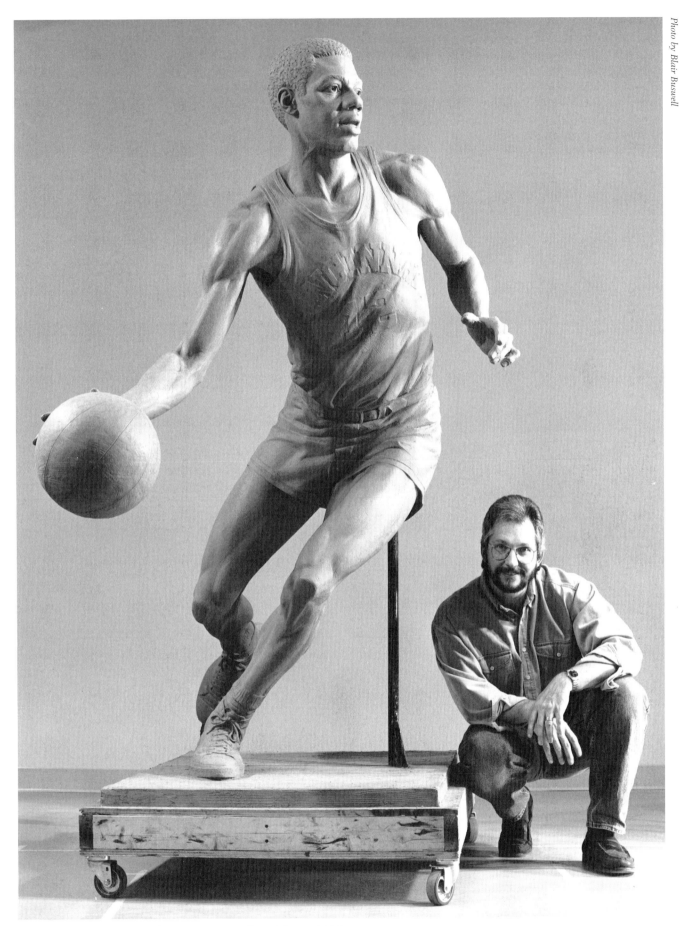

Blair Buswell with Oscar Robertson, 1994. Clay, 8' (2.4 m) high.

MODELING THE HEAD

We relate to people primarily through the head—the face and its identity and expressions—making it probably the single most important part of a figure sculpture. And while the head is often part of a figure, it is also one of the few parts of the figure to stand alone, usually as a portrait. In this form the head assumes a special importance as it records the likeness of a person for posterity. Unfortunately, the head is also extraordinarily difficult, and, along with the hands, is a dead giveaway to a badly done sculpture. This chapter will cover two basic ways to tackle this somewhat intimidating task: by using a living model, and by using photographs.

It's a curious fact that everyone can recognize other people by their faces, yet can't describe them or draw them or make their likenesses in clay except when trained in that art. A large reason for this is that the differences between heads and faces is often minute and very subtle, complicated by the constant movement of many parts of the face as it moves through different expressions. This is further compounded by the fact that we are extremely sensitive to the slightest difference between people and to the slightest change in expression. We notice in an instant a narrowing of the eyes by a tiny fraction of an inch, as when someone listening to us becomes skeptical of what we are saying. We can spot the smallest change in the corner of a mouth that precedes a laugh. And while we can get away with rather large errors elsewhere on the body, even the smallest errors on the face are crucial.

The author working on the head of Dance of Creation. *See page 193 for finished sculpture.*

THE MODEL

With that somewhat daunting prelude, let us begin. There are three ways to model a head: from a living model, from photographs, and from memory. Believe me, working from the living model is the best way; the other two are far behind.

It's not that difficult to get someone to model for you. Many people will do it for free, just for the experience. They can keep their clothes on, they can sit down, they don't need to hold still, and they can watch you work. Plus, most people will be flattered that you asked them.

A better situation, however, is to have a professional model. If you find one and can afford to pay for the work, you are more in control and can demand more than you can of a volunteer. What should you pay a model? Look up any local university or college in your area with an art department and ask what they pay for clothed and nude models. The clothed rate will be right for a portrait model.

TIP

Here are some tips for working with a live portrait model:

1. Be prepared. Have everything ready before the model arrives. That means the armature, the clay, a place for the model to sit, your modeling stand, your tools, and anything else that you might need (coffee, music, a comfortable room temperature, and so on).

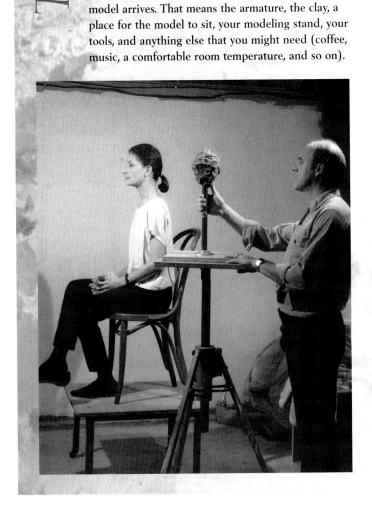

2. Pose the model so his or her head is at your eye level while you are standing. This usually means placing the model's chair on a box of some kind, or finding a tall stool. Don't let yourself be looking down at the model.

3. Arrange your modeling stand so the clay head is at the same height as the model's head, and you are looking at both of them with a level gaze.

4. Be able to turn the model easily so you can work from profiles, the back, and so on. As you work, turn the model frequently, and turn your sculpture so it is always facing the same way as the model.

5. Models will get bored and need breaks from time to time. A good working session for a seated portrait model can be forty-five minutes, less if the pose is strained, such as with a strongly turned head. As the working session continues you will need to shorten the time between breaks to account for increasing fatigue.

6. An entire session should usually last no more than three hours. After that, both you and the model will become tired and efficiency will fall to a point where little of value is being done. It's best to quit and continue working another day.

The sculpture, the model, and the artist's eyes should all be at the same level.

BEGINNING

The first thing to do is to consider the pose. Most models will sit looking straight ahead, like a soldier at attention. It's quite possible to begin this way, and then bend the head later into a more lively pose. If you read Edouard Lanteri's *Modelling and Sculpting the Human Figure* (see Further Reading), you'll see that his armatures are soft in the neck region, allowing him to begin with a straight-on pose and then animate it later. A second and more usual way is to establish the pose from the beginning and let your work reflect that pose from the first piece of clay. This is the method I prefer.

People hold their heads differently, from one person to another and from one mood to another. The *gesture* of the head is extremely important in establishing character. If you were doing two portraits, one of a strict military type and another of a depressed person, wouldn't their head/neck positions be completely different? And wouldn't those gestures contribute a great deal to the character revealed in the portrait, regardless of any likeness, features, or facial expression?

It's important to watch your model to determine a characteristic head position, as well as the way the model holds his or her shoulders (whether slumped or thrown back), and how the neck sits beneath the head. Get a feel for what is particular to the model you have chosen. Let the person walk around chatting, looking at things in the studio, and study them carefully as they respond to your conversation. Then pose the person the way they seem most natural to you.

Once you've established a pose and placed the model, bend the wires in your armature to approximate the angle of the head. In most cases, this will not require much bending at all, but check them just the same. Then begin applying clay into the center of the cage of wires on the armature, filling it completely and solidly. Press the clay in well to make a lightbulb form. It is on this form that you will build the portrait, so let the lightbulb form already take the pose.

If you are planning to add shoulders to your portrait, you can begin at this stage to add clay down the pipe to the board. This clay will later support the shoulders.

THREE METHODS OF WORKING

Here are three general methods you can use to create a head. No one of these is sufficient in itself, and most sculptors, even very experienced ones, will use one or another, with some of the other methods thrown in from time to time. And of course there are countless other methods that are unique to individual artists.

The Profile Method

This is the method Rodin used religiously, and it is probably the most secure and foolproof in the long run. You begin from directly off to one side of the model—it doesn't matter which side—and you model the profile, or outline, as you see it. Then you move to the back of the model's head and model the profile of the back of the head. Now move to the other

side and refine the side profile you created earlier. Finally, move to the front and model the outline (*not* the face itself) of the front of the head and face.

Now do the same thing with the four views in between (the quarter views) and then continue with the eight views between those. At this point, if you have modeled each profile accurately, you will have a very strong likeness of the model's head—with no details at this point. But there is much more to say about modeling profiles. Let's take each step in turn.

The Side Profile

When using an armature with a vertical pipe, the head is often placed too far back on the armature and then, when doing the neck, there isn't room for the pit of the throat (the *suprasternal notch*). The solution is simple. Begin at the pit of the throat. Stand off to the side of your model and place some clay around the pipe at about where you think the *base* of the neck will be. Now look carefully at the line from the pit of the throat to where the underside of the chin begins. Ask yourself two very simple questions: what *angle* is the line, and how *long* is it?

Model the throat, then check its angle by holding a pencil or tool parallel to the model's throat. Keeping that angle, compare it to the throat you just modeled. Adjust your angle until it is the same as the model's. (Remember, the throat usually juts forward at a fairly strong angle.)

Now measure the length of the model's throat—your fingers make a quick pair of calipers—and see that your modeled throat is the same. Do the same thing for the surface underneath the chin, measuring out to the point of the chin. If you do these two lines well you should have the chin in the correct relationship to the pit of the throat. Check that relationship. Also, check to be sure the pit of the throat is placed in *front* of the armature pipe.

TIP

Take your time locating the chin carefully as its placement is very important. You will build the entire face on the basis of the chin, and if it is in the wrong place it will affect the whole face.

Now, ignoring the lips, model the line that moves up from the chin to the base of the nose. Again, determine its angle by holding a pencil or tool parallel to the model's profile, and then use your fingers to measure the line's length. You can add some clay for a nose at this point, and then determine the relationship of the bridge of the nose (where your glasses would sit) to the base of the nose. How far is the bridge above the base? Does it sit directly above the base of the nose, behind it, or in front of it? Be accurate.

At this point, continue up the forehead to the hairline, noting carefully the angle of the line, its curve as it rounds back over the forehead, and the height of the hairline. Model the outline of the top of the head, noticing where it reaches its highest point. At this point you can make a quick check to see that the eyes are placed midway between the top of

Correct placement of the head on the armature.

Incorrect placement with problems at the throat.

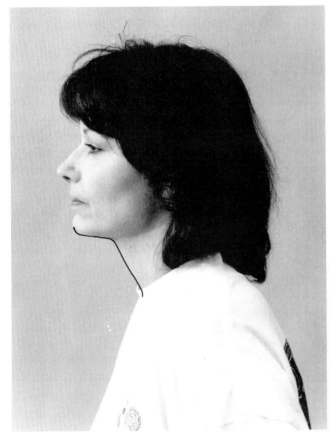

The all-important line between the throat and the underside of the chin.

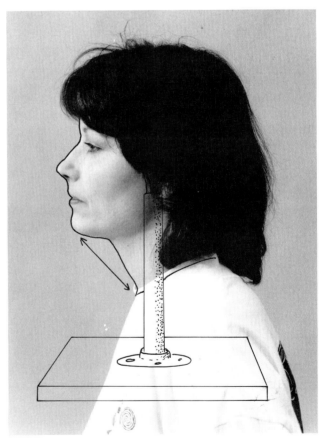

Establishing the relationship of the chin to the pit of the throat. Also note the placement of the armature superimposed on the head.

the crown and the bottom of the chin. Just halfway is the norm for nearly every living person.

Don't lose interest now. Continue down the back of the head to the neck, and finish at the base of the neck. If you've done all this carefully, the base of the neck in back should be the right distance from, and the right height in relation to, the pit of the throat.

There, you've created the main side profile of the model's head. Remember, it is the overall outside shape you are trying to achieve at this point, nothing more. Look, for example, at the line drawn on the illustration at right and block out from your mind anything inside the line. Try to see the same simple outline on your sculpture.

When a boat builder builds a boat, they begin with a keel, then add ribs down the length of the keel. The shape of the keel determines the placement of the ribs, and thus the shape of the boat. The profile I have been talking about is the keel of the face, and the ribs are the forms that go around the face, like around the eyebrows, the mouth, and so on. Imagine drawing a line down the model's face from hairline to chin, right down the middle, with a red felt-tip pen. Then imagine drawing horizontal lines, like belts around the face, across the forehead, the eyebrows, the eyes, under the eyes, and so on, with a green felt-tip pen. Now imagine bending wires to match the curve of every line you have drawn, and soldering them together to create that three-dimensional grid. You can see immediately the importance of that first red line, the profile.

The Back of the Head

Using the same outline method, you now look at the model from directly behind and create not the back of the head, but the *outline* of the back of the head. Notice the shape it makes, and add clay to the sides of your sculpture to approximate that shape. At this point your head, if lit from the front, should cast a shadow similar to the shape of the model's head.

Avoid making the head with two intersecting flat slabs, like pieces of plywood. As you work, begin creating the fully rounded form of the back of the head by adding clay. Most heads are rather spherical in back, so go for that ball shape.

The Second Side Profile

Work the profile from the other side now. Refine, adjust, perfect.

The Front of the Head

Now approach the face. Remember, you won't be modeling the face itself, but the *outline* of the entire head as seen from the front. You will actually be modeling two forms: the narrower outline of the face itself, and the wider outline of the hair behind. At this stage the form of the face, all the way back to the hair, can begin to emerge as separate from the hair.

Sometimes we miss the big things in our search for details. Here's your chance to see the big picture. Ask yourself what shape the person's face is—whether triangular, round, square, or whatever—and make that shape in clay. Don't get caught up in eyes and lips and other details; just get the overall shape right, so the head begins to look a little like the person in dim light,

or when you squint. Remember, no portrait will capture a likeness if the head shape is wrong. And if the head shape is right, it will begin to become the person even without any details.

At this stage it's a good idea to continue using outlines and working from the four quarter views, just as carefully and just as analytically as you did before. Once again, keep checking major outlines, forgetting about making a head or getting a likeness. I guarantee that no amount of fussing with eyes and lips will capture a likeness if the total head shape is wrong. But if you get this foundation right, the likeness will come.

Soon you'll come to the face itself. The big danger here is to think of the face as a flat plate, with the features placed like pepperoni on a pizza. In fact, the face is sharply angled, with the two cheeks sitting at almost right angles to each other (like the two sides of a box, with the corner of the box running down the center). To feel this shape on your own face, hold your hands on your cheeks and then carefully pull them away—maintaining the same position—and look at the angle between them.

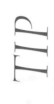
People always ask, what about the hair? When should I put it in? My belief is that hair is a form like any other and should be included from the start. So when you reach the hairline, add clay to make the line the hair creates. (Notice that it occasionally juts out farther than even the tip of the nose!)

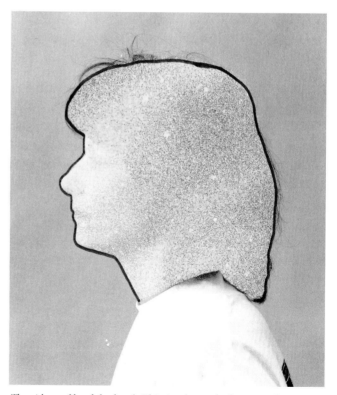
The side profile of the head. This is what to look at, not the interior details.

The head from the front. Note the overall shape of the face.

The head from the front. This is what you should see when you model the overall shape.

The back of the head. Note the complexity of its shape.

The face from below, showing the extreme backward slope of the features.

The Measuring Method

This method involves creating a headlike mass of clay that's smaller than the model, and then taking a series of measurements with calipers. You record the measurements by pushing wooden matches into the clay at the correct points and to the correct depths. If this is done carefully, you can begin to add clay between the established points and the head will take shape. Rather than detail this method here, I refer you to Daisy Grubbs's fine book *Modeling a Likeness in Clay* (see Further Reading), which describes the measuring method in some detail.

The Egg Form Method

In this method, an egglike form that approximates the human head is built up and then modified according to the model before you. Unfortunately, it's not quite as simple as it sounds. In building up the egglike form you will want to use a combination of the first two methods: Use the profile method to establish general shape and proportion, and particularly to place the head on the pipe so the pipe won't stick out of the throat later on; use caliper measurements from the measurement method to establish the main points at the correct size.

Once the general form occupies a space something like the model's head, you can make large gouges out of the eye region, and generally move the cheek forms back behind the forehead a bit. Add some clay to the nose, and you have a simplified human head. At this point you can continue with both the profile and the measuring methods to refine and build accuracy. For a much greater expansion of the egg form method, read Edouard Lanteri's *Modelling and Sculpting the Human Figure* (see Further Reading).

There is another somewhat similar method some people use, and that is to model a skull and build the head upon that. I have seen this method used with excellent effect. The problem is, of course, that you can't see the particular model's skull. It's no good thinking you can use any skull, since every skull is as different as the faces that grow on them. Still, it is a very fine exercise in learning the underlying structure of the face, and I recommend it highly as a study of the head.

Like so many things in life, one method serves one person well while another serves the next. Try one way and then incorporate those parts of it that work for you to form your own unique method. For example, if you are using the profile method, try incorporating some caliper measurements from the measuring method. Measure the model's head from top to bottom and compare it to your sculpture. Then measure the model from front to back to be sure your proportion of height to depth is correct. (We often see distances very differently when looking vertically versus horizontally, so this measurement is crucial.) Use other measurements as you feel the need.

MODELING THE HEAD FROM PHOTOGRAPHS

It has been said that there are two kinds of portrait sculptors: those who admit to using photographs, and liars. It seems like we are all called on to do portraits from photos, usually for one of three main reasons: the portrait is to be a surprise, the person has died, or the person is either far away or can't spare the time to model. If you were sculpting a portrait of the president of the United States, for example, you would take a careful series of photos and work from those, since the president could hardly spare the many hours necessary for sittings.

What Kind of Photos to Use

The worst photos you can work from are those taken from the front and shot with a flash. The flash flattens everything out, and the front view gives little clue as to that all-important outline—that "keel" of the face talked about earlier. Unfortunately, this is also the most common kind of picture taken of people. When you are given photos to work from, it is likely you will have several of that kind, from which you must try to create a three-dimensional object.

If you can take the photos yourself, here's what to take. First, use a good camera that can get close enough so the person's head fills the frame. Pocket cameras usually won't focus that close and the heads remain small in the picture. Second, select a good background and good lighting. The best background is a plain one that contrasts with the head; a blank off-white wall is perfect. The best light is clear and strong but not harsh and direct. If you have floodlights use them, but pull them back from the subject to give a softer, gentler light. If you don't have floods, try to shoot outdoors on an overcast day, or in gentle shadow. Avoid direct sunlight, partly because it causes hot spots and inky black shadows, which hardly reveal form, and also because it causes the model to squint.

Once you've found a good location and good lighting, work just as you would modeling the head. Shoot absolutely side-on profiles from both sides. Then shoot directly from the front and directly from the back. Now shoot the quarter views, and even eighth views, all the way around the subject. Then shoot some details of features—eyes, nose, lips, ears (both of them—they aren't the same). Lastly, try to get some shots from directly overhead, and one or two from beneath the chin looking up. You'll find those last shots to be particularly valuable.

Have the photos made into 8- by 10-inch prints, either color or black and white. Don't try to work from tiny snapshots. The task is hard enough without having to peer at postage-stamp sized images. Once the photos are developed, set them up so you can see them all easily. It's best to tape them all over a wall and work right in front of that wall, or rig some kind of support you can tape them to so you can see them. Don't have them lying flat on a table for you to pick up now and then—you want to be able to glance up easily so you can look at them constantly as you work. Now you can proceed to model with one of the three methods described above.

Whether your photos have been taken specifically for your sculpture or given to you, have a few of the best ones photocopied. Then you can feel free to draw lines on them indicating the angles we've been talking about, so you can model just the lines in clay, forgetting about making a human face. This is a good way to see the essential forms in an abstract sense and avoid getting caught up too early in likeness and detail.

But suppose you have a bad set of photos, as is usually the case when creating a posthumous portrait. About all you can do is to first ask for as many pictures as possible, then go through them carefully and sort out the ones that seem to show the most form, and that are consistent to one another and look like the same person. Select ones close in age and mood, and confirm with the client that they show the person as they want him or her portrayed.

At this point you have to use all your skills to try to decipher just what the profile of the head is, usually from a collection of photos containing no profiles. Study the throat and try to sense its angle. Do your best to get the angle from chin to nose correct, drawing on other models you have observed. Usually you can feel whether the top of that area, the point at the bottom of the nose, is in front of, in back of, or directly above the chin. Get that angle as closely as you can. Now try to sense where the bridge of the nose is relative to the chin, and then go for the angle of the forehead. This should give some feeling for the general shape of the face from the side, whether it is bowed out, flat, leaning forward, or leaning backward. This

shape is crucial, so spend time on it and study the photos carefully.

Since so many pictures are from the front, you won't have much trouble getting the overall face shape correct, but you'll have to dig into your experience and knowledge to create a convincing back of the head.

MODELING A RELIEF PORTRAIT

Relief sculpture is flat, like the kind of portrait you see on a coin. It looks easy, but it isn't. The theory of the relief is simple. Imagine a solid object having three axes in space: the x axis, which runs up and down; the y axis, which runs side to side; and the z axis, which runs toward and away from you. In a relief, you leave the x and y axes as they are, and compress the z axis, flattening everything.

Simple? Sure, in theory. In practice there are problems. First, there is the degree of relief to consider. Sculptors talk about four kinds of relief and give them fancy Italian or French names, which are just an indication of how high or low the relief is.

High relief is like a person standing against a wall—you can get your fingers around the backs of the forms. The sculpture *Swimmer: Alone* (shown on page 49) is a fully-rounded figure, just backed up against a wall.

Medium relief, sometimes called *mezzo relievo*, is a figure about half-buried on a wall. In the relief *The Ultimate Caregiver* (shown below), which I did for a hospital, the background figures are done in medium relief. (The most forward figures are done in high relief.)

Low relief, often called *bas relief* (*bas* is French for "low," and is pronounced "bah," not "bass") is what you have on a coin, where the z axis is considerably flattened. There are degrees of low relief, of course, with coins being quite low.

An example of medium and high relief. The Ultimate Caregiver, *Tuck Langland, 1992. Bronze, 36" (91cm) diameter. St. Joseph's Medical Center, South Bend, Indiana.*

Lastly there is something called *relievo secco*, which is Italian for "dry relief," and amounts to little more than drawing on the clay with the very thinnest buildup of form.

In practice, many relief sculptures use more than one level of relief. It is typical to have the foreground figures in high relief, with other figures getting flatter as they move back into the scene, and the clouds or distant landscape done in dry relief, lightly drawn in.

If you want to try a relief, it's best is to start by creating a smooth slab of clay. Don't work a relief flat on a table. Instead, stand it up on an easel as you would a painting. As an exercise, place a box or block on a stand so you see it with some perspective, and create that. Begin by carefully drawing the box onto the clay, getting the perspective right. Now add a very thin layer of clay on the corner that is farthest away from you. Next, find the corner *closest* to you and add about ½ inch of clay there. For the other corners, determine what fraction of the distance between the first two points (the farthest away and closest points) they are, and then add a proportionate amount of clay to each. Now add clay to connect the dots, filling in the edges of the box and letting them grow closer to you or move away in straight lines between the corners. Lastly, fill in the surfaces accordingly.

The box exercise gives you a good sense of how to flatten the *z* axis while leaving the *x* and *y* axes alone. Next, try a relief of a human head in strict profile. Draw the head carefully, then add a thin layer of clay at the point farthest from you and about ½ to 1 inch at the point closest to you. Continue as you would for the profile of the fully rounded head, except to remember to constantly flatten the *z* axis, and to flatten it by a constant amount. Medium relief would flatten it by something like 50 percent; low relief might flatten it as much as 90 percent. And remember, you're not so much making a portrait here as sorting out how planes flatten in space in a relief.

Look at reliefs in magazines, books, and, most importantly, in galleries and museums. Take coins from your pocket and study them. Look at reliefs from the side to see how the artist coped with slightly turning forms, with the distant eye just peeking out beyond the brow, and that sort of thing. Notice how edges are treated as they meet the background. From the simple profile beginning, you can move on to slightly turned heads, and even frontal views. Always remember that every point on the *z* axis must be diminished by the same percentage.

A cross section of two heads in relief. In the profile on the left, the z axis has been flattened consistently with the model, and the relief rises and falls in proportion to the real head. On the right, however, the flattening of the z axis varies, and the center of the relief sinks in unnaturally.

TIP

By working from the shallow point to the high point, you will avoid the common bind of building the highest points first, running out of room to model areas farther from you, and having to resort to digging into the background. It's generally best not to violate the flat slab of clay at all, but to keep everything on top of it. Try building a clay relief on a rigid surface, such as a Formica-covered board, which prohibits any chance of violating the back plane.

Lettering on Reliefs

You may be called upon to create a commemorative relief with a lettered inscription. Fear not, there is an easy and foolproof way to do this.

First, determine the size of the letters you want and the general idea of the font, whether classic and formal, free and contemporary, or anything else. Then send off for a catalog from Scott Sign Systems (see the list of suppliers), where you can buy trees of plastic letters. These are inexpensive (usually under ten dollars for an entire alphabet with several of each letter), they come in a wide range of sizes and styles, and they're about ⅛ inch thick and perfectly formed.

To use the plastic letters, lay the relief flat on a table. Lay a straightedge directly on the clay, and arrange the letters along the straightedge. Adjust the spacing between the letters until it is just right. Then lightly press the letters into the clay just enough to stick, and remove the straightedge. When done, a rubber mold is created over the clay, letters and all, and the whole thing is cast into bronze. Voila! Perfect raised letters that are very professional looking. (For information on creating rubber molds and casting in bronze, see chapters 9 and 11–15.)

Here's a final word on heads. I once had a student say to me, "I just want to work on portraits, and then after a couple of months, when I've mastered that, I'll move on to...." You can work your entire life on nothing but the portrait head and still never master it. Giacometti couldn't; Marini couldn't; Rodin couldn't. But rather than letting this fact deter you, realize that trying to capture the visage of another human being in clay is both the most difficult and the most rewarding thing you can do as a sculptor. And when you get your sitter to look back at you and wink right there out of the clay you have formed with your own hands, that's a kick.

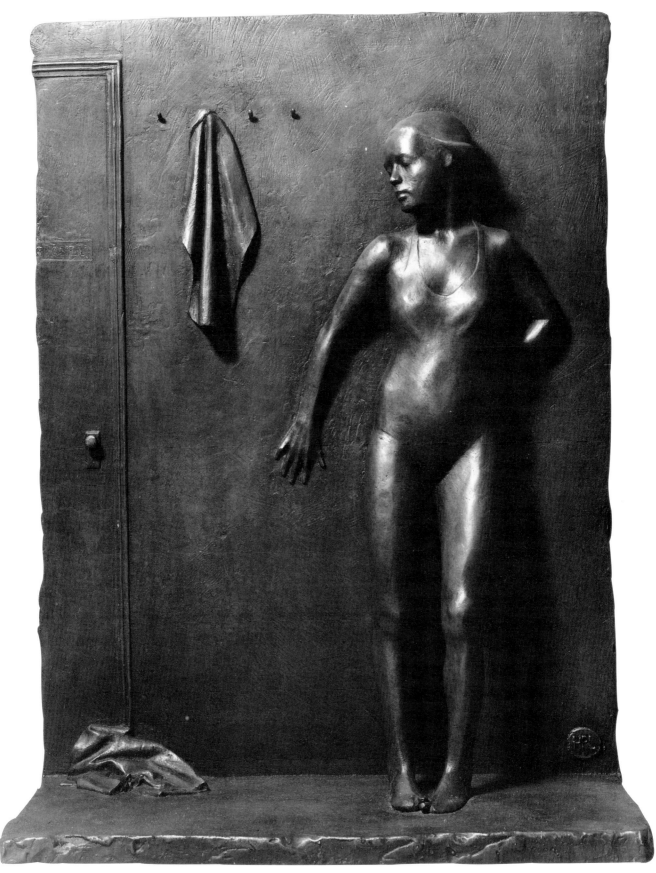

An example of high relief. Swimmer: Alone, *Tuck Langland, 1980. Bronze, 18 × 14 × 6" (46 × 36 × 15 cm) deep.*

MODELING THE FIGURE

There has been a lot of progress in this world. We all know that today's airplanes are a far cry from the Wright brothers' first efforts. But in other areas perhaps progress doesn't really exist, and the word "progress" isn't even relevant. When you attempt to model the figure, forget about the current style, forget about making a statement, forget about being cutting-edge. Just observe your world carefully and create an image that will convey that world to those who follow. It isn't easy, but it is worthwhile.

Ever since an unknown sculptor, probably a woman, carved a small piece of limestone into the so-called *Venus of Willendorf*, sculptors have been fascinated with the human figure. This little handheld sculpture is perhaps the oldest known sculpture in the world. If we are counting, it is number one.

Look at the sculpture (reproduction shown at right) carefully. At first you see a short, fat woman. But look again. The head is down, the face concealed, giving greater emphasis to the body. The belly is huge, the breasts large, and the reproductive organs are clearly portrayed. The legs are short, with the knees together, the lower legs shorter still, and the feet almost nonexistent, as if diminishing in the distance. Could this be a self-portrait of the artist looking down at her own body? Wouldn't that be the way she saw herself?

Unfortunately, we don't have space here to question the purposes of this small piece, only to look at the wonderfully sensitive carving of soft human flesh, done maybe 30,000 years ago. That's our standard, dear reader. When it comes to observing our own world and turning those observations into a permanent material so people years later—even thousands of years later—can sense what the artist sensed, we are challenged to use as keen an eye, as sensitive a hand, and as probing a psychology as the unknown artist who created this small work.

With that prelude, let's begin to model the figure.

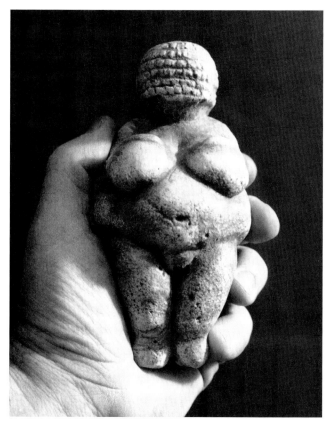

Reproduction of Venus of Willendorf, *created by Cameo Knowles. Plaster, approx. 4¼" (11 cm) high. The original, which is made of limestone, dates to c. 28,000–23,000 B.C. and is housed in Vienna's Museum of Natural History.*

STUDYING THE FIGURE

Just as with modeling the head, modeling the figure requires a combination of knowledge and observation. You can gain such knowledge from any or all of the following sources.

Courses and Books

You can take a class in anatomy, but be careful. If the class is taught at a college or university and is in the science department, whether premed, biology, zoology, or the like, it probably won't do you much good as an artist. It will mainly concern itself with what goes on inside the body: the organs and their functions, the circulatory system, and the nervous system. Though such courses also cover the skeleton and some musculature, the main emphasis is on those parts we don't see on the surface.

Better is a course in artistic anatomy, usually taught in the art department. This kind of course will cover the outward appearance of bones and muscles, and the way they change as the body moves. This kind of course, if you can find one, is extremely valuable and should be taken if at all possible.

A third kind of course, and one that is perhaps even more valuable, is an *ecorché* course. Students in these classes model a skeleton in clay and then add all the muscles one by one, creating the figure from the inside out. When coupled with an artistic anatomy class, an *ecorché* course should provide an excellent and very thorough grounding in knowledge of the figure.

Failing the availability of such courses, or in addition to them, you should obtain good books on artistic anatomy and study them. Keep books in the studio for reference as you work. In my view, the best book on the market is *Human Anatomy for Artists: The Elements of Form*, by Eliot Goldfinger (see Further Reading). This book covers the subject so completely and with such an artist's eye that I don't believe a better one has ever been written. But beware: the book is packed with information and is dense reading. It is not a book to idly peruse. It will answer virtually every question you might have about the figure, but you need to work at it and learn to use and understand the correct scientific terminology. Still, studying this book will repay the effort a thousandfold.

Observation

No study of anatomy is even half complete without direct observation of the skeleton and the living figure. It's not easy to obtain a skeleton. Genuine human skeletons are very expensive and hard to find, but good plastic ones are available, and are not terribly expensive. If you are really serious about studying the figure, I strongly suggest you buy one and keep it in the studio, even if it is a miniature.

The best and ultimately only way to study is with the living model, studying one aspect of the figure at a time. It's a good idea to create clay studies of each part of the figure, working for understanding and mastery before moving on. Remember, you are studying the figure at this stage. Don't feel you can learn to do the figure while making pieces for sale. That's like practicing your scales on the concert stage—and expecting someone to pay for it. Study, learn, and master your craft, and only then put works out for sale.

FROM THEORY TO PRACTICE

Good sculpture is not the same as correct sculpture, any more than a good piano concert is simply one with no wrong notes. It must have feeling and power and delicacy and poetry and all those things that move the listener, or, in the case of sculpture, the viewer. Creating good figure sculpture is the fusion of what you know with what you see, combined with an awareness of the history of sculpture, all in the service of what you want to say, spoken with eloquence and using the language of form. It ain't easy.

Preparation

Preparation means getting the armature and clay ready, setting the place for the model to pose and be seen, and getting yourself ready to work. Create the time to prepare properly. Don't try to squeeze sculpture into the cracks and spaces of your life, but let the other obligations fit around this work.

First, preparation means getting the armature right. Read the chapter on armatures (Chapter 3), and be sure your armature is strong enough, that it supports where it has to support, that it doesn't stick out where it's not wanted, and that it can be moved and changed as the piece progresses.

TIP

Figures can be sculpted at any size, from small figurines you can hold in your hand to monuments larger than life. The larger the sculpture, the more problems to be solved. Figures that are life-sized or larger are complex enough to warrant a preliminary sketch model, called a *working model*, or *maquette*. The maquette is then enlarged to whatever size you choose. This enlargement process is detailed in Chapter 6. If you intend your finished sculpture to be life-sized or larger, be sure to read Chapter 6 before beginning your maquette.

Have your clay ready—if oil clay, it should be well warmed and worked into handfuls ready for use; if water clay, it should be all wedged and moist—and have all your tools cleaned and at hand. Think of working from a living model as a little like surgery: You want everything ready so you don't have to waste time and money once the model is working for you.

Setting the Pose and Adjusting the Armature

When the model arrives, you need to set the pose. You are balancing several things at once here. The pose has to look natural, it has to be comfortable so the model can hold it, and it has to have enough interest to be worth doing.

Don't go crazy with your first efforts. Select a simple, relaxed pose that the model can hold easily. Let your sculpture be the exciting part, not the wildness of the pose. Think of the pose as an actor. An actor who continuously yells and screams at the height of emotion is not only tiring to watch but unconvincing, and guilty of overacting. Don't let your sculptures do that. Don't make every sculpture push the limits of emotion every time. Restraint, subtlety, suggestion—these are the qualities that can be looked at for years without becoming false or annoying.

Once the model is posed, you must pose the armature. This is a crucial part. First, decide which are the exact front, sides, and back of the model. Place the armature on a stand directly in front of the model, and facing the same way. Standing back, find a position in which the armature appears exactly superimposed over the model. Now bend the armature from that point of view so the wires lie exactly inside the various limbs of the model. Pay particular attention to the line of the spine.

Do the same from one side, then from the back, then from the other side. At this point your armature should be holding the same pose as the model. Not until now are you ready for clay.

Building Up

Building up means adding the bulk of the clay. At first, it seems like just piling on clay, but this part must be handled very carefully so you don't end up with a lot of clay all over and then have to carve half of it off again. That's just a waste of time and effort. Build slowly and logically, just as you would a large building.

The best way to do this is to begin with the two major masses of the trunk: the rib cage and the pelvis. But before you put even a dab of clay on the well-posed armature, look at the model's rib cage and try to see the "egg" lying beneath its surface. Ask yourself, is that egg standing directly up and down, or does it tip? If it tips, which way does it tip, and how much? Don't just look at it from the front, but from the sides as well. As you add clay to the rib cage, hold that exact angle of tip in your mind with every piece of clay you add.

Before you've gone too far—just as you've added a good suggestion of the egglike bulk of the ribs and the angle they have—move to the pelvis. This is a very important step. Again,

The armature visually superimposed over the model so it can be adjusted properly.

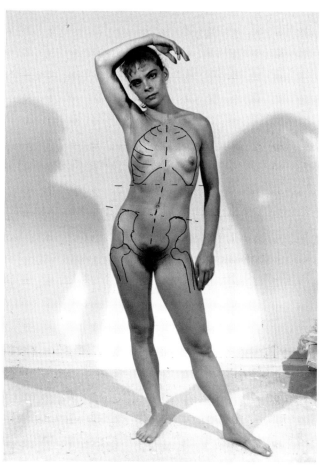

The rib cage and pelvis superimposed over a living model in the contrapposto *pose, frontal view. Note how the shapes tip beneath the form.*

This is not the way you should begin modeling an arm. Applying crude lumps and then carving them down is inefficient.

The correct way to model an arm. Lay the clay on in long strings, following the forms of the muscles.

look for the rigid bowl shape beneath the flesh, and determine how much the pelvis leans. Looking first from the front, try to see the side-to-side tip that is characteristic of *contrapposto* (a pose with the weight on one leg). Then look from the side to see how much the bowl shape leans forward or back. Again, as you add clay to the pelvis, make every piece express this tip.

As you evaluate and build up, work from profiles, just as you did with the head. Always look to see that silhouette, the outline. And don't just look—analyze carefully, asking questions. Is the silhouette vertical? What is the angle from here to here? How far does this stick out? Where does this curve begin and end? Line up forms you see on the model with vertical lines in the room, such as door frames, corners, window edges, and so on. Don't ask questions like: Is the model fat? Does she look like a dancer? Is he looking tired? These types of questions don't tell you anything about the shape you are creating. Always use a sharp eye to see the outlines as abstract forms.

Working out along the limbs, add the clay slowly in long strands, following the lines of the muscles. Don't squash on a thick lumpy sausage and then start carving it—save the carving for later. Let the limbs build up slowly, strand by strand, always slightly undersized so there is room to add clay. And always add the clay on the limbs in response to what you see in the outlines.

Measuring for Proportion

As you sculpt a figure, you must always concern yourself with proportion. There are lots of tables and diagrams in anatomy books that talk about proportion, but ultimately your eye is the best guide, since each individual is slightly different and unique. Look carefully to be sure the arms are the right length, the groin is in the right place between the figure's top and bottom, the head is the right size, and so on. If you are in any doubt at all, use the following method to determine the correct proportion of any part of your sculpture compared to the living model. You will need a tape measure, a pocket calculator, and a pair of calipers.

1. Use the tape to measure the total height of the living model and write it down. Now measure the corresponding total height of your sculpture and write that down.
2. On the calculator, divide the sculpture's height by the model's height. If your sculpture is smaller than the model, you will get a number smaller than 1. This number is your *ratio*. As an example, suppose the model is 6 feet tall and your sculpture is 2½ feet tall. You would divide 2.5 by 6 to get 0.416. So, 0.416 would be your ratio. Obviously, this ratio will vary depending on the particular sculpture and model.

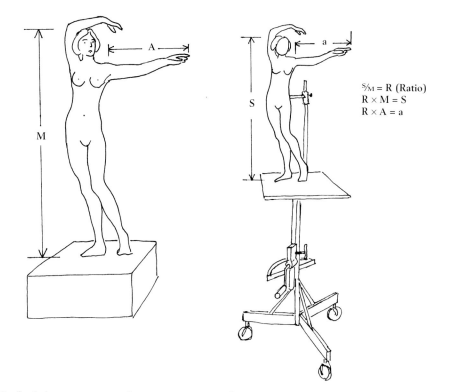

$$\mathcal{S}/M = R \text{ (Ratio)}$$
$$R \times M = S$$
$$R \times A = a$$

Using ratios to check for proportion. Divide the height of your sculpture (S) by the height of the model (M) to find your ratio (R). Then, to find the measurement of any part of the figure for your sculpture, simply multiply the ratio (R) by the measurement of the corresponding part on the model. For example, to find the correct length for your sculpture's left arm (a), multiply the ratio (R) by the length of the model's left art (A). R × A = a. This same calculation can be used for any body part.

3. To find the correct size for any given part of your sculpture, simply measure that same part on the living model and then *multiply* that measurement by the ratio you found in step 2. In the case of our example, suppose you want to find the length for your sculpture's left foot. If the model's foot is 11½ inches long, you would multiply 11.5 by the ratio (0.416) to get 4.78 inches. The correct length of your sculpture's left foot is 4.78 inches.

TIP Use a metric tape measure to measure the living model and your sculpture. Your calculator only deals in decimals, so using a metric tape measure will eliminate the need to convert fractions into decimals, and vice versa.

Note that the ratio, while different for every sculpture you make, will be constant throughout a particular sculpture, and can be used to find the length of an arm, the size of the head, and so on. You can even wrap a cloth tape measure around a thigh to determine the circumference of a form.

Adjusting the Balance

Getting a figure to stand correctly is crucial. A person's center of gravity is usually at just about the center of the chest—right in the middle. But when we stand, we always shift our center of gravity toward the weight-bearing foot. If you stand on two feet with your weight evenly spread, that center of gravity will be, with a plumb line, directly above the point midway between your feet. If you stand on one foot (and you can try this to prove it), that center of gravity will shift to lie

directly over the foot you are standing on. It has to, or you'd fall over. More typically, if you stand with 80 percent of your weight on one foot, your center of gravity will lie 80 percent of the way from the non-weight-bearing foot to the weight-bearing one.

Check this on your sculpture by comparing its center of gravity to that of the model. First, look at the model from the front and hold a plumb line with the top end on the pit of the model's throat. See where the bottom of the plumb line strikes the floor in relation to the model's feet. Now check it on your sculpture. Do the same thing from the sides and back, just to be sure.

Finding the center of balance on the model. Use a plumb line to find the center line and be sure it matches your sculpture. Note where the plumb line strikes the model at the top and especially at the feet.

Composing

Here's where the real sculpture begins to take shape. This is when you move limbs and check profiles—when you compose the piece. During this stage, the modeling should remain loose so you don't find yourself hesitating to make changes on a carefully finished form, nor disturbing a surface that will no longer fit the rest of the modeling. This is when you look at the overall pose and try to determine what it means, what it is saying. It is when you make the figure speak through body language and gesture.

Here are some pointers to help you. During the Renaissance, sculptors believed that a work should have a primary point of view, a somewhat less-important secondary angle of view, and often even a third. Think of Michelangelo—most of his pieces are intended to be seen from the front only, and then from an angle from one side, and perhaps from an angle from the other side, but rarely from the back. The notion of a sculpture existing as a completely round object in three-dimensional space is more recent, and was articulated particularly beautifully by British sculptor Henry Moore.

Today we prefer the completely round point of view, so you can rotate your piece slowly—or walk slowly around it—and watch the changing contours. Watch how a form that is hidden from view slowly appears as you move or turn, and how other forms slowly disappear. Watch how the contours change, how the whole shape and character of the sculpture changes with rotation. Look for the view that is best, then look hard for the view that is worst. Try to analyze what is good about the best view, and see if you can't incorporate some of that into the worst view.

Try to see the piece from other views, too. If it's a small piece, put it on the floor. If it's a large piece, climb up on a ladder to see it from above. Lie on the floor to look at it from below. Get your eyeballs off that orbit around the piece's equator to see it from different views. Change the light in the room, turning off this and that light. Look at the piece in semidarkness, or by moonlight, or with a candle at night. Take the piece outside and look at it in the sunlight, then from a distance.

Look hard at the silhouettes. If working large for outdoors, remember that a dark bronze against the sky will be seen mostly in silhouette. Those silhouettes have to be strong and well composed or none of the fussy detail will make any difference. Remember, the bigger you go with a sculpture, the more attention you must pay to big forms—big broad planes, clear outlines. Fussy detail doesn't count on large works.

Also, consider body language. We communicate with our bodies all the time, and a sculpture is like an actor that can neither move nor speak, but can communicate just the same. I like to think of a sculpture as having one primary mood or feeling, and then I like to suggest a second, usually contradictory, one, and perhaps even a third. For example, I once did a sculpture of a gladiator—not with any costume or armor, just a timeless nude—but he was a weathered veteran, tough as nails (shown at right). I lifted one of his hands in a soft gesture to suggest that beneath his toughness there was

a touch of fear, of gentleness even. This kind of secondary, contrasting characteristic can give complexity and life to a figure. Notice what the basic mood of your sculpture is, analyze how it is communicated, and then find a second and perhaps even a third mood to suggest and a way to suggest it.

Refining

Now that you've made the big decisions, it's time to get down to the good stuff. Assuming you've found the right pose, the right composition, the right mood and feeling, you now work on refining anatomy, drapery, form itself. Always remember that sculpture is form, and that you are making form that has depth. A belly is the other side of a back, and there is something between the two. Think always of working the surface of a complete geometric shape. If you were making a bowling ball, you could hardly do one side and then the other without thinking of the clear spherical relation between the two. The same is true of a rib cage, a skull, a knee. It is during this refining stage that the sculpture begins to come alive, and this is often the most fun.

Veteran, *Tuck Langland, 1986. Bronze, 26" (56 cm) high. Private collection.*

Finishing

I could probably run neck and neck with an Olympic marathon runner—for a couple hundred yards. But it's the finish that counts. Taking a work the final way is often the difference between a strong piece and a weak one. And just as in running, you have to decide if the piece you are creating is a marathon or a sprint.

Many a piece is flawed by not being worked out or finished carefully enough, yet just as many sculptures are ruined by overworking, when the freshness of the modeling is destroyed and smeared away in the search for a slick (and often lifeless) surface. So how can you tell if a piece is being overworked? To decide this question, look at your own modeling. How do you apply clay? How do you work the clay once it's applied? Do you pile it on and then scrape it off with a tool, or do you apply it with strong, clean strokes of the fingers, leaving a pleasingly worked clay texture? Also, what about the individual piece? Are you creating a sketch or a finished work? Is this just for you or for someone else? For example, a sketch portrait of someone who interested you, made for your own amusement and growth, would demand quite a different finish than a portrait bust commission done for a boardroom.

Finishing is vitally important, and demands a good deal of looking, thinking, and even courage—the courage to quit when others around you might want you to smooth out those tool marks.

Here are some ways to create different surfaces on clay:

■ First, there is the simple pellets pressed-on approach. This is self-explanatory, except to note that the surfaces of the pellets must be pressed down to form a continuous surface. Vary between large and small pellets as you move from broad areas to more detail. There is also the effect created by sliding your thumb over the pellets, which is rather like brush strokes in a loose painting.

■ You can use hook tools, with or without notches cut into them. You can make them, as I have, or buy them from any of the major sculpture supply houses. A hook tool—some-

times called a rake—is scraped over the surface, cutting the clay down to a new contour and usually leaving small raised ridges, something like the ridges left by a tooth chisel when carving marble. These ridges can be left as a surface texture, toned down by running the tool in multiple directions using an ever lighter touch, or eliminated by using a hook tool with no teeth.

■ For very smooth surfaces you can use rubber or metal kidney tools. These are held slightly bent in the fingers and run over the surface—but be careful you don't introduce waves and wobbles into the clay. Often a combination of rake and kidney tool is effective.

■ For really fine surfaces, use a brush and solvent. For water clay, the solvent is simply water. A good solvent for oil clay is Carbo-Sol, a dry-cleaning fluid available at paint stores. Use either solvent sparingly—don't just scrub the clay like mad, making mud and sliminess. Just use it to just whisk away those last few tool marks. You can even create a very fleshlike surface by stippling lightly with a soft brush as the final touch.

It's very important to look at a lot of bronze sculpture to notice how different surface treatments look *in bronze*. Freely modeled clay usually looks pretty good, but it looks best when the smears and slides reveal sound and solid form beneath. On the other hand, a well-worked surface, clean as a new balloon, also looks great in metal. Remember, the clay you're working on will be thrown away and all that will be left is the bronze, so look at bronzes in museums and galleries to get a feel for what various clay surfaces look like when cast and coated with patina.

The answer to the question "How do I know when it's done?" is actually rather simple: When you look at the piece and lift a tool to work, but you hesitate—no, not here…no, not over there…no, not around here—then you're done.

Clay pressed on in small pellets.

Clay applied with sliding thumb strokes.

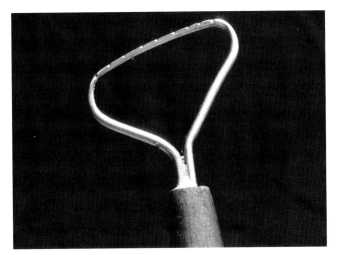

A typical hook tool, or rake, this one homemade.

Clay worked with a hook tool.

Clay worked with a lighter hook tool for a smoother surface.

Metal and rubber kidney tools for further smoothing.

Chapter 6

ENLARGING

The ability to enlarge a work is a very important tool for the sculptor. Full figure sculptures, which are often made life-sized or larger, are very complex, and are usually conceived on a small scale first and then enlarged to full size. Enlarging can be done by a professional foundry—at a professional price—or it can be done by the artist. This chapter will discuss the idea and function of enlarging, then show seven different ways to enlarge works.

So where does enlargement fit into the process as a whole? Enlargement is the final step of a particularly good three-step method for building larger sculptures. The first step involves building a small *concept model*, which can be of good strong oil clay, wax, water clay, or anything you can manipulate easily. This is rarely larger than your hand. Its purpose is to get something before you that, while three-dimensional, can also be moved and changed with great ease. You might make several concept models so you can change one without losing the ideas in an earlier model.

Once you have a concept model that you are satisfied with, the second step is a *working model*, often called by its French name, *maquette*. A maquette is larger and more detailed than the concept model, worked out in enough detail to give a very good idea of what the final piece will look like. It is often handy to make the maquette at a scale that is an easy fraction of the intended final work, such as one-third or one-quarter.

The third and final step is an *enlargement* of the maquette, made by using one of the methods described later in this chapter.

The advantage of this process is that you have great freedom at the early design stage. The concept model can be shown to a person interested in your work, and together you can make changes. The maquette allows you to decide on the final details and forms of the piece, and, if you have a client, enables you to show him or her exactly what the final piece will look like. Only when happy with both of these stages do you begin the commitment of enlarging.

FOUNDRY ENLARGING

One surefire way to enlarge is to send your maquette to a professional full-service foundry. ("Full-service" means they do work such as enlarging, fabrication, and other jobs in addition to simply casting sculpture. See pages 118–119 for more information on working with foundries, and page 223 for a rough guide to pricing enlargement work.) In general, the foundry will require you to provide a good maquette, preferably in plaster so as to reduce its fragility, although they will also take a good, strong clay maquette on a solid armature.

The foundry will enlarge the work to the specified size and in the specified clay. Most foundries will allow you a choice of clay, but if you choose one that they don't stock you may have to pay extra. The foundry will also ask you to select a degree of finish—80 percent, 90 percent, 95 percent, or whatever. This percentage indicates how far along you want the foundry to go before you arrive to do the finishing touches. Naturally, the price increases with the degree of finish required. Assuming you have opted for something less than 100 percent, you then go to the foundry and work on the clay enlargement to make it your own. This can range from a day or two up to several weeks, or even months, depending on the size of the piece and the degree of finish and detail you require.

There are two big advantages to having a foundry enlarge your work:

1. They do all the monkey work. They build a secure armature and add all the clay in the right places, leaving you with just the fun part of finishing the sculpture. Also, if the armature collapses or a measurement is demonstrably wrong, it's their problem, not yours.

2. When the enlargement is finished, it is already at the foundry, ready for molding. If you enlarge in your studio you have to

either make the mold yourself, bring in a molder at added expense, or risk damage to the enlargement by moving it.

There are also disadvantages to having a foundry enlarge. The three main ones are:

1. Many artists feel the work is no longer completely their own.
2. You must travel to a foundry and stay in a cheap motel, working several days and watching bad movies at night. This obviously isn't the case if the foundry is near your home.
3. Many artists feel rushed when working this way, hurrying more than they might otherwise because the motel bills are adding up and the time away from home is a drag. Thus, there might be passages on the work that are less well worked out than if the enlargement were done in the artist's studio.

ENLARGING ON YOUR OWN

Naturally, you must weigh all the options when making the decision of whether to enlarge by yourself or have it done for you. What follows is a discussion of several methods for enlarging on your own.

The "Eyeball" Method

This method is just what it sounds like. You simply eyeball the work and then enlarge it. Don't discount this method just because it isn't very technical. After all, when creating a sculpture from a live model, that's what you're doing—eyeballing. You use a lot of skills to work from a model, such as

working from profiles, measuring, and the like. The same thing will work with enlarging, especially if the ratio of enlargement isn't too great. Doubling in size, for example, is not too difficult to eyeball. But if the enlargement is three, four, or several times larger, you would be wise to use one of the alternative methods discussed below.

The "Frame" Method

This is a variation on the eyeball method that uses a frame, with strings strung in a grid pattern. Create a small one for the maquette and a proportionately larger one for the enlargement. For example, suppose your maquette is 2 feet tall and you want to make an enlargement that's twice as big, or 4 feet tall. Create a panel 3 feet by 3 feet for the maquette, with strings strung every inch. For the enlargement, make a panel twice as big, or 6 feet by 6 feet, with strings every 2 inches.

Set each panel so you can look through it to see the appropriate model, with the larger panel set exactly twice as far from the stand for your enlargement as the smaller panel is from the maquette. You can now look through the panels from a fixed viewing point and compare where points on each sculpture fall on their grid. As you add clay to the larger armature, compare each profile with the corresponding profile of the maquette, as seen against the grids—just as you would if enlarging a picture with grids. As you work, turn the maquette and enlargement in parallel to compare all profiles through the grids.

The advantage of this method is that it is quick, easy, and low-tech. It doesn't require any outlay of money, and it will work. The only disadvantage is that it isn't as accurate as some of the other methods, and I wouldn't recommend it for very large work.

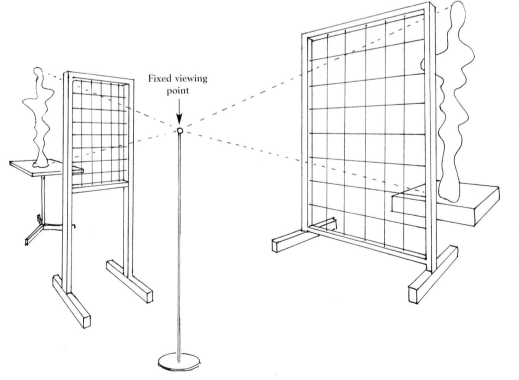

Fixed viewing point

Enlarging with the frame method, using a superimposed grid. The grids are created proportionately—if the enlargement is double the size of the maquette, the larger panel should be double the size of the smaller panel, and so on. Likewise, the larger panel is set a proportionate distance from the enlargement—in the example above, it would be placed twice as far from the enlargement as the smaller panel is from the maquette. Finally, there must be a fixed viewing point from which all observations are made. The distance between the viewing point, the panels, and the sculptures must always be in accordance with the appropriate ratio.

The "Grid-up" Method

The idea behind this method is to find points in space by first finding them on a base and then going up the correct distance. Here's how it's done: draw grids on the bases of both the maquette and the enlargement. The grids should be sized proportionately—that is, if the enlargement is to be twice as big as the maquette, the grid for the enlargement should be twice as big as the grid for the maquette, etc.

Once the grids are drawn, note where the maquette's feet lie in the smaller grid, and draw them in the same positions on the enlargement grid. Now, to locate where the enlargement's knee should go, drop a plumb line from the maquette's knee and locate where the bottom of the plumb line falls on the grid—for explanatory purposes, this will be called point A. Transfer point A to the large grid.

You must now calculate how far above point A the enlargement's knee should actually fall. To find this, multiply the distance between point A on the smaller grid and the maquette's knee by the ratio of enlargement. For example, if the enlargement is twice the size of the maquette, double the distance. Using a hacksaw, saw a notch in a pipe just above where it enters a flange, and bend it so the top of the pipe is directly at this point. To check, hold a plumb line at your newly placed knee and make sure the bottom falls to point A on the grid. Now weld over the notch.

Continue this way up to the hip, and then up the other foot through the knee to the hip. At this point you will have a strong pipe armature for both legs. From the hips, use the same method to measure all the way to the shoulders, the elbows, the wrists, and finally the head. You can also use this same method with a strong wire armature supported by a back iron.

Enlarging Machines

All enlarging machines do essentially the same thing: measure points in space. A good machine will touch a given point on the maquette and then indicate exactly where that point should be in space on the enlargement. Thus, with even a crude large armature in place, you can determine exactly where the key landmarks of the body are before applying clay. Also, you can check positions after the work is well along.

There are several kinds of enlarging machines, some simple and others complex. My own machine is based on a simple idea—that of two uprights before the sculpture, with a sliding crossbar that goes up and down. On the crossbar is a sliding element that goes from side to side and holds a pointer that goes in and out to the sculpture. Thus, every point is read as a certain distance up, a certain distance over, and a certain distance in. There must be two such machines—a small one for the maquette, and a large one for the enlargement. The maquette is placed a precise distance away from the smaller machine and must be able to rotate so that readings can be taken from the front, either side, or the back.

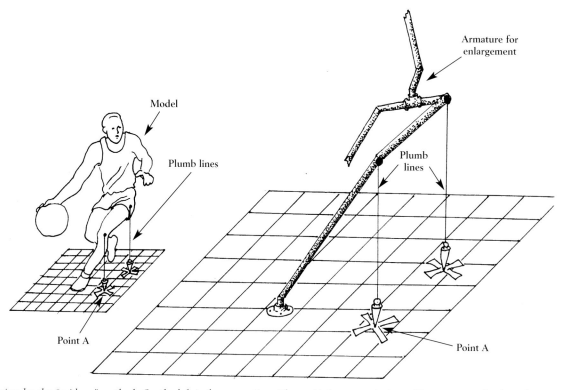

Enlarging by the "grid up" method. On the left is the maquette, with a grid drawn on its base. The armature for the enlargement is on the right, above a proportionately larger grid. Key points (knee, hip, etc.) are located on the small grid with a plumb line, then transferred to the larger grid. The distance up from each of those points is then calculated as a proportionate multiple of the distance on the maquette.

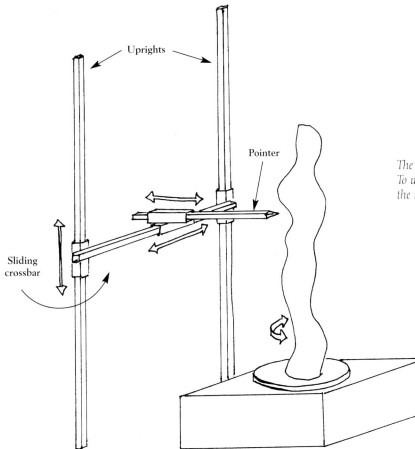

Uprights

Pointer

Sliding
crossbar

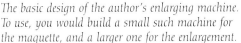

*The basic design of the author's enlarging machine.
To use, you would build a small such machine for
the maquette, and a larger one for the enlargement.*

Because I want it to be completely adjustable, my machine is rather complex. But it doesn't really need to be so complicated. Here are the important considerations:

■ The uprights must be vertical, all horizontal members must be level, and all angles must be right angles.

■ The maquette and the enlargement should be placed on turntables, and the center of each turntable must be set at a proportionate distance from the uprights. For example, if the enlargement is to be three times the size of the maquette, the enlargement's turntable should be three times as far from its uprights as the maquette's turntable is from its uprights.

■ Each machine should have three scales: one on the vertical upright, one on the horizontal crossbar, and one on the pointer. In my case, the scales are strips of wood on which I draw rulers. Each ruler has a zero center and reads outwards to the left and right. For the smaller machine, I mark the scales with centimeters copied right off a centimeter scale. (You don't need all the little millimeter marks—just halves and quarters are close enough.) Scales on the larger machine are marked with proportionately larger measures. For example, if the enlargement is to be double the size of the maquette, I make the marks two centimeters apart; if it is to be triple, three centimeters apart; and so on, for any proportion. You can also use inches if you're more comfortable with them.

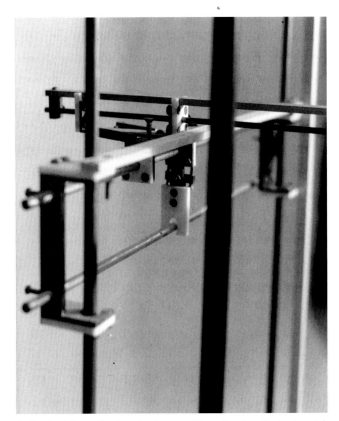

A detail of the author's enlarging machine, showing the horizontal slide and the back end of the pointer.

■ Each machine must be calibrated to the other one. This means that the scale on each machine's vertical uprights must read zero when the pointer is touching the base plate. And the scales on the horizontal crossbars and pointers should read zero when the pointers exactly touch the centerline of the turntable.

■ Each sculpture—the maquette and the large armature—should have a vertical centerline that is plumb. A pin should drop from the top of each machine's frame into a depression in the center of the head. This assures that the maquette (or enlargement) rotates on a central axis and does not wobble.

■ Finally, both sculptures must be able to rotate for readings from the front, both sides, and back.

A second kind of machine is more common, but is a little trickier to set up, although easier to use once in place. It is a long beam attached to a stand or wall. The beam must be able to turn in all directions—side to side, up and down—and to rotate on its own axis. A ball joint is best for this, though you may be able to devise other ways to do it. On the beam are two pointers, a short one and a long one, that are linked, so when one moves the other moves parallel to it.

The two sculptures are positioned at the two pointers, with the maquette at the shorter pointer, closer to the pivot at the wall, and the enlargement at the larger pointer, out near the end. The machine must then be adjusted so that when the short pointer touches a point on the maquette, the long pointer touches the corresponding point on the enlargement. This is done by adjusting the positions of the two pointers along the beam and the lengths of the pointers themselves. The sculptures can even be set up to turn in synch by placing them on two turntables connected by bicycle sprockets and a long bicycle chain. (The sprockets must be the same size.)

When everything is in place and adjusted properly, enlarging is simple. You just touch a point on the maquette with the small pointer and the large pointer is instantly on the correct point for the enlargement. You can even fit a loop tool on the large pointer and then pile excess clay on the enlargement. As you run the small pointer over the maquette, the loop tool will automatically peel the appropriate amount of clay off the enlargement.

A box of wooden matches is very handy for enlarging by machine. Once the armature is adjusted correctly (which is the heart of it all, so take your time), and a layer of clay is in place, you can use the machine to find key points and then shove in wooden matches so the heads are just where the points should be. I have often done this in rows, which makes it easy to fill in clay between the match heads and begin creating the correct form. Later, you can go along with a needle-nosed pliers and pull the matches out.

An enlarging machine will give you a good rough-up, but no machine will enlarge for you. Sooner or later, you push the machine out of the way and start making sculpture at the larger scale. Still, a machine is a very handy way to get that initial rough-up in the correct place, and it can save you a great deal of time otherwise spent tearing down, bending, and rebuilding the armature.

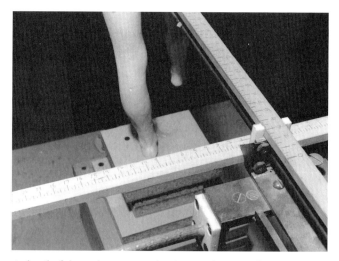

A detail of the scales on my enlarging machine. In this case, my marks are 1 cm apart, divided into quarters, but you can use any measure you like.

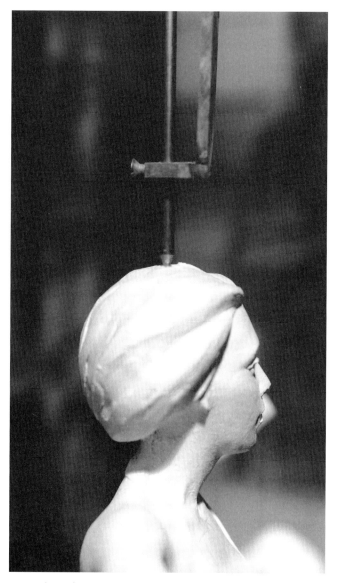

A pin drops from the frame into a depression in the center of the head to prevent wobbling.

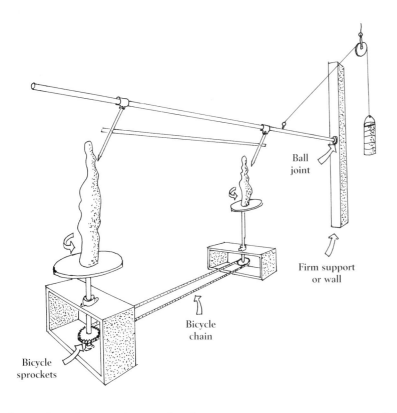

A standard enlarging machine.

Ball joint

Firm support or wall

Bicycle chain

Bicycle sprockets

The "Sliced Bread" Method

Here's a completely different way to enlarge. The idea is simple: a small maquette is created in plaster, then sliced on a band saw just like a loaf of bread. Each slice is then enlarged in Styrofoam, and those slices are stacked to create the enlargement. George Lundeen demonstrates this process in the photographs on the right and on page 64 with his larger-than-life-sized sculpture *The Aviator.*

One way to enlarge the slices is by using slides. Set up a camera on a tripod so it is looking down at a table or surface. Load the camera with slide film, and place each slice on the table and photograph it. Then the slides can be put in a projector and projected onto the material for the large slices. The projector can be moved forward and backward until just the right size is achieved—if you are doubling the size of the maquette, the slices should be twice as large, and so on. Each slice will be projected very accurately at the new size. You can then trace the outline of the slice and cut with a saber saw or band saw.

TIP

As you cut the plaster maquette into slices, make sure you hold it so its centerline is always at exact right angles to the plane of the cut. Also, the slices should be of even thickness so it is a good idea to put a fence on the band saw.

The enlarged slices can be made of several different materials. They can be cut from thick Styrofoam, or they can be made of cardboard—one piece for the top surface, another for the bottom, with cardboard set on edge in between to

separate the two layers. Note that whatever material you use, each slice will have a slightly different shape on the bottom of the slice and on the top, as would slices of a cone. To reproduce these shapes faithfully, photograph *both* sides of each original slice and enlarge each side's measure accordingly.

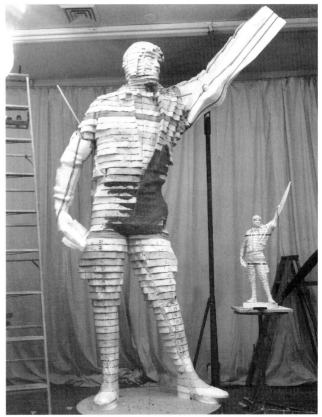

Photo by Fabrice Photography

The Aviator, *by George Lundeen, enlarged with foam slices. The enlargement is 16' (4.9 m) high.*

You should also account for the material taken out by the saw cut by making each large slice that much thicker. Finally, take about ½ inch off the circumference of each enlarged slice to allow for the clay.

It's a good idea to have some kind of alignment holes drilled in the small slices and again in the large ones so they line up and don't begin to lean off to one side. Use these holes to slip the slices over strong vertical pipes. Once you have stacked up the slices, cover the entire form with a good, sticky oil clay, well pressed in. Try to keep the layer of clay at an even thickness that corresponds to the exact amount you had taken off the circumference of the slices.

One advantage of this system, besides its speed and accuracy, is the lightness and strength of the armature. Also, it doesn't require fancy machines and is good for enlarging to very large sizes.

The Computer-Generated Milled Foam Method

There are firms around the country that will take your maquette and "read" it with a laser, which then records the many points of the surface on a computer. (See the list of suppliers for one such firm.) Usually, they take something like a quarter million points off a model. Then a special three-dimensional milling machine uses those points to mill, or carve, a piece of dense rigid foam just like your maquette, only larger (or smaller—this method will go either direction). The foam can be milled with different sized cutters—large for loose, coarse work, or small for

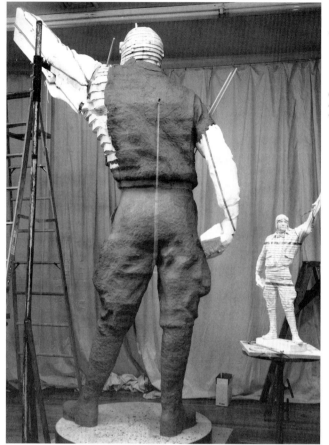

Photo by Fabrice Photography

Clay being applied to an enlargement of The Aviator.

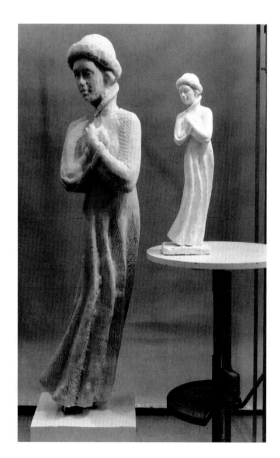

Winter, *Tuck Langland, 1999. Plaster maquette, 24" (61 cm) high, and foam enlargement, 48" (122 cm) high, by computer method.*

detailed work. They can enlarge or reduce to any amount, and can also reduce the sculpture's size to allow for a clay skin.

This process will produce a very accurate foam enlargement (or reduction) of your maquette, but there are some things this process can't do. It can't mill something it can't see. If a sculpture is a figure standing with its hand on its hip, the foam will come back with the space between arm and body solidly filled in. You would have to carve that section away yourself.

After carving away any hidden areas, coat the entire form with two or three coats of good shellac. This provides a tight, noncrumbly surface. Then, apply Classic Clay or another good oil clay in small pieces, well pressed on to make up for the thickness removed in the milling. An alternative is to melt clay in a pot and brush it on.

The advantage to this system is that the enlargement is done by outside professionals, yet it is easily shipped to your studio so you can work on the surface at leisure. Also, being quite rigid and yet rather lightweight, the final piece can be easily and safely transported to a foundry. The disadvantage is the cost, which is currently quoted at about $500 per foot, making a 4-foot enlargement cost about $2,000. This is not far from what a foundry would charge, however, so if you're going to have your enlargement done professionally anyway, foam is a real consideration.

Other Methods

I have listed six ways to enlarge. The seventh way is your way. There are many ways to attack the enlargement process, and the six I have described all differ in general principle. There are many more variations on these six principles, and no doubt several other completely different ones as well. It's probably safe to say that everyone doing enlarging today has some unique method.

One way to discover new enlargement methods is to tour foundries. Write to one of the sources listed in the back of this book for a list of foundries, and when you travel, seek them out and ask for tours. You will always learn something. Keep your eyes open in the enlarging section and try to find out, first, how they do it, and second, whether they are any good. Would you want them to do your work?

The other way to discover new methods is to think. Building on the principles described in this chapter, try to imagine ways you could enlarge with the space, equipment, and money at your disposal. Perhaps you can devise methods or variations on methods that are more suitable for you. Between these suggestions, ideas gleaned from foundry visits, and your own creativity, you should be able to devise ways to enlarge any piece of work.

Winter, showing the inability of the milling machine to carve an undercut.

Winter, with the undercut carved into the foam.

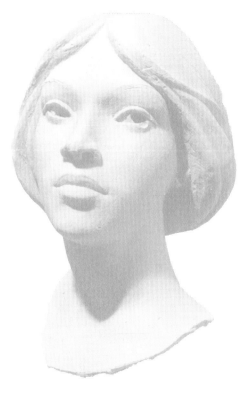

ALTERNATIVES TO CASTING

Anyone who's made ice cubes or Jell-O has done some casting. The principle behind all casting is that you put a liquid that will eventually turn hard into a mold or form, let it harden, and then remove it. Casting allows you to use materials impossible to work in other ways, such as bronze, and to create multiple casts to form an edition. But casting is also laborious and time-consuming, and often results in some loss of fidelity to the original. Besides, you might not always want to use an expensive material like bronze, or to create multiple casts. So before launching into our discussion of casting, let's explore some alternative ways to create permanent works.

FIRING CLAY

Virtually all water clays will fire into a hard and permanent material. In fact, most will fire into a material that is among the most permanent on earth. Conveniently, water clays are also among the most responsive and rewarding to model and, once fired, can take a limitless variety of surface and color treatments. Thus, modeling and then firing water clay is in general the best way to create one-off works, combining great freedom of creation with extreme permanence of the finished product.

Kinds of Clay

We're getting into pottery here, and the best thing at this point is to read this section quickly and then begin to consult serious pottery books, of which there are hundreds. Also, it's a good idea to work in a place where pottery is made and fired. Consult your local colleges and universities to find a department where you can work. Look for art centers or other places that offer classes in ceramics, and look in the Yellow Pages under "ceramics" to find commercial outlets for the medium. You will need a supplier of materials, and you will need kilns.

Review Chapter 2 for a quick and simple overview of the different kinds of clay available. You should also read about clay bodies in pottery and ceramic books. There is a limitless variety of clay bodies, and it can get very complicated, involving a good deal of chemistry. If that is too daunting, simply go to a ceramic supplier (again, try the Yellow Pages) and buy two or three good clays. The supplier ought to be able to show you what the various clays look like when fired so you have an idea of what you'll get. (They will often be able to do the firing for you as well.)

The color of clay when soft and wet usually has little to do with its color when fired. There are many factors involved, including the following:

■ *Clay type.* All clays contain impurities of many kinds, and these affect the color a great deal. It's true that a darker clay fires darker and a lighter clay fires lighter, but within that there is much variation. Porcelain will fire white, gray clays

often fire tan, and brown clays usually fire close to their wet color. But don't bet the farm on any of this.

■ *Oxidation versus reduction.* This refers to the supply of oxygen in a kiln when the clay reaches a high temperature. Usually oxidation (plenty of oxygen) means that the fired clay will have a whiter, lighter color, and reduction (reduced oxygen) means a darker, usually more brown color, particularly if there is any iron in the clay.

■ *Slip.* Also called *engobe.* This is simply clay that has been thinned out with water, which is applied to the surface of a clay object to alter its color. Slip can be any of a wide variety of colors.

■ *Glazes.* This is where the chemistry really comes in. Glazes are slip-like liquids that turn glassy during firing, and can be any color imaginable. Usually they make the surface of the work look glossy, but not always. The art of ceramics is heavily involved in glazes, and it is a subject so complex that not even a whole book the length of this one would cover a tenth of it. Again, consult a pottery department, store, or commercial shop for more information.

Methods

The first requirement for firing clay is that it not blow up in the kiln. There are three main reasons why clay sometimes blows up:

1. There is foreign matter in the clay.
2. The clay is too thick.
3. The clay isn't dry or was improperly fired. (This will be discussed in the next section, "Firing.")

The first requirement is to keep your clay clean. Plaster is the enemy of fired clay, since small pieces of plaster retain moisture. When the kiln temperature goes past the boiling point of water, these pieces will explode, popping cavities out the sides of the clay. Most sculpture studios have plaster lying around, and small pieces of it can easily drift into the clay. So unless you are working in a ceramics studio where plaster is banned, clean a separate area and keep it clean.

The next requirement is to keep the clay thin. You can't make a solid life-sized clay head and hope for it to stay in one piece when fired. In general, no part of the sculpture should be thicker than 1 inch, and the thinner the better.

There are, however, ways around this second requirement. According to the Bible, the Hebrew slaves once made bricks by stomping straw into the mushy clay with their feet, but the Egyptians forced them to make more bricks with less straw. What were the Hebrews doing? They were adding porosity to the clay, since bricks are solid blocks, much more than an inch thick, which must be fired without exploding. The straw created avenues for air and gasses to move through the bricks in the kiln, in effect making no particle of clay more than a fraction of an inch from an air channel.

You don't want straw in your sculptures, but you can add *grog* or sand to increase the clay's resistance to exploding.

Grog is simply clay that has already been fired and then ground into grains or powder. It comes in many grit sizes, which refer to the number of little pieces that would make an inch if you lined them up. Thus, 80-grit is coarser than 120-grit, and so on. (These sizes are standard for grits of all kinds, even sandpaper.) A little fine grog or sand added to clay is hardly noticeable when modeling, but will give greater forgiveness in the kiln. More and coarser grit will become obvious on the surface as you work, but will greatly increase the ability of the clay to fire successfully with thick sections.

It is still usually a better plan to have no thick sections. This can be accomplished in three different ways:

1. by building hollow
2. by hollowing out
3. by slip casting (see Chapter 10)

Building hollow

One way to build a hollow sculpture is with the *coil method.* Long snakes of clay are rolled out and coiled around, with each snake smeared and blended into the previous layer to build a continuous wall. This method is great for making a cylinder, less great for making a sculpture. If you are really sure of the form you are creating and work slowly and carefully, anticipating clearly in your mind's eye the total final shape even after only a small portion has been created, you can create sculpture this way. The general principle is to work from bottom to top, always checking the form, then allowing the lower portions of the clay to stiffen as you go up to support the weight of the upper portions. It is a good idea to have a solid clay model of what you want beside you as you work.

Another way to build hollow is to roll out slabs of clay, roll the slabs into cylinders, and then distort the cylinders into the sculpture. If you're really sure of what you're doing you can use this method, but there are easier ways. One is to create a hollow mass out of a material like wadded newspaper, and then build around the mass. It is important to remember here that clay shrinks as it dries, and the mass to which you apply the clay must collapse as the clay shrinks or the clay will crack. And, if you plan to leave the mass inside when firing, it has to be flammable.

Bruno Lucchesi demonstrates these last two methods in his books *Modeling the Figure in Clay,* and *Terracotta: The Technique of Fired Clay Sculpture,* both co-authored by Margit Malmstrom (see Further Reading). It would be a waste of my time and yours to attempt to explain what he explains so well; if you wish to create heads and figures in clay for firing, those are the books to buy and study. But be warned: Bruno is a magician with clay, and he makes things look very easy. If you find your work doesn't come out as masterful as his, don't despair. As the old saying goes, the more you practice the luckier you'll get. (And having a thorough training in sculpture from Italian masters doesn't hurt either.)

Hollowing out

This method is much easier, and allows for a great deal more caution and feeling your way.

To make a portrait head, simply pack water clay on an armature as usual, and then let the clay reach a hard, leathery state. Slice the clay in half, usually on a vertical plane just behind the ears. You should now be able to work the two halves off the armature with some digging around inside, and lay them on a soft pad. Working carefully, hollow out the insides as you would hollow out a cantaloupe. One advantage is that the clay, though hard and tough on the outside, is usually still rather soft on the inside. Feel with your fingers as you go, and try for an even wall-thickness of about ½ inch. When you are finished, take a needle and poke holes all over the inside. These will serve something of the same purpose as that straw the Hebrew slaves mashed into their clay.

To put the two halves together again, scratch up the two facing edges with a needle, as shown opposite. Take a small pad of new, soft clay, form it into a small bowl in your hand, and put some water into it. With a soft brush, stir around in the bowl until you have a nice creamy clay slip. Brush this slip onto the two exposed edges you want to join, then press them tightly together. At this point, if you can reach inside, take a needle and mush across the seam as much as possible to knit the halves together. Then you can work the outside seam to remove any traces of the disturbance.

This same technique will work with other shapes—whether figures, animals, or abstractions—just so long as there is sufficient mass to separate and hollow out. When rejoining, if you can't reach inside, be sure to wet the seams generously with slip and press well together.

Here's an easier way to do the same job. For explanatory purposes, I'll use the example of a portrait head again, since it is a shape everyone knows. Begin by building a ball of clay on the armature about 1 inch smaller than you want the head to be. Cover this ball with a thin plastic bag—the smaller the better so you have a minimum amount of wrinkles and folds. Now lay a thin wire over the bag-covered ball, running up one side of the pipe, over the top, and down the other side, as shown opposite. Tape this wire to the pipe.

Over this structure, flop slabs of fresh, soft clay. The slabs will want to fall off until you have all of them on and stuck together. Once dried a little they will firm up, and it is these you model into the sculpture. When the modeling is complete, the rest is obvious. Let the clay dry to a leathery hardness, and then untape the wire from the pipe, pulling the two ends up to cut the head in two parts, which should slip off the bag-covered inner clay form. You can then proceed as before: scoop out the inside, scratch the facing edges, make slip, and rejoin.

Some works can be simply hollowed out from below. For example, a figure seated on a block might need only scooping out from below to remove the bulk of clay. Then, assuming you have some grog in the clay and you do some liberal poking with a needle (a gentle touch with a moist finger will cover any needle holes on the surface), you should be able to get away with firing.

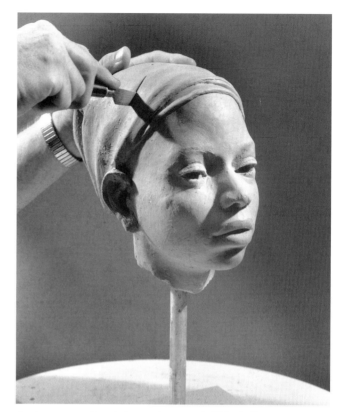

Cutting a water-based clay sculpture in half for hollowing out. Use a long-bladed knife and cut through the clay cleanly, all the way to the armature.

Using a hook tool, scoop out the soft clay from the center. You want a wall thickness of ½ inch or less. Feel with your fingers to determine the wall thickness.

Scratching the facing edge of a clay piece.

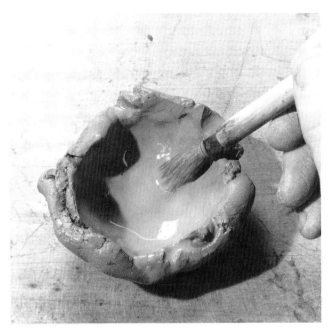

Making slip in a clay cup.

Brushing the scored edge with slip for joining.

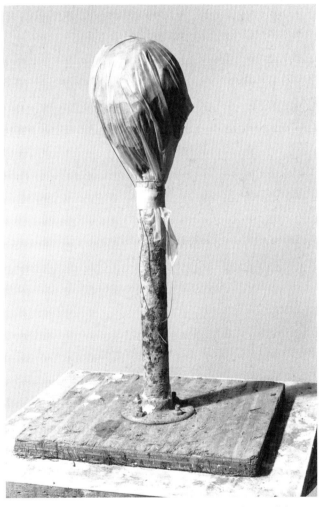

A clay-filled head armature covered with plastic, which will be used to build a hollow clay head for firing. Note the wire that has been passed over the top of the ball and taped to the pipe. This wire will be pulled out later to cut the head in half.

Firing

The third requirement to keep clay from blowing up in the kiln is proper firing. There are two unbreakable rules for firing clay:

1. The clay must be dry.
2. The kiln temperature must rise slowly.

Clay can look dry after just a couple of days, but a clay sculpture must sit out in the open air for at least two weeks before it begins to get dry. Most potters dry their wares on shelves in the kiln area where it is hot and dry. Find a hot place where you can leave your work, like sitting on the furnace in the basement. The longer you can leave it there, the better. You can also leave your sculpture in a kitchen oven set at a very low temperature for a complete day before firing. As it dries, turn your sculpture now and then to make sure air and moisture don't get trapped underneath. Often, potters will *candle* their works by leaving them in the kiln with the pilot light on overnight, or even for a day or two, to remove the final traces of moisture.

When firing, the kiln temperature should rise very gently until just over 212°F (100°C). If the temperature rises past this point too quickly, any water remaining in the clay will boil, turn to steam, and blow a chunk out. Once you have passed that point you can continue to apply heat, but ease off and go slowly while in the 550–1000°F (300–550°C) range. It is in this range that the water molecules, which are chemically combined with the clay, are finally driven off.

The clay you choose will determine your top temperature. When you buy clay, be sure to ask what *cone* it is fired to. Cones are little sticks of fired clay that melt at precise temperatures. They are numbered on a scale that goes both above and below zero, like positive and negative numbers. Numbers below zero begin with "0," such as 04, and get hotter as they approach zero. For example, a 02 cone is hotter than a 03 cone, which in turn is hotter than a 04 cone. The numbers continue above zero, such as 1, 2, 3, and so on, each one hotter than the last. In general, earthenware will fire in the 05 range and stoneware will fire more like cone 8 or 10.

Electric kilns will fire to high temperatures, but they will only oxidize. That is, they have no way to darken the clay by means of reduced oxygen. Gas kilns can usually reduce, which is done during the last phases of firing.

Again, firing is a very complex subject. It's best not to simply buy a kiln and start cooking, but to attend pottery classes, read, and learn this complex task like any other complex task, a little at a time.

SELF-HARDENING CLAY

For many people, *self-hardening clay* means children's clay. In fact, most self-hardening clays are marketed for children and elementary schools. But don't be fooled. In the hands of an artist, this material can produce fine art indeed. It's the artist that counts, not the material.

Kinds of Products

Self-hardening clays come in two major categories: those that harden by simply drying in the air, and those that are baked in a low oven (a home oven). There is also a distinction between those that shrink on hardening and those that don't. In general, the air-drying clays will be less likely to shrink than those that are baked.

Probably the most common brand of self-hardening clay is Sculpey, which is widely available in art supply stores. Sculpey comes in several different kinds and a wide range of colors, and hardens by baking in a kitchen oven at about 350°F (177°C). Another self-hardening clay, Darwi, hardens without firing, by simply drying in the air. It is purported to have very little shrinkage, and will certainly harden without cracking over a simple armature. Over a larger armature—say, a bottle—there might be enough shrinkage to cause cracking.

Self-hardening clay is a large field—there are a lot of products available and more appearing on the market all the time. Look at art supply catalogs, talk to your local art supply store, and make some phone calls to find what's out there.

Working with Self-hardening Clay

Don't expect these clays to feel like ordinary water or oil clay. They have a more puttylike feel and are a little spongy to the touch. They are probably best used in small pieces worked well together. They don't generally take well to being scraped across with rake or hook tools; direct work with the fingers should be the best. To bake the clay, simply follow the directions that come with the product.

Because it comes in a wide range of colors, self-hardening clay can be used to create brightly colored or multicolored works. A good suggestion is to buy a range of colors and begin experimenting with them. You probably don't want to think in terms of mixing colors, but rather about laying one color over another to create patterns or making different sections in different colors. Like anything else, experimentation and practice will yield better and better results.

The one caution about self-hardening clays is that they can harden before you get around to using them. They all come well wrapped in plastic, but their shelf life is limited; be sure you are buying fresh material and use it relatively quickly. If you buy a supply and leave it on the shelf for a year, chances are it won't be usable.

DIRECT BUILDING

Direct building means creating a sculpture directly out of a material that is first soft and then turns hard. The most obvious of these is plaster. Many sculptors create a great many of their major works in direct plaster. Some who come quickly to mind are Henry Moore, Kenneth Armitage, Reg Butler, Elizabeth Frink, and a host of others. For these artists, plaster was (and still is) an ideal medium because it is as workable as soft clay at one stage, and then hard for carving and filing

later on. But although plaster does become nice and hard and can be quite permanent, it is not weatherproof and is usually used as a form for later casting, as was done by the artists just mentioned to create works cast in bronze. As this chapter is about avoiding casting, we'll leave plaster out. Still, the essential techniques of direct building with plaster can be applied to whatever material you choose.

Materials for Direct Building

Plaster is the first, then come the superplasters. US Gypsum markets several varieties of gypsum cements, which work like plaster but set a good deal harder (see Chapter 10). All of these products come as powders that mix with water.

Next come the resin-based gypsum systems, such as Design Cast and Forton MG. Each of these involves a liquid rather like milk, plus one, two, or even three powders that are measured and mixed. The resulting materials differ in thickness depending on the proportions used and the product itself, and turn very hard and weatherproof. See Chapter 10 for more details, and the list of suppliers for contact information.

There are also many cements and concretes available. The cements have different properties for different uses, and can be mixed various ways for various applications. Read Lynn Olson's *Sculpting with Cement: Direct Modeling in a Permanent Material* if this is your direction (see Futher Reading). As for concrete, a popular one for direct building is Ciment Fondu, which is black and mixes to a nice workable consistency.

Some sculptors have also created works in body putty, which is thickened polyester resin. It works, though it smells.

Methods of Direct Building

The main consideration when direct building is size. For small things, the material can be applied to any sort of armature, given some surface to grip. A small figure can be created with a steel rod armature, for example, with wire wrapped around and around for the material to grab. The material can be mixed to a paste consistency, forced through the wrapped wire, and allowed to harden. Then more material is applied.

For larger works, the armature can be hollow. A frame can be made and covered with wire mesh of some kind—chicken wire, heavy screen, expanded steel, or whatever you can find and work with. An initial layer of material is worked into this mesh, pushed through to grip, and then allowed to harden. The real building begins on top of this base.

As many of these materials will set to a firm but workable consistency at first and then go really hard after a few hours, timing is important. Don't work overly large sections. Work small areas, applying the material and then scraping, carving, or rasping it down to shape soon after setting and when still rather soft. Once it has fully cured it can be a big job to alter. As with all products, read the instructions carefully. They will tell you how to mix for varying consistencies, how to join new material to old, about curing rates, and so on.

Many of these materials can be filled with stone powders, metal powders, coloring agents and so on, so the final work is already colored. The finished piece can also have color rubbed into it in the form of paints or dyes. And lastly, some kind of final surface is often applied, such as a good exterior varnish, a urethane varnish, or linseed oil thinned with turpentine. This final coat is not necessary to make the material weatherproof, but it can be used to alter the color and sheen.

INTRODUCTION TO CASTING

As introduced in Chapter 7, casting is the process of putting a liquid into a mold or form, letting it harden, and then removing it. Where the variations occur are with the different materials used to make the mold and the different kinds of liquid put in the mold. This chapter will discuss the former, showing you three different types of molds. It will also introduce the general vocabulary and concepts of casting.

Before we can go much further, we need some common vocabulary. The object you want to reproduce is called the *model*, or *positive*. This can be a clay sculpture, an object of some kind, a living human body, or just about anything.

The *mold* is the *negative* shape that is made from the positive, into which the casting material is poured. In a way, a mold is a casting in itself, since it is usually formed of a soft material or liquid that is placed around the positive and allowed to harden, taking a perfect negative impression of the positive. Molds can be anything from an ice cube tray to a complex multipiece polyurethane rubber mold in a rigid shell, to a burned-out ceramic shell mold ready for molten bronze.

The *casting*, or *cast*, is the subsequent positive form created when a liquid is placed into the negative and allowed to go hard. The word *casting* is also a verb that describes the entire process.

So the process goes from *model*, to *mold*, to *casting*.

There are lots of problems associated with casting; two of the most obvious are how to get the mold off the original positive form, and how to get the cast out of the mold after it's gone hard. It is the answers to these two questions that govern a great deal of how casting is done. Another very important question is what kind of material you want to use for the final cast. That question, too, governs much of the process.

KINDS OF MOLDS

There are essentially two kinds of mold-making materials: *rigid* and *flexible*. Flexible molds can usually be bent, folded, or stripped off the model. But for rigid molds (like ice cube trays), there must be a way to remove the mold from the original positive, and a way to get the casting out of the mold. Partly because of this, there are relatively few sculptural uses for rigid molds, and it is the flexible mold that has taken over the largest part of the sculpture casting business.

Rigid Molds

Rigid molds can be either *one piece* or *multipiece*. One-piece molds are usually open-face molds, which are pretty self-explanatory. They are the kind of molds you would use on a relief. They are generally flat, and one entire face is open to allow the model to be removed, the casting material put in, and the rigid casting removed.

One-piece molds may not have any *undercuts*. An undercut is a place where the form runs around, underneath, or behind another form, locking the casting into the mold. Open-face molds, like ice cube trays, must also have some amount of *draft*—that is, a slight slope to the sides so the casting will pull free. The same thing is true for every piece

A mold will not pull off the form on the left because its sides angle inward—the form has no draft. The form on the right, however, has outwardly sloped sides that allow a mold to be taken off cleanly.

Note the undercuts in the left side of the form (indicated with shading). These parts of the mold will tear off when the piece is removed. The pieces on the right side of the form have no undercuts, so they will pull away cleanly.

of a multipiece rigid mold. A multipiece rigid mold is simply a series of pieces, each without undercuts, which cover the entire surface of the form being cast.

Kinds of rigid molds

There are three common kinds of rigid molds: *waste molds*, *piece molds*, and *die molds*.

Having said all that about undercuts, a *waste mold* is one that ignores undercuts. It is taken off a soft original, like clay, by pulling and tearing away any undercut areas, thus destroying the original model. After being filled, the waste mold is chipped off the cast in small pieces to get it free of any undercuts, wasting the mold in the process (hence the name). So the waste mold is a destructive process by which the original positive is destroyed to get the mold off, and then the mold is destroyed to get the cast out. See page 74 to learn how to make a waste mold.

A *piece mold* is a rigid mold made in enough pieces so each one pulls freely from behind any undercuts. Since there tend to be rather a lot of small pieces that would never hold together on their own, there is usually a *mother mold* made over and around them, into which they fit and which holds them all together in one shape.

Piece molding was a way of casting relatively simple sculptures before the advent of the many flexible molding compounds available today. When you look at castings by Rodin, for example, you can often see the fine ridges between the pieces of the mold, since he left them there as a mark of the process. If you go to the plaster cast room of the Victoria and Albert Museum in London, you can see plaster reproductions of Michelangelo sculptures—and many others—taken off the originals in piece molds consisting of hundreds of pieces. The seams are all there. To learn how to make a plaster piece mold, see page 83.

The third kind of rigid molds, *die molds*, are carved or machined from metal, and are used for casting parts in very large quantities with very high precision. Die molds are rarely used for sculpture, since they are very expensive and are only practical for editions in extremely high numbers.

Materials for Rigid Molds

The simplest material for rigid molds is plaster. It is readily available, inexpensive, works easily, sets quickly, and is very permanent. Plaster molds can cast wax, clay slip, cement, plastics, and even low-temperature metals. When plaster is combined with sand or another refractory, it can even handle bronze, as we will see. Plaster is also the most commonly used material for mother molds, both those on piece molds and, more commonly, those on flexible molds, which are discussed in the next chapter.

There are many materials harder than plaster on the market (see Chapter 10), and these can be used to make more permanent rigid molds. Plastics are often used, for example, and boats, shower units, and some car bodies are cast out of molds made of resin. As mentioned earlier, metal is used for die molds.

Flexible Molds

A commonly used term for flexible molds is *rubber molds*, though the material used is rarely actual rubber. Some suppliers refer to these products as *flexible molding compounds*, and some use the term *RTV*, which means *room temperature vulcanizing*. The next chapter will detail these many products and their uses.

Why use flexible molds? The reason is those undercuts. If you have a richly textured surface with lots of detailed parts sticking out here and there, such as hair or drapery, you'd go crazy trying to make a plaster piece mold with enough pieces to pull cleanly off every little nook and cranny. The flexible mold takes care of that with one big sheet of soft rubber. Also, flexible molds give very exacting detail, are easy to make and use, and, in most cases, have long lives. Finally, the outside of the flexible mold is a smooth surface, so the rigid mother mold can be quite simple and still pull off cleanly.

Flexible molds are by far the most common type of molds used in sculpture, and will be discussed in Chapter 9.

MAKING A WASTE MOLD

This kind of rigid mold is generally the simplest mold to make. Although it yields only one cast (usually in plaster), it is a very handy technique to know and is still used quite often by professional sculptors because of its unique advantages.

One advantage is that it is a quick way to preserve a soft clay sculpture in hard plaster. It can be done just about anywhere with only plaster, a bowl, a hammer and chisel, and some skill. Another unique advantage is that the mold is plaster, and can be worked. A rough surface consists of holes and bumps. Bumps are easy to scrape off, but holes require tedious filling and then scraping smooth. When you make a plaster mold, all the holes in the sculpture become bumps in the mold and can be easily scraped off.

Shims and Clay Walls

The first requirement of a waste mold is that it have some kind of division so that it can be removed from the model. A relief needs no division, but a portrait head, for example, needs to be divided into two halves to be removed. This division can be made in one of two main ways. (There are others but they are used only rarely and need not take up space here.) Probably the most common is with brass or metal *shims*. A shim is a very thin sheet of metal. Brass shims can be purchased from sculpture suppliers, or very good shims can be made from the aluminum of soft drink or beer cans. Simply cut the ends off a can, cut down the side, flatten out the metal by pulling it over the edge of a table, and then cut to shape. Ordinary scissors work perfectly well on this soft metal.

Shims are generally cut into trapezoids about 1½ inches high and of varying lengths. These are pushed gently into the clay to form an upright standing wall that divides the sculpture in the desired plane. Every so often, a shim is bent into a "V" shape to serve as a *key*. And the tops of the shims are brought together by pushing on a roll of soft clay. Plaster can then be applied to both sides of the shims at once, and when set the mold will separate at that point.

A second way to create a parting line is with a *clay wall*. To make a wall, lay out a porous board—particle board is fine—and get a wooden rolling pin and two yardsticks. Now squeeze out a sausage of water or oil clay and lay it on the board. Use the rolling pin to roll the clay flat, with the two yardsticks lying on either side to control the thickness of the wall you are making.

Clay can stick, so roll with only a little pressure, then pick the clay up and set it down again to free it. Roll again, pick it up, and lay down; by about the third time you should be able to press the rolling pin right down on the yardsticks and get a neat, flat, clay slab. Using a yardstick as a straight edge, trim the slab with a knife—both edges—to make it ¼ inch thick, 1 inch wide, and however long your board is. If you are using nice, soft, warmed oil clay, wet the board and rolling pin for a release.

It is important to understand the idea behind the clay wall. When using metal shims, the shim material is so thin

the mold can be built on both sides at once without an appreciable gap. But the clay wall is ¼ inch thick, which would create an unacceptable gap in the mold. To allow for this, the plaster is first built on only one side of the clay wall. The wall is then removed and the exposed edge of the plaster mold greased. Then plaster is applied to the other side, butting up against the first edge to form a perfect seam. Often, small triangular buttresses are added to the back side of the wall for additional support (see page 76). These buttresses won't affect the mold since they, and the wall, will be gone before plaster is applied to the next section.

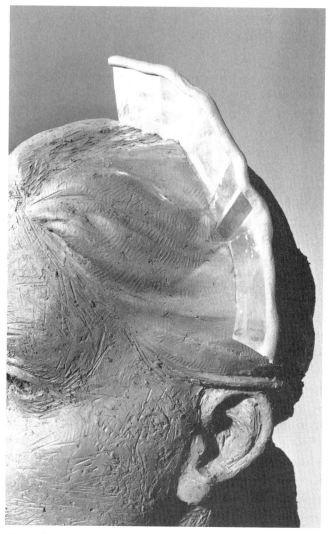

Metal shims topped with a roll of soft clay. The clay pulls the shims together and provides a good surface to clean when the plaster is applied.

Trimming a rolled slab of clay to make neat and tidy walls.

A rolling pin and two sticks laid out on a porous board for rolling clay walls.

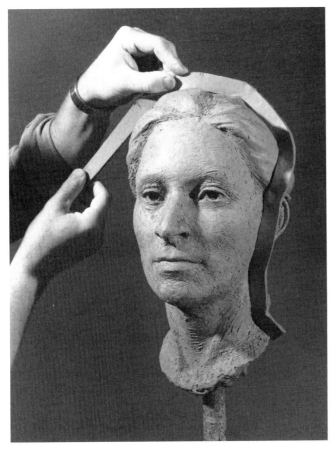

Placing the clay wall on the sculpture where the mold is to be divided.

Detail of the clay wall in place.

Small buttresses of clay added to the back side of the wall for extra support.

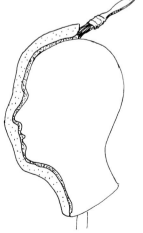

A sequential diagram of the clay wall principle. Top, left to right: the wall put in place; plaster is applied in two layers to the front of the head. Bottom, left to right: the clay wall is removed and the exposed edge of the plaster is greased; the back half is covered with plaster to complete the mold.

Mixing the Plaster

The second requirement for a waste mold is plaster. This is a very old material, mined from the earth, refined, and then fired to remove water of crystallization (the bond that holds the particles of plaster together). The result is a smooth, white powder that will set hard when mixed with water, usually in a rather short time. There are many kinds of plaster on the market, but the one most favored by sculptors is US Gypsum No. 1 Moulding Plaster. That's the one you want. It comes in 50- and 100-pound bags and will set in about fifteen minutes.

It is important to remember that plaster sets—it doesn't harden by drying like mud. This means it will set and go hard *even underwater.* And that means you can't rinse hands, tools, bowls, etc., in the sink because the plaster will run into the sink trap and harden. You can build a sink with a plaster-proof trap, as shown in the drawing below. This sink looks pretty elaborate, but is actually just plywood covered with fiberglass and resin. An alternative is to use a regular sink, but let the drainpipe drop straight down about 6 inches and stop. Beneath that you place a plastic tub or box with a drain running out one side into your regular house or studio drain.

If you haven't got a sink trap, do this: rinse everything in a bucket of water first, then use the sink. After a while there will be a layer of semihard sludge in the bucket. Decant the water off the top, let the sludge harden a bit, and throw it in the trash. Or you can rinse everything outside under a hose. It will make a white area on the ground, but so what?

There are a lot of ways to mix plaster, and they all come down to the same thing: put the plaster in the water, and stir. You will first want to consider what container to use for mixing. Best is a smooth, hard, plastic bowl, or even a smooth glass bowl, either of which will last you a long time. Buy a rubber bowl-scraper at the same time, and keep the bowl clean after every use by scraping out excess plaster and washing it right away. An alternative is to buy flexible bowls, let the plaster harden in them, and then flex the bowls to break the plaster out. They won't last as long, but it's a quick and easy way to work.

Here are three ways to mix plaster for molds and casts:

1. Put some water in a bowl and then sprinkle in the plaster. Watch. The plaster will sink to the bottom of the water and then start to build up as you add more. When it has built up so the entire surface of the water is a soft swamp with no dry piles remaining, stir. You will have a nice creamy mix that should cover the skin of your hand like heavy paint and is perfect for that first coat, whether for the mold or the cast.

If you want a thicker batch, just keep adding plaster until it piles up in dry heaps on the surface. Let these soak up wet, then stir for a much thicker batch.

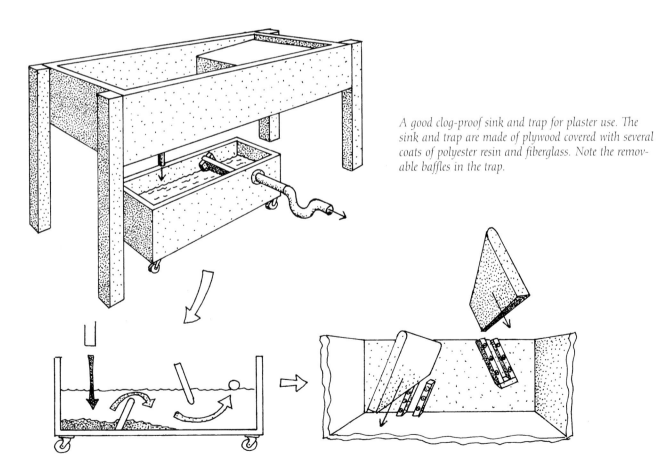

A good clog-proof sink and trap for plaster use. The sink and trap are made of plywood covered with several coats of polyester resin and fiberglass. Note the removable baffles in the trap.

2. Put water in a bowl, add plaster, and stir. Add more plaster and stir, add more and stir, until you get the thickness you want. It will be lumpy and clumpy, but keep working and you can get it smooth. Don't let old-time sculptors watch you do this because they'll lecture you and say you're doing it all wrong, and direct you to method 1, above. But hey (spoken in a whisper), it works.

3. Here's my method, the most high-tech, and definitely the best. First, buy a digital scale. Mine has a capacity of 20 kilos/44 lbs and a sensitivity of .01 kilo/0.02 lbs. (A scale's *capacity* is the heaviest object it can weigh; its *sensitivity* is the smallest increment of weight it indicates.) My scale cost about $300. Shop around—you might do better. The more important number is that second number, the sensitivity; the smaller the number, the higher the price. Get a scale with as small a sensitivity measure as you can afford, but be sure the capacity is at least 5 kilos/10 lbs. (Most digital scales can be set to read in either pounds or kilos.)

To mix the plaster, place an empty bowl on the scale and push the tare button so the scale reads zero. Put water in the bowl and return it to the scale. The scale will now give you the weight of the water in the bowl. With a calculator, multiply the weight of the water by one of the numbers listed below. Your answer will be the weight of the plaster you must add.

> 1.6 for runny
>
> 1.8 for runny, but a little more creamy
>
> 2.0 for a bit thick
>
> 2.2 for quite thick
>
> 2.4 for very thick, almost like paste

After multiplying, hit the tare button again so the scale reads zero. Add plaster until the scale reads the correct weight of plaster. Let the plaster soak up, then stir, and you will have a precise mix every time, at any quantity, without fail. Needless to say, you can use any numbers in between those listed above for intermediate thicknesses.

Applying the Plaster

Before applying plaster for a waste mold, you have to think ahead. Imagine yourself using a chisel to chip down through a white plaster mold to free a white plaster cast. How will you know when you've reached the cast, since both the mold and cast are white? The answer is, you won't. So instead, make the mold in two layers: a thin first layer of colored plaster and then a thicker backup layer in white. This way, you'll chip down through the white, hit the colored layer, and know you're getting close. When you hit white again, you'll know it's the cast.

A good color to use for the first layer is laundry bluing solution. It's something your grandmother used to add to the wash to make shirts look whiter, and you can still find it in some grocery stores, particularly in small, old, out-of-the-way stores. A short squirt into the water makes the plaster nice and blue. Powdered pigments, like tempera paint or cement colors, also work. Rodin used yellow ochre. Don't use food coloring because it will bleed through the plaster and spread from one layer to the next.

Applying this first layer is important. Mix a nice creamy batch—one with the plaster sitting in a soft swamp on the surface of the water (1.6 on the list above). You can't smear the wet plaster onto your water-soluble clay because it will alter the clay's surface. Instead, brush it on very lightly, without scrubbing, or flick it on, as you would flick water into the face of the kid next to you at camp when you're brushing your teeth. It makes a bit of a mess, but it's probably the very best way. To get the plaster into areas of detail, blow with short puffs (shorter puffs work better and won't get you so dizzy). This coat should be about ⅛ inch thick and kind of bumpy to adhere to the next coat.

After you've applied plaster all over the section of the mold you are making, clean the edge of the wall, whether shims or a clay wall. *Always* clean the edge of the wall after *every* batch. Don't forget this. I'll say it again: *clean the edge of the wall after every application of plaster—even later applications that but up against existing ones.*

When the first, colored layer is hard enough to withstand a little touching, mix a second, thicker layer (like mayonnaise, or 2.3 on the scale) that you will leave white. Apply this layer either by hand or with a soft tool, like a rubber bowl-scraper. This coat goes on full thickness, to the height of the shims or clay wall. I find that a mold 1 inch thick is fine for nearly any size mold. Try to keep the mold an even thickness that is no more than 1 inch thick, or even a bit less. Remember, you will have to chip it off, and chipping off a thick mold is more likely to damage the cast than chipping off a thin one. When you are finished applying this layer, *clean the top edge of the wall.*

Now, if you are using clay walls, wait for the first half to set and then remove the wall. Grease the edge of the first mold piece, and continue as before. If you're using shims, you can apply plaster on both sides at once. Always be sure to *clean the edges* so you can see the seams between pieces.

Flicking on the first (colored) layer of plaster for a waste mold.

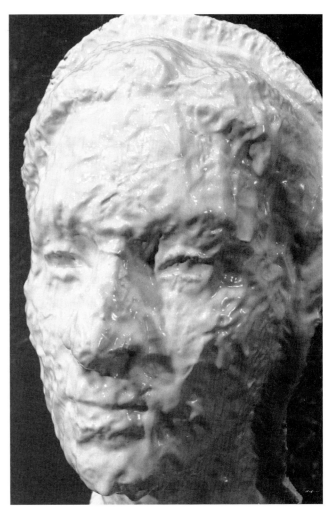

The first coat complete. It is about ⅛ inch thick, and finished rough.

Cleaning all traces of plaster off the top of the clay wall. This is a very important step.

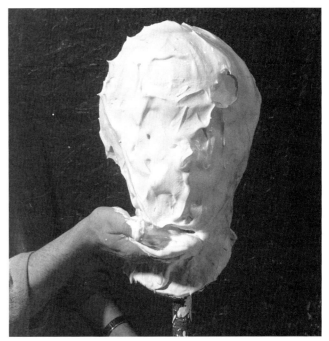

Applying the thicker, white, backup layer of plaster to the front of the sculpture. Here it is being applied by hand; this can also be done with tools.

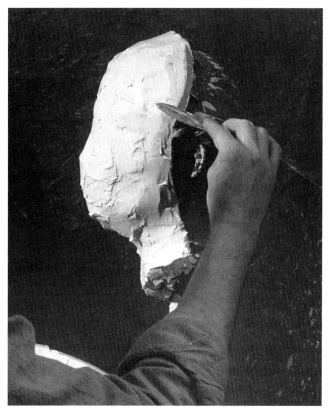

Cleaning the wall after the second layer has been applied. Again, this is very important.

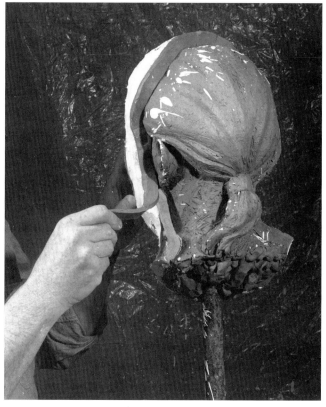

Removing the clay wall once the first half has set. Don't forget this step.

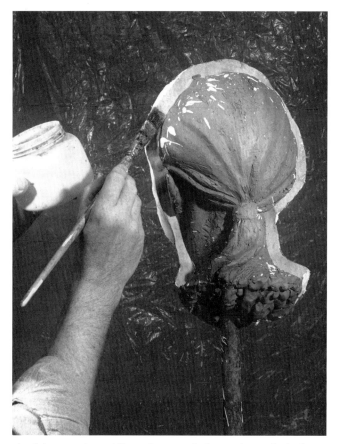

Applying petroleum jelly to the exposed plaster edge so the back half won't stick.

A detail of the mold with the fresh plaster cleaned carefully off the front half, showing the thin seam between the two halves.

Opening the Mold

When the entire mold is on, give it about an hour to harden well and then pry it apart. The best way to remove a stubborn mold (and they are all stubborn) is to cut some small wedges of hardwood and begin driving them into the seam all around the mold. Once they get their narrow tips into the seam, tap each wedge in succession to apply even pressure. For water clay, run lots of water into the seam as it opens, both to release suction and to soften the clay. Another way to open a mold made of water clay is to immerse the whole thing in water and let it soften from the bottom up. Try to be patient. Don't rush. It takes less time to ease a mold open slowly than to remake it if you break it in haste.

Once you've opened the mold, clean out all the clay. If the clay is stuck inside, dig out the center first—being careful not to dig into the mold—and then roll clay into that hollow. After the bulk of it is out, and if it is water clay, you can soak the mold in water for twenty minutes and the rest will brush out easily. If it's oil clay, pull the clay out gently and then use a piece of soft oil clay to pluck out the rest.

If you want to cast a large figure, for example, one with narrow ankles that will be hard to fill hollow later, you can make the mold this way: cover the front half with one piece, then cover the back half with several pieces, as shown on page 82. This way, you can attach one piece onto the back, reach inside to fill the seams, then attach another, and so on.

Opening the mold by driving in thin, hard, wooden wedges in sequence.

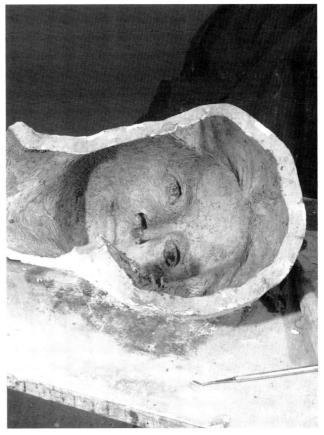

The front half of the mold, opened and cleaned.

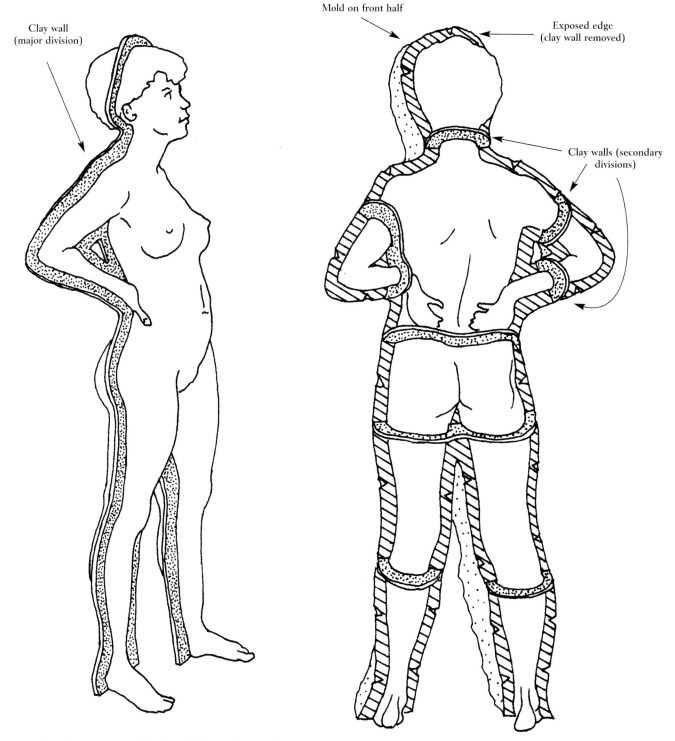

Clay wall
(major division)

Mold on front half

Exposed edge
(clay wall removed)

Clay walls (secondary
divisions)

Divisions for a large waste mold. The mold for the front half of the figure has been applied in one piece, but the mold for the back has been applied in many pieces, each separated by a seam. This allows you to reach your hand inside the figure to join pieces when filling.

MAKING A PLASTER PIECE MOLD

Here is an example of another type of rigid mold. There aren't a lot of reasons you might want to make a piece mold out of plaster, but one is to cast clay, either slip or pressed-in, for firing. A plaster mold is about all that will work for clay. Also, if you want to cast paper, plaster works best.

To make a plaster piece mold, use clay walls, as they are more accurate. First, find a section of the model that can be enclosed in a wall without undercuts; there shouldn't be any places in the section where you can't see the entire surface from one vantage point. Apply plaster to that section just as you would for a waste mold, but without the colored layer. Finish the outside surface to be very smooth.

Now move on to the next piece, again choosing one as large as possible without undercuts. Mark it off with a clay wall. Remove the wall from the first piece and grease its edge. Continue this way all around the sculpture.

As you go, make sure the top surface of each mold piece is smooth and neat. The outer surface of the many pieces should create a large, smooth shape with no undercuts. And, as each clay wall is taken away, make a fine bevel on the edge of each piece, forming a shallow "V" groove between each pair of pieces (see below). When the entire sculpture is covered in pieces, use thick plaster to make a mother mold over the whole thing. The mother mold should be divided into at least three parts, again using clay walls. Grease the outer surfaces of the piece mold before applying the mother mold. (See pages 94–95 for instructions on making a mother mold.)

When taken apart, the mold pieces should fit neatly inside the raised "V" ridges in the mother mold. But remember, like figure skating or playing the violin, this process takes practice. Don't expect perfection the first time.

TIP Wait until after you have applied the clay walls for the mother mold before you grease the outer surfaces of the piece mold. Otherwise, the clay walls won't stick to the plaster.

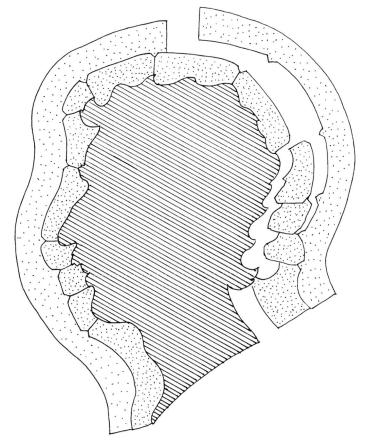

A cross section of a plaster piece mold with mother mold. Note the small "V"-shaped bevels on the edges of each piece, which cast into corresponding ridges in the mother mold for exact registration when assembled.

FLEXIBLE MOLDS

When casting a bronze, the work goes from the original clay to the initial mold, then to wax, to the investment, and finally to bronze—five materials. Most sculptors would agree that creating the initial mold is a crucial step. Many sculptors and foundries employ mold makers, who are adept at this complex art. They all have their preferred materials and methods. The individual sculptor, however, need not despair. You can make good flexible molds yourself, and they serve several purposes. You can cast plasters and other materials in them; you can cast your own waxes, which are then foundry-ready at considerable savings; and you can complete the process, casting your own bronzes. This chapter will cover the complex subject of making your own flexible mold.

Before the invention of all the flexible molding compounds on the market today, foundries made either complex plaster piece molds or used melted gelatin, which was a difficult material to use and had a very short life. But all that has changed drastically within the last twenty years. Sculptors now have a wealth of products from which to choose, all of which offer different advantages. The "big five" suppliers who handle most of these products are: Cementex, Perma-flex, Polytek, Smooth-on, and Synair. (See the list of suppliers for addresses and phone numbers.) There are also many others, and new ones may appear before this book hits your shelf, but as of this writing these five supply the bulk of mold-making materials.

KINDS OF PRODUCTS AVAILABLE

It is important to understand the many kinds of flexible molding compounds on the market and to make a choice based on your individual needs. Some of the things to consider are:

■ the way the rubber is mixed—whether straight from the jar or with two or more components
■ whether the components are "eyeballed" or weighed
■ whether vacuum debubbling is required
■ how various products release from the cured mold
■ the life of the product

There are five basic groups of molding compounds: latex, polysulfides, polyurethanes, silicones, and miscellaneous other materials. Let's look at each group and how it relates to the criteria above.

TIP

There are three terms for product "life" that are used when discussing materials for flexible molds:

1. *Shelf life* refers to how long the product will last in its container on the shelf before you use it. This is usually measured in months, with the average being six to twelve months.
2. *Pot Life* refers to how long the mixed material is workable while being applied. This is measured in minutes, usually between ten and thirty minutes.
3. *Mold life* (sometimes called *library life*) refers to how long the finished mold will last. This is measured in years, with five years being short and twenty being long.

Latex

Latex is the oldest group of materials and has been around for a long time. It is very simple in practice: it is an air-drying liquid that is brushed on straight from the jar, layer after layer, with each layer allowed to dry completely before the next is applied, until the desired mold thickness is achieved.

There are advantages and disadvantages to using latex. The advantages are:

■ It is the least expensive of all the products currently available.
■ There is no mixing required.
■ It can produce very flexible molds, including glove molds, which can sometimes be slipped off like a glove with no seams.
■ Molds can have a high degree of detail and a very long mold life.

The disadvantages are:

■ Molds take a long time to make.
■ It is difficult to fill deep voids.
■ Molds can become messy because of the many layers painted on.
■ It is impossible to create poured molds, or molds with certain kinds of built-up seams.
■ Casting wax in latex is not recommended.

This last disadvantage makes latex more or less unsuitable for casting bronzes. However, it should be considered for a great many other casting processes, particularly those using plaster or gypsum.

The primary supplier of latex is Cementex. As with all products, the supplier will provide complete instructions.

Polysulfides

Polysulfides are black compounds, usually comprised of two or even three parts that set chemically. Typical names for polysulfides are "Black Tuffy," "Black Rhino," or other variants on its color. Polysulfides are available from any of the "big five" suppliers.

Again, there are advantages and disadvantages to using polysulfides. The advantages are:

■ Their cost lies in the medium range.
■ They set chemically and can be used for poured molds.
■ They can be thickened for brushed-on molds
■ Molds have relatively long mold lives.

The disadvantages are:

■ They can be very messy, turning tools and equipment black.
■ Many are not very tear-resistant, despite their tough-sounding names.
■ Some polysulfides "revert." That is, they go soft with time.
■ Mixing usually requires a scale and careful measurements.

Polyurethanes

Polyurethanes (often called "urethanes") are a large group of products, also available from the "big five" suppliers. They are usually two-component, chemically-setting systems, and are, in my opinion, the best general choice for flexible molds.

Of all the urethanes on the market, most involve mixing just two components—some use two liquids, others use a liquid and a paste. Most involve mixing on a one-to-one ratio; others use two-to-one or another ratio. Most can be mixed both thin for brushing on, and thick for building up. Some are available in different hardnesses (referring to the hardness of the final mold), from soft and spongy for intricate, detailed molds, to hard and stiff for large, flat forms.

From my experience, the two-liquid, 1-to-1 mix products that come in differing thicknesses are the best general-purpose molding compounds available. Two examples of these are the Polygel series from Polytek and the Zero-gel series from Cementex. Smooth-on and Synair make liquid/paste products that work well but are a little slower to measure and mix. The Synair product, Por-a-Mold, is quite sensitive to moisture and is not recommended on water clay but is excellent for oil clay. (Polytek's Polygel products work fine on either water or oil clay.)

Smooth-on's PMC 724 was for a long time the preferred product but has been eclipsed, in my view. It involves a three-component system (four if you want to adjust the final hardness), which demands careful weighing and complex calculations, making the mixing time tedious and inviting errors that can result in uncured gummy rubber all over your sculpture. The molds are, I find, heavy and floppy and tend to easily drop out of mother molds. But most problematic of all is the relatively short mold life. Many of my Smooth-on molds have reverted to useless gum after only five years or less, or have even turned to liquid and run off the shelf onto the floor. I have heard that molds stored in low humidity locations, such as the Western states, do not experience this problem as severely. But for sculptors in the Midwest and East, and particularly the South or Southeast, this is a very important factor.

With the exception of Smooth-on PMC 724, the advantages to urethanes are:

■ Their cost is in the medium range.
■ Most are easy to mix and use.
■ They can be poured, brushed, or troweled on.
■ Most have adequate shelf life, good pot life, and long mold life.
■ Wax and most other materials release from them well, usually requiring only a simple one-step spray mold release.

The disadvantages of urethanes are:

■ Most have problems with the shelf life of one component requiring careful storage.
■ Smooth-on's PMC 724 is complex to mix and use.
■ Smooth-on's PMC 724 does not have good mold life.

Silicones

The next group is silicones, which are the most versatile, durable, and generally the best compounds available. They are also the most expensive. Silicones come in a wide variety of forms, including simple two-part liquids that are pourable, thick compounds that can be brushed or troweled on, clay-like mixes that can be worked in the hands and applied in sheets, and even caulking gun silicones that are applied directly with no mixing at all.

Silicones are usually either tin or platinum cured. Tin-cured silicones can be found in brushable mixes, but these sometimes have limited mold life. They can also shrink, which causes problems with larger molds. The platinum-cured silicones are usually only used for poured molds, but they have no shrinkage and good mold life.

A new silicone is Resil-Pom, available from The Complete Sculptor. (See list of suppliers.) This product mixes to a clay-like substance that can be worked out by hand into sheets and then applied like clay. It's best when used over an initial brushed-on coat of tin-cured silicone. Synair has recently come out with a similar product. I suspect we'll see more firms offering it soon, if not already.

One great advantage of silicones is their ability to release from just about anything without any type of release agent. They just don't stick to clay, plaster, metal, wood, or much of anything else, and nothing seems to stick to them. This is particularly handy if casting works into rigid urethanes, such as Por-a-Cast (available through Synair), which will stick to a urethane mold unless well buffered but will come right out of a silicone mold every time. Also, if casting any kind of plastic that is intended for paint, silicone is the only way to go, as most release agents used on urethanes will adhere to the plastic cast and interfere with painting.

The biggest drawback to silicones is the cost. They generally run twice as much as urethanes, and sometimes even more. The many fans of silicones argue that the cost of materials is a very small part of the total cost of casting a bronze, and that the advantages of silicones are well worth the extra money. This is a very good argument and one to consider carefully in your own case. Nevertheless, when beginning or experimenting with casting, perhaps it is wise to become familiar with the process using a less costly material, and graduate to silicones if needed later on.

A second disadvantage of silicones is the need for a vacuum machine to eliminate bubbles. Silicones are notorious for trapping air, and unless the bubbles are pulled out with a vacuum there will be tiny pinholes all over the mold. The cost of a vacuum debubbler can be prohibitive, especially when starting out. However, many mold makers claim that a thorough brushing of the initial coat eliminates this problem without having to use a vacuum machine.

A new silicone from Polytek called Platsil 70 is very good. It is comprised of two liquids that mix one-to-one, it does not require vacuum debubbling, and a thickening agent called Plathix can be added to it for instant thickening. It has a long pot life of nearly an hour, but is completely set in four hours.

Platsil 70 costs is nearly twice as much as Polygel, but as it needs no release agents, has a long pot life, sets quickly, and is easily mixed and used, the cost difference is largely offset.

One form of silicone that is used successfully by some sculptors is the ordinary silicone caulk found in hardware stores. A caulking gun will squeeze out a transparent goo, which will air dry. This material can be applied directly onto sculpture, brushed into detail, and then built up in layers to the desired thickness, rather like latex. Be sure to buy only caulk that is described as 100 percent silicone.

Here, then, are the advantages to using silicones:

■ They encompass an enormous variety of products that do just about anything.
■ They are tough and durable for long-lasting molds.
■ They take extreme detail easily.
■ They require no release agents.
■ Silicone caulk requires no mixing and is available at local stores.

The disadvantages are:

■ They are the most expensive type of material.
■ You may need an expensive debubbling machine.

Other Materials

The last category of flexible molding compounds is a grab bag of products that don't fall into the other categories.

Alginate is a material used for body casting. It is the same stuff your dentist uses to make impressions of your teeth. Alginate comes as a powder to mix with water, and creates a creamy liquid with about a five-minute working time. The beauty of alginate is that it will not stick to skin or hair and releases easily, even from complex forms, due to its flexibility. It takes precise detail, including every pore of the skin. It is a much superior product to use for life casting compared to plaster, and is much safer. Plaster can be very dangerous, particularly if applied to the face, and such casting is *not recommended*. People have died while someone tried to cast their face with plaster. Use alginate instead.

The one thing to remember about alginate is that it does not make a permanent mold and will begin to dry and shrink within just a few hours, so you need to pour a plaster positive immediately and then throw the mold away. For permanent works, such as bronzes, you can then make a regular flexible mold off the plaster positive.

Pink House Studios (see list of suppliers) makes a silicone that sets in about five minutes and is also used for body casting, just like alginate, except that the molds are permanent. It is expensive, but for that special job it is ideal.

Other materials include Polytek's Ply Skin Wax, a meltable wax into which hands and other body parts can be repeatedly dipped to create a mold. And one can still find various meltable polyvinyl compounds that turn liquid with heat for making poured molds, and have the advantage of being reuseable. To reuse, you simply cut up an old mold and remelt it.

The field of molding compounds is a vast one, fueled pri-

marily by industry, but with valuable products for the sculptor. This field is changing rapidly—as is so much in our modern world—and the products listed in this book might well be replaced by superior products in just a few years. The reader is urged to write to the various suppliers listed in the back of the book to receive current catalogs and product descriptions. Keep your eyes open for ads in sculpture magazines and other sources for companies other than the "big five." They're out there, and more are being formed all the time.

Sculptors tend to be experimental by nature, and we are often ready to break the rules. I have been told on many occasions by manufacturers that "you can't do this" or "doing that won't work." When I am told such things I immediately try it, and in many cases it does work. Always be ready to experiment and be creative. After all, we're artists.

Having described the many products on the market, it's time to choose one and make some molds. Please note that the principles applied in the following examples will usually work with many products other than the one selected, and, with some adaptation, just about any mold-making product.

As you read, keep in mind the three major problems to be dealt with in making a flexible mold:

1. how to apply the rubber to the sculpture
2. how to create keyed seams
3. how to create the mother mold or supporting shell

BRUSHED-ON FLEXIBLE MOLDS

The method preferred by most mold makers today is the *brushed-on mold*. The other major method is the *poured mold*, which we will cover after this one.

Materials

Sculpture is a materials-intensive art, and nowhere more so than in mold making. Selecting the best product for the way you work is crucial, and reading this section first will help you make your choices.

■ *Rubber:* You must have rubbers of varying thickness, from runny for the detail coat to creamy for a secondary coat, to thick and pasty for the heavy building up. Polytek creates rubbers perfect for this application, and it is those I will use to describe the process. There are many other products that will work perfectly well, including polysulfides, silicones, and many other urethanes. The only requirement is

that you must be able to mix the material to varying thicknesses, either through its inherent chemistry or by adding thickening agents such as Cab-O-Sil.

The Polytek products perfect for these molds are called Polygel 40 and Polygel 50. Polygel 40 is a creamy mix suitable for first and second coats. Polygel 50 is a thick paste perfect for buildup. You will generally need less of the 40 and more of the 50. Both come in 16-pound kits, each including 8 pounds of part A and 8 pounds of part B. Part A looks rather like honey; part B looks like maple syrup. It is important to remember that never the two parts shall meet or they will turn hard. Polytek also sells a trial 4-pound unit, with 2 pounds of each part, and a larger 80-pound quantity, which includes about five gallons of each part.

■ *Release agents:* Most rubbers tend to stick to things, and to prevent that you need *release agents*. First, consider the sculpture's material. If it is an oil-based clay, determine whether the clay contains sulfur. If it does, it needs to be isolated or it will inhibit the setting of the rubber. A good isolator is either lacquer or shellac. (Shellac will stick to Polygel

There are some problems with Polytek's packaging for Polygel 40 and 50 that you will need to deal with before proceeding. The materials come in buckets, and it is nearly impossible to remove and dispense accurate amounts of thick sticky liquids from open buckets without creating a huge mess. The best plan is to save some old plastic gallon jugs—bleach bottles, laundry detergent jugs, orange juice bottles, anything of that sort. Glass bottles and jugs are perfect. Don't use plastic milk jugs as they'll split and leak. Trust me.

Wash the bottles out thoroughly and *dry them completely.* There can be no moisture left inside. The only way to dry jugs is to shake out all the water you can, then leave them with the caps off for about a week. So when you order the rubber, start washing and drying jugs and they will be fine by the time the rubber arrives at your door.

Now buy two large plastic funnels and mark them "A" and "B." Remember, the two parts must never come into contact with each other, so it is critical to use only the A funnel for part A,

and the B funnel for part B. Use the funnels to pour the material into the jugs and cap the jugs tightly. What to do with the messy funnels? I store the B funnel in the old empty B bucket, and just leave it until the next use. I do the same with the A funnel, but within about a week the residue of part A left in the funnel will have gelled and can be peeled out, leaving a perfectly clean funnel.

Don't forget to label all jugs carefully. I use a fat felt-tip pen and write the number and the part (50A, for example) on several places on the jug in case I wipe off the label while wiping the jug clean. I also label the caps so they won't get mixed up.

Also, please note that the part A will solidify in a few weeks if exposed to moist air. The best solution is to fill the jugs to the very top and cap tightly. The one you are using will have an air space, but if it's just one jug it should get used up in time. If you are through molding for a long time—such as several weeks—transfer any leftover part A into smaller bottles that can be completely filled.

tenaciously. Never put Polygel on a shellacked surface when you want it to release unless you first coat the shellac with a good release agent. However, if you want the rubber to stick tight for some reason, shellac is the answer.) A good release agent must then be applied on top of the isolator.

A very good general-purpose release agent in spray form is Pol-Ease 2300, from Polytek. There are many others on the market that also work well. If the oil clay is a nonsulfur clay, a simple release of this type will work fine. If you are in any doubt, roll out a strap of clay and divide it with scratches into three sections. On the first section put nothing. On the second, spray release (masking the other sections with paper). On the third, apply shellac or lacquer and then spray release. Now mix a small batch of rubber and dribble it right down the strip. Let the rubber cure, peel it off, and you'll know how to treat your clay.

For water clay, wait until the clay is somewhat dry. Don't let it dry completely or it will crack, just let any surface moisture disappear. Then a simple spray of release will be fine. (Please note: *You should not use Synair products on water clay.*)

Petroleum jelly is an excellent release agent that works on everything. Always keep a jar of it handy with a brush for applying. If you feel it's too thick for some applications, it can be thinned with a dry-cleaning fluid such as Carbo-Sol or naptha, both available in paint departments. Pour some Carbo-Sol in a jar, add a dollop of petroleum jelly and...nothing happens. By the next day, however, it will be in solution and makes a fine, delicate release. Needless to say, you should keep the jar tightly closed as Carbo-Sol is highly volatile.

Mixing the Rubber

To mix a batch, you will first need cups. I buy two kinds from the grocery store—transparent 8-ounce plastic cups (the kind you drink cheap white wine from at art openings), and 16-ounce plastic cups (the kind they serve beer in at keggers). For an easy and rapid way to mix, mark two of the clear cups A and B, and draw a line about halfway up on each cup. To make the lines in exactly the same place, hold a felt-tip pen sideways on a block of wood the right height, and rotate each cup against the pen.

Now it's a simple matter to pour part A to the line in cup A and part B to the line in cup B. Since you have transferred the rubber into jugs, you should be able to pour it easily with one hand in a very precise and controlled way. Don't forget to wipe the neck of the jug clean before replacing the cap or it can glue itself on. Then pour the contents of the two cups together into a 16-ounce cup, and stir. To ensure thorough mixing, you can then transfer the mixture to a second large cup so any unmixed material on the bottom is now on top and can be stirred in completely. That's it—a no-brainer, hard to mess up, and quick.

If you feel the Polygel 40 (the thinner solution) is a little thick for getting good detail, here's what you can do. Order an additional kit from Polytek of 74–30. This is a very runny mix intended for poured molds. It is too runny to use as a first coat, since it all just runs off, but when mixed in equal parts with Polygel 40 it makes what I call a 35 mix, and is an ideal first brush-on coat. You can premix by combining it with equal

parts of A into one jug (well stirred) and B in another. You're now ready to mix batches of 35 the same way as the others.

You can also mix any proportion of 40 and 50 together to make intermediate thicknesses. Simply pour some 40A into a cup, for example, and then pour 40B into a second cup to the same level. Now add 50A to the A cup and pour the same amount of 50B to the B cup. Use any proportions you want to create any thickness. (The company will tell you to stir the two kinds of A together and the two kinds of B before mixing, but that isn't necessary. Just pour the whole mess into a large cup and stir as usual.)

You can make the Polygel 50 (the thicker solution) thicker if necessary. There are two ways. The first is to add a thickening agent such as Cab-O-Sil. (Note that this is not the same as Carbo-Sol. Carbo-Sol is a liquid carbon-based solvent. Get it? Cab-O-Sil is a silica-based powder.) Just spoon some Cab-O-Sil into your 50 mix, stir, and see how it turns out. If it still isn't thick enough, add more.

A second way to thicken Polygel 50 is by what I call *speed stirring*. Here's how it's done: Put your parts A and B into a 16-ounce cup and begin to stir as fast as you can, making sure you get the sides and bottom. Watch carefully. In about fifteen seconds the solution will change color to a soft gray-green. At this moment, quickly transfer the solution to a second cup, give *one quick stir*, and then let it stand for twenty

I find that the best stirrer is a wooden paint stirrer from the hardware store. They're usually free. Wipe it clean with a paper towel each time you use it and it will last a long time. Polytek's technical assistance personnel will tell you not to use a wooden stirring stick as wood contains moisture, but it works fine.

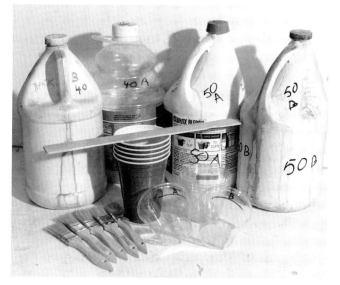

The materials necessary for making a flexible mold with Polytek. Top: jugs containing Polygel 40, parts A and B, and Polygel 50, parts A and B; bottom: throwaway brushes, large mixing cups, a wooden stirring stick, and smaller marked measuring cups.

seconds while you clean off your stirring stick. The entire mixing process should take no more than forty seconds total. The resulting mix will be a good deal thicker than if you continued stirring. (I'm not sure the company knows this trick.) Don't try it until you are familiar with mixing and stirring, because the danger is an incomplete mix.

Applying the Rubber

You're ready to apply the rubber when the sculpture has been coated with the appropriate release agent, a plastic sheet has been wrapped around the table below to catch drips—because it will drip—and any exposed wood or metal on the sculpture has been coated with petroleum jelly. The best brushes to use for applying rubber are those cheap chip brushes available from places like Harbor Freight (see list of suppliers) at about 36 cents each. The 1-inch size is good. They come thirty-six to a box; buy a few boxes.

Start by brushing on your first coat, using Polygel 35 or 40, depending on the level of detail. Your aim is to apply rubber everywhere, but not to scrub it in—you don't want to alter the clay surface with heavy brushing. Simple, smooth swipes are fine, as the rubber will settle and flow into cavities on its own. Use of a compressed air hose on low pressure to blow the rubber uphill into cavities (such as nostrils) is a good idea, or you can puff it up there by mouth. Once the piece is all covered, throw the cup and brush away. It's not worth trying to clean brushes—you'll spend more on solvents than the brush is worth, and you'll fill the air with fumes and create a fire hazard. If you do spill, you can clean up Polygel with acetone.

Continue to apply the rubber in layers, allowing for the curing times noted below. A good sequence for a built-up mold is:

1. First coat: use either 35 or 40, depending on the level of detail; apply by brush.
2. Second coat: use equal parts 40 and 50; apply by brush.
3. Third coat: use 50; apply by spatula or trowel.
4. Fourth coat: use 50 again; apply by spatula to fill thin spots, even out rough places, and so on.
5. Fifth coat: use 40; apply by brush to smooth everything out.

Keys

Many mold makers like to attach *keys* to the surface of the mold to help it stay put in the mother mold. One way to make keys is to cast them either in those plastic pill sheets from pharmacy suppliers (see the section on mold seams, page 93) or in molds you make yourself. Another way is to pour a sheet of rubber and cut it into blocks. The keys are then stuck onto the fourth layer of rubber while it's still soft. Good places for keys are around the edges of the mold, with a few in the center of large areas. The fifth and final smoothing coat then goes right over the keys, locking them on.

Curing Times

Generally, Polygel will cure in about six hours, but that depends a lot on the temperature of the room. The hotter the room, the quicker the cure. Let the first thin coat cure well, about four to six hours, as a second coat could pluck it up if applied too soon. After the second coat is rather firm, all later coats can go on as soon as the previous one is no longer able to be pushed around. Apply the final 40 smoothing-out coat directly on top of the last 50 coat without waiting, so they will kind of ooze together. Also, waiting a day or more between coats is asking for a poor bond.

Allow the mold to cure overnight or until no longer tacky to the touch before doing the mother mold. (Mother molds will be discussed in detail on pages 94–97.)

Creating Seams

Brushed-on molds usually need to be divided, and they have a *seam*, or *parting line*, which is where the division or divisions take place. Seams can be made any of several ways, including with clay walls, metal shims, paper shims, cut seams, and the like. Along the seam are usually some bumps with matching hollows for alignment, called keys.

Keys applied to the outside of a rubber mold. Notice the indentations in the mother mold (at right) into which the keys will lock.

There are many methods to create good seam lines for a brushed-on mold. The four most common arc the cut seam, the clay wall or shim seam, the paper shim seam, and then a final category of various other methods.

The cut seam

This method is ideal for a portrait head or other rather spherical, compact mass. It is quick and easy, and works quite well.

First, cover the entire sculpture with rubber, building it up in the layers described above until it is full thickness. Next, decide where you want to cut the mold for removal. In the case of a portrait head, a good plan is to cut from the bottom of the back of the neck up the back of the head to a point at about the middle of the top of the head. To understand this viscerally, put your finger on the back of your neck at the collar line, now bring it up the back of your head, over the top, and stop right at the very top. That's where you'll cut the mold. The mold will remain in one piece and be removed like an overshoe.

Before finishing the last layer of rubber, add a thick ridge of rubber right up the line you intend to cut, making the ridge about twice as thick as the rest of the mold, and with nice tapered sides.

Now make the mother mold as usual (see pages 94–97). Then, when the mother mold is removed, cut the rubber along the ridge with a sharp knife. Note that it is very easy for a sharp knife to slip while you are cutting this seam. Hold the cut open from below with one hand, and cut away from that hand with the knife in the other hand. The illustration below (right) shows a cut seam held open. When put back together, the mold should fall perfectly back into place in the mother mold. You can usually reach inside with your hand to be sure the rubber has lined up properly.

The clay wall or shim seam

This is a slow, more tedious method, but it creates a very good interlocking seam on figures and other works that are not as compact as a portrait head. The principle is to create a clay wall around the parting line of the piece, then dig a series of depressions for keys into the wall. The keys will hold one side of rubber steady against the other, while small keys built up on the outside of the mold will hold the rubber steady into the mother mold.

Rubber is then applied to one side of the sculpture, up against the clay wall. The full thickness of rubber is built up, and then the mother mold is applied. When the front is finished, the clay wall is removed, release is applied to the exposed rubber edge, and the process is repeated for the back. If necessary, pieces can be laid flat on a table and the clay wall built from the table right up.

The series of photos that follow opposite and on pages 92–93 illustrates the entire method, including the use of metal angle brackets to bolt the mold back together.

This same method can be done using metal shims pushed into the clay instead of clay walls. An advantage to using shims is that the process is faster, as shims don't need to be removed and both the front and back can be done at once. The disadvantage is that the seam is not as good, due to disturbing the clay with the shim, although with large pieces this isn't so crucial. Also, you must create keys in the shims, which is done by bending them into "V" shapes. If you do use shims, be sure to spray release on them before applying the rubber or they will stick.

TIP If you are working in water clay, you will have the problem of keeping the sculpture from drying out and shrinking while you wait for the rubber coats on the first side to cure. The solution is to press plastic wrap very tightly against the exposed side, and to keep it damp with a sprayer from time to time.

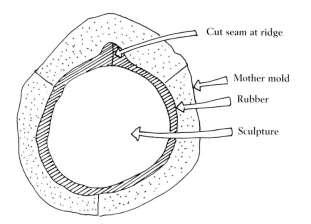

A cross section of a cut seam in a simple flexible mold. Note the ridge where the cut is made, and see how it fits neatly into the corresponding valley in the mother mold.

A cut seam in rubber, held open.

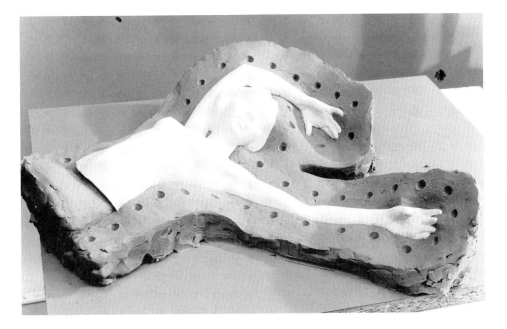

A plaster sculpture lying flat with a clay wall built up for molding. Notice the keys that have been cut into the clay wall. The next step would be to apply rubber to the front, butting up against the clay wall.

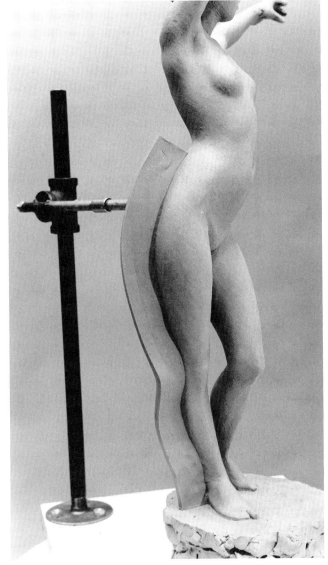
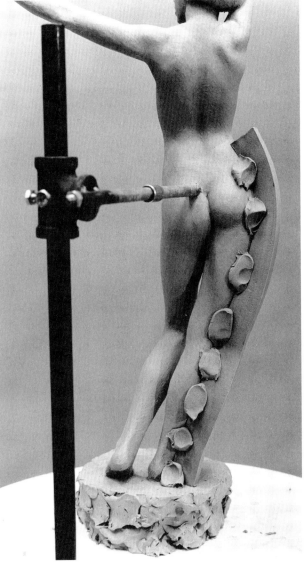

A clay wall being applied to a clay figure for rubber molding.

Gobs of soft clay applied on the back side to support the wall.

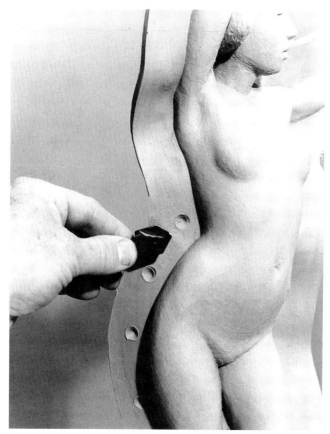

Cutting keys in the wall with a countersink.

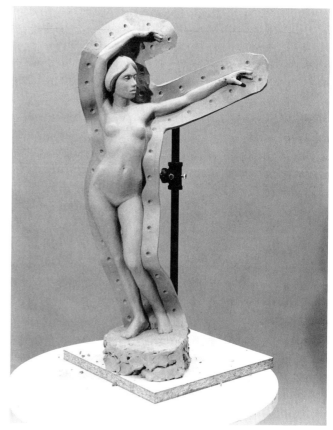

The clay wall complete, with keys.

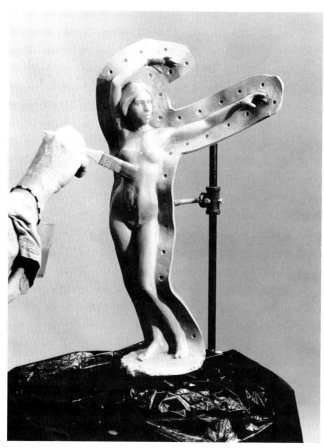

Applying the first coat of rubber by brush (Polygel 40).

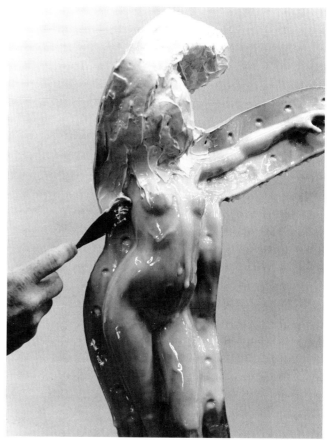

Applying the third coat of rubber by spatula (Polygel 50).

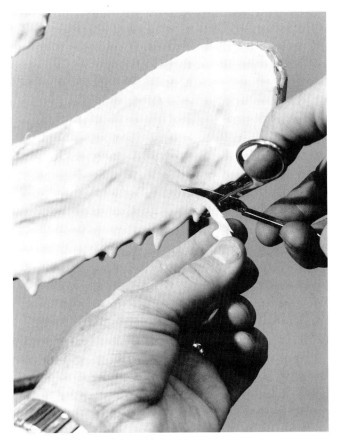

Trimming the edge of the rubber.

Smoothing the plaster mother mold. Note the metal brackets that will lock the two halves of the mold together for pouring and storage (see page 96).

Paper shims

This is a method commonly used by mold makers in Loveland, Colorado, and is a good one, though it takes a little practice to master. The principle is that two layers of rubber are painted on the model and allowed to set. Then paper shims are applied and held in place with dressmaker's pins. The shims contain keys, as will be described. The remaining rubber is then applied up both sides of the shims. When the mold is taken apart, the rubber is pried off the shims, and a knife is used to cut through the initial two layers of rubber next to the model, producing a flawless seam.

The paper most mold makers use is the waxed paper for soft drink cups, cut and flattened out. This paper is stiff, pre-waxed to release, cheap, and readily available. The keys are more tricky. Drugstore suppliers can sell you plastic trays designed to hold pills. These are made of thin, transparent plastic with evenly spaced rectangular depressions—usually thirty-one of them, for one month of pills. Cut out a block of two depressions; this will serve as the heart of your key system.

To follow this method, first coat the sculpture with two layers of rubber at brush-on consistency and allow them to set. Then cut the paper shims to fit the sculpture. Using a small, sharp hobby knife, cut a square opening into each shim for a block of two pill depressions. The block should fit neatly into the hole, and can be held in place with ordinary tape. Spray the whole thing with release and attach to the rubber

A plastic tray designed to hold pills, available from drugstore suppliers.

Photo courtesy SAV Molds, Loveland, Colorado

with pins. Now let me be very clear on this point: You must get the shims all cut to fit, have the pill depressions inserted and taped in, and spray the shims with release *away from the sculpture.* This way, the release doesn't go on the rubber you've already applied to the sculpture. *Only then* do you attach the release-coated shims with pins to the sculpture, and continue to apply rubber.

Photo courtesy SAV Molds, Loveland, Colorado

Photo courtesy SAV Molds, Loveland, Colorado

Paper shims in place with sections of a plastic pill-holder taped into cut-out openings.

Paper shims with keys in place, buttered on with a thick mix of rubber. This is now ready for coating with the remainder of the rubber.

Once the shims are in place, they can be buttered on with thick rubber. When that has firmed up, the pins are removed and the remaining rubber is applied to both sides of the shims at once to build up the proper mold thickness. The mother mold is then applied as usual (see page 95).

To open the mold, after removing the mother mold, pry the rubber off each side of the shims. Then reach in with a small sharp knife to cut that last bit of rubber against the model.

TIP — It is important to always be thinking about when you want rubber sticking to rubber, and when you want it to release. In this method, all rubber applied is intended to stick to rubber already in place, but not to the plastic shims. Think carefully about this before you start spraying release around. And remember, even spraying release in the same room can cause overspray, coating the layers of rubber already in place and making it difficult for later layers to adhere.

Other methods

I have described three ways of making seams for rubber molds, but there are many more being used out there. Keep your eyes open as you visit foundries or mold makers and see what they're doing. Ask questions. Some will tell you their secrets, others won't. Just keep asking and learn from those who are open. It's also important to think individually. Imagine ways you can make a mold that either use some of the methods described or strike out into new territory. Remember, there is never an end to how you can do things. Chances are, someone somewhere is inventing a new and superior method right now.

MOTHER MOLDS

This is as important a subject as the flexible mold itself, because if sloppily done it can ruin an otherwise good mold. First, the principles: The mother mold is a rigid shell that fits over the rubber to prevent it from flopping when it is removed from the sculpture and filled. The mother mold must be removable without hanging up on undercuts, easily reassembled, able to be held rigid for casting, and strong enough to withstand the stress of casting while light enough to allow manipulation.

There are two materials commonly used for mother molds—plaster and plastic. Plaster is the most common and is easy to use, cheap, and suitable for most things. You can apply plaster straight (see page 77 for mixing hints), or you can dip hanks of hemp (available from general sculpture suppliers such as The Compleat Sculptor) into runnier plaster and slop them in place. The hemp method is quick and pro-

duces a very strong, light mold. It is a little sloppy, so it is much better suited for large molds than small.

Mother molds can also be made of plastics. Many plastics now available are essentially the same urethanes as the rubbers, only rigid. They are usually two-component systems that mix up to a creamy paste and are applied like plaster. But with plastics the mold can be thinner, since the material is stronger.

A particularly good plastic is from Synair, called Por-a-Kast TA. It is two liquids mixed 1-to-1, and quickly thickens to look and feel just like heavy mayonnaise. It makes a great mother mold.

Dividing a Mother Mold

If you use the clay wall, shim, or paper shim seam methods, your mold will have built-in shims or high ridges against which the mother mold is placed, forming a natural division. For the cut seam method, however, or other methods not using high ridges, you need to divide the piece so the mother mold can come off in enough pieces to avoid undercuts. Sometimes, even with the high ridges, you will need to divide the mother mold into further pieces for removal.

Where high ridges are absent, clay walls make the best dividers. (See page 74 for instructions on making a clay wall.) Think about where to place the wall; you want to enclose pieces that are as large as possible without undercuts. Begin

Making a plaster mother mold. Half of the mother mold has been completed and the clay wall has been removed. It is now ready for the second half to be applied.

by walling off an obvious main area, pushing the walls towards the horizon as far as you can without them going beyond it. You must be able to see, from one vantage point, every part of the mold contained within the wall. If part of the mold disappears behind a hill, move the wall toward you so all the mold inside the wall is visible. Otherwise, the mold will hang up on that part and not want to come off.

The clay wall can be attached to the rubber mold by sticking it on with gobs of soft clay on the back side (see illustration, page 91). This process works fine with either water clay or oil clay. If you're using oil clay, make sure it is soft and well warmed.

Making a Plaster Mother Mold

To use plaster, mix it following a ratio of 2.3 plaster to 1 water, by weight. If you don't have a scale, pile dry plaster into water until it builds up on the surface so no wet is seen. Let the plaster soak up until it is all wet, then stir. If you can hold it upside down in your hand without it dropping off, it's right. If it's too thin, add more plaster and stir. The mixture should be thick enough to hold in place on a vertical surface.

Once you have your first area walled off, apply plaster to that area. Begin by applying the thick plaster well into the join between wall and mold, then start covering the main surface. Use the "glacier" technique, that is, apply the plaster full thickness (about ¾ inch is good for most molds) and let it advance across the mold like a glacier. This allows you to control the mold's thickness. You can also test for thickness by poking through with a tool.

When the plaster you applied to the first piece has set, remove the clay wall and then wall off the next area. Apply release to the exposed edge of the first piece, and continue. *Don't forget* to clean the edge of the clay wall every time you apply a batch of plaster, even if you are planning to add more to that particular mold piece. And don't forget to clean the edges between pieces, scraping any new plaster off an adjoining, finished piece. The seams between pieces should *always* be visible.

When the plaster begins to get stiff, work the surface with a tool to make it very smooth and elegant. Crummy, lava-like molds are for amateurs. Neatness counts.

TIP

Many beginners work too slowly and their plaster begins to harden on them, so they work quicker and soon create a crumbly, horrible mess. Remember, plaster is cheap. If your mix begins to set beyond workability before you are finished, throw it out and mix a new batch. You've worked a long time on the sculpture. Don't ruin it for a dime's worth of plaster.

Making a Plastic Mother Mold

Plastic mother molds can be applied in the same way as plaster, only thinner. They can be reinforced with cloth, glass cloth, steel rods, conduit, pipe, or whatever for larger molds. This is a good idea for large sections since the plastics are somewhat flexible.

TIP
Since urethanes stick to urethanes, you will need a good release between a urethane mother mold and a urethane mold. A moderately effective release can be created by first applying petroleum jelly thinned with Carbo-Sol, and then spraying on Pol-Ease 2300 or a similar spray release. A better release is a good coat of petroleum jelly, then spray release over that. No release is needed with a silicone mold. Experiment with polysulfides or latex.

Joining the Mother Mold

A simple mother mold can be held together for casting by wrapping it with rubber straps. But a more complex mold ought to have a good joining system, and the time to create that system is when the mold is first made.

One effective system is to build plaster or plastic bumps in pairs across the seams, and then join the pieces by stretching strong rubber bands (or squares of inner tube with holes cut in the middle) across each pair of bumps. Strong metal hooks can also be imbedded into the plaster or plastic to serve the same purpose.

Yet another solution is to imbed steel angle brackets in the mother mold so that they bolt together. (For another example of this solution, see top right illustration, page 93.)

Removing the Mother Mold

This is often very easy, but can occasionally present a real problem. First, try inserting a thin blade into an obvious point on the seam and prying very gently. Usually the mold pieces will begin to separate and then come off cleanly. If they appear difficult, stuck tight, or just reluctant to move, here is a trick that often works. Make a small batch of thin wooden wedges, preferably out of a hardwood like maple or cherry. Each wedge should be about 1 inch wide and ¼ inch thick, tapering to a sharp edge. Drive these wedges just a bit into the seam, placing them all around. Lightly tap on each wedge in succession and the mold will usually move and come apart (see illustration, page 81).

Sometimes you get a mold that is just stubborn. Usually you'll get all pieces off but one, and that one sticks tight. One trick is to insert a metal blade into the exposed bottom of the

A plaster mother mold created with plaster knobs and held together with squares of inner tube cut in the middle. (Note the piece of inner tube shown in front.) Heavy rubber bands can also be used.

A steel bracket set over the clay wall, ready for the mother mold to be put in place on the right side.

clay sculpture and use it to pull against the mother mold. Another is to try to force wedges into the crack between the rubber and the mother mold. A third more desperate trick is to break the mother mold piece off, replace the others, and remake the offending piece. (This time, make the piece in two parts to avoid the undercut that held it on in the first place.)

POURED FLEXIBLE MOLDS

This is a much older method of mold making, one developed before the creation of thicker, brushable rubbers. In essence, you make the mother mold first, with a space between it and the sculpture, then pour a very runny mix of rubber into that space. Poured molds are still used today, though less and less as mold makers discover the ease of the brushed-on mold.

Poured molds are of two basic types—open-faced and enclosed. An example of an open-faced poured mold is a relief. Lay the relief flat, then build a wall around it. Liquid rubber is poured over the surface, filling to just above the highest point of the relief. Once the rubber has set, a mother mold is created over the poured mold to give it rigidity after removal.

An enclosed poured mold is more complex. The first thing is to attach the sculpture firmly to a board so it won't move. The sculpture is then covered with a layer of clay, usually around ½ inch thick, which is modeled to the shape the rubber will take. A funnel or pouring vent is created at the top. Over this layer a mother mold is made in enough parts to pull off cleanly, without undercuts. The mother mold is removed, the clay blanket is removed, and a release agent is applied to the sculpture and the inside of the mother mold. The sculpture and mother mold are then reassembled, with the mother mold in the exact same position. The whole assembly is tied firmly down and all seams are well sealed

with more clay. Liquid rubber is now poured in the pouring vent at the top, filling the void left by the clay blanket.

When the rubber has cured, the mother mold is removed and the rubber blanket is cut with a knife into the sections required for removal.

Now for some details. Rather than simply slapping a layer of clay on your carefully worked sculpture, cover it first with clear food wrap, pressed gently in. Water clay works well for the blanket, and you can roll it with a rolling pin to a ½-inch thickness. This is pressed carefully over the sculpture, but you don't need to worry about pressing it into all the details as it is only a spacer for the mother mold.

What you do need to worry about is modeling the outside of this blanket so a mother mold will pull cleanly off, and creating some keys in it so the whole assembly will lock together. These keys can be small block forms made of clay, around which the mother mold will form. And at the top, build up a clay funnel shape which will be the pouring funnel.

Now make a mother mold in however many pieces are necessary, using either shims or a clay wall. The mold can be plaster or plastic—it makes no difference. But be sure to leave the top of the pouring funnel clear. Also, draw a pencil line on the base around the bottom edge of the mother mold so it can be replaced in exactly the same position.

Next, you need runny rubber. Polytek makes one called 74–30 that is very runny. Check with other suppliers for similar products. Do not use latex as it needs air to dry and will never dry inside the mother mold. To pour the mold, first take off the mother mold, the clay blanket, and the clear food wrap. Make sure the sculpture is not damaged. Now replace the mother mold exactly on the pencil line you drew, and use wire or heavy cord to tie it down well so it won't float when the rubber goes in. Seal all seams, particularly around the bottom, with

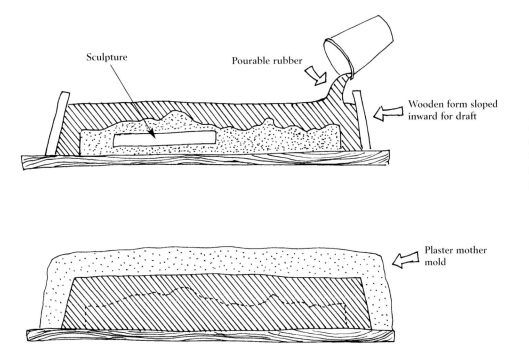

Pouring a rubber mold over a relief. The side containing walls should tip inwards slightly to allow the mother mold to release.

A poured mold. Top, left to right: the sculpture; the sculpture covered with a clay blanket; the mother mold in place being marked on the base. Bottom, left to right: the mother mold removed and the clay blanket coming off; the mother mold replaced and tied securely down; liquid rubber being poured in.

soft clay. Some mold makers also drill small holes in the mother mold so that air can escape. These holes are especially important leading off any high-pointing places in the sculpture.

Now mix the correct quantity of rubber. How much? It should equal the volume of the clay blanket you just took off. Work it out. When the rubber is well mixed, carefully pour it into the funnel at the top. If you have drilled some holes in the mother mold, keep a gob of soft clay handy and stopper them up one by one as the rubber comes out. When full, let the whole thing set overnight.

Once the rubber has cured, remove the mother mold and cut the rubber into however many pieces you need for easy removal—the fewer the better. It is best to make the cuts coincide with the seams in the mother mold.

This is an old method for making molds, developed when the molding material was gelatin and very liquid. It is a useful method for smaller sculptures, and particularly those that sit nicely on a base. There are many variants on this method, including one in which the two halves of the mold are poured separately, so the mold doesn't need to be cut and keys can be created. Polytek's catalog describes these methods in some detail.

REJOINING AND STORING FLEXIBLE MOLDS

In order to use a flexible mold it must be placed inside its mother mold and rejoined into one form that can withstand a fair amount of handling. With a simple mold such as a head, a rubber strap wrapped tightly around the mold works fine. Molds for small figures can also be rejoined easily this way.

If you want a more secure join, try the bumps and rubber band technique shown on page 96, or use metal brackets, as shown on pages 93 and 96. These methods not only enable

the mold to be joined positively and precisely aligned, but they also hold the mold pieces tightly together in storage. It may seem unlikely, but plaster will warp with time, and mold pieces left lying loose for a year or so usually won't fit when placed back together.

TIP

If you have an old plaster mother mold that has warped and won't fit back together, you can sometimes bend it back . Tie it in place with rubber straps that are stretched to apply pressure, forcing the mold back. Then wet the mold with a hose every day for a couple weeks. It will usually warp back—if not perfectly, at least much better than before.

In order for a flexible mold to last, it should be stored properly after use. Most importantly, always store the flexible mold inside its mother mold. Small molds need only be closed and rejoined, either with rubber straps or bolts. Larger molds should receive some support for the rubber inside so it won't droop and fall flat or distort. Plaster and wax make good supports, but both can adversely affect the rubber. A good plan is to line the mold pieces with clear plastic food wrap or aluminum foil, then apply a layer of plaster. This isolates the wet of the plaster from the rubber and can prolong the mold's life.

Store molds in the same conditions you would live in. Maintain a steady moderate temperature, avoiding extremes of humidity and harsh light. (Molds deteriorate less in the dark.) A well-stored urethane or silicone mold should last for at least ten years, allowing you to complete that slow-selling edition.

CASTING IN MATERIALS OTHER THAN METAL

The title of this book is From Clay to Bronze, *and certainly the major emphasis on casting will be in bronze and other metals. But many materials besides metal are also suitable for casting sculpture, and that is what this chapter is all about.*

Many materials, while ultimately less valuable than bronze, are also much cheaper to work with, and can be cast in the home studio with little or no special equipment. Also, you may not always want or need a bronze. You might need a plaster cast to send to a foundry, or a cast for a competition. The advantages of knowing the techniques of these other materials are many.

Some of these materials are as old as sculpture itself, but many are very new, with still newer materials being developed every day. The principles of using these materials will remain fairly constant, but you should always stay current in the field and be willing to write for samples of new materials as they are advertised.

CASTING IN CLAY

There are two reasons to cast in clay: first, it is a way to achieve a thin clay form for easy and sure firing. Second, and more usual, it is a way to cast multiples of fired clay. There are two basic ways to cast in water clay—*press casting* and *slip casting*—and one way to cast in oil clay. Let's look at each one in turn.

Press Casting

Press casting means pressing soft clay into a mold to form a uniform layer of clay. This is done with the fingers and soft water clay. It is an easy, no-tech way of casting in clay; the only requirement is that you have to be able to reach all parts of the inside of a mold. Thus, if you were doing a tall thin figure, it would be nearly impossible to press cast. But reliefs are very easy, and a mold for something like a portrait head, with a large opening in the bottom big enough for your hand to reach into, is the kind of thing you can press cast easily.

The first thing is the mold: it really should be plaster. A flexible mold works, sort of, but presents difficulties because the clay doesn't want to dry where it meets the mold. Casting in clay is a perfect example of when you would require a plaster piece mold (discussed in Chapter 8). A suitable mold is one that has large, open surfaces that you can reach. If it is a multipiece mold, it should join in a definite and positive way—with metal brackets, for example (see page 96). The mold should also be quite dry, meaning that it should be at least a week old and stored in a dry place.

The mold should be covered with an effective release agent, such as talcum powder sprinkled on and brushed off. As for the clay, you can use any good water clay for the job. It should be of the consistency for modeling—nicely workable in the fingers.

The technique is easy: you press the clay into the mold. But wait, it's not quite *that* easy. If you try to lay in a sheet of clay and press it down it will tear and be filled with cracks and problems. If you squeeze down little pieces, you'll get seams and cracks between pieces. But there is one technique that works really well.

Put a small dab of clay into the mold and press it down. Place the next dab of clay into the mold, but instead of placing it *beside* the first one, put it directly *on top*. Then press it down, forcing the entire mass to expand. Again, put your next dab on top of the existing one—on the front edge of the mass toward the direction you are going—and press down, forcing the clay to expand. The result should be something like a glacier moving over the land, nearly eliminating any little fissures between the pieces.

In a relief, that's all you need to do. Let the clay stiffen until it is firm enough to remove from the mold. Then take it out, retouch the surface, let it dry, and fire. In an enclosed mold, such as a head, follow the same method for each separate piece, then put the mold together and insert your hand into the mold to work clay across the seams. Let the clay dry until it is stiff enough to handle, take it out, and address any problems on the surface. Let it dry completely, and fire. If you can't reach your hand inside the mold, cast separate pieces, let them stiffen, and then join them using the techniques described in Chapter 7.

Slip Casting

In the pottery industry there are two ways of making things. Everything that's round is turned or thrown on some kind of wheel, and everything that isn't round is *slip cast*. Slip casting means pouring slip, which is water clay thinned with water to the consistency of cream, into a dry plaster piece mold. The mold is left until the moisture is drawn from the surface of the slip, leaving a thin layer of stiff clay next to the mold. Any runny slip is poured out, the rest is left to stiffen further, and then the clay is removed.

A thick plaster mold of Mask of Rembrandt, *ready for press casting.*

Pressing in clay, with the new piece laid on top of the previous piece.

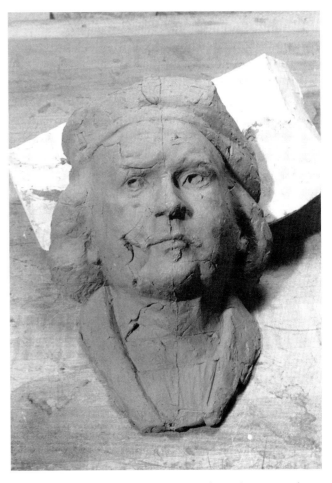

This is what happens if you just press in clay without using the technique described. It is full of fissures and problems.

Detail of the steel brackets joining the two halves of the mold.

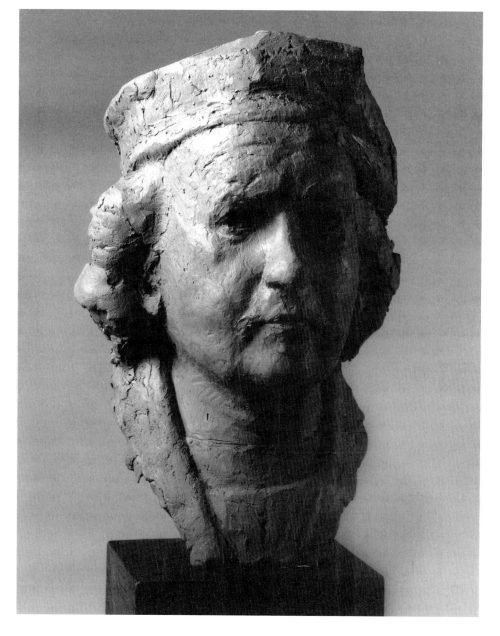

Mask of Rembrandt, *Tuck Langland, 1977. Clay, 5" (13 cm) high.*

There are hobby craft shops all over the country, listed under "ceramics" in the Yellow Pages, and just about all of them specialize in slip casting. Sure, they do things like poodles, Laurel and Hardy, and Elvis, but they do know slip casting. They are the places to go for the needed technical expertise to accomplish this somewhat tricky task. They can supply you with prepared slip, complete with *deflocculants* (see, it's getting tricky already), and they can probably even sell you special pottery plaster to make your molds. Pottery plaster is more absorbent than molding plaster, and works better for this job.

Here are the basics of slip casting: in essence, you begin with a well-made piece mold made of pottery plaster or moulding plaster. The pieces should be quite thick, like 3 inches or more. Be sure they fit neatly together to form a well-fitting mold that won't leak. Each piece must be able to be pulled off cleanly without undercuts, and must be quite dry.

With the mold well-tied together, gently pour the slip into the mold, rocking it to release any trapped air and then filling to the top. Wait between ten and thirty minutes as the clay dries. You can gauge how thick the clay is growing as water is drawn out into the dry plaster by tipping the mold slightly, so the liquid pulls away from one side of the top. When the clay sticking to the side of the mold is between ⅛ and ¼ inch thick, it is ready.

Now simply pour the rest of the liquid slip out of the mold into your original container, clean off the top edge of the mold, and allow the clay to dry another hour or more. The clay is dry when it has begun clearly pulling away from the sides of the mold and feels stiff enough to stand on its own. Then, carefully remove each piece of the plaster mold, trying not to damage the clay cast. Once it's free, allow the clay cast to dry still further until it can be handled safely. Then clean off any parting lines, repair problem areas with soft clay that matches the current consistency the cast, and allow the cast to dry completely before firing.

Since this book's focus is on bronze casting, I'll leave it to you to read, listen, and learn more about the subtleties of slip casting. It isn't very difficult, but the refinements of the process go beyond the reach of this book.

TIP

If you repair your clay cast with clay that is a great deal softer than the cast, it will shrink at a greater rate and pull out of the repair. One way to get good repair clay is to save that extra clay you spilled on the top of the mold and then cleaned off.

Casting in Oil Clay

There is one other way to cast in clay, and it is a most interesting one: casting in oil clay. This might seem crazy at first, since oil clay cannot be fired and is not a final material, but hear me out.

Suppose you have an old piece that you sculpted some years ago and for which you'd made a flexible mold. Now that you look at it, you realize that you could have improved a few things—if only it was in clay again. This process will allow you to do just that.

First, buy a deep-fat frying pot—they cost about twenty bucks. Set the pot's thermostat to about 400°F (200°C) and put in chunks of oil-based clay to fill the pot about halfway.

A plaster piece mold for slip casting.

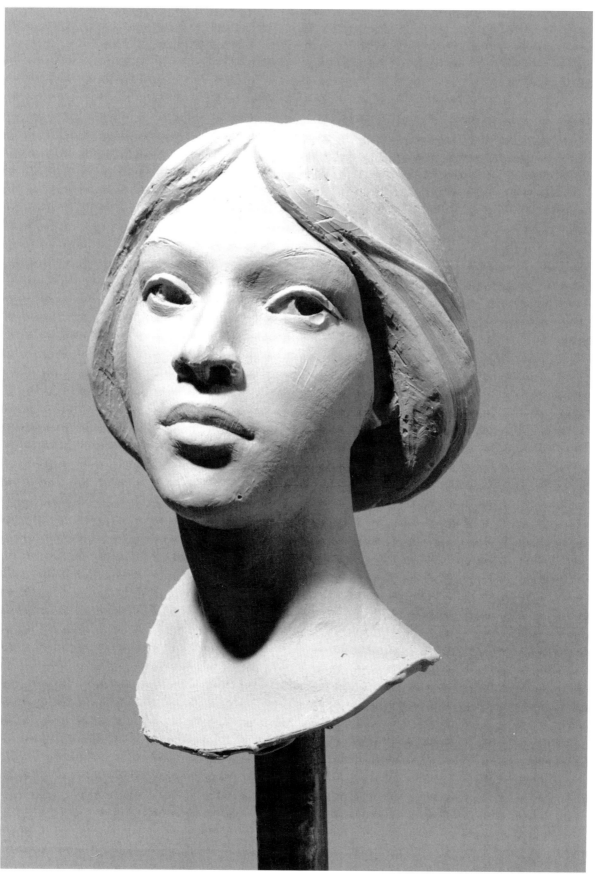

A sculpture cast in Classic Clay.

Watching carefully, stir the melting clay with a good rubber bowl-scraper with a wooden handle (plastic handles are too weak). The clay should slowly melt. Keep stirring and patiently wait until you have pudding—nice, creamy, hot pudding. At this point, unplug the pot to prevent overheating.

Have your mold (preferably a flexible one, and always within its mother mold) prepared and ready, propped up with the opening at the top. Be sure it is well closed, wrapped like a mummy with rubber straps or bolted closed. Don't underestimate the force exerted by a mold full of heavy liquid clay—it can force a mold apart and cause huge leaks. If you are at all in doubt, either wrap more rubber around the mold or slather it shut with plaster and let that set well. Note that neither rubber nor plaster molds need any release agent.

To pour the very hot and thick melted oil clay, here's what to do. Buy large waxed-paper soft drink cups—not the plastic ones. Put one inside another. Then, wearing heavy leather gloves, pour some of the hot clay into the doubled cup. Pick up the full cup and pour its contents into the mold. Shake the mold as you would for any casting, and then repeat the whole process until it is full.

What about armatures? You can drop wires into the melted clay, you can insert an armature into the mold before pouring, or you can even *slush cast* a layer of clay (see tip below), let it cool, then add wires and continue filling. Alternatively, you can slush cast a layer and then fill the rest of the mold with plaster.

TIP

Slush casting means repeatedly pouring hot wax, clay, or plaster into and then out of a flexible mold, continuing until it builds the desired wall thickness.

You can do large works this way, too. Simply open the mold and brush in the melted clay, building to a thickness of at least ¼ inch—thicker if you prefer. Close the mold and try to run some melted clay along the inside seams. Once the clay has cooled, fill the rest of the mold with plaster. (You can add all kinds of armature rods at this stage.) You will end up with a plaster sculpture coated with a layer of clay.

Any of these variations will give you an oil clay cast of your sculpture, ready to work all over again. I've used this technique for a number of reasons. Once, when I had a figure going in Classic Clay, I modeled a head in water clay as a demonstration and ended up liking that head better, so I cast it into Classic Clay and added it to the figure. I have also mixed hard styling clay and extra wax with Classic Clay to cast a softer clay figure for more detailed reworking. Casting in oil clay is a very handy technique that every sculptor should have in their toolbox. But remember, melted clay is *very* hot and burns *very* deeply.

CASTING IN PLASTER

Plaster is a wonderful material to cast. It's simple, it provides a durable and permanent product, and it's very cheap. If you are doing a plaster waste mold, chances are you'll want to fill the mold with plaster. You can also pull a plaster cast very easily from a flexible mold. You may want to do this for a few reasons: to rework the piece so you can refine a surface further, to have a plaster model to present for a commission or competition, or simply to preserve the form for posterity should the mold deteriorate.

Filling a Plaster Waste Mold

To fill a plaster waste mold, the mold preparation is very important. First, you must have a good release agent or the plaster cast will stick to the plaster mold. The time-honored release agent is soap, good old bath soap. Dishwashing detergent works, too. Soak the mold in water for a few minutes, then pull it out, add soap, and lather the inside with a soft brush, as though you were a barber getting ready to give a shave. Let the lather sit for a few minutes, then lather it some more. Submerge the mold underwater for about ten minutes and rinse the lather off. The mold should now be sodden with water—so it can't absorb water out of the plaster you put into it—and saturated with grease from the soap, which forms a very effective release agent.

If you want, once any visible water has disappeared you can spray the inside of the mold with a commercial release agent, such as Pol-Ease 2300, as it helps the releasing action of the soap. Alternatively, some people lightly brush olive oil into the mold at this point. (Guess where they learned their craft.)

Now put your mold together. Don't just strap or tie it, but butter it together with a mix of good thick plaster, slathered all around the edge to seal it firmly into one unit.

There is always the question of whether to fill the mold completely or make it hollow. Look at it like this. If your sculpture is the size of your fist, fill it solid. If the sculpture is a life-sized elephant, make it hollow. So what about sculptures in between, such as a portrait head? I feel a life-sized human head is large enough to make hollow; a half-sized head (about the size of a grapefruit) is small enough to make solid.

Anyone can make a solid cast. Just pour some plaster of a nice creamy consistency (1.7 on the scale on page 78) inside the mold, roll it well to eliminate bubbles, and then fill 'er up.

Making a hollow one, however, is more difficult. Here's how:

1. Mix a nice creamy but runny batch of plaster (1.7 on the scale method; see page 78). Pour the plaster into the mold and roll it around to coat all surfaces. Pour out the excess. As the plaster thickens, pour it back in and roll again. Continue until you can get the plaster to adhere in an even layer.
2. Mix another batch of plaster, this time a little thicker (1.9 on the scale), and do the same thing. Keep doing this with thicker and thicker batches until you have rolled an even layer about ½ inch thick. You can gauge the thickness by scraping away plaster up at the edge of the mold. (You should keep this edge clean anyway as it will make it much easier to chip the mold off.)

Whether you fill the mold solid or hollow, let it set well—for at least an hour—and then begin chipping the mold off. Here's how:

1. Buy a nice, small cold chisel—½ inch wide is good—and a small ball-peen hammer or a small mallet. Put the mold on a cushioned surface on a table.
2. Using the chisel and hammer (or mallet), begin chipping at an edge. For a portrait head, begin around the base of the neck at the back. Hold the chisel with the heel of your hand braced on the sculpture and carefully chip *downwards* toward the cast. Try to clear a small patch of mold to expose the cast beneath.
3. With a small part of the cast exposed, keep chipping downwards, working at the cliff face (the edge of the mold). Keep working that cliff face back.
4. Progress slowly and carefully. Don't be tempted to place the chisel under the edge of the mold, as shown opposite, to pry off larger pieces. If you do this you'll get big pieces off all right, but all delicate detail will come right off with them.
5. When approaching a tricky area, like the ear, first determine where the ear is. Isolate the area by chiseling a shallow ditch around it. Next, carefully chip downwards to expose the top surface of the ear, leaving a plaster support behind it. When the whole front surface is clear, very carefully work around the back, freeing the complete ear.
6. If you are doing a portrait head, it's a good idea to clear the back and sides before doing the face. This will give you some practice before tackling the harder and more crucial part. Plus, the cleared part of the head rolling around on the pad and bits of loose plaster will be the back, not the nose and lips.
7. Using the downward chipping technique and working slowly and carefully, you should be able to clear the entire head. Save any bits that come off with the mold to be glued on later. You then clean up the cast, smoothing down any plaster that sticks up with a small hobby knife. You can also fill holes with a very small amount of plaster. Wait until the whole head is bone dry, then glue on any broken bits with ordinary wood glue. Any further filling on the dry plaster should be done with spackling compound, available at hardware stores. Chapter 16 will discuss how to mount the head straight on a block.

Starting to chip off a plaster waste mold by clearing a small patch at the back of the neck.

Working the cliff face, or edge of the mold, back. This is the proper technique for chipping off a waste mold.

Don't do this! Don't be tempted to chip off large pieces with the chisel held at this angle.

Clearing the top surface of the ear. Leave plaster behind the ear for support.

The ear cleared away.

The entire head chipped clear.

Filling a Flexible Mold

The big danger with filling a flexible mold with plaster is removing the mother mold. When you molded the original clay sculpture, the clay filling the flexible mold had some give, and small undercuts were forgiven as you pulled off the plaster mother mold. But when the flexible mold is full of plaster, there is no forgiveness, and the same mother mold that came off the first time will be stuck the second time. The cure for this is prevention. Before filling a flexible mold with plaster or any other hard material, try pulling each piece of mother mold off the rubber again and again, noting any slight places where it hangs up as you pull it off. File and scrape away any such spots on the mother mold until each piece pulls easily without catching.

When pouring plaster into the mold, there is also a danger of slopping plaster all over the mother mold, locking everything together. So soak the mother mold well in water, then liberally apply petroleum jelly around the opening and on the outside so any plaster that does get slopped won't stick. As you pour, try to be super neat, wiping away any spills as they occur.

The next big problem when casting plaster in flexible molds is bubbles. Air seems to trap itself against rubber more than it does against the wet plaster of a piece mold, and the cast can be riddled with tiny, irksome holes. A good, if not always perfect, solution is to take about one cup of denatured alcohol, and add about 10 percent dishwashing liquid. Stir gently. Pour the mixture into the flexible mold, roll it all around, and then pour it out. Now pour in the plaster and roll it around the mold to coat all surfaces, releasing any air trapped by upraised arms or things like that.

Another good solution, if the mold opens into two or more pieces, is to brush the first coat of plaster into the mold. With the mold open, just scrub the plaster well into every nook and cranny, then wipe the edges of the mold clean with a damp cloth. Close up the mold and quickly pour in the same mix of plaster to fill up the mold.

If casting hollow, you can continue to add layers of plaster, just as for the waste mold. If you are pouring a solid cast, the danger is trapping air. One way to help eliminate this is to have a piece of wood handy that is big enough to cover the mold's opening quite tightly. If the opening is irregular, first cover it with a gob of soft clay wrapped in thin plastic wrap. Fill the mold halfway, then hold the wood (or wood and clay) stopper tightly on the opening and flip the mold to let any trapped air escape. Then turn the mold back over so the opening is on top, and continue to fill. Once the mold is full, stopper up and flip again to be sure any trapped air flows up and out.

An alternative method is to determine any high points in the sculpture that might not fill (see illustration, page 137) and cut fine grooves through the mold to serve as air vents, leading from those high points straight up and out. As you fill, watch for plaster rising in those vents and stopper them with soft clay.

After the last coat of plaster has set for at least an hour, try removing the mold by first cleaning any spilled plaster from the outside, which can hook the mold together. Then find a clear stretch of seam and try prying very gently with a putty knife, chisel, or other tool to work the mother mold free. Usually one side will come off and the other side will stay stuck. Gently and patiently work the stuck half against the rubber, using whatever prying tools will fit, until it comes off. Then it's a piece of cake to peel off the rubber. If you've tried everything but the mold is still stuck, you'll probably have to break either the cast or the mold.

Reinforcing Plaster Casts and Preparing Them for Mounting

There are several ways to make the cast stronger than simple plaster. One way is to glue-load the plaster. Use ordinary white glue or yellow woodworker's glue (aliphatic resin). Pour some water into a container and then add about 5 percent glue. Stir, then mix the plaster as usual. The plaster won't seem much different at first, but a week later the cast will be noticeably harder. (Note that the yellow glue will make your cast yellow, but so what?)

Another good reinforcer for hollow casts is loose strand fiberglass. This can be bought in boxes, and looks just like glass hair. Stir some of the fiberglass into the second, third, and fourth coats of your cast (not the first coat, or it will show on the surface of the cast) and it will strengthen the cast considerably.

If you are going to want to mount the plaster cast somehow, a good time to consider that is when you are making the casting. For a head, you will need some kind of metal pipe or form that protrudes out the bottom for mounting, which should be prepared ahead of time to be set into the soft plaster as you near the last coat. Galvanized electrical conduit is perfect. (If the fixture is *ungalvanized* steel, be sure to first coat it with shellac or rust-preventative paint and then let it dry so it won't rust.) Bash one end of the fixture flat with a hammer so the plaster can grip it inside the head. If you are casting a hollow head, pile a glob of creamy thick plaster in the very bottom of the mold (the top of the head) as you near the last coat. Stick the flattened end of the fixture into this glob, then use more creamy thick plaster to reinforce the pipe at the neck. (It's best to do this at the front of the neck, where it usually looks better than at the back or sides.) As the plaster thickens, work the stiffening plaster around the fixture to hold it firmly in place. If you are casting a solid head, wait until the first coat sets, then simply plunge the pipe in as you fill it solid.

If you are casting a figure, you must be more clever with reinforcing. The illustration opposite shows an open figure mold. A reinforcing system of steel rods—which have been shellacked to prevent rust—has been suspended in the mold and secured with small piles of plaster, which is first applied as a nice cream and then, when thickened, in stiff enough piles to support the wires. When the piles have hardened, close the mold and fill as usual.

If you want to avoid the potential problem of the wires touching the surface and showing through, pour a couple layers of plaster first, let them set, then drop in wires and continue. A third alternative is to set the wires in the mold and

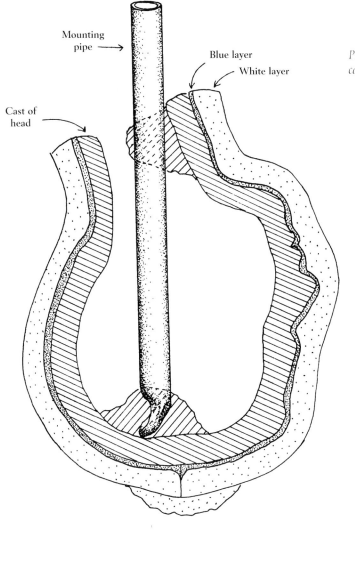

Mounting
pipe

Cast of
head

Blue layer

White layer

Placing a mounting pipe into a plaster cast of a head.

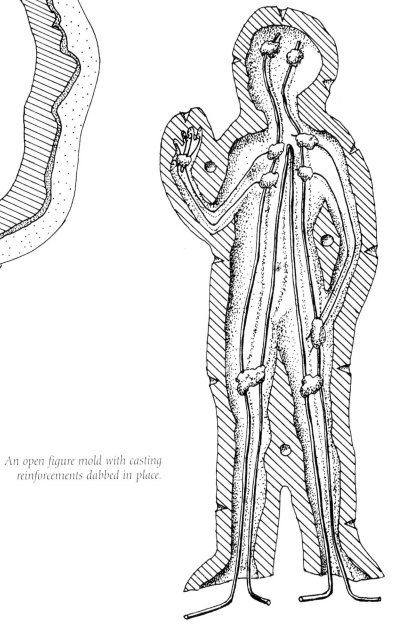

An open figure mold with casting reinforcements dabbed in place.

just let them appear here and there on the surface. They will be very tiny and hardly noticeable. If you are casting a plaster to send to a foundry for either molding or enlarging, these tiny spots of metal showing through won't matter.

Casting in Other Plasterlike Materials

There are many new products on the market that work like plaster but are much harder and more weatherproof. These materials break down into two general categories: superplasters, which are powders that you mix with water, and resin/gypsum systems, which consist of multiple elements and require a special liquid for mixing.

Superplasters

US Gypsum makes a number of products that range from plaster to materials that get sequentially harder. Hardness is measured in PSI, which means pounds per square inch and represents the pressure at which the material crumbles. The table below shows a listing of US Gypsum plasters and gypsum cements.

Winterstone USA (see list of suppliers) manufactures a multicomponent sculpting medium, also called Winterstone, that when mixed with water sets very hard and is weatherproof. It comes in a runny formula for casting or a thicker formula for direct building. The runny formula does not stay in place, but sags and runs down, so be sure to use it only if you are pouring a solid cast. It just won't slush cast.

Design Cast (see list of suppliers) makes three products, two of which are resin/gypsum systems and one a gypsum cement similar to Winterstone called Design-Cast 47. This is a powder mixed with water that sets very hard but is not recommended for exterior use. It is, however, perfect for casting a model you plan to send off to a foundry.

Resin/gypsum systems

These products are more complex and high-tech, usually involving powders mixed with a milklike liquid and sometimes additional water. They set about as hard as the superplasters, and are weatherproof. Their most common use is for architectural restoration—casting elaborate carved stone elements to replace deteriorated ones, making fancy doorways and windows, and that sort of thing.

Two major manufacturers of these systems currently sell to sculptors: Design Cast and Ball Consulting (see list of suppliers). Design Cast makes three products, two of which are resin/gypsum systems—Design-Cast 62 and Design-Cast 66—and one a gypsum cement—Design-Cast 47. Of the first two, the 62 is a runny mix for casting, designed especially to be reinforced with fiberglass. The 66 is a thicker mix for direct building. Both are powder and liquid polymers; the two parts are added together with extra water in a precise formula, requiring a good scale. The third product, Design-Cast 47, is discussed above under superplasters. All three of these products take fillers, aggregates, and colors very well. Write to Design Cast for full descriptions of their possibilities.

Ball Consulting makes Forton MG, which is similar to the Design Cast systems but comprises three powders and a liquid, which must be measured carefully. Again, Forton MG sets rock hard, is weatherproof, and takes a wide range of fillers, metal powders, colors, and the like. The normal mix is runny for casting, but thickens steadily with time so it can be slush cast. It can also be used as a backup layer loaded with chopped fiberglass that becomes thicker for slush casting.

The resin gypsum systems are almost always cast in flexible molds, and often don't need any release agent. Always be sure to try a small batch in your particular mold before committing to an entire sculpture.

US GYPSUM PLASTERS AND GYPSUM CEMENTS

Product	Setting time (in minutes)	Hardness	Expansion[1]
molding plaster	30	2,000 PSI	medium
Hydrocal	30	5,000 PSI	high
Statuary Hydrocal	30	6,500 PSI	medium
Hydrocal A-11	18	5,500 PSI	low
Hydrocal B-11	30	4,500 PSI	low
Ultracal 30	30	6,000 PSI	very low
Ultracal 60	80	5,000 PSI	very low
Hydro-Stone	18	10,000 PSI	medium
Hydro-Stone Super-X	18	13,500 PSI	high
Fast Cast	30	10,500 PSI	low

[1] In general, you want a superplaster with low expansion as high expansion can crack a mold.

One great advantage of these resin-gypsum systems is that they can be loaded with colored powders. Metal powders, such as bronze, aluminum, iron, pewter, and others, can be added to the first coat (and, in the case of the more expensive powders, should *only* go in the first coat). When the material is hard, the finest whisker of top surface can be abraded away with fine steel wool, revealing what amounts to pure metal. Sometimes it's hard for even an experienced sculptor to tell the difference between one of these casts and an actual metal cast. While they ultimately don't have the market value of true bronze casts, they can be created right in your home studio and are a good intermediate step. They are also very handy for creating models for commissions. "The large piece will look just like this," you can tell the clients. Also available are powders that imitate stone very closely, including marble.

Whenever you see the letters FGR connected to a product, for example Hydrocal FGR, or FGR-95 Gypsum, it means "fiberglass reinforced." This designates products designed to be built up in rather thin, brushed layers, with fiberglass matting stippled in after the first one or two coats to build a very lightweight but strong structure. When casting sculptures from these materials, the biggest problem is joining piece sections and repairing. Usually there will be some level of visible seam where pieces are joined. And if there is a hole or problem somewhere, a repair will often show just a little. Repairs should done with the same mix used for the first brushed-on coat. Any holes to be filled should be dug out a little, and if possible, undercut with a fine burr on a rotary grinder to help the repair get a grip on the cast. By sanding or using steel wool over the cured repair, it can usually be blended quite satisfactorily.

CASTING IN RIGID PLASTICS

There is a range of rigid plastic materials that can be used for casting, most of which are two-component systems and are available from the same "big five" suppliers of flexible molds.

To use, follow the directions that come with the product. But note that if you are casting urethanes into urethane molds, they will want to bond very tightly together unless you are very careful about the release agents. Again, follow directions carefully and don't scrimp on this step or you won't get your cast out of the mold.

A better alternative is to cast rigid urethanes into nonurethane molds, using silicone or polysulfides instead. With a silicone mold, the cast will pop out easily without any release agent at all. If you are using polysulfides, test before applying to your mold.

All the techniques described above will work for casting with rigid plastics. Most likely, you'll either pour solid or slush cast (for a hollow cast). If pouring solid, remember to first fill the mold only partially, then roll the material around to release trapped air. Cover the pouring opening and flip the mold over to let any remaining air escape. If slush casting, roll the first coat around, then pour out the excess. When the

first layer is stiff, add a second coat and again pour out the excess. Continue the whole process until the desired thickness is obtained.

TIP

If you want to paint the final plastic cast, use a silicone mold, since the release agents necessary for a urethane mold won't wash off and will keep the paint from sticking.

Polyester Resins and Epoxy Resins

In a word, avoid them if you can. Polyester resins are the less noxious of the two, and they are very noxious. They will drive you out of the house or studio with the odor, they are sticky and nasty to use, and they are brittle and somewhat delicate when set. Plus, they must be reinforced with fiberglass, which gets in your skin and irritates. In general, I never want to see them again, and you will probably soon agree with me if you use them.

There are people who will tell you that nothing could be simpler than casting with good old polyester resin. But do they tell you, these "easy-as-pie" types, that there are several types of resin on the market? That a *gel coat* is colored and intended only for an initial sprayed-on coat, that *lay-up* resin is good only for thin brushed-on coats or for application with a chopper gun, which you haven't got, and that only *casting resin* is good for solid things? Do they tell you that the resin you buy in the auto parts store is lay-up resin, and if you try to cast it solid it will crack, boil, or even burst into flames? Or that if you try brushing lay-up resin into a mold it will be too thin and will collect in puddles, and that you need to thicken it with Cab-O-Sil, walnut shell, or cherry pit flour?

Do these "everybody's doing it" types mention that you have to reinforce the resin with layer after layer of chopped strand mat, well worked in by stippling with a brush and fresh resin? Or that cleanup involves stinky and nasty acetone, and by now the place will be smelling so bad you'll be gasping for air? And finally, do they mention that the hardener used for polyester resin—methyl ethyl ketone peroxide—is *really* nasty stuff, and if you squirt a dash into your resin and one tiny drop happens to splash in your eye, that eye will turn into a shriveled brown nut within seconds and you'll be blind forever? Do they mention that? Are you still interested in using this stuff?

And one group you really don't want to listen to is the epoxy crowd—if they're still alive. Epoxy resin works much like polyester, except that it can kill you. Enough said. Forget it. Stick to polyurethanes and superplasters. You'll be glad you did.

CASTING IN CEMENT AND CONCRETE

These two materials—which are actually the same except that the addition of an aggregate turns cement into concrete—are very permanent and have many advantages. Lynn

Olson's *Sculpting with Cement: Direct Modeling in a Permanent Material* is an entire book on the subject that goes into far greater detail than I can here. It is a wonderful book and should answer any questions you have.

CASTING IN PAPER

Paper will cast very nicely, with fine detail and usually a very attractive clean white appearance. It is possible to cast paper into nearly any shape, but by far the easiest is to cast relief sculptures, especially those without deep projections or undercuts.

The best way to get into paper casting is to first create a relief sculpture in clay. If you use water clay, such as terracotta, the iron oxide from the clay will stain the plaster mold, and in turn the paper, so it's better to create your original clay relief in gray clay, porcelain, or oil clay.

For a first attempt, keep the relief rather flat and without undercuts, kind of like the relief on a coin. Make a good plaster mold of the relief by brushing or flicking on a first coat, then building the plaster up to an least 1 inch thick. It's better to use pottery plaster than molding plaster, but either will work. Let the mold air dry for several days. You can also cast paper in flexible molds, but the paper cast will take longer to dry.

The next step involves slopping paper pulp into the mold. There are many ways to obtain pulp. The easiest is to find a papermaking studio somewhere in your area and buy a gallon or so of ready-mixed pulp. Failing that, buy several sheets of good watercolor paper, tear them into tiny pieces, and boil the pieces in water for a couple hours. Then run this mix in small batches through a blender until you have a nice, even, creamy pulp.

Once you have a good batch of pulp, slop it into the mold, filling the entire area. Using a short-bristled brush, such as a stencil brush available from art supply stores, stipple downwards onto the pulp to force it into all the cavities. Use a sponge to absorb the water that appears on the surface of the pulp. The whole idea is to get rid of water, and good pulp is at least 90 percent water. Keep sponging and stippling until the pulp looks rather dry and is well pressed into the mold.

TIP As you can probably guess, there are no limits to what you put into the paper pulp. You can add colored paper, colored fibers, colored pigments, and just about anything that will blend into the pulp. Dry powdered clay can also be added to make the pulp thicker and more malleable.

Now you need to let the pulp dry. If you just leave it, however, it will curl excessively out of the mold. Probably the best solution is to fill the mold with a generous mound of clean glass marbles. These will not stain, and they will allow air to pass between them for drying while still holding the paper down everywhere. Give the paper plenty of time to dry, like a few days. A fan helps. Pour out the marbles and carefully remove the paper cast.

Another good technique is to first mix a large vat of pulp that is quite watery. Tack a piece of screen onto a frame and pass it into the water edgewise, bringing it up flat to capture a sheet of pulp. Let the water drain, sponge it a bit to remove more water, and lay the sheet into the mold. Do two or three layers like this, sponging each sheet as dry as possible and orienting the seams differently each time you lay a sheet in the mold. Then proceed as above with the marbles to prevent curling.

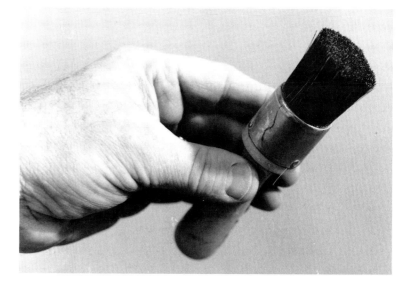

A stiff brush for dabbing paper pulp into a mold.

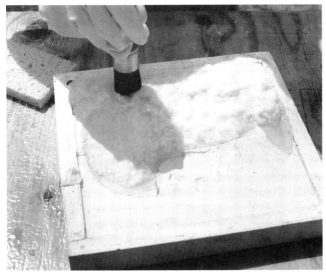

Soaking wet paper pulp into a dry plaster relief mold. The brush is used to pat the pulp into every detail with a gentle downward motion.

Using a sponge to soak up as much water as possible from the wet pulp, until it appears nearly dry.

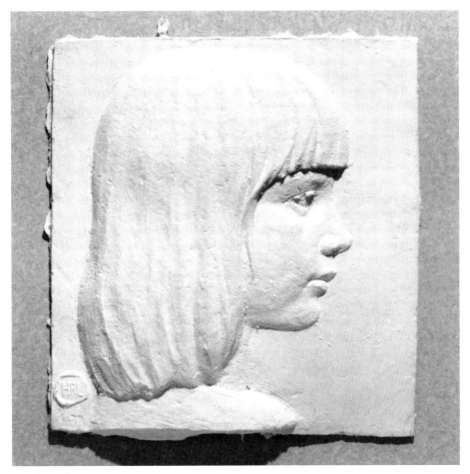

The final, dry paper cast.

INTRODUCTION TO METAL CASTING

As you will remember, casting is the process of pouring a liquid into a mold, letting the liquid harden, and then removing it from the mold. The last chapter discussed methods for casting in many materials, including clay, plaster, and paper. Now we turn to the focus of this book: metal, primarily bronze. This chapter will introduce the concepts, materials, techniques, and some vocabulary for the different kinds of art metal casting in common use today. The actual methods will follow in the next four chapters.

KINDS OF METAL CASTING

There are two primary methods of metal casting used in foundries today: lost wax and sand. Lost wax is the most common for smaller works, while sand is used primarily for very large castings. A third method is full mold casting, which will also be discussed. This method is used heavily in industry, but less so for sculpture.

Lost Wax Casting

The principle behind *lost wax* casting, sometimes called by its French name *cire perdue,* is a simple one. The sculpture is created in wax, then covered with a heat-proof molding material called the *investment.* The investment is heated until the wax first melts out and finally *burns clean,* leaving a cavity shaped exactly like the wax. Metal is poured into this cavity and, once it has cooled, the investment is broken off, leaving a very precise reproduction of the wax.

Note that the original sculpture in wax, or the wax pattern, is usually referred to simply as *the wax.* So the word *wax* becomes both the material the pattern to be invested is made of, and the object itself. The mold material placed around the wax is called *investment.* When this material has been placed around the wax, the complete mold is also called *an investment.* And the process of doing this is called *investing.*

In order to allow the wax to run out of the investment when heated, and to allow the metal to run in, a system of channels (sort of like plumbing) is made of wax rods and is attached to the wax. This plumbing consists of several parts, but in general is called the *gating system* or *sprue system.* Sprue systems will be discussed in detail in Chapter 12.

In order for the final bronze sculpture to be hollow, you need to create a hollow wax. Why does the bronze have to be hollow? There are two important reasons: First, there is an enormous savings in material and weight between a solid figure and one with only a thin shell of metal. And second, any section of bronze thicker than about ½ inch may shrink on cooling, causing sunken cavities.

Hollow waxes are made by *slush casting,* or pouring hot wax into the rubber mold and then out again repeatedly, until the desired wall thickness is formed. The hollow wax is then invested, with some investment material also poured inside to fill the hollow center. This material in the hollow center is called the *core.*

If you think about it, you will wonder what supports that core when the wax is melted away. Why doesn't it fall down into the slightly larger, vacated hollow of the sculpture itself? The answer is *core pins,* which are small metal rods inserted to support the core in its original position after the wax is gone. Another name for core supports is *chapelets.*

The process of lost wax casting is further broken down into two major methods in use today. The old, traditional one is called *solid investment,* or *traditional investment,* or even *luto investment casting.* The newer method, which is now far more common, is called *ceramic shell casting* or simply *shell*

casting. In industry, the term *investment casting* actually refers to ceramic shell casting.

So what is the difference between the two methods? In solid investment, the investment is made of plaster and various refractories, such as sand, grog, Perlite, silica flour, and the like. Many formulas for investment mix are very simple—mine is just plaster and sand—but others are more complex. The wax is placed in an empty, cylindrical flask, and the mix is poured into the flask around it, creating a rather large solid mass. This is then heated, or *burned out* at relatively low temperatures for a long time.

The other method, ceramic shell, involves a much newer technology that was borrowed from industrial casting in the mid-1960s and now accounts for at least 95 percent of all casting done in commercial art foundries. Ceramic shell is based on colloidal silica, which is a milky liquid called *slurry.* The wax is dipped in the slurry, then dusted with a powdered refractory aggregate called *stucco*—kind of like shake and bake. This mixture is allowed to air dry, usually helped along with fans, then dipped and dusted again. After between six and ten coats, a layer measuring about ⅜ inch has been built up around the wax and its sprue system. The wax is melted out, either by steam or rapid heating, and the shell is then fired to a much higher temperature than for solid investment. This both eliminates the last traces of wax

and, more importantly, fires the ceramic component of the shell, making it very hard and able to withstand the pressure of molten metal.

Solid investment versus ceramic shell

Many people automatically assume that because ceramic shell is the method of choice for most foundries, it is the best. In fact, there are distinct advantages and disadvantages to each system.

One important requirement of ceramic shell is that there must be enough slurry to dip and cover the piece. This means you need a fairly large tank. Even more importantly, you need to keep the slurry stirred twenty-four hours a day, seven days a week, and maintain it at the correct water content. Large commercial foundries have huge vats with automatic stirring motors that cycle on and off around the clock, and they assign a person to check and monitor the slurry several times a day to keep it just right. In Chapter 13, I'll describe some ways to avoid this commitment. Suffice it to say, however, that ceramic shell requires a very large commitment, both in money and time. Solid investment, on the other hand, merely requires bags of plaster and sand, readily available from nearly any lumberyard and requiring no monitoring.

A ceramic shell mold requires up to ten dippings, with drying time in between. This usually means about a week.

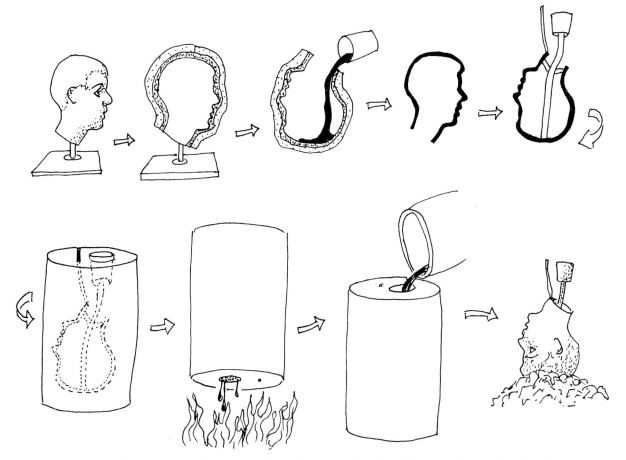

The lost wax process with solid, or traditional, investment. Top, left to right: the original clay, the rubber mold with shell, pouring wax into the mold, the hollow wax cast, adding the sprue system. Bottom, left to right: the wax with investment, burning out the wax, pouring the bronze, breaking the cast.

Most foundries can shell a hundred pieces in that same week, while at a university foundry, where students only come in a couple of times a week, the shelling time can be stretched to well over a month. By contrast, a typical solid investment can be made in about an hour. But it would take even a large foundry one hundred hours—or two-and-a-half work weeks—to invest those same hundred waxes that it could shell in one week. From that standpoint, solid investment looks like a better system for smaller foundries and for colleges and universities where students are not in every day. Ceramic shell, however, is clearly the better choice when high volume is involved, which is the case with most commercial foundries, hence the high usage by them.

The *burn-out*, which is the process of heating to remove the wax, is very different for the two systems. For solid investment, the burn-out usually runs at about 1,000°F (540°C) for two to four days. This means that fire codes must allow a kiln to run overnight, which is not always the case. Ceramic shell, on the other hand, requires a burn-out of only about two hours, but at temperatures like 1,800°F (980°C), which is usually accomplished while the metal is melting. This is a savings in gas, and it makes burning out the wax and pouring in the molten metal (called *pouring*) a simultaneous operation.

There are other considerations in choosing one method or the other that will be discussed in subsequent chapters. Suffice it to say that the choice is not as simple as it would appear. Each method has some real advantages, and each has some disadvantages. Like anything else, you have to choose based on your own particular situation.

Sand Casting

Sand casting involves making a mold out of foundry sand, which is a special fine sand mixed with binders to make it hold shape perfectly, and is generally used for very large sculptures. The pattern, or positive—which is always made of a rigid material, like plaster—is placed in a form and the sand is packed tightly around it. The pattern must then be removed from the sand, leaving an impression—kind of like a footprint on the beach. If the piece is to be hollow, a core is cast in sand out of the mold just formed and then pared down by about ¼ inch all over. This core is then suspended in the cavity by *chapelets*, which are small metal supports that become part of the final casting.

Molds for sand casting can be made in one, two, or several pieces, and fitted together for complex shapes. Essentially, sand molds are piece molds. (See Chapter 8 for a discussion of piece molds.)

There are many kinds of sands and binders, some of which retain their initial softness, some that go hard by themselves (called *no-bake*), and some that harden either by baking or by the introduction of carbon dioxide gas.

Sand casting is the primary method used in industry for things like machine parts, auto engine blocks, and just about everything else. This is a special method requiring special skills and techniques, and is outside the scope of this book.

For the vast majority of sculptors, sand casting is something used by foundries, particularly to produce large pieces and those in which great detail is not required.

Full Mold Casting

Full mold casting uses a pattern or positive of foam plastic, which is then surrounded by sand. Hot metal is poured directly onto the foam, vaporizing it almost instantly and leaving a cavity into which the metal flows.

More and more industries are using this method for casting. Many auto engine blocks are now molded in plastic foam, dipped in a refractory slurry, and then surrounded by sand, with hot iron or aluminum dumped directly onto the foam. This results in huge clouds of smoke, but the castings are very fine and the process very fast. For sculpture, many artists use Styrofoam or other types of rigid foam, which they carve with hot wires or any of an endless array of cutting tools and then imbed in sand. Metal—usually aluminum—is poured directly on the exposed foam, creating one-of-a-kind castings that are usually solid, but rather quick and thus not very expensive.

One major disadvantage of full mold casting is the amount of fumes and smoke produced by the vaporizing foam. It really must be done outdoors, preferably on a windy day, and preferably with no neighbors. Another disadvantage is the relative difficulty of creating a core for hollow castings. So most full mold sculptures are aluminum, solid, and thus somewhat restricted in size. Naturally, multipart sculptures can be made that overcome this last restriction.

Full mold casting is mostly used for abstract works and falls somewhat outside the focus of this book. There is a book by Geoffrey Clarke, titled *A Sculptor's Manual*, which emphasizes this process, but it is out of print and available only in good libraries or through book searches (see Further Reading).

If you want to try casting metal in your own studio, the best way to begin is to follow all the steps up to the investment, then choose either solid investment or a simple shell method using Shellspen. The following chapters will point out tips for establishing a small studio foundry.

POURING AND ALLOYS

The essential act of metal casting is pouring metal into a mold. This is done by melting the metal in a *crucible*, which is a highly heat-resistant refractory pot. The crucible is in turn is placed in a *furnace*, a machine specially designed to melt metal. Once the metal is melted, the crucible is lifted out and the molten metal is poured into the mold.

Bronze

So what is bronze? Bronze is a combination of copper and other metals, forming an *alloy*, which means a mixture of metals. Copper is a rather soft metal, and at some point a prehistoric person discovered—no one knows how—that mixing a little tin (an even softer metal) with the copper made a combination harder than either of them alone. But how could this

be? The explanation is that copper crystals are slippery and slide over each other, and so the metal is easily deformed, or soft. But when added at a volume of about 15 percent, tin crystals act like sand on an icy sidewalk and retard the slipping of the copper crystals, making a harder metal.

For centuries, bronze meant copper and tin, with roughly 85 percent of it copper and 15 percent tin. Later metal-workers found that adding zinc made an altogether different metal with different properties. This is usually called brass. Still later, metalworkers added tin *and* zinc, along with lead. Soon there were hundreds of recipes for various brasses, as they were called collectively. Each recipe or alloy gave different qualities, which were suitable for different purposes.

Some time in this century, metallurgists added a small amount of silicon to the copper. Silicon is a glasslike element, and isn't really a metal at all. They found that with 4 percent silicon, 1 percent manganese, and 95 percent copper, the alloy ran like water when melted, was more flexible and less brittle than other brasses, was more corrosion-resistant, and welded easily. This is silicon bronze, commonly called Everdur or 95-4-1, and is the alloy of choice for most sculpture cast today. A similar alloy called Herculoy is used by many foundries.

The traditional statuary bronze, which is usually something like 85 percent copper, 5 percent tin, 5 percent zinc, and 5 percent lead (usually called 85-5-5-5, or 85 three 5) is occasionally used, but most foundries don't like the lead content. Its chief advantages are that it is softer, allowing easier working of the bronze, and that it generally yields richer *patinas*, which are chemically induced colors. But a disadvantage of 85 three 5, besides the lead content, is that it doesn't weld nearly as easily as Everdur. Some foundries are using a low-lead alloy that is something like 85 percent copper, 7 percent tin, 7 percent zinc, and 1 percent lead.

The Italian sculptor Giacomo Manzú used an alloy that included about 15 percent silver and was a lovely golden color, which he always left without patina. Another alloy used occasionally is White Tombasil, also called white bronze. This is a high zinc and nickel content brass and is white or silver in color. It casts very nicely, and now welding rod is available through Atlas Metals that matches its color very closely.

Other Metals

One common metal for sculpture is aluminum. Aluminun has several advantages: it is very lightweight, it is far less expensive than bronze, and it melts at a much lower temperature. It is not as easy to work as bronze, and welding is a little trickier, but once the technique is learned it is not at all difficult. The only real disadvantage to aluminum is its appearance. It simply doesn't have the richness of bronze, or the wealth of colors available through patinas. Aluminum also doesn't fare as well when exposed to the weather over long periods of time.

Another common metal for sculpture, and one that is growing more popular, is stainless steel. The biggest advantage to stainless steel is its absolute permanence. It simply will not corrode or change in any way, even if placed outdoors in the harshest conditions, such as on a sea wall covered day and night with salt spray. Stainless steel is also very strong, much stronger than bronze, and though heavier, it can project further out into space without breaking. It can be worked only with some difficulty since it is so hard, but it welds very nicely. And it takes a wonderful polish.

There are only two major disadvantages to stainless steel. First, because of its high melting point it requires an induction furnace, which not every foundry has. And second, it always looks pretty much the same, lacking the great variety of finishes bronze can achieve. The look of stainless tends to be cold, impersonal, and rather "machine age," as opposed to the warmth of bronze.

Yet another metal being used more and more is iron. Iron can be melted in most gas-fired crucible furnaces, and even easier in induction furnaces, but is usually melted in a *cupola*, which is a tower containing pig iron, limestone, and coke. (See page 152 for more information about these furnaces.) It's pretty much an all-day, three-case-of-beer job to fire a cupola. You don't do it for one mold, but make it an event, with lots of molds to pour and a big party afterwards. The

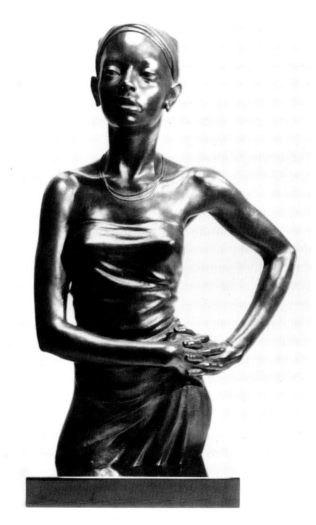

*Femme d'Afrique, Tuck Langland, 1987. Bronze, 29½"
(75 cm) high.*

results can range from awful to wonderful, and iron is certainly becoming among the chief alternatives to ubiquitous bronze for cast metal sculpture.

Naturally, any metal that can be cast can be cast into sculpture. Some alternative metals currently being used are silver, gold, brass, mild steel, pewter, lead, and many more.

METAL CASTING WITH A PROFESSIONAL FOUNDRY

The vast majority of sculptors use professional foundries to cast their work. The chapters that follow are for those few hardy souls who want to try casting their own sculptures, or for college and university sculptors who are setting up or already running a small foundry. Nonetheless, reading the material carefully will give you a good grasp of the many processes involved in casting bronze, and even if you never do it yourself it will help when you talk with foundries about casting your own work.

What Foundries Do

Foundries offer a wide range of services. Here are the main ones:

■ *Enlarging.* As explained in Chapter 6, many foundries can enlarge your work up to any mutually agreed-upon level of finish. Usually you will be required to come to the foundry to apply the final surface and detailing, as well as providing final approval.

■ *Mold-making.* Virtually all foundries can make flexible molds off either work created in your own studio or an enlargement they created for you.

■ *Casting in materials other than metal.* Foundries routinely cast in plaster, resin, and other materials to create permanent hard models.

■ *Lost wax casting.* Virtually all art foundries cast in lost wax as their main occupation. Most will use ceramic shell, some will use solid investment only, and a few will do both. More and more are beginning to use vacuum casting, which is a new high-tech wrinkle on investment casting.

■ *Sand casting.* The larger foundries can sand cast. This is a good tool for large works since it creates strong castings at a lower price. The surface detail isn't quite as fine as with lost wax, but it is perfectly acceptable for life-sized and larger castings, and the cost savings are usually substantial. Another advantage is that the castings are usually poured in much larger sections, which means less welding of separate parts.

■ *Casting in metals other than bronze.* While most foundries cast silicon bronze, many will also cast in other metals, such as iron, stainless steel, pewter, aluminum, precious metals, and more.

■ *Fabrication.* Many foundries can fabricate (build by cutting and welding) forms for you out of bronze or other metal plate, rod, tube, etc. These forms can be used for pedestals, bases, or even the sculpture itself.

■ *Finishing.* Virtually all foundries will finish and patina the

work. Some specialize in polished surfaces. They will also be able to mount your work on a base of your choice.

■ *Casting editions.* If you want to cast an *edition*, which is a series of castings of the same work, most foundries will keep a *foundry proof*, which is the first cast, finished to your satisfaction. They will then match future casts to the foundry proof so you needn't come in to supervise and approve each one.

■ *Storing molds.* If you are having an edition cast, most foundries will store your mold for you so you don't need to ship it every time. Be careful, though. Since a disastrous fire in a foundry some years ago, which destroyed many artists' molds (including some of mine), foundries now store molds at the artist's own risk. Be sure you are quite straight about this before leaving molds.

■ *Engineering.* Some foundries can supply professional engineering services for large or unusual works. If the foundry isn't in your state, they can supply specifications that can then be presented to a civil engineer in your location for sign-off. This can be very important for large public works.

■ *Shipping.* Virtually all foundries can arrange shipping, from simply packing small items in boxes and shipping them through UPS, to transporting large works on heavy flatbed trucks.

■ *Installing.* Some foundries can either assist with large installations or supply companies that will.

Selecting a Foundry

The first step is to find a directory of foundries. There are several directories available, as noted in the list of suppliers at the end of this book. Such directories always need some updating, of course, but in general the larger well-established foundries will remain the same.

The term *full-service foundry* usually means one that can do just about everything listed above. Smaller foundries that do not advertise full service will probably not have enlarging facilities or the ability to fabricate or sand cast, although they are fine for most small works. There are also many shops that only offer single, specific services. A shop might only do enlarging, or making molds, or pouring and chasing wax. There are foundries that only work with metal (you give them a wax, they give you a rough cast), and there are metal chasing shops, patina specialists, and even base makers. These specialists often link up in teams, passing a work from one to another to complete the job.

There are a few other criteria that should determine your choice of foundry. The first is its location. It is important to be able to visit the foundry on a reasonably regular basis. A foundry close by is not only more convenient, but also cheaper—due to reduced travel and shipping costs—than one across the country. This isn't always true, of course, and sometimes there are other advantages to a faraway foundry that offset the travel requirements.

Another crucial criterion is the quality of the work. If at all possible, visit the foundry. Take a tour. When you announce that you are looking for quotes to have work cast, they will be glad to show you the place. Look for general cleanliness and order. Be suspicious of a complete dump. If

they can't keep the place nice, how much care will they give your sculpture? Look at the equipment. Is it relatively new, or very old? Does it look like it's well maintained? Does the whole place have a sense of flow of process, where the work moves easily from one stage to another, or is there a criss-crossing of traffic patterns, a confusion of purpose to the layout? Keep your eyes open for failures—odd bad castings sort of hidden behind things, casts with big holes and cracks, and casts that are scrapped. No one is perfect and every foundry has failures, but they should be rare.

You should also talk to the people at the foundry. You'll have to work with these people on something very personal—your creation. You'll also have to deal with them concerning money, payment schedules, and any problems that arise. Be sure you feel comfortable with them and will be able to discuss problems openly and frankly. Be sure you feel they are honest.

As with any large purchase, it's important to shop around. The larger the work, the more important it is to get several quotes. But be careful not to call foundries for every little thing, saying "What would it cost to cast three little children, say, running around a flagpole?" You need to give the foundry the kind of information they need to make a quote. Ideally, this includes the actual piece or a good maquette, although the next best thing is a series of clear photographs that show all sides of the piece or maquette. You should also supply the final work's dimensions, the level of work required (for example, a mold, cast, finish, patina, and base), whether you want lost wax or sand casting, what kind of metal you want the sculpture cast in, and any other relevant information. Once you provide the information, listen to their advice. They may have suggestions on how to make the work cheaper or better. Remember, these people are professionals who cast thousands of pieces a year, so listen to them.

When you have the quotes in hand, don't just run to the lowest price. The bottom line isn't always the bottom line. Consider all the factors, including location, quality of work, kind of processes used, and the like. Figure in travel and shipping expenses. Figure on having to pay for work some foundries might not do, such as packing or engineering. Then factor in your assessment of the people and make your decision.

Working with a Foundry

It is usually best if you provide the foundry with your original piece for molding, since then they can make whatever kind of mold they prefer to work with. But don't be disappointed when your clay original is returned all torn up. That is standard. Expect to lose it. If you make your own mold, expect criticism. No matter how nice a mold you make, the foundry probably won't like it, since it isn't theirs. But if it works, that's all that matters.

When the wax is completed, inspect it carefully. This is an important stage. Look very carefully for any flaws, distortions, or problems and either fix them or get the wax chasers to fix them. As is the wax, so will be the bronze.

It's not important to see the bronze when it's first out of the mold; you will be disappointed as the sprues will be in place and many things will still need to be done. Wait until the bronze has been cast, finished, and is ready for the patina. Then look very carefully to see if it's what you want. When you do, remember: No foundry can make your work better than it is. If your clay sculpture is clunky and clumsy, the bronze will be as well. All you are asking is that they reproduce what you have given them, and the worst client a foundry can have is the amateur who wants miracles.

It's often a good idea to stick around as the patinas are applied, particularly for the first bronze if you are doing an edition. Watch as the color goes on and see if it's what you like. But remember that patinas usually go from lighter to darker, and not the other way around. If you start saying "I'd like it a little lighter, please," you might get dirty looks, because most of the time you'll be asking them to sandblast the patina off and start again. Finally, let them know if the piece is to be installed indoors or outdoors, and talk with them about how they finish the bronze over the patina.

Business matters

Most foundries will set out a payment schedule with their quote. It is usual for one-third to one-half of the payment to be paid before they begin.

Always keep in mind that foundries are businesses, and cash flow is both important and often tight. Don't show up until you have the money, and then don't delay payment. By the same token, be sure to get a foundry's quote in writing. If you request any changes in what you want, get quotes for that in writing, too. The foundry should honor its quote and not try to increase the price at the end, and you should insist that it do so. The vast majority of foundries will honor their quotes, but for those few that might not, keep it in writing.

A good foundry is a sculptor's best friend. Treat the staff like your best friends, and they'll treat you that way, too.

WAXES AND SPRUE SYSTEMS

The clay-to-bronze process goes from clay to mold to wax to investment to bronze—five major transfers. At this point, you have most likely created a clay sculpture and then made either a rigid or flexible mold. The next step is to make a wax positive from your mold, which will then be invested, burned out, and cast in bronze. This chapter is all about making that wax positive and then attaching a sort of plumbing system—called a sprue system—that will allow the melted wax to drain out of the investment, and channel the molten metal as it is poured in. Alternatively, you may have skipped the clay and mold steps, opting to simply build a sculpture directly in wax. If this is the case, there are some important restrictions you should know, which will be detailed in this chapter as well.

Wax can be found in nature, mostly in beeswax and some vegetable waxes, but the wax most commonly used for sculpture is microcrystalline wax, which is a petroleum by-product. It can be obtained in many varieties, from very soft to very hard, from inexpensive to quite expensive, from simple wax to specialized wax (such as water-soluble wax), and in a wide range of colors.

Most, though not all, waxes are labeled according to their purpose. One exception is a wax called Victory Brown, which is also the most common wax. It is a relatively cheap wax, brown in color, and medium soft. It is a good basic wax for general use, and is often mixed with other waxes to either improve or extend it.

More specialized waxes can be found at firms like J. F. McCaughlin in California, Kindt-Collins in Ohio, and Westech in California. (See list of suppliers for these and others.) Many of these waxes have names like AB55, followed by a designation such as "Slush Casting Wax" or "Injection Molding Wax." These designations and the accompanying descriptions are your guide to choosing a wax.

If you are going to be casting a wax positive, my recommendation is a 50/50 mixture of McCaughlin's AB55 and Victory Brown. I find the AB55 on its own too brittle, making castings that keep breaking, while the Victory Brown alone is

Wax slabs as they are shipped. The top slab is AB55 and the bottom slab is Victory Brown.

too soft, creating parts that distort and have a less satisfactory surface. The 50/50 mixture is a good one, in my view, but is like someone's recipe for chili. Everyone makes it differently. Sculptors and foundries all seem to have their favorite formulas, and sometimes when visiting you can weasel these formulas out of them. Listen and learn, buy several different waxes from different suppliers, and find what works best for you.

If you're going to be direct building the wax positive, you can buy good modeling wax from suppliers like The Compleat Sculptor and many others. You can also make a good modeling wax yourself by starting with beeswax or microcrystalline wax (Victory Brown is good for modeling), and adding such things as paraffin wax, lanolin, petroleum jelly, and/or coloring agents. Alternatively, you can also work in Castilene or a similar burn-out clay. (*Burn-out clay* is a wax that feels like clay but burns out like wax.)

Heating and Mixing Wax

After trying many methods, I have found the best way to melt wax for blending or casting is with a deep-fat frying pot, available in the housewares department of any large mega-mart. They cost around twenty dollars, hold several quarts, and have a plug-in thermostat and a Teflon lining. They also come with a glass lid, which you should save. Since they are cheap, buy two—you'll use them. A handy addition is a flat electric frying pan for melting sticky wax. (Sticky wax is explained in the section on sprue systems, page 130.)

You should also buy a standard cooking thermometer from the grocery store. Get the kind with the round, flat dial and the long point, plus a clip to hold it to the side of the frying pot. It should read temperatures from room temperature up to about 400°F (204°C).

There are two other pieces of equipment you should buy for melting wax. First, buy a small, one-quart saucepan with a handle to serve as a dipper, which you will use to take melted wax from the pot to pour in the molds.

Second, you need a good paintbrush. Stand the brush in the empty pot, bristles down, and then lift the brush until the ends of the bristles are ½ inch above the bottom of the pot. Mark where the lip of the pot touches the handle. At that

point drill a ¼-inch hole in the handle and insert a ¼-inch wooden dowel, sticking out about ½ inch. Cut a nick or notch in the dowel, or insert another small dowel to its end, so the brush can safely hang on the edge of the pot with its bristles in the melted wax, but not touching the pot bottom (see illustration below). The reason for a wooden pin instead of a short screw is that a metal screw gets hot.

Now you're ready to melt wax for pouring or brushing. You can also make your own modeling wax by melting different kinds of wax, or adding things like petroleum jelly.

To melt the wax, simply place it in the pot and turn the thermostat to the temperature you want the wax. You will never use wax above 250°F (120°C), so *never* turn the thermostat above that number. Remember, the pot *will not* heat the wax any faster if you turn the thermostat way up. As long as the little light is on, the pot is heating as fast as it can.

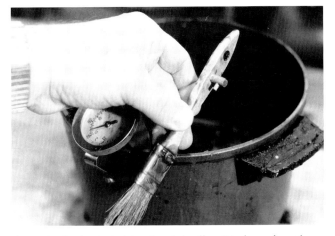

A wooden hook attached to a brush to allow it to hang from the side of the pot. You can also see the cooking thermometer used to read wax temperatures.

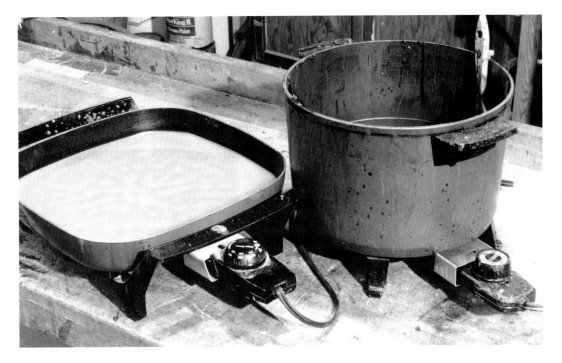

Right, a deep-fat frying pot for melting wax; left, an electric frying pan for melting sticky wax.

If you drip wax all over the thermometer, if the saucepan gets loaded with wax, or if you drop the brush in the wax, here's how to get your tools clean. When the pot is full of melted wax, just drop the wax-covered item right into the wax and let it sit at the bottom for a couple minutes. Then fish it out with tongs, or a wire with a hook, and wipe it clean with a handful of paper towels. You'll find it cleans right up.

WORKING DIRECTLY WITH WAX

As you have read, there are two main ways to create a wax sculpture. One is to make the sculpture directly, the other is to cast it. The earliest lost wax sculptures were created directly, by working beeswax in the fingers into small figures that could then be cast solid.

Small solid sculptures are self-explanatory. I once taught bronze casting in Uganda, and people kept arriving at the sculpture studio when they heard we were casting. They all made small animals and figures out of wax, just working it right there with their fingers. We attached sprues to their sculptures, made simple solid investments, and cast over fifty pieces in a just a few weeks. The results were quite magical, particularly watching people as they retrieved their sculptures from the water, where we placed the hot bronzes after breaking open the investments.

A solid wax pattern means, however, that you can't go very thick. You should keep the piece no more than ½ to 1 inch thick at its widest point. Otherwise, there is likely to be shrinkage in the metal and a caved-in place. So it's best to use direct building for the stick-figure, thin-bird-with-wings sort of pieces.

There are, however, ways to make larger things directly in wax. The most immediate way is to use wax sheets to build a hollow sculpture. Make wax sheets by pouring a plaster tray, then soaking the plaster well in water to make it damp, and pouring hot wax into the tray to the desired thickness. The wax sheets can then be cut and assembled at will, using the same joining techniques outlined in the section on sprues, pages 132–133.

A second way is to work your piece solid, then slice it in half and hollow it out—a task best done with a heated knife. This, however, can be clumsy and may distort the piece. It can be done successfully if enough care and skill are used, especially if the piece is a relatively simple form with little detail, but it's too tricky for general use.

A third way is to create the core of the piece out of investment material, either a mixture of plaster and sand (see page 134 for proportions), or a proprietary jewelry investment. (A *jewelry investment* is a ready-made combination of plaster and various aggregates that is manufactured for the jewelry casting industry. Random and Randolf [see list of suppliers] creates one specifically formulated for sculpture.) Mix the investment material to a thick, putty-

Hot wax can be very dangerous. If you leave the wax on with the thermostat turned too high, it will spontaneously ignite. If you overheat it with the lid on, it will not burn, but the moment you take the lid off there will be serious flames coming out the top. Here are some solutions:

1. Never turn the thermostat higher than 250°F (120°C).

2. Never forget to turn the pot off when you leave the studio, even for only a short errand. It's a whole lot easier to remelt some wax than to rebuild a studio. Perhaps you can get an electrician to wire your studio such that when you turn off the lights it also turns off the plug for your pots of wax. Then when you leave at night you can't forget and leave the wax on.

3. Remember that glass lid that came with the pot? Keep it handy. If the wax does overheat and burst into flame, the best remedy is to clap on that lid and the flames will go out for lack of air. Then unplug the pot, move away, and let the whole thing cool down. Don't try to put the fire out with water or you'll have an explosion, you'll get serious burns all over you, and the fire will continue. And pouring sand in a burning wax pot will only force the wax and fire out all over the place.

Be very sure of these points before you start to heat the wax. Remember, put the lid on quickly if there is a fire. And never put water into hot melted wax as the water will instantly boil and spray hot wax into your face. Finally, it's a good idea to wear heavy gloves and goggles any time you are heating wax.

like consistency and work it directly onto a steel armature. Once it has set, file the material down to refine the shape. This core is then covered with a layer of wax—by dipping, painting it on, or laying sheets of it on—and the surface worked to finish, so that it has the final surface and detail you want for your sculpture. The entire structure is then sprued and invested. This method, by the way, is how the ancient Greeks and Romans first invented hollow casting, which they used to create the first life-sized bronzes. They built an iron armature, constructed a clay and sand core, coated the core with wax, and finished the outside surface. The famous Riace bronzes still had these original cores and iron armatures inside when they were discovered. This method was used throughout the Renaissance and Baroque periods, as described by Italian sculptor Benvenuto Cellini in his autobiography

There's also a fourth way to make hollow wax sculptures directly, using some modern materials. First, create a core out of Styrofoam or a similar foam plastic. Carve it into the shape you want, being reasonably accurate but keeping the whole thing a little small. Then coat the foam with a layer of wax

by either dipping it in wax or brushing on a layer, just as in the previous method, and work the finish. When complete, dissolve the foam core using acetone and presto, you have a hollow wax sculpture.

And there is a fifth, and rather clever, way to create direct waxes and then make them hollow. Make a wax sculpture of any thickness, then invest it in ceramic shell (see Chapter 13). Burn the wax out and fire the shell to make it good and hard. When the mold is cool, pour melted wax back in to form a ³⁄₁₆ inch thick layer on the inside, and then pour a self-setting core of jewelry investment. Drill holes through the shell and into the core and drive in core pins. Burn the wax out again, this time at temperatures no hotter than 1,000°F (538°C), and cast. This also works for casting things like large pieces of wood, which can be shelled, burned clean, then a layer of wax poured in and a core poured.

Tools for Direct Building

The handiest tool for working with wax is a hot knife. I have seen effective tools made of electric arc welding rod with about 3 inches of rod stripped bare of flux on one end, then hammered into a blade form. The remaining flux makes an insulated handle. These can be made quickly and easily in a variety of shapes, then heated over a gas ring, Bunsen burner, or similar heat source. In Africa we used a charcoal fire and it worked beautifully.

A tool that is a little more "upscale" is a hot knife made from a small soldering iron. Soldering irons come in different levels of wattage, and 25 watts is usually fine. Buy the kind with a screw-out tip, ³⁄₁₆ inch in diameter. This tip is copper with a plated coating. Unscrew the tip and hammer the end flat into a blade. You can also buy ³⁄₁₆-inch brass welding rod, hammer the ends into shapes, and then thread the end of each with a die to

make your own tips. A short tip will conduct more heat, and a long tip less heat, since the heat from the soldering iron must be conducted out the tip. Still more upscale is a special hot knife with a rheostat to control the heat and with delicate replaceable tips. These are available from jewelry supply houses. You can also use most of the tools you use for clay—not the wooden ones, but any other spatulas, knives, hook tools, and the like. Solvents with abrasive pads are very useful, too.

When *chasing* your wax (cleaning it of any defects), one of the best tools to use is the tool you used on the original clay. A hook tool or rake with a few teeth makes a certain surface in clay, and will re-create that same surface in the wax.

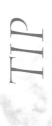

When hammering a copper soldering iron tip, you can only hammer it so much before it needs annealing, which means that it needs to be heated it to a dull red in the flame of a utility propane torch, cooled naturally or quenched, and then hammered some more.

CASTING IN WAX

This is a very important part of the process from clay to bronze. Each of the process's five steps—clay to mold to wax to investment to bronze—involves a reversal of form from positive to negative and back again, and each results in a very accurate reproduction of detail—except the *mold to wax* step. This is where the most detail is lost. Also, you will be creating a hollow cast and the wall thickness should be as even as possible, which isn't easy. Wax casting is a special art. Pay attention, here we go.

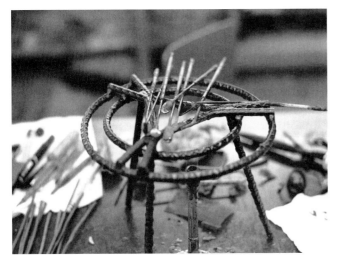

Wax-working tools made from welding rod, heating on a Bunsen burner.

Two soldering irons modified into wax-working tools. The longer one will be cooler at the end, the shorter one hotter.

Preparation

If you have a silicone mold, you won't need a mold release. If you have a urethane, polysulfide, or latex mold, spray the inside of the mold with a standard mold release such as Pol-Ease 2300 from Polytek. If you have a plaster piece or relief mold, thoroughly soak it in water so it's damp—no standing water, but damp.

If the mother mold is plaster, take it off and soak it in water for ten minutes. Let it drain so there is no free water, and reassemble. *Wax will stick tightly to bone-dry plaster. It will peel easily off damp plaster.* If you get wax stuck to dry plaster, soaking it in water for some time will make the wax let go. If you have a urethane or rigid plastic mother mold, spray the outside with release for easy wax removal.

There is a lot of controversy about which temperatures are best for the various layers of wax. I have had good results with a first coat heated to about 220°F (104°C), and subsequent coats cooling off rapidly from that: a second coat at 200°F (93°C), a third at 180°F (82°C), a fourth at 170°F (77°C), and a fifth at 160°F (71°C) or so. One way to do this is to have two wax pots going: one hot one set at 220°F (104°C), and a cooler one at 180°F (82°C). It might take quite a while to let them settle down to those temperatures, but be patient. Always give yourself something else to do while waiting for wax to reach the right temperature so you're not tempted to rush.

To get each layer at about the right temperature, pour the first coat from the hot pot. Wait five minutes, then dip some hot and some cool with your dipper for the second coat. Use mostly cool for the third, and then unplug the pots and wait until the cooler wax settles to about 160°F for later coats. If you don't want to fool with two pots, use just one, but unplug it when you begin casting and time your coats to the cooling of the wax.

Have everything ready before you move on to the next step: actually pouring the wax. The mold should be well tied together and secure. The wax should be melting in one or two pots, preferably on newspaper for easy cleanup. The mold should be handy and capable of being laid down easily. Your dipping pan should be clean and ready, and you should be wearing heavy gloves. It's also a good idea to wear goggles any time you are melting wax.

Pouring the Wax

There are two ways to apply the melted wax to the inside of your mold: pouring and brushing. To pour the wax, take a generous dip with the saucepan and pour it gently down one side of the mold, adding enough to fill the mold about one-

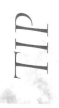

TIP

Setting a newly dipped dipping pan on newspaper will make it stick and create a mess. Instead, find a piece of polished marble, tile, or metal. Spray the piece with release, and set the pan on that after pouring.

third full. Now set the dipper down on your release-sprayed marble and begin to carefully roll the wax inside the mold to coat the whole surface with an even layer—easy now, you don't want to make bubbles. Rotate and tip the mold until you can hold the open end over your wax pot and pour the excess out. Look to be sure you covered the mold's entire inside surface. If you've missed a spot, add a little more wax to cover it. Be sure you pour all the excess out so it won't puddle and make a thick spot on the bottom of your mold.

That will be your basic action for all coats. The only difference is that you should pour the wax down a different side of the mold each time, and roll in different directions. Also, the temperature of the wax you pour should decrease with each layer, as discussed earlier.

The biggest problem you'll find is wax eroding off thin ridges, leaving no wax at all in areas such as the join between two legs. There are two cures for this: The first is to wait a long time for the wax in the mold to cool, perhaps even a half hour or more, and then gently add a very cool layer. (You can tell the wax is cool enough when it shows a faint haze appearing on the surface in the pot.) The second cure is to reach down into the mold with a brush, or a brush taped to a stick, and dab some wax on the ridge. Usually the first cure works best.

Another problem you will encounter is wax shrinking a little as it cools and pulling away from the edges of the mold's opening. The cure for this is to coat wax over the whole end of the mold right out onto the mother mold, and even around onto the backside of the mother mold. If the mold is small, you can do this quite easily by dipping the end of the mold in the wax pot after each pour. Otherwise, brush it on. Wax normally shrinks as it cools, but this overlap forces it to retain its shape. When the wax is quite cool, you can trim this excess away.

So how do you know when to quit pouring wax? You can pare away wax from the top edge of the mold (see illustration opposite) to see how thick you are getting. If you're casting with solid investment, your layer should be between ⅛ and 3⁄16 inches thick. If you're using shell, you're better off with a 3⁄16- to ¼-inch layer.

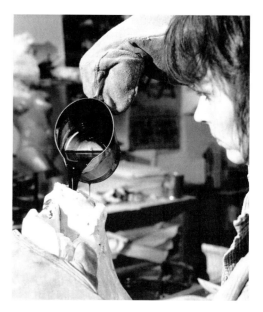

Pouring wax into a mold.

How do you know if you've covered everything and haven't left any holes? When you think you have enough wax in the mold, place it in the sink and fill it up with water. Watch carefully to see if the water level descends. If it does, there's a spot in the wax that's so thin it's acting as a hole. Pour out the water and add more wax.

Some people have success with the *pour and wait* method, in which you pour the wax to fill the mold completely, then let the wax cool, watching it slowly thicken at the edge. When it seems the right thickness, you pour out the rest. This takes some practice, and doesn't always cure that problem of wax running off high ridges, but if you are casting a number of waxes from the same mold, and if it's a small one, you can get the timing down and produce great waxes this way. Time yourself for each pour, note the wax temperature, and note how thick the cast is.

Another common practice, if you are using a flexible mold, is to heat the mold first, usually with a handheld heat gun, being very careful not to burn the delicate mold or your hand. Adherents claim that this allows the wax to run better and gives a better first coat. If you do this, allow a longer time between the first and subsequent coats so that the mold can cool and the new wax won't just run off.

TIP

If you need to repair holes in your wax, it means you will be adding hot wax to very cold wax—this usually won't adhere all that well, and can create layers. If you're going to use ceramic shell for your investment, the shell can creep under any such layers and wreak havoc. You'll need good, tightly adhered layers of wax, so if you cast a wax and find that there are holes in it, it's best to scrap it and do another one. If you're going to use solid investment, or a solid core in a shell investment, this doesn't matter and you can repair holes with a new layer of hot wax.

Brushing in the Wax

If you're doing a relief, or a large mold that opens wide, you will probably want to try brushing in the wax. Use that same brush you prepared with the little wooden peg (see page 121), and begin brushing with wax set at about 220°F (104°C). Begin in the deepest valleys and work uphill so wax doesn't run ahead of you and make puddles. Brush with smooth, well-loaded strokes. Don't scrub the wax into the mold; lay it in cleanly.

When you have covered the entire surface with a layer of wax, unplug the melting pot and keep brushing as the wax cools. Again, you're looking for a layer about 3/16 inches thick. It takes a while to build up this thickness, but go evenly all over the mold, from one end to the other, remembering where you've brushed so you hit all spots the same number of times. Generally, you will want to brush the wax right over

the edge of the mold and the mother mold to keep it from curling in as it cools. When you feel the wax is getting thick, check its thickness by cutting it clear at one edge. Once the layer is thick enough, heat the wax in the pot again and brush in a final smooth coat of hot wax.

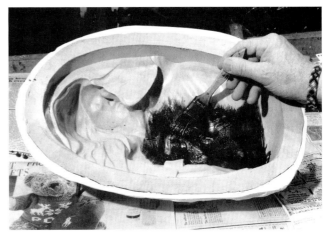

Brushing wax into an open mold, beginning in the deepest hollows to avoid drips.

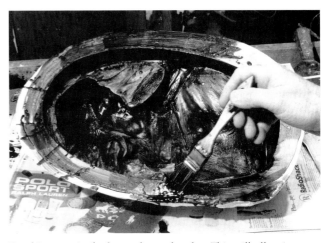

Brushing wax in further and over the edge. This will allow it to cool without shrinking away from the mold.

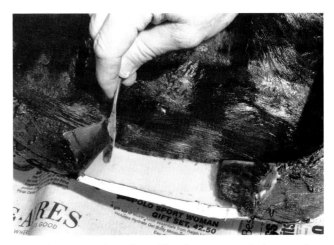

Cutting wax away from the mold's edge to test its thickness and to trim the cast.

If you're casting in ceramic shell, you want to be very careful that all layers adhere tightly to each other to prevent the shell from flowing between layers. One way to assure this is to hold a heat gun in one hand while you brush with the other, constantly melting and blending wherever you've added wax. This will also give you a nice, smooth, final surface.

If you are using a multiple piece mold, you may want to brush a first layer of wax into the mold, then close the mold and pour the rest of the wax. Be advised, however, that you will have problems with the brushed-in wax curling away slightly at the edges and with the new poured wax running behind the brushed-in wax. A solution is to brush the first layer into the mold pieces and out over the edge, while all subsequent layers stop at the edge. The mold is then put together with that thin layer of wax sandwiched in the edge, and the remaining wax is poured in. This leaves a large ridge of wax to be carved off, but it prevents the new wax from running behind the old.

Removing the Cast and Chasing

You can either let the wax cool naturally or cool it yourself by running cold water in and out of the mold. But remember, there is a lot of heat in there and the wax is an insulator, so even it if feels cool, projections like ears and fingers may well be hot and soft and tear off if you are impatient and open the mold too soon. It's best to give the wax about an hour to cool naturally, or an extra ten minutes if you cool with water.

Once the wax is cool, open the mother mold gently and peel back the rubber carefully, remembering where the projections are and easing the mold off them. If you tear something off, save it—you may be able to stick it back on. Sometimes the cast comes out easier if you take it out under running cold water.

Now inspect the wax carefully. Feel its weight and look up into it against the light to see if there are thin spots. (Remember to pour any water out before you do this or you'll get a wet face.) Check the seams to be sure none folded in when you put the mold together. And look at the surface very closely to see if there are any little pits. (There will be.) If you used a release agent on the mold, wash it off the wax using plenty of dishwashing soap, a good soft paintbrush, and lots of running water.

Chasing is a word used to mean cleaning up a cast, whether wax, clay, plaster, or bronze. Chasing a wax cast involves the following tasks:

■ *Removing extra wax.* Extra wax may be sticking out along seams or other places where there were voids in the mold. Cut the extra wax off with a small, sharp hobby knife. For thin projections along seams, a clay hook tool works well.

■ *Filling holes.* These are open holes where the wax was too thin. It's best is to simply recast a better one. If you can't or just don't want to, cover the hole carefully with some soft clay and pour in cool wax to recast that spot from the inside. You can also add cool wax with a brush to thicken any places that are too thin. But remember, only do this if you are casting in solid investment. You will get bad results if you try this with ceramic shell.

There are often small dents and holes that are too large to be patched with soft wax. These can easily be filled by holding the blade of a hot knife just over the hole, then touching the blade with a small stick of wax and allowing the melted wax to flow into the hole. You may need to do this several times, allowing the wax to cool between applications to get a good solid patch.

■ *Fixing misaligned parts.* If a seam is misaligned, you may be able to cut the wax and push the pressed-in part into shape, then rejoin the seam. If something tore off, like an ear, and you saved it, you can often stick it back on and rework the join.

■ *Filling tiny pits.* These will usually be present to some degree, and if you don't fill them they *will* show in the final bronze. Use *patching wax* from your wax supplier, which is a very smooth and creamy pastelike wax—usually green or red—that can be smeared into tiny pits with your finger and then smoothed off. There is a white version of patching wax called *disclosing wax*, because it will leave tiny white dots where the pits are, disclosing their locations.

■ *Addressing general surface problems.* One common problem is delaminating between the first and second layers of wax. This means that areas of the wax's surface will pull off and stick to the inside of your mold. If these areas are small and not in crucial places, you can usually fix them. If they are large or crucial, you will have to recast. Clean the mold well,

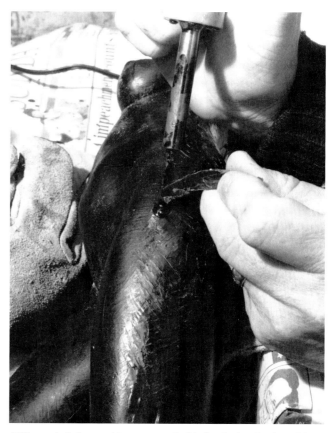

Filling a hole by touching wax to the blade of a hot knife and letting the hot wax flow into the hole.

apply more release, and then pour the wax a little cooler this time, with a shorter time between coats.

Another problem is wax seeping behind the first layer, which shows as a scablike layer lying on top of the form. This can happen when the first coat doesn't cover everything completely, and the second coat runs through any openings to flow underneath. Often the scablike sections will peel off with little problem. If there is a big problem, like it is sticking and not coming off, or it is taking lower layers off with it, recast the wax.

There can be many kinds of surface problems. In general, if the surface of the wax isn't just like the clay was, recast. Each mold is different and needs to be learned to get a really good cast. I often cast two, three, or four waxes before I figure out the needs of a particular mold.

■ *Joining wax parts.* Many waxes need to be molded and then cast in pieces, for ease of removing the mold. A good example would be a horse, where it's easier to cast without the legs and tail. Once cast in wax, these separate pieces then need to be rejoined before investing. The best way is to dip their ends in hot sticky wax (see next section) and then press them together. Let the wax cool thoroughly, then work the joint so the seam is invisible. There will be either a ridge along the joint, which can be carved off, or a gap, which can be filled in by holding a hot knife against a bar of wax and letting the melting wax flow into the gap.

Once any repairs have been carved down to the right contour, blend the surfaces together. Getting wax that has been disturbed by cutting, filling, or whatever to look like the adjoining undisturbed wax isn't easy, but it's made easier with a wax solvent. A common solvent is lighter fluid from the drugstore. Better, in my view, is Carbo-Sol, since it isn't flammable, which lighter fluid certainly is. Also, Carbo-Sol is a little more active in softening wax and evaporates quicker. To blend the surfaces, squirt some solvent in a small can, dip a Scotch-Brite scouring pad (or similar brand) into the solvent, and use it to gently scrub the wax. It should smooth very

nicely. Some people use fine window screen to do this, old nylons, or even a relatively stiff brush, like an old toothbrush. (*Caution*: Use any solvent with good ventilation, like a fan at your back. And guess what, lighter fluid will burn. So be absolutely sure you have no flames around and are not smoking anywhere near an open container of lighter fluid.) A fine paintbrush can soften tooling marks, and stippling action can restore some of the original wax surface. Fool around.

Signing Your Wax

Most works of art receive the artist's signature at some point, and with bronze sculpture this is the usual point. There are also other points at which a signature can be applied; some artists sign the clay, and Rodin is famous for his huge signature gouged deeply into the clay. (Rodin sometimes also signed his individual waxes *up inside*, as though he knew his works would be cast posthumously and wanted a code to show which pieces he had actually touched.) I prefer to apply a stamp to the finished wax. This stamp is a piece of hardwood carved with my initials—backwards, of course.

Your signature ought to be carefully considered. It ought to be distinctive, relatively simple, and dignified. It ought to be one you can live with and use all your working life, so there is consistency.

When you sign a wax, you should also add the edition mark. (See Chapter 18 for a discussion of editions.) The usual practice for edition marks is to first mark the number of the cast, then a slash, then the number of the edition. So, for an edition of seven, the first would be marked 1/7, the second 2/7, and so on. You may also want to scribe a date. And sometimes artists will inscribe a dedication to someone special, which is quite permissible too.

You should now have a good hollow wax reproduction of your original clay sculpture, ready for spruing, investing, and casting.

The author's signature stamp applied to a wax.

The author's signature stamp, carved from wood.

SPRUE SYSTEMS AND SPRUING

A *sprue system* is a system of channels that allows the wax to leave the mold, and, more importantly, allows the molten metal to flow into the mold. These systems are designed with the metal flow as the primary consideration.

Most sprue systems consist of four parts:

1. At the top is the *pouring cup*, which is the funnel-shaped cup into which you will pour the metal.
2. The pouring cup is attached to the *sprue*, which is the main channel through which the metal flows downwards to the sculpture.
3. Coming off the sprue and attaching to the sculpture itself are several *gates*, or channels for the metal to enter the sculpture.
4. Lastly there are *vents*, or *risers*, which come off any high points in the sculpture and rise to either an even higher point or straight up to the top of the investment. These allow any air or gas in the cavity to escape as the cavity fills with metal.

The Theory Behind Sprue Systems

While every sculpture demands a custom-made sprue system to feed metal most effectively, most systems are one of two kinds: top feed or bottom feed.

Top-feed systems
This system is exactly what it sounds like. The metal is introduced into the top of the sculpture and drops through the void to fill it from top to bottom. It is the simplest system, and the most direct.

Bottom-feed systems
Bottom-feed systems are sometimes called *J-gating* systems. The principle is to bring the metal to the bottom of the sculpture with the main sprue, then let the metal fill the cavity by rising from the bottom to the top, forcing out any air through the vents.

Advantages and disadvantages of the two systems
In general, top-feed systems work better with ceramic shell and not as well with solid investment. The reason seems to be that with solid investment, as the melted metal cascades down the inside of the cavity, some of it wets the surface and instantly freezes. Then, when the main mass of metal rises and incorporates the metal from the surface, the frozen skin doesn't completely fuse. This can cause a slight peeling of fine layers of bronze from areas on the surface, a little like a

peeling sunburn. With ceramic shell, however, this wetting action doesn't seem to take place, and the metal dashes cleanly on by to fill the cavity without problem.

Secondly, the larger the sculpture the better bottom-feeding systems seem to work. For small pieces, say 12 inches and under, top feeding is fine, even for solid investment, because the cavity fills so quickly. But with larger pieces, there is a significant time lag when filling the cavity. As the metal pours in through a top-feed system, it splashes and tumbles, creating turbulence and possible air inclusions. With bottom-feeding systems, the metal rises like a fast tide with no splashing at all.

Some foundries, such as Tallix Foundry in Beacon, New York, are using what they call the "antigravity" feed, in which the piece has a ceramic tube running out the bottom of the shell. The fired shell is placed in a large drum, with the tube extending out the bottom like a mosquito stinger, then the drum is filled with dry sand and closed at the top. It is hoisted over a crucible of molten metal and lowered so the tube enters about half way down. A powerful vacuum is then applied to the top of the drum and the metal is drawn upwards, just like drinking a soda through a straw (or a mosquito sucking out your blood).

This is a great system because the metal rises gently and evenly, because it is drawn into every cavity by the vacuum, and because it draws clean metal from the middle of the pot, assuming impurities will either float or sink. However, it also demands a serious outlay for equipment, not least of which is a huge vacuum pump. So, great though it is, antigravity casting is beyond the reach of most of us.

Bottom feeding, though, allows the metal to rise in a gentle and even manner not unlike the antigravity casting, but without the expense. For that reason, I generally recommend bottom feeding for all but very small pieces.

TIP

If a sculpture has any thick sections, they can shrink and collapse as the bronze cools. The solution is to place a large mass of wax directly above the thick area when spruing. Because gravity pulls liquid metal down, the large mass, which will fill with metal, will do the shrinking as it is pulled down, while at the same time supplying fresh metal to the lower mass. Make sure the large mass isn't separated from the lower mass by a narrow neck, or that neck will freeze first, negating the effect.

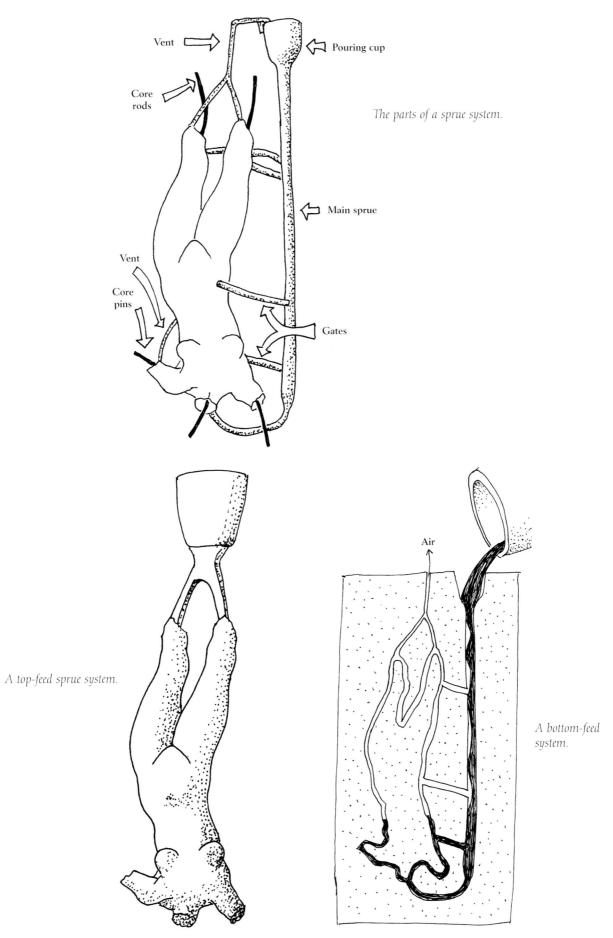

Vent

Core
rods

Vent

Core
pins

Pouring cup

Main sprue

Gates

The parts of a sprue system.

A top-feed sprue system.

Air

A bottom-feed system.

Materials for Sprue Systems

Sprue systems are made of wax, just like your wax sculpture. Sprues, gates, and vents can be round, square, or rectangular in section. They can vary in size from ⅛ inch in diameter all the way up to 3 inches or more. You will find that the most useful sizes are ¼ inch for small vents, then ⅜ inch, ½ inch, ¾ inch, and 1 inch. And probably the best all-around shape is square, though round works.

Sprues can be made by creating a mold and casting them in wax, but nearly every foundry I've seen buys them ready-made. Kindt-Collins is a prominent supplier, among many. If you buy them, you'll find that while they come in a variety of waxes, the standard red sprues are the most common. They also come either cored or uncored, meaning hollow or solid. You should generally buy solid (uncored) sprues in sizes below ½ inch and cored sprues that are ½ inch and above. Most sprues commercially available are 24 inches long, and come in 50-pound boxes.

You will also need pouring cups. The easiest ones to use are Styrofoam coffee cups. They're a good size, they burn out cleanly, and they're very cheap (especially if you scrounge them out of the trash—who cares if there are coffee stains in the bottom?).

There is one other thing you should buy: *sticky wax*, which is available from most suppliers. It comes in chunks of what look like beeswax, but it contains rosin. The easiest way to melt sticky wax is in an electric frying pan that you salvage for the purpose. The wide, flat surface allows you to dip sprue ends easily (see illustration, page 121).

Designing a Sprue System

First, orient your sculpture as it will be in the investment. I make it a rule that whatever opening there is in the wax should be oriented at the top, to allow any gasses generated in the core to rise without having to bubble through liquid metal. This usually means that your sculpture will be invested upside down. Next, decide whether the sprue system will have a top or bottom feed. If a top feed, you are simply going to attach the main sprue to the highest point of the piece, and that's more or less it. The sprue should be attached to a place where it can be sawn off later, and the area reworked. Imagine yourself trying to get at that spot with a hack saw or cutoff wheel—pick an easy one.

Bottom-feed systems are a bit more complicated. First, you must decide whether the system will go inside or outside the sculpture-referred to as *internal* or *external gating*. If the piece is wide with a large opening, like a portrait head, you can easily gate inside. If the piece is long and narrow, however, like a small

A selection of wax sprues and gates. Left to right: ¾-inch square cored; ¾-inch round cored; ½-inch square cored; ½-inch round cored; ⅜-inch square uncored; ¼-inch square uncored.

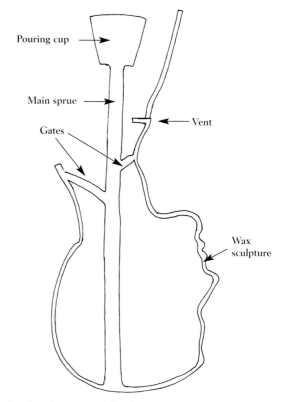

Pouring cup

Main sprue

Gates

Vent

Wax sculpture

Internal gating for a portrait head.

figure, you must gate outside. Naturally, there will be some pieces that fall right on the line and take a little further thinking.

The next decision is where to make the first, or main feed. It should be at the bottom or near the bottom, and in a place where the gate can be cut off easily and the area reworked. Now decide where the other gates are to meet the sculpture. In general, using ½-inch gates coming off a ¾-inch sprue, you can space the gates about 8 inches apart. Any closer and you don't fill the mold any fuller, you just make extra work. If you go too much farther apart, however, there's a chance the metal will freeze before reaching all areas, leaving holes.

TIP

Sometimes the sawn-off sprue can serve as the mounting tab that you use to attach the finished bronze to a base. Think about this when you plan where to place your sprue.

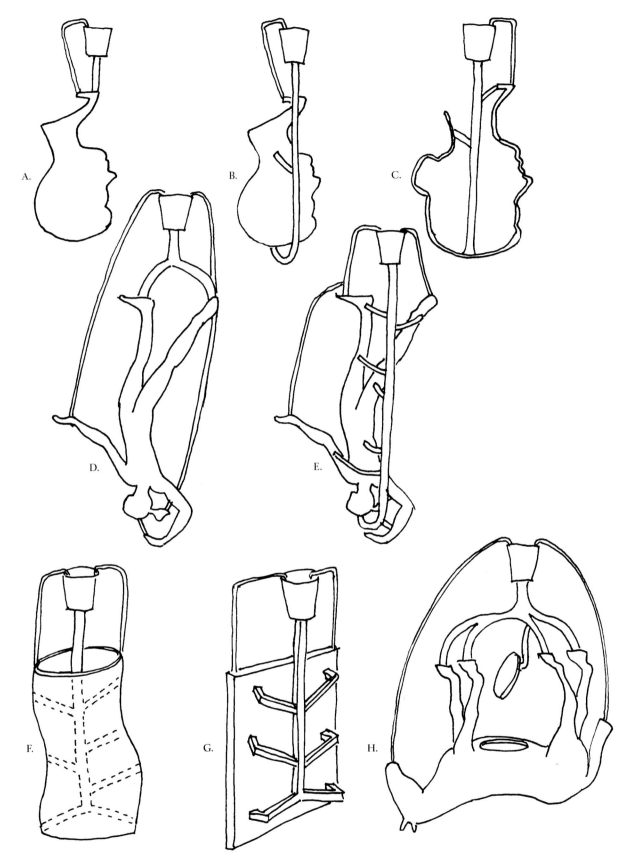

A variety of sprue systems. (Top, left to right) A: top-feed system for a small portrait head; B: bottom-feed system with external gating for a small portrait head; C: bottom-feed system with internal gating for a larger portrait head. (Middle, left to right) D: top-feed system for a small figure; E: bottom-feed system with external gating for a small figure. (Bottom, left to right) F: bottom-feed system with internal gating for a large, hollow section (such as a torso, section of leg, etc.); G: bottom-feed system for a relief (the sprue system is on the back); H: top-feed system for a horse, through the feet (note window cut from belly for core, as explained on page 146).

The next thing to think about is the *angle* of the gates as they leave the main sprue. With the whole affair upright as it will be poured, the gates should move from the sprue *uphill* towards the piece. This is to prevent the metal from running down the gates prematurely as it flows down the sprue; instead, it should enter the gates sequentially, coming through each gate only when the mold is full to that point. You don't want metal coming into the cavity from two opposing sources. Look back at the bottom right illustration on page 129 and notice how the metal waits until the general level of metal is at a certain point before running up each individual gate.

Assembling Your Sprue System

Once you have made all those decisions, you are ready to assemble the system. First, you need to learn how to stick sprues and gates to each other and to the wax sculpture. It's done in three steps:

1. Melt some sticky wax in the electric frying pan at about 200°F (93°C). Once it is melted, dip just the tip of one gate (or sprue or vent) into the wax.
2. Lightly lay the blade of a hot knife onto the sprue you intend to attach the gate to, and leave it there while you press the gate down onto it. Slide the knife out.
3. Allow the wax to cool, since it will be weak if it's warm. Then tidy up the joint with the hot knife.

First, cut the main sprue to length and fix it to the pouring cup. To do this, pour a little melted regular (not sticky) wax onto the upturned bottom of a Styrofoam cup until it is level. Let cool. Now stick the sprue to this patch of wax using the steps listed above. Unplug a wax pot and let it cool until the wax is thick and mushy, almost like soft clay. Using a metal spatula, add wax around the base of the sprue, flaring it into the cup as shown opposite. The reason for the flared edge is that when metal is poured rapidly into a cup with a flat bottom, it tends to splash back out. With a flared continuous cone shape, from cup rim to sprue, the metal will drop in much faster.

You can bend the main sprue to follow the line of the sculpture, and even hook the bottom in a "J" to meet the bottom of the piece as the first point of feed (hence the term *J-gating*).

Next, cut all the gates so they fit your design, and will hold the main sprue to the sculpture. The ends of the gates that are to attach to the sculpture should be slightly tapered (which I find produces better castings). Attach the gates to the sprue using the method listed above (using melted sticky wax this time), inserting the hot knife into the joint just before pressing together, and cleaning up all joints. Let the wax cool or you'll knock gates off at the next step.

The main sprue and gates should now fit nicely to the sculpture. If they don't, bend the gates—you can even take one off if it's all wrong, but make it fit. Dip the ends of all the gates quickly in sticky wax and then attach the whole thing to the sculpture. Alternatively, you can attach the main sprue with just two gates, then cut and add individual gates at will.

For internal spruing, say for a portrait head, run the main sprue down the inside to the bottom, or near the bottom, of the sculpture. Then add what few gates are necessary, still running uphill from sprue to piece. For a life-sized head you can get away with the main sprue hitting the bottom and just two gates up in the neck region. That's all you need.

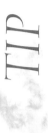

TIP To be sure that your main sprue is attached way down inside your sculpture and doesn't have any gaps where it's stuck, pour a little hot wax into the piece and roll it around the join to fill any spaces. And here's a tip for a life-sized head: run a ¾-inch sprue down the inside of the head, but attach it to a ½-inch sprue for the last 2 inches. The smaller end will come out so much easier after it's cast.

Unless you are using ceramic shell, there is one more thing to do: the vents. (In general, no vents are needed for ceramic shell molds since they are usually top fed and are porous enough to allow any trapped air to escape.) First locate any parts of the piece that rise up into dead ends, such as fingers. Attach a vent from each of these points to another point further up on the sculpture. (See illustration on page 129 for an example of this.) Now locate the high point or points of the whole piece (on page 129, the tips of the two legs), and attach vents that rise from that point or points straight up above the rim of the pouring cup. These vents can be very small—only ¼ to ⅜ inch in diameter. They will likely fall off if you just stick them on, so I make them detour at the top to reach over and grab the lip of the cup for support. I also attach a short piece of wax to make a pincher that helps hold the vent to the cup rim (see below).

In the past, sculptors ran gates all over the place, with vents sprouting everywhere until the sculpture looked like briar patch. You can still see gating diagrams like this in books on casting, even those published recently. Pay no attention. It's nonsense to add so many gates. Use the minimum number possible, and don't put vents all over. The air will still manage to escape, believe me. The secret is not to overkill on the gating, but to think carefully about how the metal will run, where it will go and in what sequence, and how far it must run. Then feed it carefully with a minimum of gates. Use good hot metal, pour fast, and it'll work.

Dipping the end of a gate into hot sticky wax.

Inserting the hot knife blade between the gate and the sculpture to join.

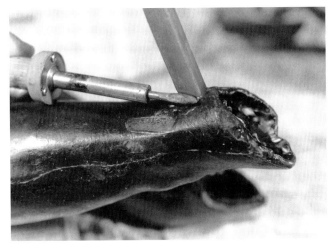

Using the hot knife to tidy the joint after attaching.

A Styrofoam coffee cup with wax poured on the bottom.

The main sprue attached to the pouring cup and flared with soft wax.

Attaching the vent to the rim of the pouring cup.

INVESTING

At this point, you should have a wax positive, fitted with a well-designed sprue system and ready to be invested. This chapter will cover both ways of investing—solid, or traditional, investment and ceramic shell investment, in that order. There will be a greater emphasis on solid investing primarily because it is the method most suitable for beginning casters and small foundries.

INVESTING WITH SOLID, OR TRADITIONAL, INVESTMENT

Before investing, weigh your sprued and gated wax carefully and write its weight down. Now multiply that weight by ten—this is the weight of the bronze you'll need to fill your mold.

Materials

The main material for investing is plaster, but it will be mixed with any of several *refractories*, or heat-resistant materials. These can be sand, silica flour, grog, perlite, vermiculite, and/or luto.

The plaster most commonly used is US Gypsum No.1 molding plaster, the same kind used for utility jobs in the studio. Some people use Hydrocal with good results, though it is more expensive; you can also use Perlited Ready Mix.

As for the various additives, the *sand* mentioned can be any kind of sand. I find the best to be washed and dried 80-grit silica sand. It is clean, dry, and predictable, and is available from most lumberyards in 100-pound bags. However, if you live near a free supply of good, clean sand—like a beach—go ahead and use it.

You can also use *silica flour,* sand that has been ground as fine as flour. It's available through various ceramics catalogs, where it is often called *flint.* It, too, comes in a variety of grits, but the coarsest is good for our purposes. And some sculptors use *grog,* which is fired and ground-up ceramic. I can't see that this does anything different than sand, though, and it costs more.

There are various weight-reducing additives you can use, such as *perlite,* which looks like fine Styrofoam beads and is heat resistant, or *vermiculite,* which is a form of mica available from garden supply stores. Either of these will extend the investment mix and reduce its weight. Personally, I don't bother.

Another ingredient is called *luto,* or sometimes *ludo.* It is old, fired, and ground-up investment that's added to a new mix. This ingredient is so common that sometimes this entire way of investing is called a *luto investment.* Personally, I find the process of grinding up old investment far too time-consuming to be worth the effort, so I never use the stuff.

My investment mix is a simple one: one part water, one part plaster, and two parts sand (with parts measured by volume). You will need to do a little fine-tuning with the volume of water to get an even, creamy mixture every time, but the basic recipe creates a good, strong investment with a minimum of containers and measuring. The ingredients are easy to find and the formula is difficult to mess up.

You'll also need a first coat for your wax, and for that I use silica flour instead of sand, though sand will also work. Another good addition is fine metal fibers, or even fine glass fibers, which help prevent cracking. These are a little more tricky to find, but you can locate them both in the list of suppliers at the back of this book.

Some casters buy ready-mixed jewelry investment from suppliers like Ransom and Randolf. These mixes are excellent, though more expensive. But remember the basic rule—the cost is in the labor, not the materials, and if using a proprietary jewelry investment gives better castings and therefore saves you time in the end, then it's money well spent.

You will need to make a flask to contain the investment. There are many options for this, which I'll discuss a little later (see "Alternatives," page 143). Probably the simplest one is to buy *plasterer's lath* or *expanded steel* sheets that are 28 inches wide by 8 feet long, available at most lumberyards. You will

secure the sheets into the shape of a cylinder with *black stovepipe wire*, which you can buy at a hardware store. The illustration below shows two wire lath flasks, rolled and tied with wire.

Next, buy a roll of ordinary tar paper or roofing paper from the lumberyard. Wrap the tar paper around the cylinder, overlapping by at least one full turn, then tie tightly with rope. If you don't overlap the ends of the tar paper enough, the liquid investment can come pouring out. I've been there, done that. Also, notice that these flasks don't need bottoms. (More specific instructions are given on page 141.)

One other thing you will need is some ordinary steel chain, usually the rather light kind. This helps with the initial coats and will be discussed later.

Pouring the Core

The *core* is the mass of investment that will fill the inside of your hollow wax and make the bronze cast hollow. There are a number of considerations for the core. The first is the material to be used. The second is how it will be supported once the wax is burned out. The third is when to pour it.

Material for the core
In general, the material for the core is the same as for the rest of your investment. Some people find that adding a certain amount of ordinary sawdust to the core mix makes it more porous for gas dispersal and softer when it comes to digging out the core. In my view, sawdust helps, but not all that much. So for most purposes you can just use the regular mix.

TIP When you are finished investing your wax, you can take the tar paper off and save it for another use. You won't be able to save the lath, however, as it will have been weakened too much by the burn-out.

Supporting the core
So how is the core supported once the wax is burned out? The traditional method is by using *core pins*. These are metal pins that are pushed through the hollow wax, leaving some pin inside and some outside. When the wax is gone, these pins will be anchored in both the core and the outside investment, thus preventing the core from moving. You will need enough core pins to hold the core securely—one or two won't work. Imagine actually holding the core (which is the shape of the sculpture) with the pins you are adding and you can quickly see if you have enough. Core pins will leave little holes in your bronze, which you later fill when chasing.

The material for the core pins is open to question. Some people use ordinary nails, but they can be a problem if they stick in the bronze—which they usually do. I prefer the short ends of bronze welding rods. They are usually available in plenty of sizes, and they don't seem to stick like nails. And even if they do stick, you can just weld over them—since they're bronze it's no problem. I have also heard of people using dressmaker's pins for small works, and though I haven't tried them, it sounds like it would work. Stainless steel is also very good.

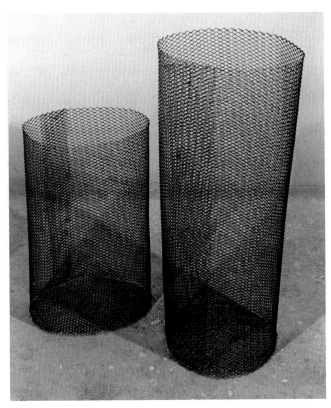

Two wire lath flasks ready for tar paper.

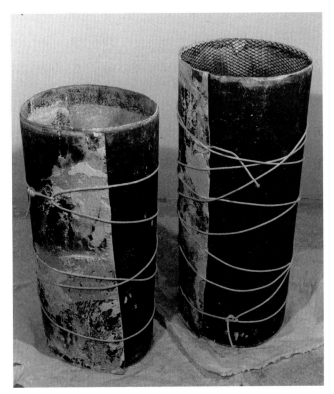

The wire lath flasks wrapped in tar paper and tied, ready for investment.

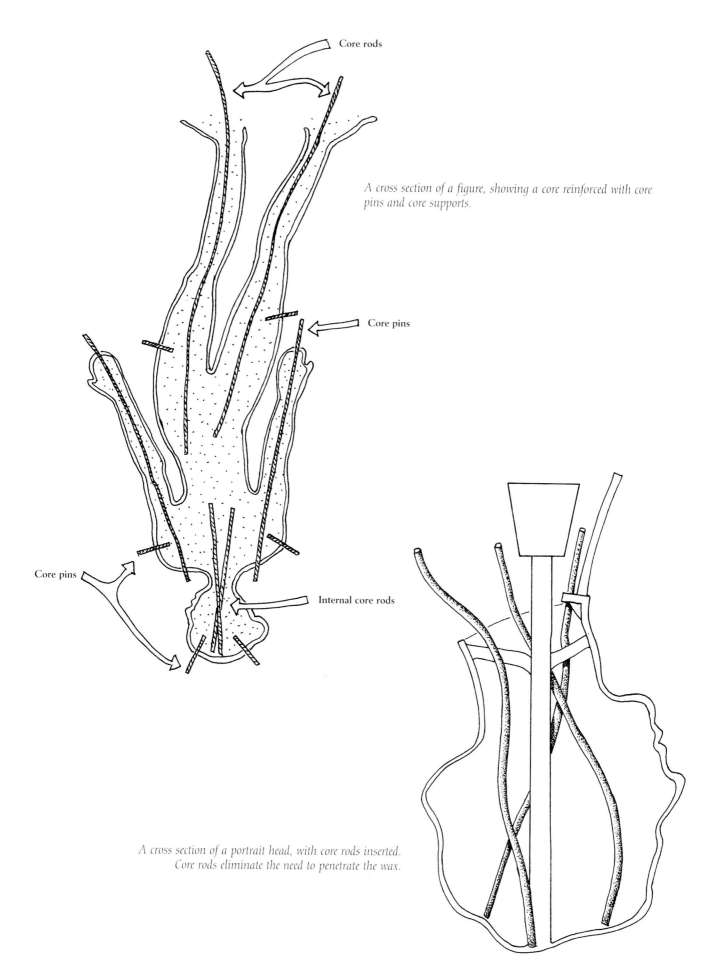

Core rods

A cross section of a figure, showing a core reinforced with core pins and core supports.

Core pins

Core pins

Internal core rods

A cross section of a portrait head, with core rods inserted.
Core rods eliminate the need to penetrate the wax.

An alternate way of supporting the core, and one that doesn't require penetrating your wax, is with *core rods*. These are steel reinforcing rods that are inserted inside the hollow cavity of the wax. If casting a portrait head with a nice opening at the neck, for example, you can insert three ⅜-inch steel rods at different angles like umbrellas in an umbrella stand, with their top ends protruding about 4 inches above the rim of the wax. Bend the rods a little before inserting so the core can't slide on them. If the rods are heavy and you use a minimum of two, they should support the core just fine. And of course, for that really tricky sculpture you can use a combination of core pins and core rods.

Any long, thin sections of your core, such as down arms or legs in a small figure, can create big problems. These sections are often pencil thin and tend to break during the burn-out or pour. When that happens you get a *flash*, or thin fin of metal, across the arm or leg, making it nearly impossible to get the rest of the core out. Also, the bit that broke floats around, touching the sides of the mold and creating very thin bronze or holes at these points. It's a good idea to reinforce such places in your core with wire. I have even had success feeding fine chain down arms and legs. The chain will follow bends better than stiff wire, it has lots of openings and holes for the core material to flow around, and it reinforces very well. It's not terribly easy to pull out after casting—simply pulling will only break it—but if the core is loosened with water it can come out all right.

Pouring the core

The next question is when to pour the core. There are really only two answers: before you invest or while investing.

If you are casting a portrait head, you can brush on the first coats of investment, then set the head upside down in the wire flask, place the core rods, and pour the investment around the head. As the investment material reaches the neck, it will spill in and fill the core. In other words, you can pour the core *while* you are investing. This can be done with any shape that meets the following requirements:

1. It is able to be filled completely without any areas that will trap air and prevent the core from filling.
2. It has a large enough opening so the investment material can flow in easily.
3. It is a wax that you can handle without fear of distortion.

If your sculpture does not meet the above requirements, you should most likely pour the core *before* you invest. For example, a figure might have an arm that, with the sculpture upside down and the core opening at the top, points uphill, creating an air trap. In this case you would need to make a small pinhole in that high point to let air out when the core is poured, or else tip the piece as you pour to allow air to escape. You might also have to pour the core through a rather small opening, using a funnel.

More importantly, some waxes will distort when handled, but if filled with a core while still in the flexible mold, they will hold their shapes perfectly. This is especially important for

sections of large sculptures that must be welded together. This is also good for large reliefs, as the mold keeps the wax flat. In fact, for reliefs I always make it a rule to paint in the wax, add the complete gating system to the back, and then pour in a good thick layer of investment for the core. When set, I turn the whole mold over, remove the mother mold, peel off the rubber, touch up the wax if necessary, and proceed with the investment. This way, the relief stays perfectly flat.

Another reason to pour the core in advance is so you can place one or more core rods in it, and then clamp the end of one rod into some kind of support, to hold the piece secure

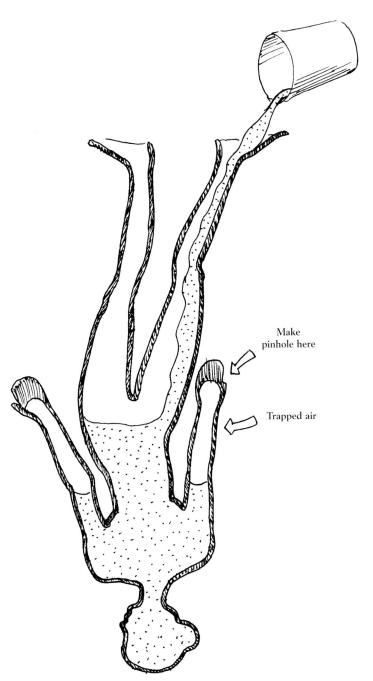

Make
pinhole here

Trapped air

Pouring the core into a wax figure. Notice the areas of possible air entrapment: the forearms and hands. Small pinholes in the wax will solve this problem.

while you apply the first coats of investment. The small head shown at right, for example, has a core poured in it and three core rods sticking out. One of the rods has been placed in a piece of square section steel tubing with a bolt threaded through to clamp it. This holds the head quite steady for brushing on the initial coats of investment.

Applying the Brushed-on Coats

It's now time to start applying the actual investment. There are several schools of thought on whether it's necessary to brush on the first coats, and if so, how it should be done. In general, if you skip the brushed-on coats and merely place your wax in the flask and fill it up, the investment will be loaded with bubbles that will collect on the surface, and the bronze casting will be covered with little bronze beads, each of which must be chiseled off. I have heard various methods to prevent this, but none that I have tried has gotten rid of the bubbles as well as first coats well brushed on. I'll discuss these other methods a little later. (See "Alternatives," page 143.)

The first requirement for brushing on investment is to hold the wax steady. In many cases the wax can merely be placed over some kind of upright, like the steel tube shown at right. In that case, the core was poured first, leaving a core rod sticking out that was then clamped securely. If there is an external sprue system, you might tie the main sprue to an upright with rubber straps, also shown at right. Just be sure of two things: the wax must not wobble and spin around while you work on it, and the support must not distort the wax by poking through or anything like that.

Now you're ready to brush on the investment. My formula for a good brushed-on coat is one part water, one part plaster, and one-and-a-half parts silica flour (each part measured by weight). In order to make the mix quickly, I take a balance beam scale or lab grade digital scale and three of those plastic water glasses they use to serve drinks in truck stops. I put a plastic glass on the scale and set the tare to zero, to account for the weight of the plastic glass. Then I set the scale to 100 grams (virtually all lab scales are metric) and fill the glass (still set on the scale) with water until it balances. I carefully mark the level of the water on the glass. Now take this glass off the scale and replace it with the second glass. Fill this glass with dry plaster until the scale balances, and mark the level of plaster on the glass. Again, take this glass off the scale. For the third glass, I reset the scale to 150 grams. Fill the glass with silica flour, and mark the level on the glass.

For the plaster- and silica flour-filled glasses, I simply cut them off at the marked levels with a band saw. That isn't accurate enough for the water-filled glass, however, so for that one I carefully drill a ¼-inch hole with the hole's bottom just touching the marked line. This way, water will automatically pour out the hole until it falls exactly at the marked level.

To mix, place the water glass in a shallow dish and pour water in to just above the hole; when water stops dribbling out, the measure is perfect; dump the water in a mixing bowl. For the plaster and silica flour, simply fill each measuring cup to the top and scrape level, like a baker measuring

A small wax head with its core already poured. A protruding core rod is clamped into an upright support, thereby securing the head for application of the investment.

An alternate way to hold a wax for the brushed-on coats. Strap the main sprue to a back iron with rubber straps.

flour. Dump the contents into the mixing bowl, and stir. This method is quick and accurate, and very hard to mess up.

After stirring you should have a mix that will brush on easily but will not slide down the wax. You can change the consistency of the mix by making very slight adjustments to the amount of water used. I actually drill a somewhat larger hole, then partially cover it with duct tape, which I can reposition until the water measure is precise. Once I have the formula perfect and am ready to start brushing on investment, I premix several batches of the flour and silica flour in cups and place each set of cups behind a mixing bowl that contains the correct measure of water. This way, all that's needed to mix a new batch is a quick dump and stir.

You're going to brush on *three* coats of this mix, but here's the big caution: you must brush them on wet-on-wet or they can delaminate in the kiln and create *scabs*, which are surface skins on the casting with investment behind them. Imagine, inside your mold, the layers peeling apart like paint on an old barn. Not good. The cure is two things: first, never leave an investment coat to set that is thin and has wax showing through. Always apply so the mix is thick, although not so thick that it slides down the wax. Second, apply the second coat before the first one has had a chance to set.

So here's the method: First, make sure you have several batches of flour and silica flour premixed, each standing behind a bowl of water for your mix. Next, look at the piece and decide how much mix you can brush on before it begins to set. (Remember, the layers need to be brushed on wet-on-wet.) Usually, you can cover about half a life-sized head. Don't try to do the whole thing. You want to apply all three layers in one area, then move on to the next area and again do all three. Don't worry about creating joins between areas—this is never a problem.

Begin brushing with your first batch of mix. If you have a controllable compressed air hose, so much the better as you can hold it in one hand and brush with the other, blowing the mix into the smallest crevices. Otherwise, just use your breath to blow as needed. I begin by covering the selected area with a thin coat brushed in well but rapidly. Then I go back and gently glob on the mix as thick as it will go without running down. If it runs down, it's too thick—back off.

Materials for the first brushed-on coats of investment. The two bins in the back are for plaster and silica flour, and are well labeled as both materials are white powders and are easy to confuse. In the foreground, the small measuring cups for plaster and silica flour have been cut off at marked levels; the larger measuring cup for water (in the center) has been drilled with a hole for accurate measuring.

A portrait head with three coats of investment brushed on the bottom area only.

When you are halfway through this first coat, dump your next dry batch into the water. When the first coat is done, quickly wash out the brush and squeeze excess water from it, stir the next batch, and begin applying the second coat right on top of the wet first coat. Repeat this for the third coat and you'll have three coats well bonded one to another. Repeat the whole process for the next area (if there is one), making sure to brush well into the join between areas. Also note that the first coat has a tendency to expand a bit, so try, if you can, to make sure each area you work on goes all around the sculpture. Then apply the next batch up against the seam as quickly as possible.

TIP

If the sculpture is large, you can mix double or triple batches and use a large brush. And you can also use help. Two or even three people can apply this coat all over even a rather large sculpture.

After you've cleaned up a bit from the final batch and the third coat has set, take ordinary rather fine chain and begin to wrap up the sculpture like a mummy. To prevent the chain from falling off when you place the piece upside down in the flask, dab more investment mix here and there to hold the chain in place. The chain will help greatly to prevent cracking of the investment and subsequent flashing. The coats can also be reinforced by adding small steel fibers (see list of suppliers) to the second and third layers for a knitting effect, which helps the face coats hold as a unit. How much to add? About one heaping tablespoon for the mix described above.

If you are casting a relief sculpture, you have a special problem. The pressure of metal inside a narrow flat form—a relief—puts tremendous strain on the edges, and the investments can break there, particularly across the bottom. When this happens you get a *run out*, which is dangerous and will ruin the cast. You don't want this to happen. There are two cures. The first is to wrap the relief (after it has been coated with three initial layers of investment) extremely well with chain, particularly covering the sides and bottom. The second is to wait until the wax has been burned out and then, before pouring the bronze, place the investment on the floor on a bed of sand. Set a strong wooden box around it and fill with dry sand to hold everything in place while pouring.

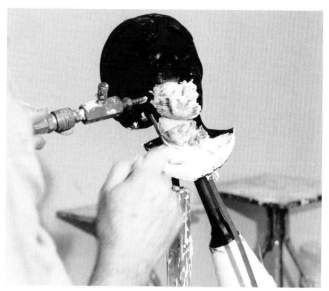

Brushing the first coat of investment onto the wax. Note the air hose held in the left hand that is being used to blow out bubbles.

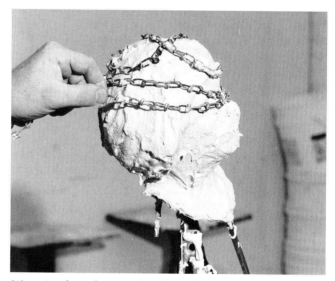

Wrapping the sculpture with a chain after the third coat has set.

Chain applied and secured with dabs of more investment so it won't fall off when the head is inverted in the flask.

Completing the Investment

While the brushed-on coats are setting, make the flask, or basket. If you are using expanded steel and tar paper, you need to figure out the size of the cylinder to make. To do so, measure the diameter of the sculpture at its widest point, then add 4 inches. Multiply this number by pi (π), which is 3.14, to find the length of lath you will need to make a cylinder with that diameter. Now add three more inches because the lath has to overlap. Cut off a length of lath to that measure. Use good tin snips for the job, and wear gloves unless you like the sight of your own blood.

Your next measurement is for the height of the flask. Measure the total height of the piece from the very bottom of the sprue system or wax to the lip of the pouring cup, and use that as your height. In practice, once you have put the piece in the flask, you'll see that the pouring cup will actually ride a little high out the top. If the lath is wider than the height of your piece (it usually is), don't cut it down, but fold over the appropriate amount, stamp it flat with your feet, and leave that doubled part on the bottom for strength.

Now roll the lath into a cylinder with a 3-inch overlap, and secure it with lengths of twisted stovepipe wire. (See illustration of rolled lath baskets, page 135.) Wrap tar paper around the basket, being sure to overlap by at least a full turn around the basket. The tar paper should be a few inches taller than the lath. Tie the paper in place with rope, place the basket on a sheet of plastic, and you're ready to fill. (See illustration of completed flasks, page 135.)

To mix the investment quickly, have three identical measures handy: one for water, one for plaster, and one for sand. Empty 3-pound coffee cans are good measures to use. You'll use one measure of water, one of plaster, and two of sand for

Comparing the height of the piece to the width of lath, which will become the height of the flask.

Determining the length of lath to cut for a flask. Measure the diameter of your sculpture, then add 4 inches (2 inches for each side). Multiply by pi (3.14), then add 3 inches for overlap.

each mix. But first, dump the plaster and sand out of their bags into plastic or metal garbage cans. I do the mixing in those white five-gallon plastic buckets used by food manufacturers. Look in the Yellow Pages for anyone who deals with eggs, jams, jellies, sauces, and so on for industry. They get their raw materials in those buckets and can't reuse them; see if they'll give you about ten of them. Wash them well and keep them clean.

To make life easy, have two of the buckets nearly full of water. One will be rinse water for sticks and gloves, the other for buckets. Get a good stick for stirring, and, if you can find one, a tough, long rubber glove for your dominant hand. A glove is handy for two reasons. One, it keeps your stirring hand dry so you don't have to wash and dry it continually. And two, it saves your skin. If you are also pouring the core at this point, have your core rods ready and waiting.

Now for the basic mix. Fill the water measure to the very rim with water and pour the contents into a bucket. Fill the plaster measure, level it off, and dump it in as well. Let this stand about three or four minutes, then stir with the stick. Swirl the stick in the rinse water to clean it. Now add two measures—just level—of sand. Slip your hand in the glove and reach in and stir. The mix is just right if it is creamy and liquid. If it is too thick, add a *little* water. Next time, you'll know to add a bit less plaster and sand from those measures. You're looking for a mix that will run but is thick, rather like

gravy. When you're done stirring, swirl the glove in rinse water to clean it off.

Pour this first mix into the flask a bit at a time, looking for leaks. It should hold and not leak, just sitting on the floor. If it does leak, wait a few minutes until it begins to set and the leak stops. Give the mix a quick stir with the stick to be sure it penetrates the lath, and then wait until it stiffens enough to support the wax. Now carefully place your chain-wrapped sculpture in the flask with the pouring cup at the top, centering it carefully. If necessary, hold it in place with cups or blocks or anything.

Now you're ready to fill the rest of the flask. Begin mixing batches. Add the plaster to the water, wait a couple minutes, stir with a stick, rinse the stick. Add the sand, stir with your gloved hand, rinse the glove, and pour the mix into the flask. As the lower layers stiffen, remove any supports you added to hold the wax centered. And after each pour, do two things: first, reach down in the flask with the stirring stick and agitate the mix so it flows everywhere, in particular through the loops of the chain. And second, take that second big bucket of rinse water and pour a good slosh into your just-emptied mixing bucket, swirling it around to clean the bucket and then pouring it back. You can now use that mixing bucket over again.

Repeat the process until the flask is full of investment mix. If you are pouring the core at this point, just let the mix flow

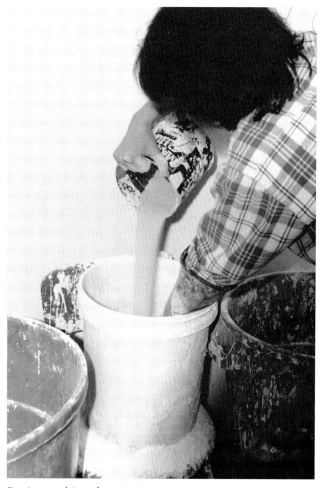

Pouring sand into the main investment mix.

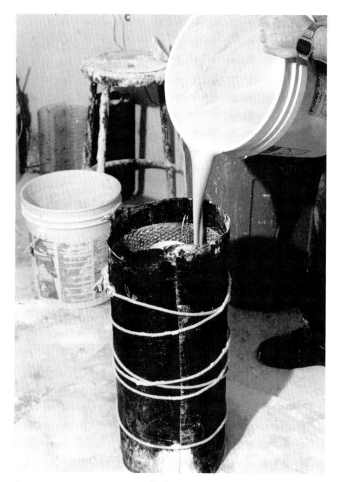

Pouring investment into the flask. Note that it is fluid but not watery.

in naturally and remember to add any core rods. Go carefully and don't rush, but at the same time don't dawdle so much that a layer sets before you pour the next one. Aside from the first pour, the others should go in liquid into liquid. But be careful. If you get help and every one is mixing and pouring like crazy, you can fill the flask so fast that it becomes one entire column of liquid, and the tar paper can let loose from the strain. Try to have two or three buckets wet while the ones below are set. Pace your rhythm so they set upwards behind you as you fill. And don't forget those core rods!

TIP If you get a leak somewhere in your flask, an easy way to stop it is to pat on a handful of dry plaster.

When you've reached the top of the flask, the last batch should level out nicely, leaving about 1 inch of the pouring cup showing above the surface. That's ideal. Also, any vents should be sticking up. Now add a "hex mark" to the fast-setting material on the top. This can be any mark personal to you. Don't neglect this—the sculpture gods are watching! Also, write into the soft investment the amount of bronze (in pounds) needed to fill that mold. Remember back when you weighed the wax (page 134)? Here's where that number becomes important.

Placing a "hex mark" on the completed investment.

Alternatives

There are lots of other ways to make solid investments. Some people dispense with the brushed-on coats and instead spray the wax with WD-40 or a similar product, claiming that it makes the bubbles slide off the wax. Others pour the mix around the wax, brushing the surface constantly as the liquid rises. If the brushed-on coat seems a pain, try one of these methods. You might also try brushing on a ready-mix jewelry investment, which works very well. Many sculptors also use more aggregates in their mix, such as those mentioned on page 134. And some fill the whole flask with Ransom and Randolf jewelry investment.

There are also a lot of other materials you can use for your flask besides lath and tar paper. Some people use large sections of steel pipe, which have some very good advantages. One, they will never burst. Two, when they come out of the burned-out investment and hit the cool room-temperature air, they begin to contract, squeezing any cracks in the mold shut and eliminating flashing. The disadvantages are that you have to find and buy them, you have to store them, and it can be difficult to get the investment out of them.

Some artists take pipe sections, cut them down both sides, and weld on flanges so they can be bolted together, as shown at right. They can then nest the halves of the pipe together to minimize storage space, and, more importantly, the halves will pop open for easy investment removal. A variation is to make the flask out of sheet stainless steel on a brake in hexagonal sections, again with flanges to bolt together.

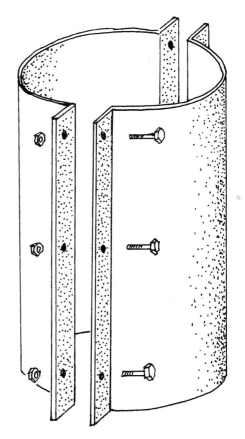

A flask made out of a section of steel pipe, cut down the middle and fixed with flanges so the halves can be bolted together.

Very large investments

Since investments have to burn out and the wax has to drain, the filled flasks are usually turned upside down when they go in the kiln. If you are making a very large investment, however, this can be a problem as it will be too heavy to turn over. The solution is to create a drain on the bottom. Build the investment on a thick steel plate, which will go into the burn-out kiln and remain in place through the pouring. Find a heavy steel plate large enough for your investment and small enough to go in the kiln. It should be at least 1 inch thick, and will be very heavy. Set it in place where you will do the investing, preferably up on concrete blocks.

Run a large wax sprue from the lowest point of the wax, when positioned for pouring, straight down to stop 1 inch above what will be the bottom of the investment. Drill a ½-inch hole halfway into the sprue at its bottom end, with a drill bit just held in your fingers. Insert a ½-inch diameter steel rod into this hole. The rod should run horizontally and slightly downhill, away from the sculpture. Grease the rod lightly with petroleum jelly.

Now support the entire wax, first brushed-on coats and all, over what will be the base of the investment. You can do this any number of ways. One good way is to set the coated piece on two firebricks to lift it off the plate. The bricks then become part of the investment. Another way is to hang it from the core rods previously placed. A third way is to imbed

short steel rods into those first investment coats to serve as legs, so that the piece can stand in the right position.

The steel drain rod should now be running at a slight downhill angle from the sprue you attached over to the edge of the investment. Your flask will need a small cut-out to go around the rod, and a bit of clay to seal around the hole. Fill the investment as usual, and when set, pull the rod out with pliers. As the wax burns out, it will drain out that hole. Then, before pouring the bronze, you simply reinsert the steel rod to plug the hole.

A final word on solid investments. Be creative. Experiment. Take notes so you can remember what works and what doesn't. For example, I filled paper cups with investment mix in portions of sand to plaster of one-to-one, two-to-one, three-to-one, and four-to-one. I put the cups in a burn-out kiln and examined them later for strength and cracking. The mix I use, two-to-one sand to plaster, was clearly the best. Make your own experiments. Talk to others who use solid investments and pick their brains. The methods described here are in no way the final word on this complex and still-evolving process. This method is one way, and it works, but use it as a springboard to find your own way.

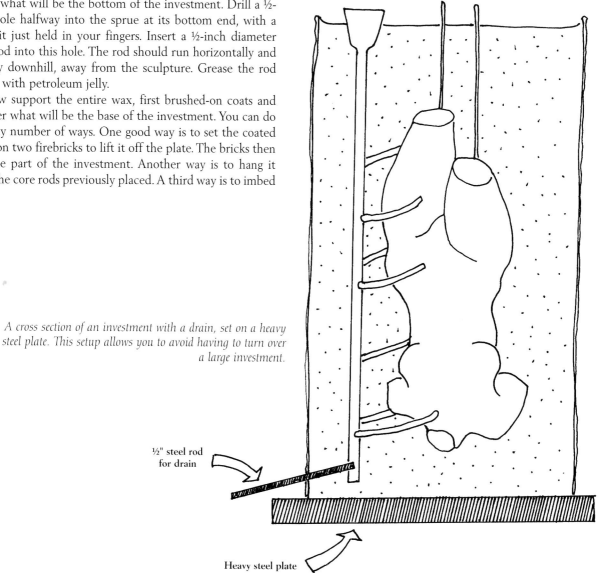

A cross section of an investment with a drain, set on a heavy steel plate. This setup allows you to avoid having to turn over a large investment.

½" steel rod for drain

Heavy steel plate

INVESTING WITH CERAMIC SHELL

This section is aimed at the person in the small foundry with modest funds, who wants to cast a small number of works using ceramic shell. This is not the guide for commercial foundries casting hundreds of pieces a week. Their materials and methods are quite sophisticated and beyond the scope of both this book and the sculptor trying out ceramic shell for the first time.

Materials

Ceramic shell casting involves two classes of materials: *slurry* and *stucco*. The slurry is a colloidal silica mixture that looks like yellow milk, and it's this that the wax is dipped into; the stucco is a fine refractory powder that is dusted on the freshly dipped wax. Once the piece has been allowed to air dry, the dip-and-dust process is repeated until a shell of the appropriate thickness is built up.

There are several slurries on the market, and it's a good idea to call various distributors and listen to their advice. (See list of suppliers for contact information.) A particularly good slurry for the small foundry is Shellspen, available from Johnson Atelier, as it is designed to stay in solution without constant stirring. Johnson Atelier also sells a very good kit that includes complete instructions and coating charts and is an ideal introduction to shell casting. After using this process you will feel much better prepared to expand to larger production methods.

Preparing the Wax

Your first consideration is the sprue system. Simple top-feed systems work fine on most pieces. The only concern is that the sprues be very securely attached to the piece since there is some strain as the wax is dipped, and you really don't want them falling apart when half-dipped. Be sure the hot knife is well worked around in between the gate and the piece while attaching.

The second consideration is how to hold the wax for dipping and drying. One solution is to use a steel rod that you've repeatedly dipped into wax (see below). You can also feed a steel rod down the hole in the center of a cored sprue and then fill the rest of the hole with melted wax, sealing it in. This wax-coated rod then becomes your main sprue. The pouring cup is fitted over the rod, and about a foot of rod remains sticking out above the cup (to be used as the handle), while the rest is imbedded in the sprue. The piece is attached to this sprue with gates as usual.

To use, handle everything by the bare rod sticking out, and support the wax for drying by placing the rod in a vertical pipe. An alternative is to place a wire hook in the rod for hanging the wax. When the wax burns out, the rod or wire will drop out.

Cores present a special problem for ceramic shell because the shell doesn't want to dry inside enclosed spaces. The most common way to solve this problem is to cut a window in the wax to create two openings, one at each end, to allow air to flow through. This also allows the shell to be supported at both ends by wrapping around and becoming one with the outside shell.

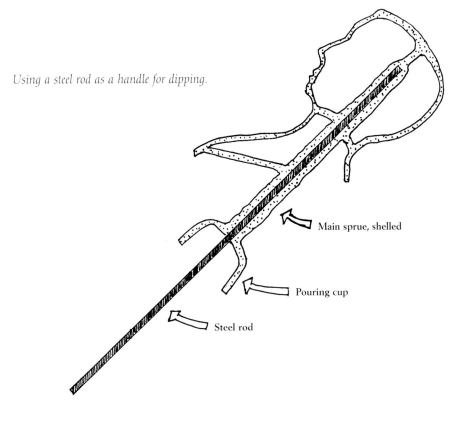

Using a steel rod as a handle for dipping.

Main sprue, shelled

Pouring cup

Steel rod

For a small solid piece, this won't provide any problem as there isn't any core. But if you are shelling a larger portrait head, for example, you should cut a window about the size of a playing card out of the top back of the head (see below). This window is then attached to another sprue somewhere to cast with the head. The piece is welded back in after casting.

You can also avoid the drying problem by filling the core with a good commercial jewelry investment instead, particularly a high temperature one like the kind used for platinum. Pour in the investment core as usual, using stainless steel rod for core pins. In this case no window is cut.

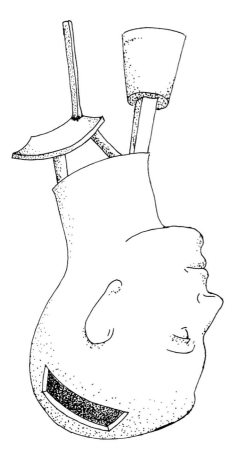

A portrait head ready for shelling, with a window cut from the top and attached separately by gates. This will allow the ceramic shell to flow through the wax for drying and support.

Maintaining the Slurry

When the materials arrive, you can mix the slurry according to the instructions. But if you let it sit, it will slowly settle and solidify in the container, eventually becoming a solid mass. There are two solutions. The first is to use Shellspen, which will remain liquid without stirring for a long time—long enough to shell several pieces in one six- or seven-day session. The second and more usual solution is to have a constantly stirred tank of slurry. A typical stirrer is a motor with a shaft and propeller, placed so the liquid swirls around the tank, catching every part

of the mix. But don't run a shaft directly from the motor into the tank because it will turn too fast. Instead, reduce the speed with a pulley or two. Plus, if the slurry does go solid, it will burn the pulley, not the motor. Your motor should be large—no wimpy motors here. Get one with a minimum of one horse-power, preferably larger. Set it on a timer so it cycles on and off, say 50 percent on and 50 percent off at five- or ten-minute intervals. Some people leave it on all the time.

Another, more elaborate, method uses a rotating tank, with the entire tank turning and a stationary blade reaching over the edge to scrape along one side and agitate the slurry.

The slurry must also be constantly monitored. Follow the instructions from the slurry supplier very carefully, and take this job seriously. You have to monitor both the slurry's viscosity and its specific gravity. Be sure your lab scale is accurate, and be very precise. The quality of the castings is directly dependent on correct slurry maintenance.

Applying the Slurry

Most large foundries have tanks of slurry for dipping, and air flotation boxes for the stucco. This is not necessary for the occasional piece. You can coat the wax by pouring the slurry over it, holding a pitcher in one hand and the wax in the other. Pour over a large catch container, like a clean garbage can, and keep pouring until you have coated every part of the wax. Now pour the stucco over the wet wax by shaking a strainer filled with stucco, raining the particles down while you turn the wax. Again, the aim is simply to coat all surfaces. You can also sprinkle stucco on by hand.

Now the piece must dry. You will have thought ahead and figured out a way to hang or stand the piece so the wax is not touched, such as inserting a steel rod in the main sprue (see page 145). Most foundries use fans to circulate air for drying, and this will greatly speed the process. If you have no fans it will dry, but it will take a lot longer. If a piece has a large interior form covered with a shell core, it may need extra air to dry well. A small squirrel cage blower can be used to speed the process, with a plastic hose attached to force air inside the forms.

When the first coat is quite dry, apply the second coat in the same way. (A note of caution: be absolutely sure that each coat is quite dry before adding the next. Most slurries have a coloring agent in them that changes color to indicate dryness.) Some slurries require a prewet liquid to bond coats. Usually second, third, and following coats will involve ever coarser slurries and stuccos. Once you have the knack of applying one coat, you pretty well use the same technique to keep applying coats until the desired thickness is reached. This is usually around ⅜ inch.

Shell Casting Larger Pieces

If you want to get more serious about shell casting, you will need slurry tanks and stucco boxes. A slurry tank should be large enough to dip the largest piece you intend to cast. But remember, a large sculpture is best made of several smaller pieces welded together. It's quite amazing how many

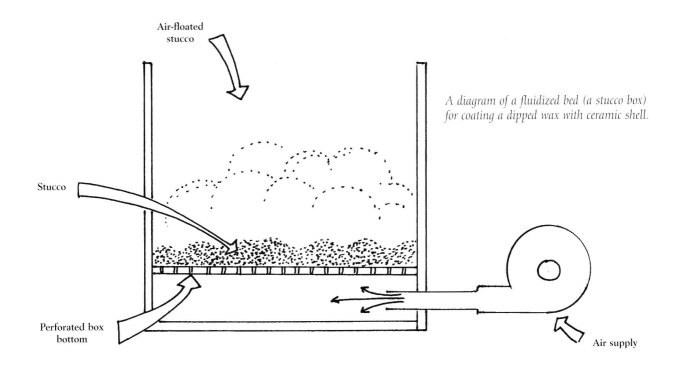

Air-floated
stucco

Stucco

Perforated box
bottom

Air supply

*A diagram of a fluidized bed (a stucco box)
for coating a dipped wax with ceramic shell.*

foundries casting monumental works rarely cast a single piece larger than a bushel basket.

Most foundries use two tanks containing slurry of different consistencies: a fine one for the initial coat and a second, thicker one for subsequent coats. Be sure to follow all directions from the slurry manufacturer concerning slurry maintenance. This is crucial—failure to maintain slurry correctly can cause the entire batch to solidify, burn out your stirring motor, and grind your whole operation to a maddening halt. Think of slurry as a baby who must be babysat at all times.

A stucco box is a large box with a double bottom that forms a narrow, closed space. The top surface of the double bottom is filled with a zillion tiny holes and has several inches of stucco on it. Compressed air is forced into the space between the two layers of the bottom, and flows upwards out the tiny holes, floating the stucco that is resting on top and creating a sort of contained sandstorm. You can pass a freshly dipped wax into this sandstorm and coat it easily on all sides. The air supply to create the sandstorm is usually controlled with a foot pedal. It doesn't stay on all the time, but is turned on only when a wax is being passed through the box.

Reinforcing

Shell molds are subject to high stress at their edges, and it is there that they are most likely to fail. To help prevent this, wrap stainless steel chicken wire (available from major shell suppliers) around larger shells after about the fifth coat, and then continue with the dipping. This bonds the wire to the shell and helps reinforce the entire mold.

When the wax is burned out (see Chapter 14), there can be cracks left in the shell. One way to find them is to fill the empty shell with water and watch for leaks. Any cracks can

be repaired with refractory repair material—a sort of gray paste that is applied by hand. Filling the shell with water also rinses out any loose particles that may have found their way inside. And if the wax sculpture had contained any material other than wax, like wood, insects, or whatever, the water will flush out any ash. If you do this, drive off any water in the shell before pouring by heating the shell to red hot.

To get started with shell casting contact a good supplier, such as Johnson Atelier, McCaughlin, Ransom and Randolf, or others as listed in the back of this book. Get their catalogs and instruction books. Call with questions. Start small, preferably with Shellspen. Get comfortable with the shelling and drying process, as well as the burn-out and pouring. Then move to more production-oriented equipment, materials, and methods.

Investing with ceramic shell is an excellent way to cast. It is, however, as full of problems as any other complex method. The book *Methods for Modern Sculptors* by Ronald Young and Robert Fennell (see Further Reading) is an excellent book on ceramic shell casting. If this is your direction, I strongly urge you to buy and study this book carefully.

SAFETY

Ceramic shell stucco usually contains silica. This material is extremely bad for your lungs, and can cause silicosis, a lung disease in which the ability to breathe is lessened, sometimes to the point of suffocation and death. Always wear a high-quality fine-particle respirator when working around stucco. Don't skip this step. Don't say, "Oh, this once won't hurt," because this once will hurt. Silicosis is a disease that builds up over time, and every "just this once" adds up.

BURNING OUT, POURING, AND DEVESTING

Here we come to the "macho rite of sculpture": pouring hot metal. Ooooh, the orange glow from the furnace, sweaty bodies glistening, muscles straining, the mesmerizing stream of shining metal filling the molds, the danger—wow, great stuff. Manly-man stuff. Forget all that. There is a job to do, and it must be done carefully and safely or the sculpture will fail or, worse, someone could get seriously hurt. This entire aspect of the process must be approached with the greatest care, because it involves the greatest risk.

BURNING OUT SOLID INVESTMENTS

Burning out simply means removing, or burning out, the wax, and the first major requirement for burning out is a kiln. Most common are old pottery kilns, but some kilns are purpose manufactured, and others are made by the artists themselves. Whatever type of kiln is used, it must meet the five following general requirements:

1. It must have a strong enough floor to support heavy molds.
2. There must be a good way to move heavy molds in and out.
3. It must have some kind of temperature control.
4. There must be good ventilation.
5. All the usual safety equipment relevant to high-temperature kilns must be in place.

Given these general requirements, the first problem is a strong floor. Most kilns are built up off the ground and may need some extra support. Be sure the floor is well supported from below so a particularly heavy mold doesn't either warp it or crash through. Bricks piled up and wedged tight are a good support, as are pieces of heavy steel angle iron.

Another potential problem is getting heavy molds in and out; this often requires some ingenuity. The best method is a rolling car, which is actually the bottom of the kiln on a heavy steel frame mounted on strong steel wheels, so it can roll out of the kiln into the middle of the floor. Some burn-out and pottery kilns are manufactured with such a car; if you are making your own kiln, consider this option. (More information on making your own kiln will be provided on page 151.)

A variant of the rolling car method is the *top hat* kiln. In other words, if the bottom can't move, perhaps the top can. In a top hat kiln, the entire upper structure lifts off. If this structure is heavy it may require a hoist. If it is made of thin steel with ceramic wool insulation, it can be lifted off by two or three people. The kiln floor is built directly on the floor of the studio, made of firebrick with appropriate openings for burners and flame flow. Then the main part of the kiln simply drops over that floor. There is no door, and when the top is removed the investments are ready for moving to the pouring floor, or can even be poured in place.

Another good alternative is a forklift. These need not be the heavy engine-powered jobs you see in factories, but there is a good line of small, foot-pedal operated, forklifts. They have no power supply at all, only a hydraulic foot pump, and are pushed around the room. But they can easily

lift a thousand pounds, and will usually reach nicely into a kiln to either place or remove investments. (See list of suppliers for more information.) If you use a forklift, however, you must have a smooth foundry floor for rolling. Forklifts won't roll on packed sand.

A fourth alternative is to use an overhead hoist to lower investments into a top-loading kiln. Many electric pottery kilns are top opening. If there is no overhead hoist, a moveable one can be built using heavy angle iron bolted together, strong casters for rolling, and a differential chain or electric hoist. A cable hoist with a crank, designed to pull boats up onto trailers, will also work.

Failing any of these options, you will be very limited in the size of investment you can burn out, since muscle power can't really be counted on for much over a hundred pounds. Add to that the idea of reaching into a hot kiln to grab a hot investment and you can see why the above suggestions ought to be taken very seriously.

As for temperature control in your kiln, the best option is a controlling pyrometer, which has a control for rise, fall, and turn-off. Pyrometers are a bit expensive but well worth the money, and there are many kinds on the market. They will determine the rate the temperature rises, a hold time, the rate the temperature falls, and will turn the fuel off, all automatically. Some work on the principle of a cut cardboard cam, others are digital. Talk to the kiln manufacturers for details.

A second, lower-tech way to control the kiln's temperature is to put in place a good temperature-reading pyrometer so you know what's happening inside. Then monitor the first few burn-outs, noting exactly how much fuel is turned on and what temperatures are reached in what time.

The two most common kiln fuels are gas and electricity. Gas can mean either natural gas or bottled gas. Electricity usually means an electric pottery kiln, though one could also wrap kiln elements in an insulated box with the proper electrical controls. Most gas kilns have a pressure gauge on the gas line just before the burners, telling how many inches of gas pressure are being fed to the burners. If you have a U-shaped tube with water filling the bottom, this tells you how many inches up the left tube the water would be pushed when gas pressure is applied to the right tube.

My kiln is a 24-cubic-foot (0.7-cubic-meter) Alpine gas kiln with eight burners. I run it on four burners only, at 1 inch of pressure, and it will rise to 1,000°F (540°C) over a period of about six hours and hold steady at that temperature. You want to find your own magic number—the setting at which your particular kiln will reach and hold no more than 1,000°F (540°C). This setting will vary with every kiln, so you have to babysit yours a few times to find it. Once you have, however, you can set it and leave it every time.

For electric kilns, there is usually a series of elements controlled by separate switches. Again, babysit your own kiln a few times until you find the combination of settings that will give you the right temperature.

A small foot-operated forklift for moving investments.

A typical gas-fired ceramic kiln used for burning out solid investments.

A rolling overhead hoist. These can be purchased or made. If you make your own, use heavy steel, heavy casters, and a differential or electric chain hoist.

SAFETY

Firing an unattended kiln overnight can be very dangerous for a number of reasons. First, it can set a building on fire and burn everything down. Second, if the gas flame blows out and there are no safety devices it can blow up the whole building, or maybe the whole block. Third, it can overheat and ruin the investments, and possibly start a fire. Fourth, it can emit gasses and fumes that are dangerous, and can themselves cause all kinds of problems.

So first, make sure you place the kiln in a fireproof place, preferably a concrete block room with a cement floor and a metal ceiling. Even better is to locate the kiln outdoors, protected by a chain link fence and covered with a metal roof for rain. Don't even think of placing your burn-out in a wooden building unless the kiln can be very far away from any walls, like a minimum of 20 feet in every direction

Second, both gas and electric kilns need good ventilation. That doesn't mean an open window. It means a hood right over the top of the kiln leading directly to the outside, with a fan to draw air through. Look back at the illustration on page 149 and note the size of the hood over the top, and how close it is to the kiln. (Obviously, if your kiln is outside you won't need the fan.) Don't skimp on this part. Burning wax is very noxious and dangerous, particularly if it builds up inside a closed building. You need to vent it quickly, completely, and surely outside. And don't forget, if you install a fan that blows air outside, you must also have an inlet to allow fresh air back into the building.

Third, you need the proper safety controls on the kiln itself. For a gas kiln, a thermocouple shut-off is mandatory. This is the same device that is on your home gas furnace, and it feels the heat of the pilot light. Should the gas fail or the pilot light blow out, the thermocouple shuts off all the gas. This way, if the gas comes on again it will not enter the kiln and explode. If you are building your own gas kiln, have a trained gas installer check over your installation before you use it to be sure it is safe, and all safety devices are in working order. Electric pottery kilns come with safety overload switches. Don't disconnect these. If you are building an electric kiln, call a kiln company and buy this type of device. It could save your whole place.

Finally, be careful of hot kilns. Heavy gloves, a heavy jacket, a cap, and a full face shield should always be worn when taking investments out of a kiln for pouring.

Building a kiln

With the introduction of ceramic wool, the possibilities for building your own kiln have improved. Ceramic wool, available from refractory suppliers and some pottery suppliers, is a soft, woolly-feeling material that comes in blankets about 1 inch thick. It has extraordinary insulating properties and is capable of withstanding very high temperatures.

In general, home-built kilns are gas fired, and consist of a box made of heavy sheet metal or light gauge steel plate, often bolted into an angle iron frame and then lined with ceramic wool, which is quilted in place with wires. The box can have a hinged door, or it can be a top hat kiln (see page 148). The base can easily accommodate a wax reclaiming device. This is a hole in the kiln floor over which you place the pouring cup of the investment, so the wax drains through the kiln floor into a large basin of water set beneath. This both saves wax and cuts down on smoke.

Gas burners can be found at some pottery supply stores and manufacturers of gas kilns. Don't forget to buy the safety equipment at the same time. Homemade gas kilns can use either natural or bottled gas, but be sure to have a professional check your setup before lighting.

Good information on building kilns can be found in any of several books in the pottery or ceramic section of the library or bookstore, such as Frederick Olsen's *The Kiln Book* (see Further Reading).

The Burn-out

To burn the wax out of your investments, first place the investments in the kiln. They should be turned upside down and set on two firebricks, with the pouring cup unobstructed on the bottom, as shown on page 149. Large investments should remain right-side up, with a drain on the bottom. Avoid placing the investments where flames can lick them directly.

As the wax burns, it will drip out and ignite, slowly burning off after a few hours. Many sculptors have a hole or holes in the bottom of their kilns through which the wax can drip into pans of water below, thus saving the wax and cutting down on smoke.

There is a lot of discussion on the subject of temperature, and I hope to cut through much of it here. First, the general rule for solid investment is low temperatures for a long time. (The rule for shell is the opposite—high temperatures for a short time.) I burn out solid investments at 1,000°F (540°C) for between thirty-six and forty-eight hours, depending on the size of the investment.

Ramping up and down

I do not *ramp up* or *ramp down*. Ramping *up* means gradually increasing the kiln temperature until the top is reached; ramping *down* means gradually decreasing it. I simply turn the kiln on to 1 inch of gas pressure (the pressure I know will top out at 1,000°F (540°C)) and go home. Six hours before pouring I turn it off and open the door. It's that simple.

Some years ago I decided to find out just what was going on inside my kiln, so I buried one thermocouple down inside an investment and had a second that read kiln temperature. This allowed me to read both the kiln temperature and the temperature inside the investment. Here's what happened: over the first six hours the kiln rose steadily to about 950°F (510°C). Meanwhile, the inside of the investment rose slowly, and after about two hours had reached only 212°F (100°C), the boiling point of water—and there it sat for about six more hours, not moving one degree higher. It couldn't, until all the water was gone. By eight hours into the burnout, the investment was still at 212°F, while the kiln had risen to 1,000°F (540°C). Then, suddenly, the water was finally gone; within an hour, the inside of the investment rose to about 950°F (510°C).

What this told me was that no amount of ramping up would do any good, because the inside of the investment would just wait patiently until the last molecule of water was gone, and then up it goes. A kiln ramped up slowly would likely be at 800°F (427°C) or above by that point anyway, so why bother? Just turn the kiln on and go home. Likewise, if you just turn the kiln off—rather than ramping down—the insulating property of the investment will make sure it cools slowly by itself. It can't do otherwise.

As for burn-out time, some people burn even small molds for five days. I find that excessive, as they should be clean after thirty-six hours. I have burned molds weighing over 1,000 pounds and they were completely clean in forty-eight hours.

Judging the Burn-out

When I was teaching bronze casting in Africa, we had no such comforts as kiln controls or thermocouples. The kiln was an old electric job at least forty years old, with live 400-volt wires protruding from the front: "Don't touch those," the man said. It had massive cracks and leaks that we sealed with handfuls of soft clay, and the voltage actually increased during the night, driving the temperature up. I went once to check it after midnight, accompanied by a soldier carrying a fully automatic AK47—cocked.

With that kiln, burn-out was all guesswork. Still, I had to be sure the investments were clean before pouring. There are two main ways—by using color, and smell. Any dark soot on the investment is a danger sign; they should be clean and white, and the inside of the kiln should be clean as well. During the burn-out the inside of the kiln will first turn sooty and black, but that should all burn away.

Mostly, you can smell the investment. Be careful—don't take a huge noseful of hot air directly out of the pouring cup. Be gentle. But if you smell any kind of petroleum, any smoky smell, or any oily or waxy smell, *don't pour.* If you do, at best the cast will be riddled with holes. At worst, the metal will boil and bubble and perhaps come flying out at you. If there is any trace of a waxy or oily smell, put the investment back in the kiln for at least another twelve hours. And please note that you should never rinse a solid investment with water. If you do, there is a 100 percent chance that water will remain inside, and bronze will fly out if you pour with any moisture present.

DEWAXING AND FIRING SHELL MOLDS

Unlike solid investments, ceramic shell usually requires two separate operations—dewaxing first, which means burning out the wax, and then firing. And also unlike solid investments, shells can be dewaxed at one time, and then stored and fired later.

Dewaxing

The main problem encountered when dewaxing shell is that before the wax can melt out, it first expands with heat and can crack the shell. There are three generally accepted ways to overcome this problem: dewaxing with a torch, dewaxing with steam, and using a flash kiln.

Dewaxing with a torch

A simple method is to use a handheld torch. The shell is suspended by chain, with the pouring cup facing down over a basin of water. Then an acetylene or strong propane torch is played on the shell, beginning at the bottom and working slowly up to melt the wax until the shell is relatively empty.

This method works because the wax melts at its front edge, rather than heating generally, and therefore doesn't expand. An advantage is that it requires only a torch, and is simple. A disadvantage is that it is slow, and professional foundries with hundreds of investments to dewax could never spend that much time on one, which is why you won't see this method used in commercial foundries. But for the odd shell here and there, it's fine.

Dewaxing with steam

A second method is to steam the wax out. This requires a steam chamber and a source of steam, or an autoclave, which is a pressurized steam chamber. This method is rarely used by the small foundry because of the problem of obtaining an autoclave, but some larger foundries have one and use it with great success.

Dewaxing with a flash kiln

The third and most usual way to dewax is with a flash kiln. The principle here is that the shell is thrust into a very hot kiln and the first thing that happens is the outer surface of the wax softens and begins to slide out, thus minimizing shell cracking and usually eliminating it altogether. This is the method used by the majority of foundries.

A good flash kiln should be able to reach 1,800°F (980°C), and have either a wide opening door or an open bottom so the shell can be thrust up into the flames. Some people make small flash kilns out of 55-gallon drums lined with ceramic wool and fired by several large gas burners, so the insides are infernos of flame. They are supported with the bottoms about 4 feet off a brick floor, and shells are thrust up into the heat. A large pan of water on the floor catches most of the wax. The other usual form is a kiln with a door that can open and close quickly and easily. Shells are thrust in while being held by long tongs, and openings in the floor allow wax to drain into water pans below.

After burning out, the shells can be fired (see below), then allowed to cool. At this point they can be rinsed out with water. Rinsing accomplishes two things. First, it rinses out any ash or residue that would otherwise contaminate the metal. Second, it exposes any leaks, which can then be repaired with special shell repair material, available where you bought your shell supplies. (Remember, you should *never* rinse a solid investment with water—only ceramic shell.)

Firing

With ceramic shell, burning out only removes the wax. Now the shell must be fired to become hard. Don't omit this step or the shell will burst when you pour in the hot metal. Firing usually means heating the shell in a kiln at 1,800°F (980°C) for about two hours. Usually foundries fire the shells while melting the metal. They are then very hot and ready to be taken straight from the furnace to the pouring floor. It is for this reason that most foundries have a door kiln in which the shells can fire while the melt proceeds.

POURING METAL

The most important task involved in pouring hot metal is making absolutely sure you follow all safety procedures—particularly the one called *common sense*—and avoid injuring yourself or anyone else. Read and memorize all safety instructions, and be sure you are comfortable with the process before attempting it with hot metal.

Equipment for Pouring

With that preamble, let's examine what you need for pouring hot metal.

The bronze melting furnace

You'll need a furnace to melt the metal. There are three common sources of heat for melting furnaces: *oil*, *gas*, and *electricity*. Oil isn't used very often, but it does produce fierce heat. Gas is the most common and also the cheapest of the three. Gas furnaces heat with natural gas or propane gas plus a blower. An *induction* furnace heats by electrical current. Induction furnaces are silent, fast, and the metal can be sealed to prevent gas absorption. They are clearly superior, but they are sufficiently more expensive that most small foundries can't afford them. Larger foundries, however, find that the advantages easily offset the cost. Also, induction furnaces can reach much higher temperatures, allowing the melting of such metals as stainless steel.

There are also three types of furnaces, each named after the way it holds metal: *crucible furnaces*, *tipping furnaces*, and *cupolas*. A crucible furnace is stationary; the metal is melted in a crucible, which is lifted out for pouring. A tipping furnace holds the metal directly in it, and tips to pour the melted metal into a crucible, which is then carried to the molds for

pouring; it can also pour metal directly into very large molds. A cupola, used for iron, is stationary. The metal melts inside and is drained out though a spout in the bottom into a crucible. We're not going to deal with cupolas here.

Crucible furnaces are usually smaller, and tipping furnaces are usually larger in capacity. Most small foundries will purchase a gas-fired crucible furnace, while larger foundries are likely to have induction tipping furnaces. There are several gas-fired crucible furnaces on the market, but the McEnglevan Industrial Furnace Company seems to have the major share of the smaller ones.

These types of furnaces consist of a refractory-lined cylinder with a removable lid, a burner assembly, a blower, and electronic controls. Many people have made their own furnaces, but my recommendation has always been to purchase one, primarily for the safety equipment that is included. Pumping large amounts of gas under pressure into an enclosed space and tossing in a match is asking for serious trouble. Commercial furnaces have self-igniting features, plus instant shut-off circuits to prevent explosions. These could save your life. Don't risk blowing your head off with a homemade furnace.

Unless you both have a lot of money and are pouring very large amounts of metal, you probably won't need a tipping furnace. And while electric induction furnaces are wonderful, being quiet, fast, and capable of sealing off the metal to prevent gas inclusions, they usually cost around ten times as much as a gas furnace, and are therefore rare in the smaller foundries. There is one notable exception: the newly developed portable electric kiln by Melting Pot International, which is priced at around $1,200. (See list of suppliers for contact information.) This kiln uses a number 6 crucible, which will theoretically melt 18 pounds of bronze, but more realistically 16 pounds. It's electric, but it plugs into an ordinary 115-volt wall socket. It will melt a crucible-full in a little over an hour, it's completely quiet, and it emits no fumes. It can be carried around in the trunk of your car and used in your basement. It works.

If you want to try casting small things, try the Shellspen material for your shell and this electric kiln for melting the metal. The only other thing needed is a flash kiln for burning out and firing, which should be kept outside for ventilation. With these pieces of equipment, it's quite possible to set up a small foundry in a garage or even a basement, with the flash kiln outside.

Other equipment
Along with your furnace, you will need several smaller pieces of equipment.

■ **Crucibles.** The first piece of equipment after the furnace is the *crucible*, which is a container for holding metal in the furnace. Crucibles are made of various materials, with clay-graphite being the least expensive and silicon carbide more expensive but higher quality. An advantage to the higher-priced silicon carbide crucible is that it usually has thinner walls, giving it a slightly higher capacity for the particular furnace it fits; it will also last longer.

A gas-fired number 30 melting furnace from the McEnglevan Industrial Furnace Company.

A silicon carbide number 30 crucible.

TIP

I have always heard that a new crucible should be fired slowly the first time it's used or it may crack. I have gone through maybe a hundred crucibles, and never have I fired one slowly. I always put a new crucible right in the furnace and blaze away. Not one has ever cracked. Use your own judgment.

Crucibles come in many sizes, and the *number* of a crucible is the number of pounds of *aluminum* it will hold. Bronze will weigh about three times what aluminum does for a given volume. Thus a number 30 crucible will hold 30 pounds of aluminum or 90 pounds of bronze. A number 120 crucible will hold 360 pounds of bronze, and so on.

■ *Tongs.* To lift the crucible out of the furnace, you use *lifting tongs*, which reach down inside, lock around the bulge in the crucible, and lift it out (usually a two-person operation). When you get a new setup, be sure the tongs fit the crucible properly. Most will have some kind of adjusting screw so that when lifted they close to a stopped position *that does not pinch the crucible.* The idea is that the crucible nestles into them, with no pressure being put on the hot crucible. Be very careful about this part.

You will also need *ingot tongs* to add metal to the crucible. You should have two sizes: one with jaws wide enough to hold a full ingot securely, and one with narrower jaws to handle small pieces of scrap. The handles should be long enough so you don't need to lean over the hot furnace.

■ *Shanks.* Using the tongs, you carefully lift the crucible from the melting furnace and set it into the ring of the *shank*, which is lying on the floor. The shank holds the crucible firmly and allows two people to lift and carry it, and to tip it to pour the metal. Larger crucibles—those too heavy for two people to lift—are lifted instead by a ceiling hoist hooked to a *bail*, or hook structure, which straddles the crucible.

Like the tongs, the shank has adjusting nuts that are used to position the pads around the circumference so the crucible will nestle nicely in it, with no chance of slipping through. Be sure the shank has some kind of hold-down to prevent the crucible from falling out as you tip it to empty it. Note the hold-down on the shank illustrated.

Left, tongs with wide jaws for handling whole ingots; right, tongs with narrow jaws for small pieces of scrap.

The adjustable stop screw on the lifting tongs. This prevents the tongs from pinching the hot crucible.

A pouring shank with a hold-down.

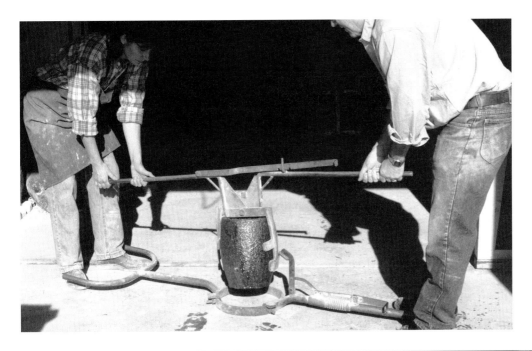

The lifting tongs in use. Please note that this is a demonstration photo only, so no protective clothing is being worn.

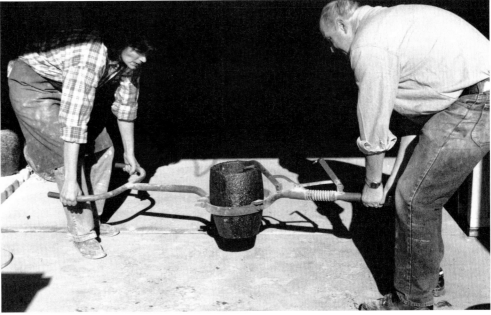

A pouring shank in use, with the hold-down in the clamp position.

Once you lift the crucible out of the furnace, you'll need someplace to set it. Don't set it on a concrete floor because the concrete, containing water, will begin to crack and will explode beneath the hot crucible. Instead, place the shank on firebricks or a plate of heavy steel, and then place the crucible inside the shank. (Note: The photos demonstrating the tongs and shank are for illustration only. The crucible is cold, there is no plate on the floor, and the workers are wearing no protective clothing.)

And here's another important safety tip: avoid keeping a wide range of crucible and shank sizes on hand. It's easy to mix them up and use the wrong crucible in the wrong shank. A few years ago this happened in a major art school foundry. A crucible was used that was just a little bit too small for the shank. The crucible just barely fit, and the pourers picked it up. Soon the heat of the crucible expanded the ring of the shank so the pot slipped through just as it was being carried to the molds, splashing hot metal over one of the pourers. In my foundry we have two sizes, a number 10 (very small) and a number 30 (distinctly larger). There is no way the two can be confused.

A set of one-person tongs for a number 10 crucible.

A one-person shank for the number 10 crucible. Note the welded-on metal heat shield and the simple hold-down.

For small crucibles you can use a one-person pouring system with a special set of tongs and shank. The tongs have handles moving straight up (see illustration above). Since you are now reaching directly over the melting furnace to remove the crucible, you must wear very heavy heat-proof foundry clothing, strong gloves, and a good face shield. The crucible is then placed in a one-person shank. The one shown has been modified with a welded-on heat shield to permit your hand to come close to the crucible without burning, and there is a simple hold-down.

■ *Skimmers.* Before the metal is poured, the *slag* or *dross*— all the accumulated impurities that collect on the surface of the molten metal—must be removed. This is done with *skimmers*, which are shallow steel ladles filled with holes. Buy those commercial skimmers that are shallow discs filled with holes on long handles.

■ *Pyrometer.* Many people use a *pyrometer* to test the temperature of the molten metal. These are very good tools and worth the expense until you become more familiar with judging the temperature of molten metal.

■ *A stirring rod.* You will need a long steel *stirring rod* that is about ⅜ to ½ inch in diameter and about 4 feet long, bent to almost a right angle at about the middle. This is used to reach down in the crucible to feel for any remaining lumps of metal, and also to the test the metal's temperature before pouring.

■ *Ingot molds.* After the metal has been poured, any excess is poured into an *ingot mold*, which forms the excess into a handy *ingot*, or mass of metal, for the next melt. Never leave metal to cool in the crucible. When you go to remelt the metal, it will first expand, cracking the crucible (perhaps

TIP

Here's a trick: buy at least three skimmers. Before you use them, turn on the acetylene flame of your welding rig *without oxygen* and play the flame over each skimmer until it is well sooted-up and black. You don't have an oxy-acetylene rig? Use a candle or kerosene lamp instead. Then, when you skim the metal, use each skimmer *only once.* Don't double dip. Before your next pour, clean each skimmer and soot again. If you follow this simple practice, any bronze that sticks to the skimmers will come off easily and they will always be like new. If you don't, you'll soon have a wad of bronze on the end of a rod instead of a skimmer.

invisibly). Lifting a cracked crucible full of melted metal can be dangerous, and even fatal. Always empty excess metal into ingot molds and then replace the crucible in the hot furnace to cool slowly, and to stay out of people's way.

The best ones are cast-iron molds from smelters, if you can find them. They will cast ingots just like the ones you buy. Next best is to make one out of heavy ½-inch-thick steel plate, welded into an open box with all sides sloping out at least 5 degrees. They can also be made of steel channel iron with ends welded on, but these will be small and you will need several. Worst is a hollow in the sand, since the metal picks up a lot of sand that way.

Skimmers. If cleaned and sooted before each use, and used only once per melt, they can remain clean for years.

A homemade ingot mold. Commercial cast-iron ones are better.

SAFETY

Before you melt, here are some important safety rules to read and memorize. Don't skip this part.

1. *Always preheat.* Never put anything into the hot metal that is not preheated. Metal, such as a stirring rod, skimmer, or more metal to melt, always contains some moisture. If you plunge such metal into already molten metal, the moisture will instantly turn to steam with great force and blow hot metal up and into your face.

Metal to be added to the melt should always be placed on the cover of the crucible for several minutes, then held by tongs into the flame before lowering into the crucible. Stirring rods, skimmers, ingot molds, and the like need to be preheated in the flame of the furnace before coming into contact with melted metal.

2. *Wear proper safety gear.* Let's start from the ground up. Heavy leather boots are best, and best yet are the ones without laces. Wear them with your pant legs outside the boots. You don't want to have any place that can trap melted metal. It should always be able to run off instantly.

Next, you can wear jeans, but heavy leather leggings are a good idea (always going over the boot tops). A heavy leather or fire-resistant foundry apron is recommended, and most pourers also wear either a heavy leather or foundry jacket to protect their arms and chest. A heavy coat usually works, but be sure it's not of a material that will burn; it should be leather or heavy denim.

Always wear heavy leather gloves whenever you are near hot metal. If possible, pull the sleeves of your jacket over the gauntlets of the gloves so metal cannot find its way into the glove.

Finally, a full face shield is absolutely mandatory. There are two kinds—plastic and stainless mesh. The stainless mesh shields are better, though they obstruct vision more. The plastic full face shield will actually stop small, flying spatters of metal. Do not go near the furnace, do not peer into it, do not load metal into it, and do not pour without a full face shield. Many pourers also wear a hard hat, often with the face shield attached. This is a good idea.

3. *Always have an escape route.* The best location for a foundry is right beside a large overhead door so you are inside, but just steps away from outside. If anything goes wrong, you can run. Be sure that any foundry you design does not leave you cornered without any way to escape.

4. *Always have a CO_2 fire extinguisher handy.* Don't use water, since water and hot metal really do not mix. Use the CO_2 kind since it cools things very rapidly.

5. *Cover the floor.* You will usually be pouring on the floor, so cover it with a layer of dry sand. You can dam the sand up around the bottoms of investments to catch any small spills. For major spills, run!

A word about foundry floors. Concrete is usual in the kinds of buildings we are given in which to build our foundries. But concrete is a bad floor for pouring because any hot metal spilled will cause the moisture in the concrete to expand, breaking out pieces of the floor and sending everything flying. Many foundries use packed sand for a pouring floor. If this is impractical, spread a layer of sand everywhere the metal might go. Have a person with a shovel handy to scoop up any metal that strays off the sand and drop it quickly onto more sand. Make sure you have something heat-proof under the shank ring so you can set the hot crucible on it; I use a steel plate, ½-inch thick. Firebricks also work, or a layer of sand.

6. *Think.* The best safety equipment of all is your brain. First, think about what you are doing and respect the hot metal—it can burn instantly and very deeply. It can disfigure and it can kill. Work out the pouring routine with your partner with everything cold until the motions are smooth and easy and you can work together without a lot of need for talking.

I want to repeat that last instruction. Work out the pouring operation with everything cold until you are secure and comfortable with all aspects of the job. The moment when you are actually faced with hot metal is no time for improvising.

The Melt

Here we go. First, assemble and train your team. You should have three people to help with the melt: two to lift out the crucible and do the pouring, and a third standing by to catch any runaway metal with a shovel. Having three more people to remove and turn over the investments is also a good idea.

Place the proper crucible in the furnace, well centered. Sometimes the crucible will want to stick to the bottom block when it's hot. To prevent this, lay a piece of cardboard on the bottom block and put the crucible on that. It will burn out and the ash that remains will act as a release agent. A small sprinkle of sand on the block does the same thing.

You should try to gauge the amount of metal you will need by the weight of the waxes you invested. In general, it's a ten-to-one ratio of bronze to wax. If you heeded my instructions in the last chapter, each investment will have the weight of metal required scratched in the top. Increase each amount by about 10 percent for insurance, and combine the amounts from each investment to find the total metal you need to melt. Weigh your metal—both ingots and scrap. Add new ingots to the crucible, and then, if you have any scrap, fit pieces of scrap down the edges. If the melt requires more metal than you can fit cold, place the extra on the furnace lid to preheat, then add it slowly when the metal inside has melted.

Preheating an ingot on the furnace lid during the melt.

Always follow all instructions for lighting the furnace. In general, light it with the lid open and both the air and gas turned off. When the blower starts and the safety devices kick in, add gas to obtain a good flame, then add air along with more gas until the air is fully opened and the gas is such that you have the loudest noise you can get. Close the lid and fine-tune the gas for the loudest roar. You'll notice that with less gas the sound diminishes, and with more gas it diminishes. But there is a point in the middle where the sound becomes loudest, and that's what you want. Keep an ear out as the melt continues to be sure the furnace is running evenly.

The Pour: Solid Investments

While the metal is melting, get the investments out and ready to pour. Keeping them still upside down, use a portable shop vacuum to suck directly on the pouring cup, pulling out any small particles that have accumulated inside. This step really helps.

Now turn the investments right-side up, being very careful not to brush or sweep any crumbs from the top down the cup. If you have a large mold with a bottom drain, don't forget to put that steel rod plug back in the drain hole. Place the investments on a bed of sand so they can be reached easily by the pouring crew.

Let's assume the metal furnace has now been going for about an hour. Insert the bent steel stirring rod into the crucible and feel around for any lumps. Then watch how the metal runs off the end of the rod as you withdraw it. If there aren't any lumps and the metal flows neatly off the rod, use the pyrometer to see if the metal is hot enough. (With prac-

Two clean burned-out investments placed right-side up on sand, ready to be poured. The pouring cups have been burned off, leaving only holes.

tice, you will be able to judge the temperature very closely just by using the steel rod, so that when the pyrometer breaks down—and it will—you won't really need it any more.) What temperature is hot enough? In general, thicker walls of the wax will take cooler metal and thinner walls take hotter. Cool is around 1,950°F (1,066°C), and hot is near 2,050°F (1,121°C).

Your crew should be assembled and dressed in the proper safety gear. There should be one person for each end of the lifting tongs and pouring shank, plus one more standing by with a shovel to catch any spills. All other visitors should remain a healthy distance away. Try to have as much silence as you can for easy communication.

Turn off the furnace. Open the lid all the way. Yeah, it's hot. At this point remember to move slowly and deliberately. Don't rush, and don't do anything unpredictable. Reach down into the furnace with the lifting tongs and seat them on the crucible. But don't lift yet. Feel how well they have seated, and give a little trial lift of about an inch to be sure they are secure. Now lift with a clean motion, being sure to lift high enough so the bottom of the crucible clears the rim of the furnace; you don't want it hitting or

catching. Sometimes, despite your precautions, the base block sticks to the crucible and comes out with it. If this happens, hold the crucible in the tongs over a heat-proof surface (like a bed of sand), and get your third team member to gently pry the base block loose. Don't bang, just gently pry with the edge of a shovel or something. If it just won't come off, don't bang too hard or force it. Leave it and pour with it on.

Set the crucible down in the center of the shank ring. Remember, you should have some firebrick or a steel plate beneath the shank to protect the floor. Remove the tongs and set them aside.

Now skim the metal. The three skimmers should all be lined up, sooted, and preheated. Take the first one and skim right around the top of the metal. Immerse the skimmer about halfway, using a clean sweeping action to gather the impurities and pull them out. Be sure you have something hard to knock the skimmer against to dislodge the still-soft dross, and someplace heat-proof for that dross to go. If there is still foreign matter on the metal, use a second skimmer, and, if necessary, a third. Remember, no double dipping.

With the metal clean and ready, lift the shank level until it engages the crucible, then lower or attach whatever hold-down it has so it is secure (see illustration, page 155). The two pourers should stand up, move to the first mold, and pour the metal into the pouring cup. Pour in a steady stream, and as fast as you can. Try to keep the pouring cup full. This means you will be dumping in metal rather fast. As soon as the metal pops up the vents, and/or the cup fills, move on to the next mold.

Lifting the crucible clear of the furnace edge.

Skimming the molten metal.

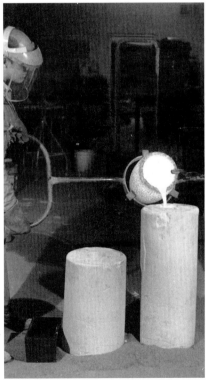

Pouring metal into a solid investment.

You don't want to run out of metal before an investment is full. Be sure you have enough in the crucible before you begin pouring. If there is any doubt, place the crucible back in the furnace and add more metal.

Most gas furnaces can be relit while hot without your having to shut down the air and gas valves and light as though from scratch. When you shut the furnace off to pour, simply press the "stop" button and leave the valves alone. If you need to melt more metal, replace the crucible, leave the furnace top open, and hit the "start" button. The blower will start up, it will blow for a moment, then the furnace will light, usually with a bit of a "whump." Then you can close the lid and remelt. (Always remember to heat new ingots on top of the furnace before placing them in the crucible.)

TIP

So what should you do if you *do* miscalculate, and you run out of metal before the investment is full? First, you groan. Then you melt more metal and pour it in. The two pours will not fuse but, if you're lucky, they will form a join that can be easily welded later. Once sculptor I know regularly casts pieces taking more than the crucible will hold, deliberately pouring twice and then welding the two parts together.

When you have filled the last investment, there should be some metal left. This you pour into the ingot mold(s). Then set the shank down, release the hold-down, and let the shank settle to the floor. Retrieve the lifting tongs and use them to replace the crucible in the furnace. Close the furnace lid, and you're done. Don't leave the hot crucible sitting out for two reasons: rapid air cooling is hard on the crucible, and someone might touch it or back into it.

The Pour: Ceramic Shell Investments

Pouring shell is the same as pouring solid in all the aspects of taking out the crucible, using the shank, and so on. The main difference is that you want to pour the shells while they are still quite hot.

Most foundries keep a trough of sand as a pouring area. In this trough they create some means to hold the shells upright. This can be holes dug into the sand, or steel racks of some kind against which the shells are leaned or braced. Work out how you will support the shells first, while they are still cold.

While the metal is melting in the furnace, the shells should be in the kiln, being fired to 1,800°F (980°C). They should be yellow-hot. Here is where pouring shell gets tricky, so you will need two teams of two people each. While one team pulls the shells from the kiln one-by-one and places them on the sand, the other team pours the melted metal into each shell as it appears.

Have the crucible out of the furnace, skimmed, and held in the shank before the first shell is pulled from the kiln and placed on the pouring floor. There is then almost

no cooling time before the metal goes in. Pour steadily, but go a little slower if you have not included any vents to allow air to escape through the porosity of the shell. If the piece has vents you can pour as quickly as the pouring cup will allow.

While you are pouring, the first team should be getting the next shell out of the kiln and placing it for pouring.

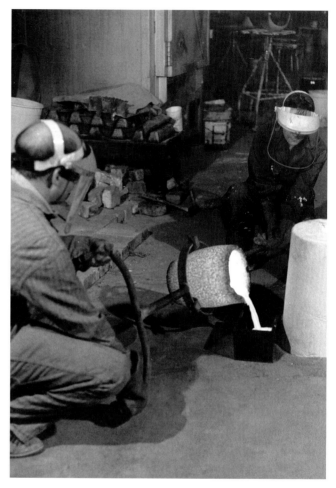

Pouring excess metal into an ingot mold.

SAFETY

Taking very hot shells out of a very hot furnace is tricky and dangerous. Work out this process when everything is cold; you don't want to improvise with red-hot shells. Usually long, strong, and secure tongs are used, along with highly heat-resistant clothing and gloves. Don't depend on jeans and denim jackets for this work. Buy proper metal cloth heat-proof gear—including gloves—from a foundry supplier. Make sure every tiny bit of skin is covered—any bare skin showing will burn. Standing with a red-hot shell in your tongs is no time to decide you should have put on a hat because your hair is burning off.

DEVESTING

This simply means removing the metal cast from the investment, whether solid or shell.

Devesting Solid Investments

When using Everdur you can devest a short time after pouring. I have seen solid investments poured with silicon bronze broken out ten minutes after pouring with no problem. Or you can wait until the next day—or next month, for that matter. I usually wait an hour. If you have poured 85 three 5 or a similar alloy, do *not* devest while hot and blast with water. The bronze will crack. Wait until the next day and devest cold.

The easiest way to remove a solid investment made with a lath basket is to chop with a hammer down the seam, cutting through the wires holding the basket closed. Then peel off all the wire. Next, use a heavy hammer and beat on the sides of the investment all around, filling it with cracks. Soon, chunks will fall off. You can often shake the pouring cup to remove more chunks. Be careful not to hit the bronze with the hammer or you will dent it. If there is chain wrapped around the piece it can often be pulled loose, popping off more investment. Be careful, that chain is hot.

When most of the investment is off, aim a strong stream of water from a good nozzle onto the cast and pop yet more off, usually getting just about all of it. At this point you can often aim the hose up into the core and remove most of that as well.

If you are removing the investment a day or more later and it is cold, squirting with a hose won't work—it'll just make a mushy mess. Instead, use a hammer to try to knock off as much loose investment as you can *without hitting the bronze*, and then bang on the pouring cup or an exposed sprue to knock more loose. Finally, you can use wooden chisels. Cut wooden sticks from hardwood, like maple or oak, and sharpen them on the disk sander like chisels. Use them as you would ordinary chisels to chip off investment and they won't mar the bronze. They dull quickly, but can be sharpened with a quick lick on the sander.

Devesting Ceramic Shell Molds

Wait a little longer for shell to cool, like several hours or overnight. By then some shell will start breaking off on its own. Gentle beating with a hammer removes a lot, as does banging on the pouring cup. You can also use a blunt chisel to pry off some of the bits. Blast off the more stubborn pieces with a sandblaster or work them away with a wire brush. Many foundries leave substantial amounts of core inside, and it doesn't seem to matter to the finished bronze.

Now you have a rough metal casting. Next comes cleanup and chasing.

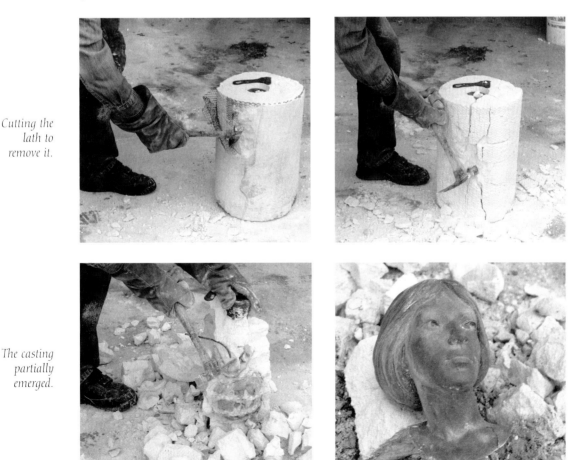

Cutting the lath to remove it.

Pounding on the investment to fill it with cracks.

The casting partially emerged.

The rough cast free of the investment.

CHASING

Chasing is the term for cleaning up, repairing, and refining your bronze cast after it has been removed from the investment. This chapter will follow a typical casting from the moment it is devested until it is ready for mounting and patina. It will also cover that all-important task of welding, both to repair and to assemble a multi-piece cast.

In centuries past, chasing sometimes took a year or more. But don't panic. Today chasing is often a rather brief task for three reasons: we have power tools; we allow the as-cast surface to remain (in past eras it would be completely reworked); and new technologies and materials enable us to cast better than in the past. With a good cast, chasing can be sometimes just a few minutes. Other castings call for rather more elaborate chasing efforts. And there is always the Holy Grail—what I call a "magic wand" casting—the one that needs no chasing at all!

CLEANING

When you have finished devesting, you will have a plaster- or ceramic shell-encrusted, rough-looking bronze lying on the floor. Your first task is to clean off the remaining investment so you can see what you have.

Sandblasting

If it is a solid investment, you can scrub the cast with wire brushes and water. This will clean it quite thoroughly. But a sandblaster is the preferred method of cleaning, since it is very thorough and is nearly indispensable later when it comes to patinas. If you cast in ceramic shell, a sandblaster is just about mandatory unless you want hours of picking away at the shell.

Air compressors
The number one requirement for a sandblaster is an air compressor. This can be a confusing area if you are just buying one. Here is some terminology to help you through the jungle.

Compressors come with either a horizontal or vertical tank. Either one is fine. The larger the tank, the longer you can use air before the compressor kicks on. The illustrations opposite show examples of the two sizes.

Air compressors can be powered with either electric motors or gasoline. Electric is more efficient and usual for

studio application. Gasoline motors are really for portable compressors you take out on the job. Unless you're a roving sculptor, get an electric one.

The motor will be rated in horsepower, or HP. Three HP is minimum, and 5 HP is about right for a typical small sculpture studio. More workers using more tools means a higher HP, like 7.5 or 10. Most compressors of any size will be 220 volts, which means you'll need to have a special circuit and electrical socket installed.

There are *single-stage* and *double-stage* compressors. Single-stage compressors ram their air with one piston. Double-stage versions ram it first with one piston, then ram that further with a second piston. The latter are more efficient, can produce higher pressures and volume, and are not much more expensive.

There are two numbers you should know concerning the air compressor's output. One is PSI (pounds per square inch), which measures the *pressure* it will produce. Most compressors will easily do 100 PSI. A typical 5 HP compressor will produce 150 to 175 PSI. The second number is CFM (cubic feet per minute), which is the *volume* of air the compressor can push out. Most CFM ratings will be at a particular pressure. The lower the pressure, the higher the CFM.

A small, 3-horsepower, horizontal tank compressor. This is suitable for a one-person studio.

A typical specification for a single-stage compressor might read:

> 5 HP
> Max. pressure 110 PSI
> CFM @ 40 PSI 11.8
> CFM @ 90 PSI 9.4

A typical specification for a double-stage compressor might read:

> 5 HP
> Max. pressure 175 PSI
> CFM @ 175 PSI 17.1

A larger, 5-horsepower, vertical tank compressor. This is better for a multiperson studio.

What you want is a CFM @ 100 PSI of 10 or more. Much less and you'll be constantly having to wait for it to catch up.

Your dealer can supply you with the necessary gauges and filters. The main gauge controls the PSI leaving the compressor, which you usually won't set above 90. You also need a filter that removes any dirt, but mostly water, from the line. Get the biggest one you can afford because water builds up in the tank and then comes misting out of the nozzle, clogging your sand flow and stopping up everything. Empty the water filter regularly.

Once you have a compressor, it is important to maintain it. This means changing the oil in the crankcase regularly, just as you would for your car. Failure to do so can ruin your compressor. And keep an ear cocked for any strange clanking noises as it runs. If you hear any unusual sounds, shut it down and get it fixed.

Other sandblast equipment

A second requirement is a place to sandblast. A sandblast cabinet is the most convenient, because the work can be placed inside, the lid closed, and you blast. You don't need to don heavy protective gear, and all the sand is saved Most industrial suppliers sell a variety of sandblast cabinets.

A sandblast cabinet.

If you don't have a cabinet, you can also use a bucket blaster, which you use outside and let the sand go everywhere. These are available from any number of suppliers, such as Sears or Harbor Frieght, and consist of a bucket on wheels with a hose coming out the bottom. Bucket blasters are gravity fed; the sand falls into the hose and is then drawn into the gun. There are also pressure systems that are more efficient, but the bucket system is cheaper and quite effective. If you use a bucket blaster, blast outside where some sand is not a problem. Actually, out on the lawn is a good place since the sand disappears in the grass. Don't blast inside, and particularly not where there is any machinery into which the fine sand could filter.

As for blast media, initial cleanup of your cast is best done with clean, dry, 80-grit sand—the same that you buy for your investment mix. We'll talk about more refined blast media in Chapter 17 when we discuss patinas.

A bucket-type sandblaster.

Removing the Sprue System

Usually your best next step is to remove the sprue system. There are several ways of doing this, so here are a few. You will probably use all of these at one time or another for different situations.

■ *A plasma cutter.* A plasma cutter works like an arc welder, with compressed air blowing out a tip, and will cut virtually any metal with ease. The machines are expensive, but well worth the money as soon as there is any significant production. When using a plasma cutter be sure to receive training from the distributor, and follow all instructions. A plasma cutter will quickly remove sprues and gates from even the most convoluted and cramped quarters. (Plasma cutters will be discussed further on page 173.)

■ *Cutting discs.* These are available from industrial tool suppliers, particularly those catering to the automotive repair industry. Sometimes called *muffler cutting discs*, they are about 4 inches in diameter and very thin. They fit on a standard 4-inch disc grinder. To use, bear the edge of the disc against the gate or sprue to be cut until a slice is made. But here you need to be careful: the disc will bind very easily. The solution is to keep backing out and widening the cut you are cutting more of a "V" shape than a narrow slot. Be particularly careful near the end of the cut as that's a point where the blade tends to bind.

■ *An oxy-acetylene torch.* A large tip on an oxy-acetylene torch will melt the gates away. Do not try to use a gas-cutting torch because it won't work on bronze; they are designed to burn steel with pure oxygen, which doesn't work with metals other than steel. To use a regular torch, put on a big tip and then just play the flame's inner tip wherever you want to cut and wait while the bronze heats. Soon the metal will begin to melt and drip, and you can work the flame back and forth to increase its action. When nearly through you can often break the gate off as the hot bronze will be soft.

■ *A hacksaw.* A hacksaw in good hands is a wonderful tool. It will cut with great precision in any place the saw can be manipulated. Buy the best blades you can—cheap ones are for amateurs. Always remember that with any mechanical cutting tool, it's the part that actually does the cutting that counts the most.

■ *A band saw.* Some foundries cut off gates and sprues with a power metal-cutting band saw. This can be very tricky, since if the blade should bind even a little it can jerk the casting down, making the blade bind even more and usually breaking it. So the band saw should only be used when the piece can be guided through with complete stability.

■ *An abrasive cut-off saw.* This refers to a bench-mounted 12- or 14-inch disc saw with a downward chopping action. Again, only use this tool if the piece to be cut can be very securely fastened. This tool is mainly handy for cutting already cut-off sprues to shorter lengths for remelting.

Most gates and sprues will come off rather easily with one or more of these methods. But what about gates down inside a casting? First, you'll need to remove the core to get at them (see below). Then there are really only three ways to remove the gates: with the plasma cutter, with the oxy-acetylene torch, or by dumb luck (don't laugh).

A plasma cutter can often be made to reach inside a casting to cut off gates. If so, fine. Often, however, it won't reach deep enough, and you have to use the oxy-acetylene torch to melt the gates. This is tricky and can be dangerous. The problem is the supply of oxygen to the torch. When inside a sculpture, the flame quickly uses up the available oxygen and burns differently, usually with an excess of gas, thus large flames emerge from the casting. To offset this you need to add more oxygen.

Here's how: using a large tip, adjust the flame to be neutral and then insert the tip about 2 inches into the opening of the casting. Wait a moment. If the flame changes, try adding a little more oxygen until it settles down. You may need to adjust the acetylene as well. Now insert the tip deeper, and adjust again. Be patient. You are looking for an adjustment that allows the flame to burn steadily without sending soft flames out the opening. When you have reached that adjustment, proceed to melt off the gates inside. But don't do them all at once. Cut one, then pull the torch out and shut it off to cool a while before cutting the next. (It is important to note that using an oxy-acetylene torch this way is a dangerous operation. Be sure you are wearing heavy gloves, a heavy jacket, and proper welding goggles *plus* a full face shield. Most importantly, *don't attempt this unless you are experienced with oxy-acetylene torches.*)

Finally, there is the dumb luck method. I have found that if you run a ¾-inch sprue down the center of a head, then reduce it to ½ inch for the last 2 inches it will often shrink right at that spot and break off easily in your hand. (This option was described on page 132.) It works about half the time, and even if it doesn't it's a lot easier to melt through a ½-inch sprue than a ¾-inch one.

Removing the Core

Once all the external sprues and gates are off the piece, you can remove the core. For solid investment, this is a rather easy task. The best tool is a length of ¼-inch steel rod, heated and flattened into a blade at one end and then chucked in an electric drill. Just run this in and out of the core many times to create all kinds of holes. Hold the sculpture over a garbage can, with the opening facing down, and use a hammer to bang on gate stubs and knock the core loose. Keep using the drill and banging and most of the core will eventually come out. You can also make scrapers from steel rods, and bend them to reach around corners inside. Once you feel you have removed all you can, fill the cast with water, let it soak overnight, and then give it several rinses. It should come out quite clean.

Hydrochloric acid will help break down core material, but it will leach into the porosity of the bronze and cause problems later. If you use it, I can almost guarantee that you'll wish you hadn't later on. You can also use strong industrial ammonia, but the odor is so bad it's not worth the trouble.

To remove the cores from shell casting if there is a plaster-based core, use the same techniques. If the core is shell, blast out all you can with the sandblaster, and generally leave the rest. Unlike plaster-based cores, it won't hurt to leave some ceramic shell.

REPAIRING AND REFINING

Once the sprue system and core are gone and the casting has been blasted clean once more, inspect it carefully to get an idea of what kind of chasing you will need to do. Here are the kinds of surface problems you will encounter:

■ *Flashing,* or fine fins where metal has run into cracks in the mold. Flashing can be prevented by wrapping the initial investment liberally in chain (see page 140).

■ *Beads and globs of metal* resulting from bubbles introduced when the investment was applied incompletely.

■ *Scabs,* or areas of metal that have flowed behind peeling layers of investment. Scabs will have a fine layer of investment beneath them, usually leaving a shallow depression.

■ *Holes,* which can be of several kinds. A *gas hole* will have an edge that is concave, as if it is surrounding an invisible bubble. A *mis-run* is metal that has frozen before the investment was filled. The edges of these holes will be convex, as if the metal is flowing and cools too quickly. Sometimes mis-runs are caused by the core shifting, cutting off the space where the metal is supposed to flow. Other types of holes include those left by core pins and areas of thin wax.

■ *General surface problems,* such as a crusty surface, wrinkles from a first investment layer that ran and drooped on the wax, and so on. There's a good remedy for general surface problems: recast.

■ *Joins in the metal.* When casting, it is very common to cut the wax into sections for ease of casting, or to cut windows in the wax for shell cores. Once cast, these sections have to be rejoined by welding, and the welds need to be blended so they are invisible.

The first thing is to remove any flashing, and the easiest way to do this is to cut it off with a small, cold chisel and a lightweight hammer. You can soon develop the technique of "snipping" along the flash with a chisel. Just imagine the chisel blade to be one blade of a scissors, and use it to cut the flashing off in a long row. You can also use the cold chisel to remove any small beads or other extra lumps of metal resulting from incomplete application of the investment. The cold chisel will also pry up and chip off any scabs.

At this point a quick second sandblast is usually a good idea.

Left, a gas hole (with concave edges); right, a mis-run (with convex edges).

An example of flashing.

Removing flashing with a chisel.

Tools

Once you have done all you can with the chisel, it's time to get serious. Chasing tools fit in several categories. There are disc grinders, die grinders, and sanders of various kinds. There are also hammers, punches, and other chisels,. And lastly there are files, rifflers, sandpaper, and various rotary sanding devices. The following is a list of the most important chasing tools to have on hand.

■ *4-inch disc grinder.* This is a very handy tool that can be fitted with a standard abrasive disc, the kind that comes with the machine. It can be used for all sorts of rough metal removal, from heavy flashing to large extra gobs to the initial grinding down of welds. It can be a heavy metal remover or a delicate one. And it can hold cutting discs, which are also very handy for removing sprues and gates.

■ *¼-inch die grinders.* These come in two varieties: electric and air. Both turn a collet chuck, which will hold ¼-inch shank carbide burrs, at around 25,000 rpm. You should always use solid carbide burrs, as the high speed steel or vanadium steel burrs dull far too quickly on

SAFETY

Any long hair must be pulled well back and secured when using a die grinder. If you don't, you risk catching your hair in the grinder, which will quickly become wrapped around the tool, yanking it up to your head and ripping out a piece of scalp. Sounds painful, doesn't it?

TIP

Don't drop a ⅛-inch air die grinder or you are likely to ruin it. They come with a section of air hose attached. Make a tie of heavy cord near the end of this hose and attach it to a hook at the back of your bench, so if you drop the tool it won't hit the floor. It could save the tool.

bronze. The best burrs (sometimes called *rotary files*) are those shaped like cones, pine trees, or even balls. Buy the very wide-grooved ones for aluminum. Electric grinders are handy if you don't have a compressor, and I feel they have a bit more power. Air die grinders are much smaller and can reach in tighter places.

■ *⅛-inch die grinders.* These are air-powered tools, about the size of small cigars, with ⅛-inch collets for the smaller rotary files or burrs. Again, only use solid carbide. You can buy a Dremel tool rather inexpensively and it will work fine, although it spins only about 25,000 rpm instead of the 50,000 or higher that's usual for an air tool. A good source for relatively inexpensive air die grinders is Harbor Freight. Theirs cost about $85, while many others are over $400. Of course, the quality is usually tied to the price.

■ *Sanders.* Sanding discs can be fitted to a 4-inch disc grinder. You can also buy air-powered sanders, which work well. There is a very valuable tool called a random orbit sander that is usually air powered, but electric ones are also available. The random orbit sander moves a sanding disc in a wiggly, random pattern, eliminating swirl marks in the bronze. Other sanders include small, air-powered belt sanders, and right angle grinders, which hold 2-inch snap-in, snap-out discs or cross pads. These are very handy.

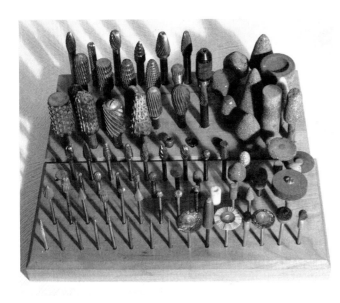

A collection of rotary burrs for die grinders. The burrs in the front block are ⅛-inch shank; those in the back block are ¼-inch shank.

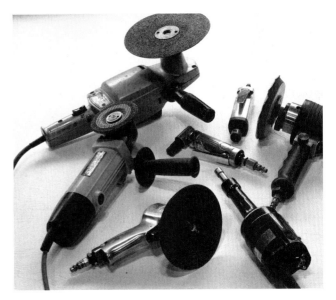

A collection of power grinders for chasing. Clockwise from top: 7-inch electric disc sander; ¼-inch air die grinder; 5-inch air random orbit sander; ¼-inch electric die grinder; 6-inch air disc sander; 4-inch electric disc grinder; (center) ¼-inch air angle die grinder.

■ *Hand tools.* This category includes cold chisels—buy a range of sizes, including a nice small one—hacksaws, hammers, and punches. Punches, sometimes called *matting tools*, have textured ends and are good for banging a soft texture into worked bronze. But silicon bronze doesn't respond well to them and they are falling out of use somewhat. If you can find a set, they are useful on occasion. Files are very handy and come in many sizes and varieties. Small files with rounded ends are called *rifflers* and are good. Buy several kinds and sizes, and remember, files grow dull like everything else, so buy new ones occasionally.

■ *Rotary wheels.* There are many rotary abrasive wheels that work well for a final surface on bronze. Heavy paint-removing discs work well in an electric drill. Sandpaper *flap wheels* are

Some matting tools, which are small punches used to enhance the texture of the bronze.

also good; use them with lower speeds, like an electric drill. *Cross pads* can be used with a 25,000 rpm die grinder and many chasers swear by them. There is a product called Aluma lox, which is a wheel of plastic strands imbedded with abrasive that works to impart a soft unifying sheen on bronze. And a good old wire brush wheel used in a drill, in a 4-inch grinder, or on a bench grinder, is very handy.

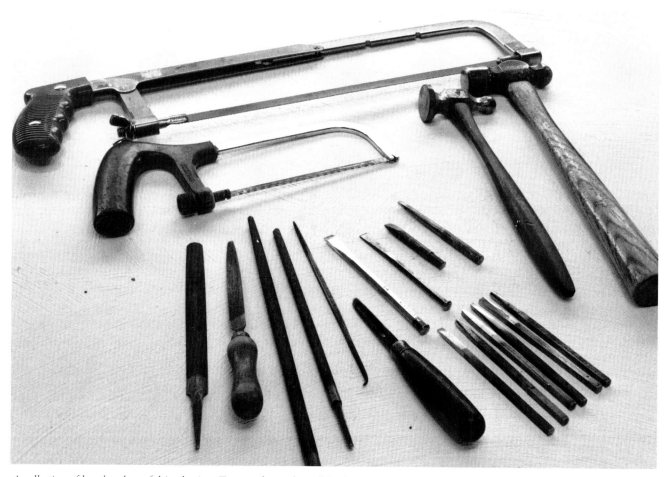

A collection of hand tools useful in chasing. Top: regular and small hacksaws. Bottom, left to right: five different files, machinist's scraper, four cold chisels (above), six matting tools (below), hammers.

Techniques

Your task in chasing is to remove all signs of anything but the original modeling. That means grinding down any bumps, joining parts, welding holes, and then blending the surface to look untouched.

You will use lots of tricks to do this, but some you will use more than others. In general, you can use the 4-inch disc grinder to remove heavy metal deposits. Practice until you can use it delicately. It can be done. It's particularly handy for the initial grinding-down of a weld bead. Be aware that when one of those 4-inch wheels is new, its edges will be sharp and will tend to dig in. Use a new one for heavy work; when it gets nicely rounded it is better for finer work.

Try to *contour* the metal with the disc grinder, getting the overall outline right. Next, use the ¼-inch die grinder with a good carbide burr to work over the area, removing the marks of the heavy disc and refining the form.

The next stage is to use the ⅛-inch die grinder to re-create—carve, actually—any texture that should lie across the worked area. If you used a hook tool with slight serrations on the clay, leaving tracks, then you can use a carbide burr cut with a diamond wheel, as shown at right, to re-create those tracks in the bronze. If the surface is a series of small pellets pressed in with the fingers, use a pencil to draw where you think some should be on the bronze, then carve around them with a small die grinder and actually re-create them. It works. You can even replicate fingerprints with a small chisel carefully used.

To see if what you have done matches the rest, give the worked area a heavy brushing with a wire brush, preferably powered. Or you can sandblast the area so the sheen is gone and you see the actual form without a color change throwing you off.

WELDING

Sooner or later you will have to weld. Welding can be required to assemble separately cast pieces, or to fill holes and build up depressed areas. There are six ways to join pieces of a casting: Heliarc, or TIG, welding; MIG welding; oxy-acetylene welding; powder torch welding; silver soldering; and cold joining. The latter two are not actually welding, but are additional alternatives for joining pieces of metal.

Heliarc or TIG Welding

The principle of this machine is that an electric arc is struck between a tungsten electrode and the bronze, heating the bronze to melt a puddle. Meanwhile, argon or a similar inert gas is pumped through a nozzle surrounding the electrode to produce an oxygen-free atmosphere. A rod of metal matching the bronze is then fed into the puddle with the other hand, melting into and enlarging the puddle and creating the weld.

Heliarc is short for helium arc, because helium was once the inert gas of choice. Today argon is more frequently used, and the term *argon arc* is heard on occasion. More common is the term *TIG* which stands for tungsten inert gas.

A ⅛-inch shank rotary burr, cut with a diamond wheel. On the bronze it can reproduce the marks a hook tool made in the clay.

TIG machines are expensive, but are nearly indispensable for welding bronze. If you can't afford one, you may be able to take your pieces to a local welder who has one (they are used for welding aluminum, so they are quite common) and bring your own rod. Always buy silicon bronze rod, or be sure you are getting Everdur rod. If you are casting in other alloys, either try to buy rod in that alloy, or cast your own. Some people cast a thin sheet and saw it into rods. Rod comes in several sizes. The smallest—1/16 inch in diameter—is only for very small things. Your workhorse rods will range from 3/32 to ⅛ inch.

To weld with a TIG unit, you should first read the manual very carefully so you understand all the switches and gauges. For welding bronze, you'll use DC straight current, with *continuous* high frequency, as opposed to "start only" or "off." Most machines give you three separate ways to control welding power:

1. A large lever allows you to choose "low," "medium," or "high" power. The medium setting will do most of your work.
2. A dial on the front of the machine gives you a finer range within whichever setting you choose.
3. The foot pedal gives you a third range within the other settings you have chosen.

All electric welders work on the principle that the arc is a current that passes from the electrode (the thing you hold) through the work (the sculpture) and then back into the

The control panel on a TIG welder.

SAFETY

The light from a welder is about twenty times as strong as sunlight. It will blind you—permanently. Don't mess with it. Always use a proper arc welding hood with at least a number 10 glass. The new hoods with instant darkening lenses are fine (be sure to get one rated for TIG machines). Otherwise, the old-fashioned kind work just as well. It's also a good idea to hang a heavy fire-retardant canvas curtain around the welding area to protect the eyes of those working in the same room.

It's also important to protect your skin. If you burn like a lobster after two hours in the bright sun, any unprotected skin will look the same after only twelve minutes of welding. Honest. Cover up. Wear a heavy shirt, buttoned up around the neck and with the sleeves down, and good gloves.

Finally, while TIG welding does not produce as many fumes as straight arc welding, it is mandatory to have some level of ventilation, even if nothing more than a good fan at your back.

machine through a *ground*. The ground is a heavy wire with a strong clamp, which must be clamped to either the sculpture or to a steel plate on which the sculpture rests. It's preferable to clamp the ground onto the sculpture because the grounded steel plate method, while faster and easier, may create small pits in the bronze, created by arcing between the sculpture and the plate. The secure clamp on the piece itself eliminates this.

The next requirement for welding with TIG is gas. A bottle of argon gas should be supplied with the welder, and it should be turned on. The usual gauge is a vertical plastic cylinder with a ball that floats in the gas stream. With the gas running, adjust the ball until it is about one-third of the way up the tube.

The illustration opposite, top, shows a complete weld booth set up for TIG welding.

Now to weld. First, adjust the electrode. Take the torch apart by unscrewing the ceramic nozzle, then unscrew the cap at the back of the electrode and take the whole thing apart. Next, you need to dress the end of the electrode. Grind it to a point on the bench grinder, like sharpening a pencil, but finish so the lines of the grinding run down the length of the rod, rather than around it. Reassemble the torch so ¼ inch of electrode sticks out beyond the ceramic nozzle.

Lay a piece of scrap on the table, and clamp on the ground clamp. Turn the welder on, set the power to medium, and set the fine power gauge to the upper end of its range. Select a

A TIG torch, taken apart. Left to right: end cap, electrode, collet, body of the torch, ceramic nozzle.

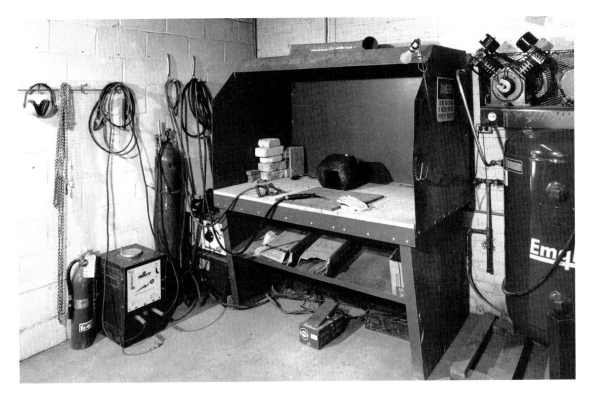

A TIG
welding
booth.

The argon gauge on a TIG welder. When in use, the ball should ride about one-third of the way up the tube.

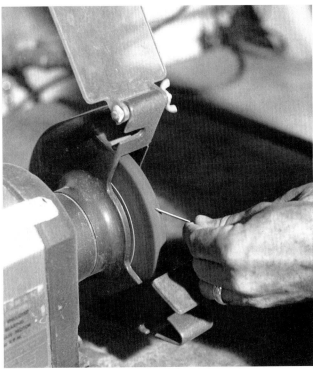

Grinding the electrode. It should come to a sharp point with the lines of the grinding running down the electrode, not around it.

The electrode protruding the correct amount for bronze welding.

³⁄₃₂-inch rod, and sit down on a stool so your foot is resting lightly on the foot pedal.

Now, if you flip your helmet down, you won't be able to see anything. Here's what to do. Lay the tip of the tungsten electrode about ¼ inch from the bronze and hold it there. Flip the helmet down with your free hand, and press the foot pedal. You should get an arc, and you will be able to see by that arc. If you have one of the new instant dark helmets, this won't matter. You will be able to see the work without an arc, and then the instant the arc begins, the glass darkens. These new helmets are expensive, but wonderful.

Your first task is to control the arc. Notice how it changes if you move the electrode further away or closer to the bronze. Notice what happens when you press the pedal all the way down, and then back off. Try to create a puddle of melted bronze on the scrap piece, and then try to elongate that puddle, dragging it along into a little river of melted metal.

After you can create these long rivers of metal (called *beads*) with confidence, create a puddle and just touch the tip of the rod into the puddle until some of it melts off, enlarging the puddle. This is the basic action of welding. The mistake most beginners make is to melt off the end of the rod with the electrode, depositing globs of metal on the casting. The metal won't fuse that way. So the rule is: *no puddle, no rod*. In the illustration below, you can see globs on the left that have not fused to the bronze, versus some pools on the right that are well fused. If you get globs, you can fuse them by concentrating the arc on them and pressing the foot pedal harder. Watch carefully as they begin to flow out and fuse

with the base metal, then back off the pedal. Practice creating a glob of metal by melting some of the rod off, and then using the torch alone to meld it in and flow it out. Once you feel confident creating a controlled bead of metal by making a river and then extending it with melted rod, you are ready to try welding on your sculpture.

You may experience some problems. One common problem is melting away a thin part of the casting. You apply some heat and *bloop*, the hole you were trying to close just got bigger. This is typical if the hole is caused by a shifted core that leaves a thin wall. The solution is to use gentle heat (ease off on the foot pedal), but let the thin metal retreat back until it gets thick enough for you to add to the edge. As the edge grows thicker, you can begin to add a bead along the edge to start making the hole smaller. Add a little, wait for the area to cool, add a little more, wait again, and keep going until you can close the gap. The trick here is to keep letting the metal cool. If you don't, the heat will build up and then it's *bloop* again.

Another common problem is cracking of the weld. In general, you can weld in one spot once, and usually twice, but three times or more is asking for trouble. If you go over the same area many times the weld is likely to develop cracks as it cools. There are no really good solutions to this, but this one often works: use a 4-inch disc grinder and grind out much of the cracked weld, leaving a rather large groove. Now weld that shut and cross your fingers. Another trick to try is welding the crack shut and then immediately, while it's still hot, peen along its length with a ball peen hammer.

Sample welds on a bronze plate. Left: With too little heat, the welded metal doesn't fuse properly to the plate. Right: With the correct amount of heat, the metal will fuse.

Cracking can also occur when you weld two ends of the same piece. For example, suppose you have a figure with its hand on its hip, and you have cut off and cast separately that angled arm/elbow section. You weld on at the shoulder. Fine. Now you weld on at the wrist, and it cracks. That's because it can't move while it cools, and hot metal is very prone to cracking. The solution is to *tack weld* it on both ends, which means adding just a few spots of weld here and there. Now add a little more weld on each end. Let it cool completely. Keep adding a little more welding on both ends, allowing it to cool each time, and you should be all right.

You can use welding to fill any depressions in the form. I like to identify a depressed area by drawing its edges with chalk, which I can see through the mask. Then I lay a bead across the middle of that area, building it up to what I believe to be the right contour. At that point I take a grinder and actually grind the top of the bead to be just the right contour I need. At this point, your weld will look like the Great Wall of China marching across the depressed area. I then lay another bead, crossing that one at right angles, and grind again. I try to get the tops of the beads to define the new surface I want. I add more beads, then fill in the quadrants between beads, and I will have built up an entire area. It can then be ground to a good contour, any low spots refilled, and finally worked to match the surface texture.

MIG Welding

MIG, which stands for metal inert gas, is a cousin of TIG welding. It is based on the flow of argon or another inert gas out a nozzle at the torch tip, which allows the metal to flow in an oxygen-free atmosphere. In TIG welding the electrode is tungsten, which does not melt away. But in MIG the electrode is the actual weld metal, so there is no rod held in the other hand.

The MIG torch feeds a thin wire of the required alloy, which acts as both electrode and filler metal. There is a motor that feeds the wire forward when the trigger is pulled. To use, you strike the arc as with a TIG, but then you merely follow along, allowing the ever-advancing wire to fill the weld.

There are both advantages and disadvantages to MIG welding. The biggest advantage is that it is fast and relatively foolproof for long, repeated welds. Once set up with the proper wire size, wire feed rate, and power for a particular weld, it will run beads perfectly with just a simple forward motion of the torch. For this reason, MIG welding is sometimes called *automatic welding*. It is the main form of welding for robots that assemble cars and other products automatically.

In the sculpture studio, MIG welding is very good for fabricating things out of bronze plate. It is also good for long welds joining various sections of large castings. Its main disadvantage is a certain clumsiness for repairing odd holes, for just a bit of filling in, and that sort of welding. For that, a TIG offers much more control since there is no wire forcing itself into the weld.

An MIG welder.

Many foundries use MIG welders, and silicon bronze wire is now available. If you purchase or obtain a MIG welder, study the instruction manual for your particular machine carefully, and practice on scrap metal.

Plasma Cutting

A *plasma cutter* isn't actually a welder. In fact it's the opposite of a welder, because instead of joining metals it cuts them apart. It is included here because it is a large metal-working machine rather like a welder, it is likely to be placed next to your welder, and it works rather like a welder.

If you've ever cut steel with an oxy-acetylene cutting torch you know how it can cut. It's fast, it makes a shower of sparks, and it slices right through steel. But a cutting torch will only cut steel—it relies on the fact that steel burns when made red-hot in the presence of pure oxygen. Bronze won't cut with a gas-cutting torch; it just gets hot.

A plasma torch works on a very different principle. Air passes through an electric arc and becomes a plasma, whatever that means, which then conducts electricity. This electric charge is carried to the metal, heating and melting it, and the stream of compressed air blows the melted metal away. It's fast and cuts cleanly, and will cut virtually any metal. There

are various brands on the market, most rated for the thickness of metal they will cut, with ½-inch sizes being rather small, ¾-inch sizes larger, and the 1-inch size being a pretty hefty machine. Naturally, the price goes up with the power.

To use, first read all the instructions very carefully. After the machine is set up with the proper power and air or gas supply, and after you have a ground clamp securely attached to the metal, hold the torch tip near the metal you want to cut and press the button on the torch handle. Compressed air will flow out the tip for about two seconds, then a small arc called the *pre-arc* will begin at the tip. With that small pre-arc going, hold the tip very close to the metal. The pre-arc will change to a cutting arc, with a stream of metal flying out the back side of the cut. You can now move the torch along to make the cut.

When you cut thick sections, such as a sprue, watch the actual advancing surface of the cut and be sure you don't overrun it by moving the torch too fast. Let it work its way through. Be patient, and it will eventually make the cut. To cut very straight lines use a straight edge or guide.

The big disadvantage with plasma cutters is that there are several parts to the tip that will deteriorate and cause poor cutting. There is some kind of removable screw-off cover or tip guard that will become corroded and pitted with time; when it does, it should be replaced. Inside the tip are several parts—usually an electrode, a gas lens, and the tip itself, although these may vary with the kind of machine you buy. Both the tip and the electrode will wear out with use. Inspect them regularly, and replace them when they show obvious signs of wear. If the torch is cutting slowly or erratically, nine times out of ten the tips need replacing. You can prolong the tip's life by giving it a frequent and light wire-brushing. Also, try not to cut in such a way that you blow the cut back on the tip.

Oxy-acetylene Welding

This system involves a gas-burning torch that simply melts the metal. It is a complex system involving dangerous gasses at high pressures, plus a flame over 7,000°F (3,870°C), which can do serious damage. Before buying and using oxy-acetylene equipment, be sure to obtain, read, and understand a complete set of instructions, available from your welding supply source. Even better, take a welding course from a local school.

You can weld silicon bronze with oxy-acetylene, but since there is no stream of argon to drive off oxygen, you need to use flux to keep the metal from oxidizing. A gas flame does not put out nearly the intense heat of an electric arc, therefore it takes some time for the heat to build up with a gas torch. You need to be more patient than with TIG and let the metal reach heat, then begin to puddle. After that, the action is very much like a TIG, with one hand working the torch to maintain a controlled puddle, and the other hand feeding the rod into the puddle.

There is also, however, the flux to worry about. Buy Brazo flux, which is a white powder that comes in a can. Use the torch to heat the area you are going to weld, and when it is a little bit hot, sprinkle a pinch of flux on that spot. Now heat the end of your rod a bit and dip it in the flux to coat it. As you weld, continue to dip the hot rod in the flux from time to time. The flux will form a glasslike deposit on the metal, which will have to be removed completely before applying any patina. You can get most of it off with a small hammer, tapping lightly on the beads; a sandblaster or power wire brush should remove the rest.

An advantage of the gas torch is control. With a TIG you either have an arc or you don't, and it's often hard to turn the arc down to the point where you can weld very thin metal. With a gas flame, however, you can move the flame closer and back for perfect control. So when I want to weld something very delicate, I use gas.

Powder Torch Welding

This is a rather rare and little-known form of welding. It uses an oxy-acetylene torch that looks something like a gas-cutting torch, with a lever handle to add extra gas. On top of the torch is a fitting to which you screw a small bottle containing metal powder.

To use, the flame is played on the area to weld until it is quite hot, then the lever is pressed. Extra gas flows out, carrying with it a stream of metal powder that deposits itself in the weld, instead of melting a rod.

My friend, the late Roel d'Haese of Belgium, used this method and swore by it. He felt that it created a more uniform flow of metal and was faster than his TIG. It is good for coating an area with new metal, such as an area with excessive pitting. A disadvantage is the relatively high cost of the metal powders used.

Silver Soldering

This is an excellent way to fasten bronze parts together when you don't want the bulk of a weld fillet. Silver solder is strong and nearly invisible. It is more like glue than welding. You can buy small coils of silver solder wire at your welding supply store. You must also buy a jar of silver solder flux to match. To use, follow these four rules:

1. *The joints must fit well.* The liquid silver solder is drawn into the joint by capillary action, and the better the fit the more it will be drawn in.

2. *The surfaces to be joined must be clean.* Use sandpaper, a wire brush, or a sandblaster on the two surfaces until they are bright and shiny.

3. *The joint must be well fluxed.* Apply the liquid flux to the two cleaned surfaces. If you want to avoid solder flowing elsewhere, you can buy solder resist from a jewelry supplier and it will inhibit the flow to areas where it would be unsightly.

4. *The joint must be the correct heat.* To find the correct heat, begin to heat the joint with a torch. Oxy-acetylene works well, as does propane, if a bit slowly. When the joint is getting hot, apply a touch of the silver solder wire. You can melt a tiny drop off with the torch, and then, as the joint gets hotter still, it will suddenly melt out and flow into the joint. At this point work the flame around all sides of the joint until you see the bright shiny line of solder just appearing. You can add a bit more of the wire if necessary. When the solder shows all around, quit. Don't move the piece until cool.

Cold Joins

Up until the twentieth century welding was unknown, and bronzes were joined cold. This was done by first casting overlapping joints, then drilling holes through the joints, inserting bronze pins through the holes, and expanding the pins by hammering. I suppose a true purist might want to try this technique, but two words of advice: first, don't try it with silicon bronze. It's just too hard to form by hammering. Use something like 85 three 5 instead. Second, cast a small extra ridge around each side of the joint to give you some extra metal to chase (or hammer) down into the joint to close it after the pins are in. You then file this extra off.

You may find a need now and then to join by a cold means more modern than pins. The most common is drilling, tapping, and bolting. We live in a wonderful world where there is a huge wealth of machine tools available: drills, taps, and dies are just a few. Drilling and tapping will be covered in the next chapter.

Another way to join metal while cold is with glue. Consider that many jet planes are glued together. There are some good glues on the market. You might want to use glue to repair a small, nonstructural broken piece of a work where welding or soldering would ruin the patina. Epoxy glues are probably the best, over all. Instant glues are good, but generally not as strong.

The main concern when gluing is cleaning the areas to be glued so no trace of grease, wax, or oil remains. To do this, use Carbo-Sol or a similar product. The larger the surfaces to be joined, the better. Don't try to glue a small figure broken off at the ankles. It won't hold. In that case you have to silver solder and repair the patina. And in some cases you can drill holes into the two broken parts and insert a short piece of steel or bronze rod.

A final word on chasing. As mentioned at the beginning of this chapter, in centuries past chasing sometimes took a year. This kind of attention produced wonderful bronzes with silky flawless surfaces, but it assumed the casting to be a sort of blank that was then carved into the sculpture. Today we aim more at bringing the casting back to the original clay form. When you're anxious to quit chasing and get to that patina, be sure to look carefully everywhere on the piece, to wire brush it or sandblast it thoroughly, and to be hypercritical of flaws, because once the patina goes on there is only one way to fix things, and that is to take the entire patina off and begin again. Chasing can sometimes make or break a piece, so give it your best efforts.

BASES AND MOUNTING

Not all sculptures need bases. Some stand perfectly well on their own, or are modeled with an integral base. When you are creating a work, begin to think right from the beginning about how it will stand or be presented. A standing figure, for example, might well be modeled with a small base in clay that will eventually become metal, and that may be all that's needed. This chapter will introduce many types of bases for you to consider, and show you how to prepare your sculpture for mounting.

Figures in chairs, kneeling figures, horses on three or four feet, and such can often do without a base entirely. But most sculptures will need some sort of support to hold them securely upright. Often, a simple flat slab of metal can serve the purpose, or a flat polished rectangle of stone or wood. In those cases the base is intended to be like the perfect English butler, fulfilling a function discreetly and unnoticeably.

But bases can be much more than that. In the case of my sculpture *The Gymnast* (shown on page 178), the base is not only the balance beam, but also a surface to hold the commemorative plaque, since it was a presentation piece. And in my sculpture *Reflecting* (shown on page 180), the base becomes part of the sculpture, as the floor of the room in which the woman stands.

The base can also operate like the frame of a painting, setting the sculpture apart from the world, lifting it and defining it as fine art. Most smaller pieces ultimately rest on a pedestal, usually a simple box designed to lift the piece from floor to eye level. Sometimes the base and the pedestal become one. And in some cases, the base is clearly part of the work from an artistic standpoint. Constantin Brancusi, the great Romanian sculptor, used to carve elaborate base/pedestals out of roughly hewn wood. These bases lifted his delicately polished works above the tramp of ordinary life into a realm of ideal perfection, something like a temple object.

Bases have style, just like the work itself. Sculptors in the western United States prefer walnut, usually contoured to fit the shape of the piece, sometimes with a marble slab inset into the top and sporting a small brass label on the front with the work's title and the artist's name. Sculptors looking more to the European tradition—and this would include most sculptors in the eastern United States—prefer a simple black marble cube or slab, with no form-following contours and no brass name tag. It is often the sign of the amateur or folk artist to make bases of unusual materials like gnarled wood, lumpy boulders, and that sort of thing. So the very style of the base can say something about the artistic origins and intent of the sculpture that sits on top.

It's always a good idea to visit as many museums and galleries as you can, and when you do, pay attention to the bases—what materials are used, what sorts of shapes they are, whether they make outspoken bold statements or recede quietly. And look at how the sculptures are mounted. Some will be mounted cleanly and invisibly, while others—and this occasionally includes sculptures by big-deal artists—will be mounted in the most awful way, with huge, even rusty, bolts sticking out in plain view.

TIP

You want to do all the mechanical jobs necessary to mount your piece on a base *before* applying the patina, which is why this chapter comes before the one on patinas. The sculpture should not actually be mounted, however, until after it has been patinaed and waxed.

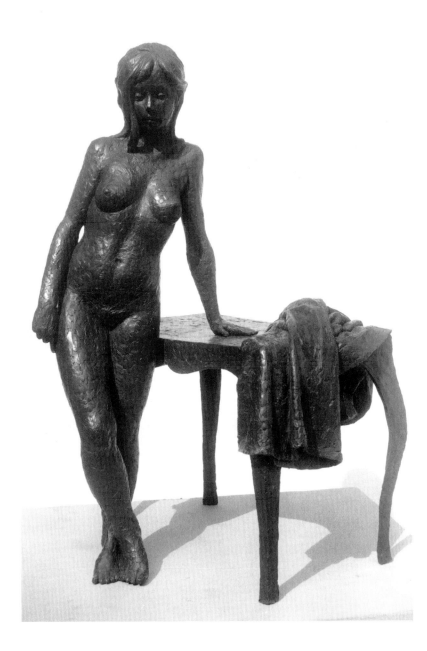

The Table, *Tuck Langland, 1992. Bronze, 22" (56 cm) high. An example of a piece that needs no base.*

Masai Mother, *Tuck Langland, 1993. Bronze, 20½" (52 cm) high, edition of seven. An example of a simple wooden base, with the piece floating above it.*

The Gymnast, *Tuck Langland, 1991. Bronze and bloodwood, 15" high. World Gymnastics Federation. An example of a base that is part of the sculpture; this one is also designed to hold a commemorative plaque.*

Mlle. Pogany, *Constantin Brancusi, 1919. Veined marble, 17 ⅜" (44 cm) high without base. Private collection. An example of a base that creates a philosophical statement about the work.*

Slicker Shy, *Herb Mignery, 1992. Bronze, 28" (71 cm) high. An example of a Western-style base: marble and wood, contoured with a molded edge and name plate.*

Head of Dawn, *Tuck Langland, 1998. Bronze, 9" (23 cm) high without base. An example of the type of base favored by artists in the eastern United States and Europe: a black marble cube.*

Mounting a tab onto Head of Dawn. Notice the hole drilled and tapped for mounting, and the antiswivel pin in place.

Reflecting, Tuck Langland, 1989. Bronze, 15" (38 cm) figure, 12 × 15" (30 × 38 cm) base. An example of a base that becomes the floor of a scene.

PREPARING A SCULPTURE FOR MOUNTING

Once you've seen several kinds of mounting jobs, you'll probably want to design one for your own piece that is neat, as invisible as possible, and strong. The most common method is to drill and tap the bronze in two or more places, and then run screws, bolts, or threaded rods up through the base from the bottom to draw the piece tightly down.

Let's look at a few examples. The portrait head is a common subject, which often ends down on the neck somewhere, commonly in a rather small point. A very satisfactory way to mount this type of bronze is to create a small tab on the wax head *before* investing and casting; the tab then becomes bronze along with the rest of the head. If this is forgotten, or if it is placed at the wrong angle, a bronze plate can be welded on after casting. (And here's a hint: if you create a tab by welding on a bronze plate, drill and tap the tab *before* welding as it's much easier to do it then than later.)

When making such a tab, there are two main considerations. First, the tab must be strong enough to support the weight of the head. Make any such tabs about ¼ inch thick, and no less. If there is any doubt, add a triangular brace as shown at right for support. The second consideration is the angle of the tab. To check its angle, hold the head upright as you want it on a flat table, and be sure the tab sits dead flat on the table surface. You

Mounting a tab on a larger piece with a triangular brace. This should be added to the sculpture in the wax stage, before investing and casting.

Drilled and tapped bars attached to the bottom of a flat-bottomed piece for mounting.

can usually press the soft wax down against the table while someone holds the head at just the right angle.

If a sculpture naturally sits on three or more points, or has a large level bottom, you won't need a tab as just described. Often a piece can be drilled and tapped right into whatever surface touches the base. If the piece is cylindrical, you can add tabs or bars to the inside.

Once you have a surface to drill and tap—either a flat part of the sculpture or a tab—you can proceed to the next step.

Understanding Taps, Dies, and Drills

A *tap* is a machine tool used to cut screw threads inside a hole. It looks like a long, threaded bolt with grooves cut down the sides. A *die* is the counterpart of a tap, and is used to cut screw threads onto a rod to make a bolt. A tap and die set is a collection of taps and dies in various sizes, and is a worthwhile purchase.

Taps and dies are measured with two numbers: the outside diameter and the pitch, which is the number of threads per inch. Thus a typical tap, and one that you will use often, is a ¼ × 20 tap, meaning that it has a ¼-inch diameter and 20 threads per inch. The reason the pitch is specified is that there are two kinds of threads—national coarse (NC) and national fine (NF)—which have different threads per inch for any given diameter. Compared to a ¼-inch NC bolt of 20 threads per inch, for example, an NF bolt with the same diameter has 28 per inch. When you buy a tap from the hardware store, its barrel will be stamped with those two numbers, and usually either NC or NF. In general, you will use the NC threads for just about everything.

Many different kinds of taps are available, but the commonly used ones from the hardware store are just fine.

Others get very sophisticated for production machinery and need not concern us. If you are tapping a hole that isn't very deep, you may need what are called *plug taps* or *bottoming taps*. To understand how these taps work, look at the tap shown below, left, and notice the long, pointed taper before the threads reach full depth. If you are tapping a shallow hole, that point will hit bottom before many threads are cut. To cut threads all the way down to the bottom of a hole, you can do this:

1. Buy three regular taps of the size you want. Set aside the first tap.
2. Take the second tap and, using a bench grinder or disc sander, grind off most of the point, to the spot where the tapered thread begins.
3. Now take the third tap and grind it way down so there is a flat end at full thread depth.
4. These three taps—the first untouched one; the second, which still has tapered threads but no point; and the third, ground to a flat end at full thread depth—will be your set of three to tap full threads to the very bottom of a hole. Follow the directions on page 182 to tap the hole.

A tap, which is used to cut threads inside a hole.

A die, which is used to cut threads on a rod to make a bolt.

A tap, with its size and recommended drill size stamped on the barrel.

A set of three taps ground successively flatter to tap the very bottom of a shallow hole.

The next consideration is drill size. You will need to drill a hole with a diameter equal to the tap diameter measured at the bottoms of the valleys between threads. You also need to understand how drill bits, often called simply "drills," are sized. There are four basic types of drill bits on the market, each sized differently:

■ *Fractional drill bits.* There are measured in fractions of an inch, and are the most common. A typical set of fractional drills goes from $\frac{1}{16}$ to $\frac{1}{2}$ inch, in increments of $\frac{1}{64}$ inch. Thus the smallest drill is a tiny $\frac{1}{16}$ inch, then comes $\frac{5}{64}$ inch, then $\frac{3}{32}$ inch, and so on. If you really want to be familiar with drill sizes, take a piece of paper and list all the fractions from $\frac{1}{16}$ inch to $\frac{1}{2}$ inch by 64ths. You'll have to think and remember the math lessons of your school days, but the exercise will help.

■ *Metric drill bits.* These drills are sized by the number of millimeters in the diameter. Metric drills are essential if you are using metric bolts, in which case you should also buy metric taps. If you decide to use metric, everything gets a whole lot easier, as we shall see.

■ *Number drill bits.* These are sized somewhere between fractions, and are simply given numbers, from 1 to 60, with 1 being the largest (about $\frac{1}{4}$ inch) and 60 very small.

■ *Letter drill bits.* Lastly, letter drills are sized somewhere between fractions and number drills and are lettered A through Z. These are for specialized machine use and are not very useful for us.

For the vast majority of purposes you will use fractional drills; you can buy sets of them at any hardware store. Don't buy cheap drills, which will dull quickly and won't cut. Buy the very best they have, particularly in the commonly used sizes. A good compromise is to buy a complete set of moderately priced drills, then buy much more expensive (and thus harder and longer-lasting) drills in $\frac{1}{8}$, $\frac{3}{16}$, $\frac{1}{4}$, $\frac{5}{16}$, and $\frac{3}{8}$ sizes, plus the tap sizes listed below. These are the sizes you're likely to use most frequently.

Here are some common tap sizes with the appropriate fractional drill sizes:

$\frac{3}{16}$-inch taps use a $\frac{9}{64}$-inch drill

$\frac{1}{4}$-inch taps use a $\frac{13}{64}$-inch or number 7 drill

$\frac{5}{16}$-inch taps use a $\frac{11}{64}$-inch drill

$\frac{3}{8}$-inch taps use a $\frac{21}{64}$-inch drill

$\frac{1}{2}$-inch taps use a $\frac{25}{64}$-inch drill

All those odd 64ths sizes may seem confusing unless you think of it this way: the main tap sizes are $\frac{1}{8}$, $\frac{3}{16}$, $\frac{1}{4}$, $\frac{5}{16}$, $\frac{3}{8}$, and $\frac{1}{2}$. It would be logical to assume that each tap would require a drill one size smaller—a $\frac{3}{16}$-inch tap would use a $\frac{1}{8}$-inch drill, a $\frac{3}{8}$-inch tap would use a $\frac{5}{16}$-inch drill, and so on. Right? Well, that would be a bit tight, so increase each drill size by $\frac{1}{64}$. This may be confusing here on paper, but when all your drills are in a little stand, lined up in order, just pick the one that is a major notch below the tap size, then take the drill next to it, which is one size bigger.

With metric, things get a lot easier. First, don't try to play the game of converting between metric and English. Use one or the other. If you do metric stay in metric. Metric taps have two numbers: the diameter, which is measured in millimeters, and the pitch, which is the distance between two ridges of the threads, also measured in millimeters. A typical metric screw (this one is close to $\frac{1}{4}$ inch) is 6×1. This means that it has a 6-mm diameter, and 1 mm between peaks. To find the correct drill size, simply subtract the pitch from the diameter: 6 minus 1 is 5. There's the drill size.

Other metric sizes *close to* English sizes are: 8×1.25 (close to $\frac{5}{16}$ inch), 10×1.5 (close to $\frac{3}{8}$ inch) and 12×1.75 (close to $\frac{1}{2}$ inch). You can easily figure the correct drill size for each of these taps.

Tapping the Bronze

To tap the metal, first drill the correct size hole. This is not always easy. The typical handheld electric drill is not an effective way to drill, since it is hard to hold the angle steady and to apply enough pressure. The drill press is far superior, which is just another reason you should have this tool. But whichever tool you use, holding an awkward sculpture upside down so it is perfectly braced and unable to move, while at the same time presenting the bottom surface to be drilled at an exactly horizontal plane, requires some creativity.

Here are a few tricks you might try, although in the end you'll probably make up your own solution. First, you can sometimes move the drill press table to one side, set the piece on the drill press base plate, block it up with wood so the piece reaches past the level of the table, then rotate the drill table back against the piece to brace it. You might also make a wooden fixture, like a box, into which you set the piece, braced against the sides.

If you can't rig either of the above, there is always the plaster pan method. Select a plastic basin or bucket—one with a flat bottom—that's large enough to hold the sculpture when inserted upside down. Wrap the sculpture in a plastic bag or foil, as shown in the photo. Pour several inches of good, thick, freshly mixed plaster into the pan, and imbed the wrapped sculpture in the plaster. (The bag keeps the sculpture clean.) Use a level to get the surface you're going to drill exactly horizontal. If you don't have a level, lay a longish stick on the surface and sight from the stick to a window sill, table, or another flat surface. Be sure to do this in two or three directions. When the plaster has set hard, put the whole thing—pan and all—on the drill press for drilling. When done, beat on the plaster with a hammer to get it off.

To tap the holes you have drilled, fit the correct tap into the tap wrench. Insert the tap into the hole, trying to line it up straight. Now press down into the hole while you turn the tap clockwise. Keep pressing and turning the tap wrench until you feel the threads begin to bite. When you have a good solid bite, back off a half-turn. From this point, the procedure is one turn forward, a half-turn back to break the chips loose, one turn forward, half back. A drop of tapping oil, often called cutting fluid, will ease the job.

Head of Dawn *wrapped in foil and imbedded in a pan of plaster as support for drilling the mounting tab.*

Your biggest danger is breaking the tap. They are brittle and will break easily, especially the smaller ones. If you are using a long tap wrench (as opposed to the T type), hold your hand cupped over the center of the wrench and feel when the tap is binding, then back up to free it. Don't hold the ends of the handles as they will provide too much leverage. If the hole is deep, back the tap right out from time to time and clear away all chips.

If you do break a tap, most of it will usually be stuck fast down in the hole. Sometimes there will be enough sticking out to grip with a pliers—if you're lucky, you can make it move and back it out. If there is too little showing, or if it just won't move, about all you can do is grind it off flush and drill another hole. Be more careful next time.

For blind, or shallow, holes, use the first tap, just as it comes from the store, until you feel it bottom out. Be careful because it's easy to strip the baby threads you have just cut. Now use the modified second tap (see page 181) as deep as you feel you can safely go. Finish with the third tap right to the bottom.

Here's a good tip to clean up threads running all the way through when you're finished tapping. Chuck the tap into your reversible variable-speed electric drill, and slowly run the tap forwards and backwards in the hole.

The correct way to hold a tap wrench, so as not to twist too hard.

The incorrect way to hold a tap wrench. This hold gives too much power and risks breaking the tap.

CHOOSING A BASE AND MOUNTING YOUR SCULPTURE

Your sculpture should now be ready to mount, so the next step is to select a base and drill it for mounting. Naturally, there is a limitless variety of materials that can be used for bases, but three are the most common: stone, wood, and metal. Even if you've already decided on a wood or metal base, don't skip the section on stone as it introduces many terms and concepts also used with other materials.

Stone Bases

Of all the thousands of kinds of stone in the world, only four are most commonly used for bases: marble, onyx, limestone, and granite. Of course, any stone can be used, so your choice is hardly limited to those few.

Marble is certainly the most common base material. It comes in an infinite variety of colors, one of which is jet black. It can be cut to any size and shape, and it takes a lustrous, glasslike polish. It drills rather easily, and it is generally just about the ideal base material—thus it is the most common. But remember that polished marble will lose that polish rather quickly outdoors, so it is really only suitable for indoor placement. There is, however, one form of marble, called Travertine, that weathers rather well outdoors. Travertine is pale tan and filled with holes and pockmarks. It is a very beautiful stone that is both informal and elegant, and makes very fine bases.

Onyx comes in a wide variety of colors, some translucent and very light, others looking just like black marble. In general, onyx has the same characteristics as marble, with a highly polished and somewhat formal look. Also like marble, it is unsuitable for outdoor placement.

Limestone is another common stone for bases, particularly for very large works. Limestone is usually shades of gray or grayish pink, and does not come in deep colors or black. It does not polish, but takes a soft matte finish, thus it doesn't seem to have the feeling of high formality that polished black marble has. Limestone has a more informal quality, and is particularly good for outdoor placement since weathering, which does occur, does not detract from its appearance

Granite is the hardest of all these stones. It will take and keep indefinitely a high polish—even outdoors—and it comes in very dark colors, including black. Because of its extreme hardness, granite is more expensive than marble or limestone, and it takes extra effort to drill it. But for that special commission, particularly an exterior piece, granite is the base material of choice.

When creating very large bases, you can often attach slabs of stone over an inner structure made of some other material, such as concrete or steel, preferably stainless. Most stone that is quarried is sawed into thin slabs, usually an inch or less thick, for architectural work, and so is readily available from stone suppliers. Another alternative is composite stone, which is a thin sheet of stone glued to an aluminum honeycomb structure to make a sort of stone plywood. It is available from Stonewurks, Inc. in Kansas (see list of suppliers). It works.

Determining the shape and size of a stone base

This is a tricky but crucial task, and one you must do before ordering. You have several variables to consider. First, consider the thickness of the base. As a rule of thumb, portrait heads generally look better on thick cubelike bases, while figures generally look better on flat bases. But consider all kinds of thickness. Consider mounting a figure up on a column, or a tall block. Consider stepped blocks, made by placing smaller bases on top of larger ones. Consider a pedestal-base—one that reaches to the floor. And consider round or oval bases.

As for the size, try this technique. Set the sculpture on a large sheet of paper on a table. Now draw on the paper a base that is too big. Next draw a base that is clearly too small. Now, between those two, begin to sketch in a base that might be about right. If the sculpture is contained and rather vertical, you probably want a base that will extend a bit beyond the sculpture. If the sculpture flows out rather freely to each side, you'll need a base that is smaller than the lateral extent of the piece.

Keep looking at the lines you drew and try to imagine a base that size. If you are buying an expensive base, it's a very good idea to cut a piece of wood the size you feel is right, paint it dark, and place or mount the sculpture on it. Then walk all around it giving it a good look. Don't be afraid to cut another piece, or cut down the one you have if you think it's too big.

Take your time with this step. Remember, a finished bronze sculpture will have its base as a permanent part of the work. You must get it right. And don't trust just your own eye. Mount your piece on a trial wood base and get other people's opinions. To do this best, you might try two or three alternative bases. Once you've made your decision you can call and order that pristine piece of stone.

Where to buy the stone base

This question is easy to answer. First, look in the back of this book and you'll find a few suppliers listed. Second, look in the advertising sections of the several sculpture magazines available—such as those listed in the back of this book—to find ads for manufacturers of marble and other stone bases. In general, these suppliers will have many sizes and kinds of stone in stock, but will also be able to custom cut bases for a higher price. The easiest way to order is to figure the size you need, telephone the supplier to find out which of their pre-cut sizes will work, then give them a credit card number and address; the base should arrive in just a few days. Naturally custom-made bases take a little longer and cost a little more.

Marking the stone for drilling

All right, the clean and perfect stone has arrived. Now you have to drill it to mount the sculpture. First, you need to locate where the holes will go. There are a lot of ways to accomplish this next step; I'll give three. But before you begin, cover the top of that perfect shiny stone with masking tape. This will not only protect the stone from being scratched as you place the bronze on it, but it will give a good surface on which to mark the holes with a pencil.

Method 1: At this point you should already have two or more holes drilled and tapped in the bronze. Whatever thread size they are (¼ inch, ⁵⁄₁₆ inch, whatever) take some bolts that size and cut the heads off with a hack saw. Now chuck one of the bolts into your electric drill. Hold the bolt's end at an angle against a grinding wheel or disc sander and run the drill against the spinning wheel. Your aim is to sharpen the bolt end, just like a pencil, but by holding it in a spinning drill you will get the point of the sharpened end directly in the center of the bolt. Do this for each of the bolts.

Now cut these bolts shorter still, to just ½ inch long, and clean up the cut thread ends so they will screw into the sculpture.

The last step is easy. Screw the sharpened and cut bolts into the holes in the bronze so their points are sticking out. Set the sculpture in place on the base, apply a little pressure, and the pointed bolts will leave clear dots on the masking tape, telling you where to drill. Remove the pointed bolts from the base and save them for future marking jobs.

TIP Never mount a sculpture with just one bolt, as it will swivel around. There must always be at least two, even if the second one is only a short antiswivel pin.

Method 2: Buy a tube of graphite powder from the hardware store. (They're used to squirt out black graphite powder to lubricate locks.) Squirt some powder into each hole in the sculpture. Now carefully set the sculpture on the base in the correct position, and tap on the sculpture several times with a wooden mallet or piece of board. When you remove the sculpture, the graphite should have deposited itself into neat black circles, telling you where to drill. You can also do this method with bronze dust collected after grinding on your piece.

A variant of this is to press small pieces of wax or oil clay into the holes to mark the masking tape. Some people even lay a thin sheet of oil clay or wax on the base and then press the piece into it.

Method 3: Stick a piece of masking tape across the bottom of the sculpture to cover the holes. The tape should be long enough so its ends extend beyond the edges of the sculpture. Using a pencil, do a rubbing of the holes on the tape, revealing where they are, and then poke a small hole through the center of each.

Place the sculpture in position on the base, and use more tape to secure the extended ends of the tape to the sculpture. Very carefully lift the sculpture off the tape, leaving it stuck to the base, then mark through the tiny holes you poked, and there are your centers.

No matter what method you use, always double-check to be sure the holes are right. If there are two holes and one of them is just a tiny bit off, don't worry. All that *really* matters is that the two holes are exactly the same distance apart as on the sculpture. To check this, use a piece of paper to mark the exact distance between the holes on the sculpture.

Method 1. Pointed stubs inserted into holes on the bronze. These will be used to transfer the hole locations to the base.

(Instead of guessing the imagined center of each hole, mark from the same edge of each.) Then use the same paper to see that the distance is correct on the base. With three holes you can do the same, but use distances between all the holes. If you are getting significant variance, remove the masking tape from the base, apply a new layer, and start over.

Drilling stone

Remember way back in Chapter 1, when I recommended buying a drill press? Here's where you really need one. If you are at all serious about making sculptures and mounting them on bases, buy a drill press before going further. It is really the indispensable tool for this job.

The next things to buy are the proper drill bits for drilling stone. Hardware stores sell *masonry bits*, which look like ordinary drill bits but have carbide tips. There are several different kinds of these. The one called "Lickety Split" has a small cut or split in each blade of the tip, and seems to me to cut faster and better than those without these cuts. In general, the more expensive the masonry bit, the better. Avoid cheap brands as they will be more prone to slow cutting, overheating, and spalling (chipping flakes from) the stone, or even cracking the base in half. Save a couple of bucks on a drill and ruin a sixty-dollar base. Not smart.

A "Lickety Split" carbide-tipped masonry bit.

You should also look for and buy *glass-cutting* drill bits. These are single plain shanks with cone-shaped slices of carbide on the end. They are designed to drill holes in glass (although I've tried them on glass, and the glass broke every time), but they work beautifully on marble. You can use a glass-cutting drill to begin a hole, or to drill an entire hole if the marble isn't very thick. With other stones, like Travertine, limestone, or granite, they aren't necessary; just use the masonry drills.

It's a good idea to practice drilling on an easy stone before placing that perfect piece of polished stone beneath the spinning drill. Find a piece of scrap limestone and a piece of scrap marble. Drill the limestone first. You'll notice that with steady but gentle pressure the drill will work its way nicely through the stone. Drill all the way through. Now look at the back side. You'll probably see a spalling out where the drill emerged. We'll talk about curing that in a moment. Now try drilling the scrap marble. You'll find it is harder and slower, but use steady, gentle pressure and take your time. Let the drill work its way through, don't force it. Again, check out the spalling on the back side.

There is a question of whether or not to use water as you drill. Many stones, such as limestone, Travertine, onyx, and others, will drill just fine without water. But some marbles tend to heat the drill and will drill better with water used as a lubricant and coolant. The biggest temptation is to squirt water down the hole as you drill. This method is easy, but not terribly effective, and dangerous in that the water can easily turn the slurry into a glue and grab the drill bit, spinning the marble around and ruining it. If you do this, clamp the marble to the drill press table very securely and use plenty of water, pulling the drill bit up frequently and squirting more water down the hole.

The second, and better way, is to drill underwater. If the base is rather small, fill a flat-bottomed basin with water, place a scrap piece of stone on the bottom to serve as a hard support, then place your base on top of that and drill. Be sure the water covers the top of the stone. The water will lubricate the drill and keep the stone cool. Back the drill out of the hole from time to time to be sure water is down in the hole.

If the base you bought is hard black marble, perfectly polished, you'll probably get some spalling on the top where the drill enters, as well as on the back. The cure for this is the glass-cutting drill bit. If the base is 2 inches thick or less, drill all the way through with the glass-cutting drill. If it's thicker, begin the hole with a glass-cutting drill slightly larger than the masonry drill you'll use, so the flutes of the masonry drill don't touch the top surface of the stone as it enters.

For spalling on the back side of the hole, there are a couple methods you can use. One is to locate the back side of the hole before you drill by carefully transferring the marking from front to back, then drill in from the back first with a slightly larger drill or your countersink (see below). Another method is to drill most of the way through the block, then switch to a much smaller drill, say ⅛ inch, and penetrate through the stone with that, resulting in very small spalling. You can then drill back from the bottom with the larger drill, following the small hole. The large drill will usually swallow any spalling left from the smaller drill, thereby eliminating it.

A glass-cutting drill bit, perfect for drilling hard marble.

Left to right: flathead stove bolt, round-head stove bolt, hex-head machine screw.

Small and large carbide-tipped countersinks, suitable for stone.

Some people have good luck using the glass-cutting drill all the way through. In any case, always ease way off on the downward pressure as you approach the bottom of the hole.

Next, you need to *countersink* the bottom of the hole to allow the head of the bolt or flathead screw to be recessed. First, decide what kind of countersink you need. If you are using flathead stove bolts, you need a simple angled countersink. If you are using a round-head or hex-head bolt, or a threaded rod onto which you will screw a nut, you need a flat-bottomed countersink. Now here's the joke. There are no flat-bottomed countersinks—they're are all angled. Ha ha. But don't worry—an angled countersink will work for both bolts and hex-head screws.

You can also countersink with a large masonry drill, 1 inch or so. They cost a bit, but they'll work. A second, better kind of countersink is a commercial carbide-tipped one bought from an industrial supplier. The illustration opposite, bottom, shows small and large versions. If you look hard, you may be able to find a flat-bottomed countersink with a pilot, as shown to the right, or have a machine shop make one for you, and then you'll have the laugh on me.

Drawing of a flat-bottomed carbide-tipped countersink, which must be custom-made.

Wood Bases

This part is easy. Everything you've read about size and so on for stone bases applies equally to wood bases. The one trick with wood bases is that they rarely come thick enough for 5- or 6-inch cubes, which are perfect for portrait heads. If that's what you want, you should either build a hollow block of wood or glue slabs of wood into a block. But be warned: working wood to flat surfaces that are at right angles to each other is not easy. You'll need a good band saw, or a large table saw, and a stationary belt sander to do the job right. Before you run out and buy all those things, look in the Yellow Pages under "cabinetmakers" or "pattern shops" and make some calls to see if someone with all the equipment and experience can make a base for you.

Another important decision is what kind of wood to use. Most lumberyards have only utility pine or fir, such as two-by-fours and boards. These are not sophisticated woods, and are usually not suitable for fine art. Don't mislead yourself into thinking that slapping on some stain will make cheap wood look elegant. Many stores now carry some hardwoods such as maple, cherry, and walnut. As with marble bases, darker woods usually work better than lighter woods since they call less attention to themselves. Of course, good quality hardwood bases can be darkened with stain, or even painted. An alternative to local lumberyards or home improvement stores is specialty wood suppliers. A few are listed in the back of this book, and more can be found by picking up an issue of a woodworking magazine like *Fine Woodworking*. These suppliers can provide all kinds of wood, from light to dark, from domestic to exotic, from inexpensive to oh-my-gosh!

A readily available, hard, naturally dark wood is walnut. This is probably the most common wood for sculpture bases. It looks great with a natural finish, and it can be easily darkened further. To make walnut really dark, apply several coats of black acrylic paint well thinned with water. As the paint soaks in it will raise the grain, which can then be sanded down. Walnut will go nearly black this way, while still showing a little subtle wood grain. Other, lighter, woods will also take this stain, but it's best when used on something that is already pretty dark.

Finishing wood is a whole subject in itself. Today there are zillions of ready-to-use products on the market, all aimed at the home handyperson. Check out your local paint store or woodworking store, and read the cans themselves to see the many products available. They all work.

Drilling a wood base is the same as drilling marble, except you use wood bits. Countersinking with a flat bottom is easy with a spade bit.

A spade bit, used for wood only.

Composite bases

A very popular style of base, particularly for Western sculpture, is the composite wood and stone base. For tabletop works this is usually a flat walnut base, about an inch thick or a bit more, with a piece of marble inserted on top.

The first step is to get the marble cut to shape and finished. This is then placed on the wood and a line traced around it. A second line is drawn about 1 inch beyond the first line, following it exactly. That second line will be the outer shape for the base.

The inner marble shape is routed out with a router to about ½ inch deep, and the wood is then band-sawed to the outer shape. The edge of this base is run past a shaper, giving it a molding or beading. The piece of marble is then set into this recess, projecting up only about ¼ inch from the wood; the bolts that hold the sculpture to the base will hold the whole thing together. (See the composite base illustrated below.) If band saws, shapers, and routers are more than you want to get into, look up a cabinet maker or pattern shop and have them make the base.

Don't limit your thinking to this wood-and-marble style. Think about how you might combine materials to create a unique and interesting base, always bearing in mind the idea of the perfect butler, serving but unnoticed. You may be tempted to use a gnarled bit of log, or a natural field stone. Be careful here or the base can overshadow the sculpture. This is clearly not a hard and fast rule, however, as sometimes a freeform or natural object can be the perfect base for a sculpture. You must always trust your innate sense of taste and balance.

Metal Bases

Metal is a wonderful material for bases, and metal bases can take many forms. One is a dark slab of metal, such as in Rosetta's *Running Cheetah*, shown at right. Here the metal is

Orkney Sheep, Lena Olson, 1995. Bronze, 10" (25 cm) long. An example of natural stone used as part of a base.

Running Cheetah, Rosetta, 1987. Bronze, 20" (51 cm) long. An example of a plain steel base.

steel, which has been specially coated to remain black. Her base is only about ⅜ inch thick, and lies quietly beneath the sculpture, serving it perfectly. Such flat slabs can be employed in any number of basing situations.

Bronze can be used for a base in the same way. Silicon bronze plate can be purchased from suppliers in many thicknesses and sizes, and most suppliers will cut the metal to shape for you. (See the bronze manufacturers in the list of suppliers, most of whom also sell plate.) If you order metal cut to shape, be sure to clarify whether they'll be using a *shear cut* or a *saw cut*. The shear cut will leave a slight rounding along the edge, which isn't what you want.

Cutting metal on a table saw is dangerous. First, it can bind and fly out if it does not have a clear path and a strong, steady hand. Don't cut very small pieces if you want to keep your fingers. And second, cutting bronze on the table saw produces lots of flying pieces of sharp metal. I recommend a heavy, long-sleeved shirt or jacket buttoned to the neck. Wear double eye protection: plastic goggles and then a full face shield over that. Wear heavy gloves, and put on a cap to keep metal out of your hair.

You want the more expensive saw cut, since the edge is then a clean right angle.

You can cut your own bronze plate if you have a 10-inch or larger table saw. Buy a nonferrous metal cutting blade—Freud makes a very good one that you can order through most woodworking stores. It looks like an ordinary carbide-tipped saw blade, but it will cut through bronze plate with ease. Set up your cut as you would for wood, then turn on the saw and push the metal through with a firm pressure. Keep in mind that it will be slower than wood, and be sure to hold the metal *down*, as it will want to rise up.

With this equipment and skill, you are now ready to make the best bases of all: welded bronze boxes. For small bases 8 inches and under per side, ⅛-inch bronze plate is fine. For medium-size bases, up to about 20 inches, use 3/16-inch plate. For larger bases, go to ¼-inch plate.

The illustration on page 190, top, shows you how to set up the edges to weld. Cut the pieces to the proper size, then apply a bevel. These bevels are easiest to make by running carefully along the edge with a 4-inch angle grinder. Then weld the pieces with a TIG or MIG welder. Set up the first two pieces, clamped to form a perfect right angle, and then tack two or three places. Add the next piece and tack, and continue until the entire box is tacked into place. At that point, check to be sure it's all square, then complete the welds.

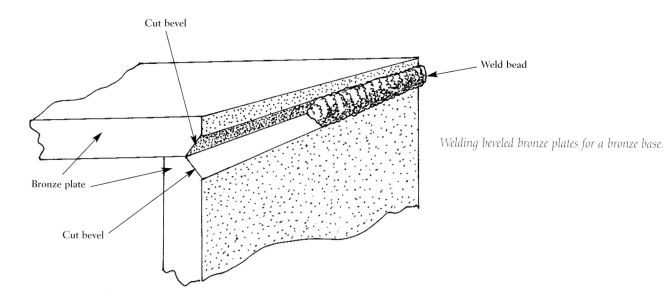

Cut bevel

Weld bead

Bronze plate

Cut bevel

Welding beveled bronze plates for a bronze base.

After the box is all welded, use the 4-inch angle grinder to *very carefully* remove the weld bead only, just down to the metal surface. Now use a disc sander to bring the metal smooth and level. If you dig in somewhere, reweld that spot. You should be able to create perfect corners all around. Then use a random orbit sander to apply a uniformly smooth surface to the entire base. At this point I use a fine file to apply the slightest angled bevel to all corners, breaking that very sharp edge. Finally, I like to add corners to the bottom so that felt pads can be applied, or the corners can be drilled and tapped for permanent mounting.

To mount the sculpture, drill the same as described above. Locate the holes, then drill, using round-head bolts (there is no countersinking).

To make a cylindrical base in metal, cut a sheet of metal to the right size and have it rolled into a cylinder by a metal-forming company. Take their advice as to how much overage to use to get complete arcs all the way around. Don't use a piece just exactly long enough, because the last little bit doesn't take the same curve and when you weld there will be a slight ridge down the seam. Cut your metal longer, let it overlap after rolling, then cut to final size before welding.

Once all the mechanical work is done, the base is cleaned by sanding or sandblasting, coated with patinas, then waxed. If the base is made dark, the gentlest lick with a pad of fine steel wool along the edges gives a fine little glint. The beauty of a bronze base is that is can be any size and shape (given flat surfaces), it is easy to attach sculptures to, it is very strong, and it won't break. If scratched or dented it can be repaired, which marble can't, and it looks very good with a bronze sculpture on top.

Other Considerations

There is one other trick you might want in your tool kit: How to drill a hole in a base to accept a pipe coming at some odd angle out the bottom of a sculpture. Suppose you cast a

Small corners welded to the bottom of a bronze base to hold felt pads.

portrait head in plaster, for example, or fired a clay head, and had imbedded a pipe inside for mounting. And suppose that pipe is not vertical, but off a bit. Here's the method:

1. Get your base and locate *where* on the base you want to drill the hole. Mark this place on the *top* of the base. Also mark the *front* of the base.
2. Select a drill bit, probably a spade bit, that is the correct size for the pipe. Take a thick piece of scrap wood as a trial base and drill a hole using the drill press, so the hole is perfectly vertical. Place the pipe into the hole, set it on a level surface, and look at it. The sculpture will likely be at some goofy angle.
3. Take two pieces of plywood, about 12 by 12 inches each,

and place them on top of each other. Put the sculpture, still on the trial base, on top. Using wooden wedges, separate the two pieces of plywood so the top one tips to an angle that makes the sculpture look right. Ignore the angle of the base—just get the sculpture upright the way you want it.

4. Take the sculpture and trial base off the angled platform you made and replace them with the real base, *but turn the real base exactly backwards.* Put this whole thing—the plywood platform with wedges and the real base—on the drill press. Drill straight down through the base at the place you'd marked.

The sculpture will now be at the correct angle when placed in the hole. This basic idea can be used in any number of applications.

Right: The real base placed on the tipping platform, facing backwards for drilling.

Below left: A portrait head with its pipe in a trial block and set on a tipping platform. Notice the wooden wedges stuck between the platform's two layers.

Below right: Drilling through the real base on the tipping platform.

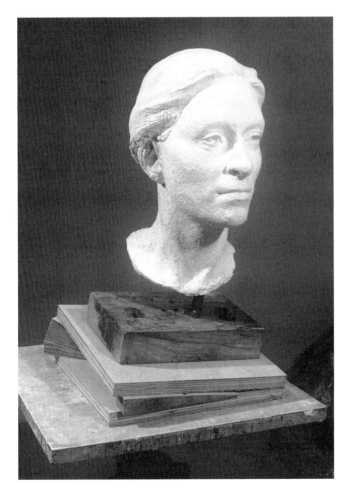

PATINAS

It's been said that you make the sculpture for the critics, and the patina for the sales. There is a good deal of truth in that. Consider, when looking at the finished sculpture, that all you are really seeing is the patina, which is given a shape by the bronze beneath. It is certainly true that a bad patina can make a good sculpture look bad, and a good patina can help a bad sculpture look better. This doesn't mean you can get by with being a bad sculptor and a good patineur, rather it means don't skimp on this final, but crucial, step.

What is a patina, anyway? In general terms, a *patina* is a surface that is acquired, usually through age, and that is commonly considered attractive. An old piece of furniture often gets a deep glow, for example, that new furniture doesn't yet have. In terms of bronze sculpture, the Chinese found that ancient bronzes long buried in the earth emerged with crusty greens and blues, and those colors were highly valued.

Today we can "age" a bronze very quickly by applying chemicals in far higher concentrations than occurs in nature. Actually, a patina on bronze is a sort of controlled tarnish created by these chemicals. There are also chemicals that are colored, and particles of this color adhere to the bronze, creating color on the sculpture. Some of these pigments come from chemicals, and some are the same sorts of pigments found in paint. Some adhere by chemical means, others by means of resins or other paintlike substances.

Please note that because color is so important to the process of patina, examples of several have been reproduced in full color, starting opposite. This color section also includes step-by-step illustrations for applying two particular chemicals—ferric nitrate and cupric nitrate—and will be referred to throughout the chapter.

PREPARING THE BRONZE

As with any step in the clay-to-bronze process, preparation is essential for successful patina application. The bronze must be cleaned, mounted securely, and, in most cases, heated.

Cleaning the Bronze

No patina will take well to a bronze if the bronze is not clean, so this is an absolutely crucial step in the patina process. There are three primary ways of cleaning the surface of the bronze: mechanical cleaning, chemical cleaning, and electrical cleaning.

Mechanical cleaning
The best and most common method of mechanical cleaning is by blasting with sand or beads. For this you need, first of all, an air compressor with enough muscle to supply a large quantity of air and high pressure for a long time. This means a minimum of 3 horsepower, with 5 a better choice.

You can blast in a sandblasting cabinet, which is best since it contains the sand—not only keeping the studio clean but also enabling you to reuse the sand. For large works, or if you don't have a blast cabinet, you can use a bucket or pressure blaster. These are discussed in Chapter 15. In that chapter, however, we were only concerned with removing investment material. Now we want a refined, finished, perfectly clean final surface. This is where different blast media come in.

For rough cleanup blasting, use ordinary dry blasting sand, 80 grit. To really clean thoroughly, getting rid of all discoloration and even chasing the surface slightly to remove fine grinding marks and blend subtle textures, get a silicon carbide blast medium. This will be black in color, and the pieces will be very sharp. It comes in a variety of grits—50-grit is

A COLOR GUIDE TO PATINAS

We usually think of sculpture as being form, and leave color to the painters. But sculptures are also colored, through the use of patinas, and the color of a sculpture has a profound effect on its final appearance and the impression it makes on the viewer. This section of color photos is intended to show samples of various colors on bronze, and to show two patinas being produced step-by-step, giving you some idea of what the patina looks like at each step in the process.

Dance of Creation, *Tuck Langland, 1984. Bronze with cupric nitrate patina, 5' 8" (173 cm) high. Farr Park, Dowagiac, Michigan.*

FERRIC NITRATE

The illustrations below show ferric nitrate being applied over liver of sulfur to *Head of Dawn*, by the author.

The bare metal, fresh from the bead blaster.

A first application of liver of sulfur.

Liver of sulfur applied heavier, with heat.

Liver scrubbed back.

A first coat of ferric nitrate applied (right half only).

Ferric applied all over, full strength.

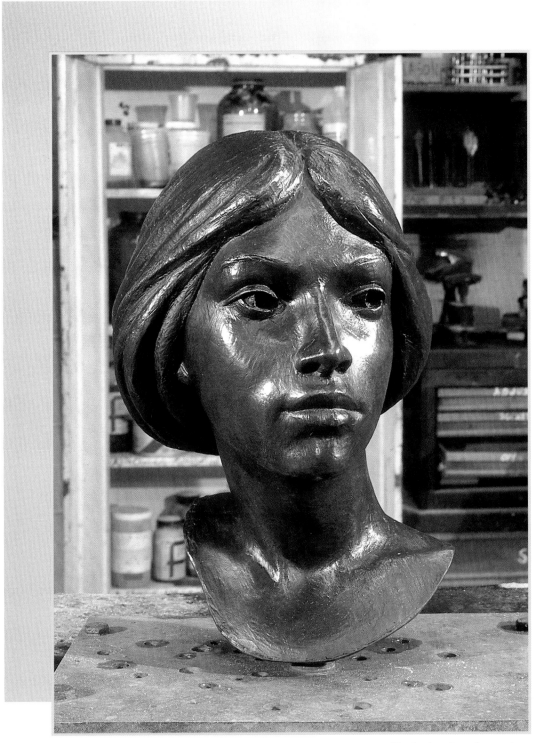

The final patina after waxing.

CUPRIC NITRATE

The illustrations below show cupric nitrate patina, with dyes, being applied to *Japanese Woman*, by the author. (Please note that the final patina shown here can be achieved without so many intervening steps. They are shown to demonstrate various other possibilities.)

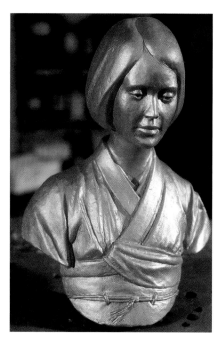

The bare metal.

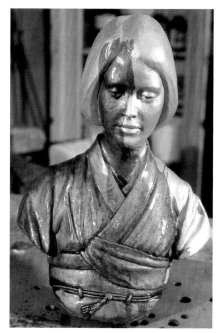

Liver being applied.

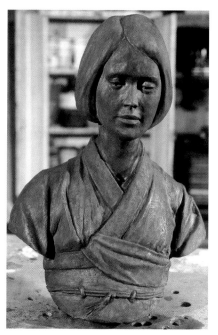

Liver on in a heavy coat.

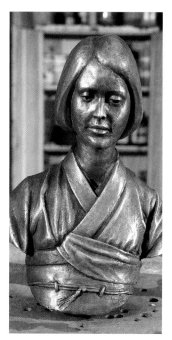

Liver scrubbed back.

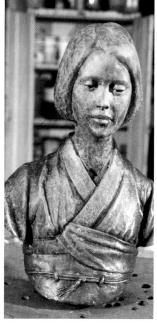

Cupric being applied, hot.

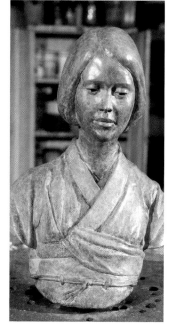

A moderate coat of cupric.

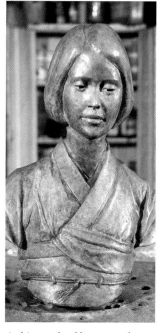

A thin wash of liver over the cupric. This can be a finished patina.

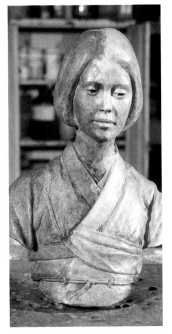 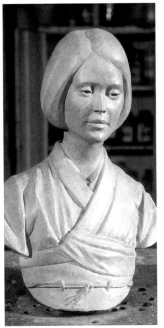 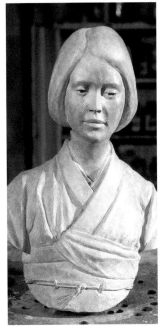 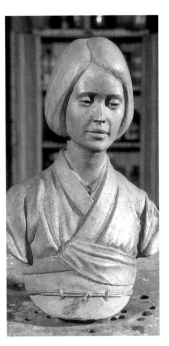

More cupric being applied over the previous liver wash. Going back and forth between cupric and liver can add depth and richness.

A final, rather heavy, coat of cupric, unrinsed.

The previous state after rinsing. Note the whiter, more even, look.

More cupric applied, this time with a squirt of blue water-soluble dye (Ron Young, supplier) added to the cupric.

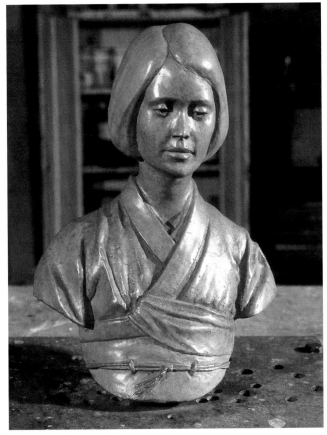

The final patina after spraying with artists' fixative and waxing.

Tiny Nike, *Tuck Langland, 1986. Bronze, 10" (25 cm) high. This sculpture was made blue with a rinse of household vinegar, then fumed in household ammonia. This patina cannot be rinsed, but must air dry and then be sprayed with fixative.*

A SAMPLING OF PATINAS

The following pages show sculptures by various artists, each showing a different aspect to the game of patinas. Remember, color is stronger than form and the patina can enhance, change, or obscure your sculpture. Look at these sample patinas carefully and think about the principles involved before deciding on a patina for your work.

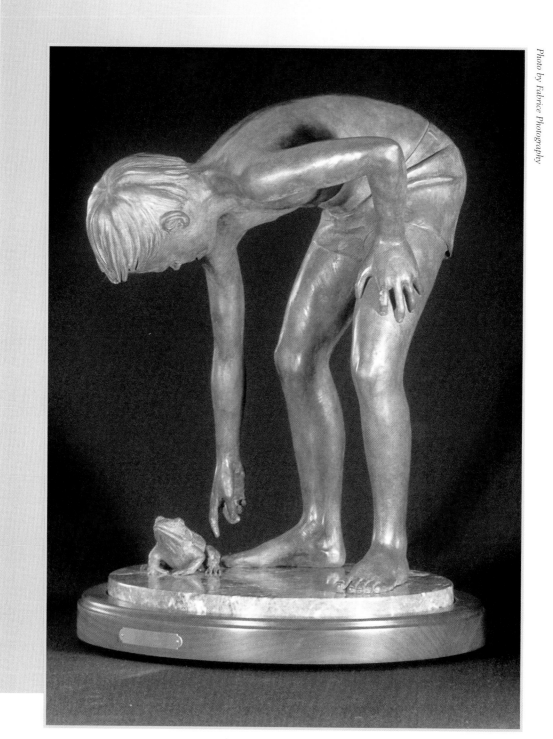

Photo by Fabrice Photography

Jump! Frog! *Gary Alsum, 1988. Bronze, 19" (48 cm) high.*
This piece shows the richness of gold color that can be achieved.

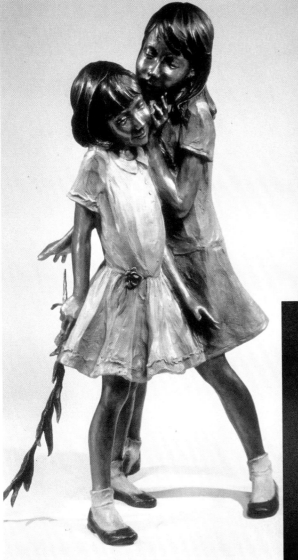

Secrets, Jane DeDecker, 1991. Bronze, 4' 4" (132 cm) high. This is a perfect example of "toy soldier" coloring, where each part is differentiated by an appropriate color.

The Cellist, D. Clements, 1991. Bronze, 20" (51 cm) high. Here is another kind of "toy soldier" coloring where colors typical of bronze patinas are used.

Photo by Mel Schockner Photography

Cowboy Coffee Break, *Herb Mignery,
1995. Bronze, 11" (28 cm) high. A perfect
example of "cowboy brown."*

The Table, *Tuck Langland, 1992. Bronze, 22" (56 cm) high.
Here is an example of an opaque red patina created by adding fer-
ric oxide (rust) to the ferric nitrate solution and applying hot.*

Trail of Forgiveness, Denny Haskew, 1997. Bronze and stone, 11' (335 cm) high. A clever joining of bronze and stone, made stronger by the color achieved on the bronze. What it will look like after ten years outside, however, is anyone's guess.

Mare, Carol Gold, 1985. Bronze, 14" (36 cm) high. The broad simple lines of this piece accept the slight stippling very well.

Tiger, Rosetta, 1987. Bronze, 11" (28 cm) high. Here is a little stronger stippling.

Autumn, Tuck Langland, 1989. Bronze, 6' (183 cm) high. City of Portland, IN. This sculpture has a ferric over liver patina.

Debate, *Carol Gold,
1991. Bronze, 10" (25
cm) high. Notice the effec-
tiveness of leaving the dark
undercoats visible through
the cracks of this cupric
patina.*

Anubis, *Mark Leichliter, 1995. Bronze, 7" (18 cm) high. Here a lighter color has been dropped onto a darker base while very hot and
allowed to spread out in circles that then sizzled dry, leaving overlapping rings.*

Photo by Mel Schockner Photography

Vantage Point, *Rosetta, 1996. Bronze, 17" (43 cm) high. The same technique of developing rings has been used here, this time all in shades of gray. Check out the base.*

Photo by Mel Schockner Photography

Snow Leopard, *Rosetta, 1991.
Bronze, 11" (28 cm) high. An exam-
ple of a white patina—but not an
even white, like paint. Again, notice
the base and how the artist used that
form from the beginning of the mod-
eling.*

Photo by Mel Schockner Photography

Stormscape, *Tim Cherry, 1995.
Bronze, 16" (41 cm) high. One
doesn't usually think of making
clouds out of bronze, though Bernini
made one out of marble once. The
white patina is effective, this time
very flat. And the polished (gold-
leafed) sun works well.*

Photo by Fabrice Photography

River Mates, Tim Cherry, 1988. Bronze, 15" (38 cm) high. My guess is that some dyes or pigments crept into this patina.

Rites of Spring, *Kent Ullberg, 1988. Stainless steel, 12' 6" (381 cm) high. Polished stainless steel neither takes nor needs a patina.*

Spirit of the Wild Things, *Sandy Scott, 1986. Bronze, 7' (213cm) wingspan each bird. When going large outdoors, forget fancy patinas. It's the silhouette you must worry about, as can be seen beautifully here.*

very aggressive, 80 is better—and is available through suppliers listed under "sandblasting" in the Yellow Pages.

For the final cleaning, you'll want to bead blast. The bead medium consists of tiny beads of glass and looks like fine, silvery-white sand. Bead blasting will give a soft luster to the bronze, as shown in the first image of *Head of Dawn* on page 194. Once the piece is well bead blasted, don't touch it with your bare hands. Use cotton gloves or a clean cloth. As above, you can find suppliers listed under "sandblasting" in the Yellow Pages.

Another way to clean mechanically is with a wire brush. This can be held in an electric drill and worked all over the surface. It's good, but it doesn't reach into deep nooks and crannies the way blasting does. Some foundries blast first, then wire brush afterwards to semi-polish the surface.

An alternative to wire brushing is a new product from Premier Abrasives (see list of suppliers), called a Patina Prep pad. It's like a Scotch-Brite pad doubled over and fitted with a center-screw mount to go on a mandrel—the same mandrel used for cross pads, also available from this firm. They give a luscious surface and only cost about 80 cents each; a medium-size sculpture will pretty much use one up.

A third way to clean mechanically is with an abrasive scrub. The abrasive can be sand, coarse cleaning powder, or even kitchen cleanser. Use a heavy sponge and water and rub the abrasive well all over the sculpture. This is the least effective of the three methods, but requires virtually no equipment.

Chemical cleaning

This means cleaning with acids and pickles. If you create a large bath containing acid in water and soak your piece in it, the piece will come out like a shiny new penny and look terrific. But beware! Every time I have used an acid bath or pickle I have regretted it, because most castings have some porosity, and the acid soaks into those pores only to leach out later in unsightly blotches. The only solution is a thorough rinsing of the bronze, but, like Lady Macbeth, it doesn't seem possible to rinse enough of the acid out to be sure it will never reappear. Therefore, my recommendation is to forget the acid baths and stick to mechanical cleaning.

There is one form of chemical cleaning, however, which is very effective when used in tandem with mechanical cleaning to remove any traces of grease and oil: solvent cleaning. A good solvent is Carbo-Sol, which, as we have seen, is useful for a number of tasks in the studio. Another very good cleaner is carburetor cleaner in a spray can from the auto parts store. Spray it on and then wipe off with a paper towel. It leaves a good patina-ready surface if you have been wire brushing.

Electrical cleaning

When metal is electroplated, a current is passed through a solution in which the sculpture is suspended, as well as a bar of the metal that does the plating. (This is a highly simplified description, but bear with me.) Molecules of the metal bar are removed by the current and deposited on the sculpture. By reversing the direction of the current, you can remove a few molecules off the surface of the sculpture and deposit

that metal on the bar. With this method, sculptures can be cleaned to absolute perfection.

The only trouble is that you have to take the work to a plater, or lay out the huge investment of tanks and corresponding equipment yourself. So while this method works very well, it doesn't have any real advantages over a good bead blasting, and is far more difficult.

Thus, the best overall method for cleaning your bronze is bead blasting. If you don't have an air compressor or blast cabinet, the next best option is a thorough wire brushing, use of a Patina Prep pad or abrasive scrub, and perhaps some solvent.

Supporting Your Sculpture and Prepping the Workspace

Your next consideration is supporting the piece during the patina process. If the sculpture has been predrilled for a base (it should have been), then you should attach it to some kind of scrap metal base for the patina process. I use a plate of stainless steel with a couple of strips along the bottom so bolt heads are up and out of the way. I drill holes in the plate to fit the sculpture and, after doing so for hundreds of pieces, there are enough holes so that I can always find two that fit the piece. Don't bolt the piece directly down on a metal

plate, however, as the patina solutions will pool there at the bottom and create a different color. Instead, stand it up with a few washers so it's clear of the metal.

Be sure the mounting is stable, and stand the piece on a modeling stand so you can rotate it during the job. I recommend covering the modeling stand with firebricks and then placing the piece on the bricks so you don't burn your stand. A piece of heavy steel plate works, too.

Another consideration is preparing the area where you will work. First, get good light. The piece will be well lit in the gallery, and there is little that is more disappointing than finishing a patina in bad light, waxing it, and taking it into good light only to have the many places you missed jump out at you.

It's also a good idea to work in a place where you can dump water over the piece for rinsing. And be sure to see the safety box on page 209 for information on ventilation.

Heating the Bronze

Some patinas go on cold bronze, but most must be applied to hot bronze, which means the sculpture must first be heated. This is referred to as applying the patina "hot," versus "cold."

The most common method of heating the bronze is with some kind of torch. Oxy-acetylene torches can be fitted with rosebud tips, which produce large bushy flames, but there are two problems with this. First, the gasses are very expensive and are used up quickly. And second, the flame is just too hot and too small. This setup creates small overheated areas rather than a gentle heating of large areas.

It's better to use a natural gas or propane torch. Natural gas coupled with low-pressure compressed air is about perfect. The flame is large and bushy but quite clean, the temperature is low enough to make burning the patina low-risk, and the fuel is inexpensive.

Propane also works perfectly well. There are many propane torches on the market, some with natural air draft, some using compressed air. Some are very large, and though they are intended for tasks like burning weeds off sidewalks, they heat large bronzes just beautifully. Try to find one that burns with a small pilot flame, which you can fire up by squeezing a handle. You can save a lot of gas that way.

Another approach is to heat the bronze in an oven—a burn-out oven is a perfect choice. You simply place the sculpture inside the oven, although you must be sure to have a way to handle the piece without touching it once it's hot, such as putting it on a shelf that can be removed. The biggest advantage to oven heating is the overall uniformity of heat and the general control. A good idea is to set the oven for the temperature you want and then leave the sculpture long enough for it to reach that heat all over. Once removed, a small torch can be used to add extra heat here and there.

TECHNIQUES

Almost all patinas involve dissolving various chemicals in water and then applying them in some way to color the sculpture. Before we talk about the actual chemicals, however,

A rosebud tip for an oxy-acetylene torch.

A natural gas/compressed air torch.

let's discuss some basic techniques. The most common ways of applying patinas are (probably in this order of frequency of use): brushing them on, spraying them on, dipping the bronze into them, burying the bronze in them, and fuming the bronze.

Brushing the patina solution on usually provides the greatest control, since the chemical can be applied exactly where it's needed, and in light or heavy amounts. Brushes can

act on the patina by scrubbing, stippling, swiping, and so on, to even up the color or bring out highlights on high spots.

An ideal brush for patinas is one without a metal ferrule, which can interact with the chemicals; plastic ferrules are available if you look for them. Sometimes restaurant supply stores have pastry brushes, which are perfect. The brush should hold a good quantity of chemical, and natural bristles are best for that. If you can find round brushes rather than flat ones, you'll probably like them better.

Spraying is another very common way of applying patinas, and most professionals use a combination of spraying and brushing, usually building up an overall layer with spray first, then touching up and texturing with the brush. A sprayed-on patina will have an even, sometimes transparent look. If you use this method, be careful not to miss spots such as top-facing and bottom-facing surfaces.

Patinas can be sprayed on with something as simple as an ordinary spray bottle, or with an airbrush or a heavier paint sprayer. Just a common plastic spray bottle is a cheap, low-tech way to begin spraying patinas.

To dip patinas, you need a container large enough to hold the sculpture, and then enough chemical to make a reasonably concentrated solution in that container. For this reason, dipped patinas, though they have advantages, aren't commonly used except for very small things or for coloring a great many identical sculptures. Many foundries keep a large vat of Birchwood Casey's M-20, Antique Black, for dipped base coats (see list of suppliers).

Buried patinas are interesting and can produce some lovely, unpredictable effects. Essentially, sawdust is soaked with a chemical solution and the sculpture is buried in the sawdust for a period of time, usually measured in days, weeks, or even months, during which the chemical is occasionally renewed. This kind of patina imitates the crusty greens and blues so loved by connoisseurs when found on ancient bronzes. It will produce blotchy, unpredictable patinas which, while not the best for most sculptures, are occasionally just right.

Fuming involves placing the bronze in a closed container, along with a dish containing the chemical; the fumes then cause the coloration. An easy one to try is a brilliant blue, which can be obtained as follows. Dip or rinse a very clean bronze in household vinegar, then place it in a large plastic bucket or garbage can. Pour in household amonia ½ inch deep. Cover the bucket or garbage can and leave it for several hours; the sculpture should turn a bright blue. (For an example of this, see *Tiny Nike*, page 197.)

There are some problems with this method, and they are typical of fumed patinas. First, the color often settles on the bottom surfaces of the sculpture, leaving top surfaces a lighter color or even blank. Turning the sculpture from time to time will help, as will placing a small battery-operated fan inside. Second, some fumed patinas will rinse right off if you pour water onto the sculpture. If you let the piece dry thoroughly and then spray with ordinary artists' fixative, the color can be quite beautiful and permanent.

A plastic-ferruled, natural-bristle round brush, perfect for applying patinas.

Working with Color

At this point, let's consider some of the aesthetics of color. I see three ways of coloring a sculpture. The first is overall color, which accounts for the vast majority of sculpture. The second is what I call "toy soldier" color, where different parts of the sculpture are colored differently, such as a pink face, red coat, black trousers, and so on. (See Jane DeDecker's piece *Secrets*, page 199, for an example of this approach.) The third way is also polychromed, but the color is freely applied without being limited by form; in other words, painting outside the lines. Manual Neri, Harry Jackson, and Veloy Vigel are three artists that come to mind who use this approach. Look at their work in books or galleries, and study what they are doing. Also, look at other sculptures to see how color is handled.

Always remember this: *color is more powerful than form.* Imagine modeling and casting a simple portrait head, then painting it black and white, divided right down the middle. Or imagine a room of portrait heads, all of different people, all painted white, with just one painted bright red. See what I mean? Color must be considered very carefully. It is not an afterthought, something tossed off at the end. Try to think from the beginning of what color your sculpture will ultimately be, and imagine it that way throughout. Use color carefully, since it can cut across form, create form, enhance form, negate form, and overshadow form.

Photo courtesy of Manuel Neri and Charles Cowles Gallery, NY

Mujer Pegada Series No. 1, Manuel Neri, 1985–86. Bronze with enamels, 69½ × 55 × 10¼" (177 × 140 × 26 cm). An example of color being freely applied without limitation by the form.

THE CHEMICALS

Here we come to the heart of the matter. Many patina books have long lists of chemicals to buy, but remember this: most professionals rely on three main chemicals, with only occasional use of a few others. The "big three" are liver of sulfur, ferric nitrate, and cupric nitrate. Let's take them in order.

Liver of Sulfur

This chemical's real name is sulfurated potash, but it is commonly called *liver of sulfur*, or *liver* for short. It has nothing to do with that thing in your body. It comes as a jar of small, tan rocks that smell like rotten eggs. For this reason, its slang name is *stink*. It is also the easiest patina to use, and is often the first or base coat over which other patinas are applied. Liver will produce browns and blacks on bronze. Unlike many other chemicals, liver gives a "true" patina, meaning that it involves a chemical change in the surface of the metal and does not rely on depositing pigment. The illustrations on page 196 show you what liver looks like on a bronze.

To use, take a wide-mouthed glass jar, like a peanut butter jar, and put in about one cup of hot water. Then add a piece of liver no larger than a lima bean. The hot water should speed the dissolving process. When you drop the liver into the water it will seep a yellow color. (If it doesn't, the liver is dead and won't work.)

Once the liver has dissolved entirely, you can paint it directly on the bronze for a brown color. If you heat the bronze and paint or spray on more, the color will deepen, and can go all the way to black. This patina can be wonderful by itself, or it can be a base for further patinas. When used as a base coat, liver is usually "scrubbed back" with a clean (no soap), plastic Scotch-Brite pad to lighten the overall color

TIP

Let's talk about water. Many *patineurs* swear by distilled water, claiming there are already too many chemicals in city water. Here's a little story. I was attending a patina workshop in West Palm Beach, Florida. We were working outside, and I had brought a bronze relief, which had been sandblasted. We were watching the instructor demonstrate his skills on another piece when it began to rain. No big deal, we took our things and moved indoors. After five minutes someone asked me what I had done to my piece. It was covered with black and green streaks, just as black and green as could be.

The reason? The rainwater had picked up sulfur from car exhaust and chlorides from the nearby ocean and had "patinated" the sculpture. Well, if that's in rainwater, what's in city water? So those who use only distilled water have a very good point.

and create light high areas and darker crevasses. When used this way, it is referred to as *liver scrubbed back*. The pads come in various grits, or coarseness. Buy several and try them. Some people also use steel wool, which works, though you must remember that it applies a fine layer of iron to the surface. Also, some steel wool contains oil, which is a no-no. To be safe, it's a good idea to follow with carburetor cleaner any time you use steel wool.

Note that when you store liver, it will go off if even a few drops of water get into the jar. Keep it very dry and keep the jar tightly closed.

Ferric Nitrate

You can make your own ferric nitrate, also called *ferric*, which will help explain what it is. Soak some nails in water for a week until they are good and rusty, then take them outdoors. With your face protected and standing well back, pour in some nitric acid. *Whoom!* You'll get one heck of a reaction, so step back quickly. When all has settled down, like the next day, you can drain off the liquid to get a sort of rust-colored sludge. This can then be added to water to form a more diluted solution.

So ferric nitrate is what you get when you mix iron (ferric) with nitric acid. When you buy this chemical it comes as white crystals, sort of like translucent sugar. When added to water, the water goes reddish brown, like tea.

To use ferric nitrate, add about a teaspoon of it to a cup of hot water, then let it dissolve. You can apply it with either a sprayer or a brush, but either way the bronze must be so hot it sizzles. If you apply ferric to a bronze that isn't hot enough and then play a torch over that area to reheat, it will instantly go deep red-brown. You don't want that. So keep a cup of plain water with a clean brush handy—or a sprayer with plain water—to continually test the bronze and see if it's hot enough to make the water really sizzle. Then apply the ferric.

When you apply the ferric, don't just slop it all over. Dip just the tips of the brush bristles in the solution, shake off the excess, and then stipple or dab the ferric on very carefully. As the patina continues, you'll need very little on the brush and can go on stippling for a long time after you think the brush must be empty. A little goes a long way.

Ferric will work on bare bronze, but is often applied over a base coat of liver scrubbed back. It warms the somewhat cool brown of the liver, giving a reddish tinge that is very nice. This is a very common patina, perhaps the most common, and is usually called *ferric over liver*, or French brown, or sometimes cowboy brown.

Ferric can also be rinsed with water, and scrubbing usually helps it a lot. I often apply layer after layer of ferric, with generous rinsing and scrubbing between applications, which seems to build a deeper, more subtle, and certainly more durable patina. See the color illustrations on page 194 for more information on applying ferric nitrate.

Cupric Nitrate

If you took old pennies or copper shavings and poured nitric acid over them, you'd get something like cupric nitrate, also called *cupric*. More common is to buy it as blue-green crystals. These dissolve in hot water, again about a teaspoon per cup of water. Like ferric nitrate, cupric is applied with the bronze so hot it sizzles. Also like ferric, cupric will work on bare bronze but is often applied over liver. A cupric patina is not a true patina like liver, but rather a bonding of those blue crystals to the bronze. Proof? If your bronze is sitting on a brick, the cupric will patina the brick as well.

When applying cupric, you won't notice a strong green at first, but more of a haze, particularly if you are applying it over liver. If you apply the chemical too heavily and then blast it with a torch because the bronze wasn't hot enough, it can instantly turn black. This will come back to green with more application, so don't panic if it happens.

Keep applying layers of cupric—either by brush or spray—and watch the green color come up. You can apply more of cupric than you can of ferric, but be sure the bronze stays hot enough for a good sizzling action. When the sizzling is there, and the green is building, you can apply solution and hit it immediately with the torch to keep the bronze good and hot. The green will usually come up as a pale turquoise color, and will likely be uneven. As you work over an area you can get the color to be more and more dense, deeper, and more opaque. You can scrub with the brush to make the patina still more opaque and solid.

Now, if you rinse, everything changes. Pour water over the piece, and when it dries off the color will be considerably lighter, sometimes verging on pale sky blue, even a whitish color. (Hot water will make it bluish, cold water more yellow.) You can go then over this with more cupric, bringing the color back a little darker.

Here are some combinations you can try. A very light application of liver over the cupric will darken it, moving it towards an olive green. Going back and forth—adding liver, going back to cupric, and so on—can build depth and richness. For a fun one, build a strong cupric color, then spray ferric on with the bronze nice and hot. The result is a sort of orange color. It's a little difficult to get this one even, but it does work.

TIP As you apply chemicals, the bronze will be constantly cooling. Use a brush in your dominant hand and a torch in your other hand to keep reheating the bronze as you work. Unless you are working a very small piece, don't try to heat the whole bronze at once. Instead, work from top to bottom (my preference) or bottom to top.

Other Chemicals

Liver is a "true" patina, which means that is it does not involve a buildup of pigment on the bronze. If you do a cupric patina, as mentioned, and your piece is resting on a brick, the brick will get a nice green. This shows you that a cupric patina is *not* a true patina; it involves depositing blue-green crystals on the metal. Most other commonly used patina chemicals are of this pigment-depositing sort.

One exception is Birchwood-Casey (see list of suppliers). This company makes a number of excellent patina solutions, including very nice browns and blacks. All of these solutions are very effective as dipped patinas, and you might consider using a large plastic garbage can with such a solution. Just suspend the cleaned bronze in the liquid and look at it from time to time to see what's happening. An advantage of dipping is that the timing controls the depth of color, and the color, if the piece is well cleaned, is very even—no drips, runs, or errors.

Another chemical, ferric oxide (which is nothing more than powdered rust), can be used to make a ferric patina even more red. Just add a little ferric oxide to your ferric mix after you have a good patina going, then dab it on quite hot and the color will redden considerably.

The same thing can be done with cupric by using dry blue or green pigments that are manufactured for paints. These pigments are easily found at large art supply stores, like Pearl Paint, but some of them may have difficulty dissolving in water. Try dissolving troublesome ones in a little alcohol first, then add the solution to your cupric or ferric mix. Be careful—a little goes a long way, and we're after something that still looks like bronze, not a garish painted look.

Titanium oxide, or zinc oxide, combined with bismuth nitrate will give a white color. A little of these white chemicals mixed into other patina mixes will lighten the patina and lean it towards more pastel shades. They are used hot.

Silver nitrate is very expensive, but if applied *very* hot and with persistence can give a beautiful silvery-gray that can come up just like real silver, slightly tarnished. For a truly beautiful patina, use silver nitrate as a base for cupric.

Paints, Dyes, and Stains

Cupric is really just a pigment that adheres to metal, and nowhere in the big book of rules does it say you can't paint bronze. Paint is, after all, just pigment stuck down with something else.

One of the best paints to use on bronze is acrylic. A multitude of colors are readily available, and they can be thinned with water and brushed on a hot bronze like any other patina. They can color flowers, add accents or naturalistic color, or color the overall piece. There are also water-thinned acrylic enamels on the market that work very well on bronze.

Oil paints will also work, but they go on cold after a base patina is applied. They can be thinned, put on in washes, and then wiped so they don't look quite so paintlike. To make a medium for oil paint, use linseed oil, turpentine, some drier, and a little naphtha. Then add some oil color from the tube, and apply.

Ron Young, a patina guru, has brought out a line of dyes for metal. There are two kinds: those that thin with lacquer and those that thin with water. The former are intended to be applied after the regular chemical patina is on, and to

enhance it. I suggest buying a sample kit and experimenting. Keep the concentrations thin and think of applying layers of color rather than one heavy coat. The water-thinned dyes can go on as a last coat, or be added to patina mixes for enhanced color effects. (The color illustrations on page 197 show what happens to a cupric patina when a little water-soluble deep blue is added to the mix.)

Going Further

With this basic beginning, and after you've gotten comfortable with the three main chemicals, it's time to buy one of the many books on the market about patinas. Three good ones are *Patinas for Silicon Bronze* by Patrick Kipper, *Contemporary Patination* by Ron Young, and *The Art of Patinas for Bronze* by Michael Edge. These fine books cover the subject in much more detail than I can here, and give dozens of wonderful patina recipes, some of which are quite exotic. They provide an advanced course in the subject. Another good source of patina recipes is also a fine source for chemicals: Bryant Laboratory (see list of suppliers). If you ask specifically, they will include a manual with your order.

But be careful of a couple of things. First, be careful which chemicals you use. Many exotic patinas involve potassium ferrocyanide. My advice is to stay away from anything with the name cyanide. It isn't worth risking your health. Even with the precautions outlined above, the stuff is too dangerous. And second, a patina should ultimately show off the sculpture, not be the object of attention itself. The very opaque, paintlike, and completely nonmetallic patinas, while they can look stunning with a spotlight on them in a gallery, begin, in my view, to ring a bit false after a while. Remember what's important, and with sculpture that usually means the form.

FINAL COATINGS

This is a very big subject and the source of a lot of controversy. The final surface coating is what protects the bronze, and it also has a profound effect on the look of the patina. It must be considered very carefully.

First, there is the option of leaving the sculpture without any surface coating at all. This can work, particularly for indoor pieces. Sometimes there is a fine matte surface to the patina when you finish that you just don't want to change. So leave it. Try not to handle this surface and tell others to keep their mitts off. If you try this outdoors, however, the piece will change rapidly, and usually for the worse.

A second option, and by far the most common, is wax. There are many paste waxes on the market, with Johnson's, Trewax, and Butcher's waxes readily available in stores selling housewares, and Renaissance Wax in specialty stores and by mail (see list of suppliers). All work well, but many foundries swear by Renaissance Wax, particularly for green

patinas. Clear shoe polish is also a very good wax.

The typical surface for brown patinas is a hot wax job. To apply, first get the bronze nice and hot. This is usually the case when you're finished with a ferric or liver patina. Using a soft clean brush, like a chip brush, simply brush an even coat of wax all over the bronze. It will look very dark. Don't allow puddles or thick places—even it out. Now let the bronze cool to room temperature and buff with a soft, clean cloth. Voilà, the sculpture will look great. A hot wax job will protect the bronze for years indoors, and for about a year outdoors. Outdoor pieces should be rewaxed once or even twice a year. Wait until there's a good hot day to apply the wax, then buff in the cool of the evening.

Don't try a hot wax job on a green cupric patina, because it will go blotchy. Many swear Renaissance Wax won't do this, but Johnson's certainly will. The solution for green patinas is to allow the patina to cool, spray it lightly with an artists' fixative, then apply the wax cold with a brush. Let it stand for a few minutes, then buff.

Sometimes a surface can be "juiced up" with colored wax—translation: shoe polish. Have a can around and try it now and then. I would advise, however, against leaning heavily on shoe polish. Someday you'll sell a piece to a buyer who will put it in the car trunk on a hot day, pick it up, and have a colored hand; you'll probably get a phone call. Real patinas are better.

Another popular surface is a laquer called Incra-Lac, which was developed to protect bronze outdoors, although it does break down with time. The manufacturers recommend stripping it off and reapplying it every five years, but it doesn't want to strip off with any known solvent. Also, I find that Incra-Lac can begin to flake off, leaving lighter areas showing, which is very unsightly. If that happens, your only option is to sandblast, reapply your patina, and swear never to use Incra-Lac again. I recommend against using it. Use wax instead.

There is another whole area that, to my knowledge, is unexplored. There is a huge industry devoted to creating hundreds of final surfaces to protect metal outdoors—the car wax business. I suspect that lurking somewhere among the Turtle Wax cans there is an ideal exterior finish for bronzes. A lot of experimentation is waiting to be done with these products.

Another option that I have used with good success is linseed oil. Thin the oil with some turpentine, Japan drier, and naphtha, then brush it on and wipe it right off. Naturally, a little oil color can be squeezed into this mix to enhance the color. The oil mixture penetrates down into the bronze, rather than sitting on top like a lacquer, and hardens in a few months to a very tough finish indeed. When thoroughly dry—I'd give it three months—it can be waxed

Your sculpture should now be patinaed, waxed, cooled, and buffed. Assuming you did all that with your piece bolted to a temporary metal base, it's now time to take it off and mount it on that pristine base you so carefully drilled. Stick some adhesive felt circles on the bottom of the base at the four corners so it won't scratch furniture, then stand back and admire.

PRESENTING YOUR WORK

Well, that's it, then. You have conceived a sculpture, created the armature, modeled it, molded it, invested it, cast it, chased it, applied the patina, and mounted it. There are only two steps left: photographing and selling it. And that's what this chapter is all about.

PHOTOGRAPHING YOUR WORK

The first task you should tackle after completing a piece is to record it with photographs. There are five kinds of photographs commonly used for sculpture: slides; color prints; black-and-white prints; large format transparencies, or negatives; and digital images. Let's discuss each one in turn.

■ *Slides.* These are kind the most commonly used. They are simple to take, process, and have copied. Most shows, commissions, galleries, and the like ask for slides. When used correctly, the slides will be projected for everyone to see at once. A projected slide is the best photographic reproduction of a sculpture you can get. But read the section on prints, just below, to see how slides are often misused.

Always keep your best slides so you can make copies from them. Never send originals out, only send copies (called duplicates, or "dups"). You'll need lots of them.

■ *Color prints.* Color prints are also excellent, and many places require them. If you're showing images to someone who is not going to project images on a screen, prints are far better than slides. When a sheet of slides is handed over, most people squint at them against some kind of uneven and patchy light, like a window, and try to assess your worth as an artist by looking at postage-stamp-sized images. Studies have shown that the average person looks as long at a single print as they do a whole sheet of slides. If you can, hand people prints. And be sure to get big 8- by 10-inch prints rather than small, snapshot-sized ones. Remember,

you're trying to sell expensive items and you can't do that if you look cheap.

■ *Black-and-white prints* Some organizations want black-and-white prints, usually if they are going to publish them in a catalog. So it's handy to shoot a roll of these while you are still set up. As with color prints, these should be large, 8- by 10-inch prints.

■ *Large-format transparencies or negatives.* For the highest quality color prints, large-format transparencies, or negatives, are the best. They are also preferred for the highest quality printed reproductions, as for a catalog or book. They usually measure either 4 by 5 inches or 2¼ inches square, and are basically just large slides without the cardboard mount. The only problem is that they require a large-format camera, which not everyone has. If you do have one, use it. Otherwise, go to a professional.

■ *Digital images.* These are images made with a digital camera, which does not use film. It operates something like a television camera by recording the images electronically on a disc, which goes into the computer. There are several real advantages to digital images, and some disadvantages.

The advantages are, first, you can see the actual image you will get before you shoot, as it appears in the viewfinder just as the picture will be. You can also see the image immediately after shooting. Second, digital cameras are very good in low light. Third, the digital images can be fed into a computer and manipulated. Fussy backgrounds can be removed, and images can be moved and joined to other images. A small model of a sculpture, for example, can be shown as though large and in a park. And finally, the digital image is ready for web sites and other electronic means of communication, and can be transmitted electronically.

The only disadvantage to digital images is that they don't yet have the clarity and pinpoint focus of good film images,

though this may change with technological advancement. It is not beyond possibility that in twenty years film will be as rare as vinyl records, and the digital image will have taken over nearly completely.

When choosing a digital camera, look for the number of pixels that make up the picture. The larger the number, the higher the image quality and the higher the price. Isn't it always like that? Also, look at how you see the image. Some cameras have a tipping screen that allows you, for example, to place the camera low to the floor without having to get down on your knees to see the image clearly. Another factor

is the number of images the camera can store, and how the images are transferred to a computer or printer.

Hiring a Photographer

Here's the easiest and best way to handle this tricky job: hire a professional. They have the equipment and expertise to do a better job than you will, if you can afford them and if there is one available.

But hiring a professional isn't always that easy. Most professional photographers have little or no experience shooting sculpture. Don't be afraid to ask the following questions before selecting a photographer:

■ Do they specialize in or have experience shooting artwork?
■ Do they shoot your medium? Shooting paintings and flat art is very different from shooting works in the round.
■ Do they work with objects that have shine, like pots with glazes, or glass?

Lastly, don't be hesitant to ask to see a photographer's portfolio. If you like what you see, go ahead. If you don't feel your work would look its best with that person's style of photography, look around some more.

Taking Your Own Photographs

If you can't afford a pro, or can't find one, you will have to do the job yourself. Sure, there are books and books on the subject, and it's about as complicated a job as you can imagine, but there are some basic principles that can be learned.

Equipment

First, you will need a camera. Those little pocket cameras that are so popular are fine for taking snapshots on vacation, but you can do better for serious photography. The world of cameras is very complicated and full of more claims than California during the gold rush. Ignore the vast majority of them. What you need is a good, workable single-lens reflex camera (SLR) with at least some level of manual override of any automatic features. You don't need a programmable camera or auto-focus, or any of the many advanced options available. Those are great, and if you want that kind of camera so you can use it for other sorts of things, fine. But you can get by with a relatively inexpensive model, just so long as it allows for manual control of exposure and interchangeable lenses.

The reason for the interchangeable lenses is this: first, you use lenses of varying focal lengths for different kinds of photos. Second, you will probably want to fit a filter to the camera at some point, and small pocket jobs won't take one. Also, you might want to attach a close-up lens for very small work or details; pocket cameras rarely focus closer than three feet.

Lenses come in a bewildering variety, but nearly all fit some easily understood categories. They will be either fixed

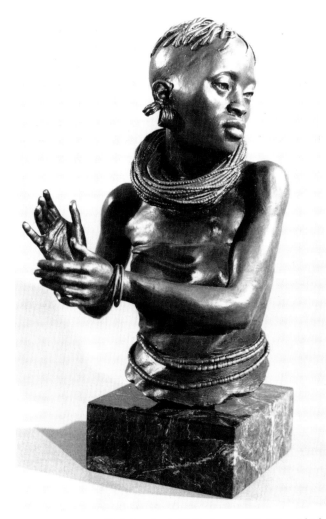

Kenyan Dancer, *Tuck Langland, 1993. Bronze, 12" (30 cm) high.*

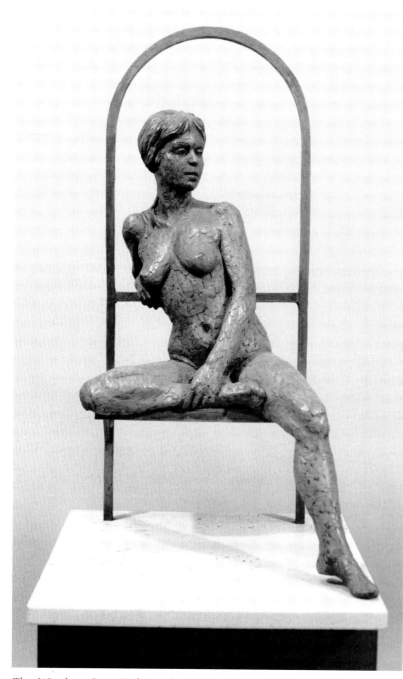

The Window Seat, *Tuck Langland, 1992. Bronze, 24" (61 cm) high. This photo was shot with a 50mm, or normal, lens.*

Telephoto lenses bring you closer to the subject, and their numbers are *larger* than 50mm, with 75mm or 80mm being medium, 135mm being a true telephoto, and 200mm and higher for very long shots.

Zoom lenses change their focal length with a sliding ring, so you can stand in one place and make it seem as if you are moving closer to or farther from the subject. There is a kind of distortion that can happen with zoom lenses called *pincushion distortion*, which you only see when shooting square things like paintings. The edges of the painting will appear to bow in slightly at the centers. With organic forms like sculptures, this isn't a problem.

It is generally best to use a lens slightly longer than 50mm, like 75mm or so. These are usually called *portrait* lenses. A good zoom lens from 35mm to 80mm or thereabouts is perfect for shooting sculpture when set in the 75mm range.

You can use a camera with no built-in exposure system at all if you buy a good light meter, which is what many professionals do anyway. A *spot meter* is one that reads only a very small spot rather than taking in light from the whole scene. It's a good idea. If you have an automatic camera, be sure you have one that allows for manual override, or, at the very least, bracketing capability. That means you can shoot at the exposure the camera says, but then also shoot brighter and darker to see which you like best.

To set your exposure, buy what is called a *gray card* from the camera shop. The gray color of the card represents a good average of light and dark colors. Hold it up in front of the sculpture and "read" off it to set your exposure, either with a handheld meter or through the camera. Bring your camera close to the gray card (or to the sculpture itself) until it fills the viewfinder, then read the exposure and set it manually to those numbers.

After the camera, the next most important piece of equipment is a tripod. Don't scrimp here. Buy as good a tripod as you can afford; it will last you all your life. It is the single most important piece of equipment after the camera for improving the quality of your pictures. This is not only because it holds the camera still, but also because it allows you the time to look carefully at the image you have framed—to look at all four corners, to look at the lights and shadows, to see what unwanted things have crept into the picture, and to really study the image before shooting. If you're holding the camera in your hands you tend to rush, to move, to forget to look at all four corners.

focal length, or variable (zoom lens). And they will be either wide angle or telephoto. Cameras usually come with a 50mm lens, which projects the world as though there were no lens at all on the camera. You can also buy a *wide-angle* lens, which comes in numbers *smaller* than 50mm, like 35mm, 28mm, or even smaller. The smaller the number, the "wider" the lens. These lenses make it look as though you are standing farther away from the subject than you really are, and as they get extreme, they distort rather seriously. I'm sure you've all seen photos taken with a "fish-eye" lens in which everything is strangely distorted.

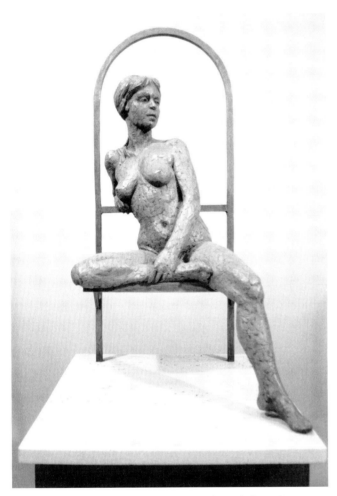

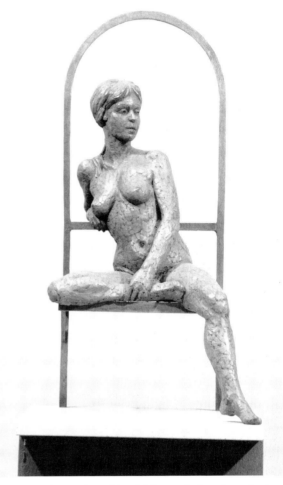

The same sculpture shot with a 28mm wide-angle lens. Compare this to the photo taken with a normal lens (shown opposite), especially the lower leg and the angle of the head.

The same sculpture shot with a 200mm telephoto lens. Again, compare with the shot taken with a normal lens. Notice the angle of the lower leg and the top surface of the folded leg.

Film

What kind of film should you buy? There are three basic kinds on the market: slide film, color print film, and black-and-white film. Let's look at each one.

■ *Slide film.* These brands always end in the word *chrome,* like Kodachrome, Ektachrome, Fujichrome, and the like. They'll produce slides, or transparencies, that look just like the scene. They will come back to you from the processor mounted and ready to label and project. (Note: Ektachrome and Fujichrome use what is called the E6 process, and can be developed in only a couple of hours. Kodakchrome must be sent to Kodak and takes about a week.) To get duplicate slides made, just send your originals to a photo lab that does that sort of work.

■ *Color print film.* These film names end in the word *color,* such as Kodacolor, Fujicolor, and so on. They will come back to you as a strip of color negatives and usually a packet of prints. From the negatives you can make enlargements, more prints, and the like.

■ *Black-and-white film.* There are still many brands of black-and-white film on the market, with Kodak Plus-X, Tri-X, and TMax being standards. Of the three, TMax is probably the best for shooting sculpture. Another good brand is Ilford FP4 Plus. One problem with black-and-white film is finding a good processor, as most film processors are set up for color. Look for a professional lab, one catering to professional photographers, and ask if they can do good black-and-white custom prints. This means working the print by hand (what they call *burning and dodging*) to bring out its best qualities.

Color and light

There are two kinds of light: daylight and artificial light. Artificial light is often called indoor light, or *tungsten* light. Daylight is white and artificial light is red, which to the eye looks yellow.

There are also two kinds of color film: daylight film and tungsten film, sometimes called indoor film. Use daylight film outdoors and tungsten indoors. If you use daylight indoors, the pictures will be too orange. If you use tungsten outdoors, the pictures will be too blue. Another option is an 80A filter, available from any good camera store. This is a bluish filter that you put on so you can use daylight film indoors. It works.

Another kind of artificial light is fluorescent. This is green-colored. In general, avoid it. If you must use it, buy an FLD filter for use with daylight film, or an FLB filter for use with tungsten film.

When you shoot, decide if the light is going to be outdoor natural light or indoor artificial. It should be all one or the other—the film can't mix—although if you're using natural light, you can get away with a few artificial lights, but not too many. If you're using floodlights and you have either tungsten film or the 80A filter, darken the windows or shoot at night. Do not use photo floods as they slowly change color with use and you can never tell how orange they have become. Buy quartz halogen instead, which remain constant. Kill all fluorescent lights—they make things greenish. (Of course, none of this matters if you're using black-and-white film.)

If you're going to shoot outdoors, try for two things. First, choose a day that is bright but just slightly hazy. Heavy overcast is too dull, shooting in shadows looks like you're shooting in shadows, and bright sun directly on the piece usually creates heavy, pitch-black shadows and bright burned-out spots—hardly conducive to describing form. A nice hazy day is perfect.

Backgrounds

It is important to avoid fussy backgrounds that will detract from your sculpture. Professionals use large rolls of paper that are pulled down towards you over a table, making a seamless background. Look at photos of sculptures in magazines and you'll see this seamless background used again and again. If you haven't got that, or the space for it, use a plain wall, a large sheet of paper, or a piece of plywood painted off-white or some other color—something that is plain and not wrinkled or textured. Set the sculpture on a simple pedestal in front.

For very large works, you can shoot outdoors. Again, look for a location where the background is either quite plain or well off in the distance and does not distract.

Framing the shot

The first thing you have to do is place the sculpture and frame the picture. In general, you want to shoot horizontally across at the work, not down on it from above or up from below. A good rule of thumb is to place the camera as high as the midpoint of the sculpture.

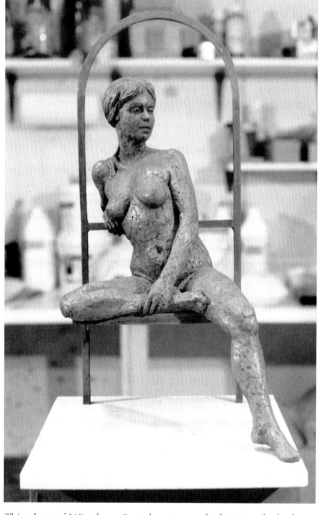

This photo of Window Seat has too much clutter in the background, distracting from the sculpture. Compare it to the much cleaner background in the photograph on page 218.

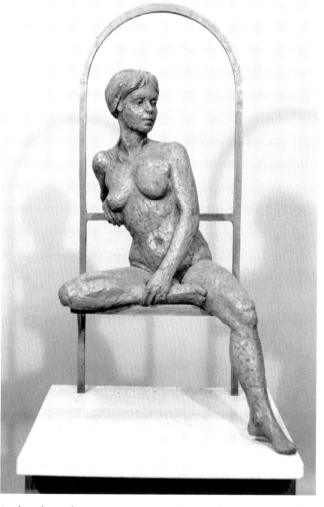

In this photo, there are too many shadows in the background. The sculpture should be pulled forward and the lights shined more from the side to eliminate shadows.

Next, turn the sculpture to find the best view or views. You'll usually take a few views, but pick one that is the most telling, the most descriptive, the one you'll send out when you're only sending one. Take your time turning the piece and looking through the tripod-mounted camera. Later you can select one or two secondary views, and even some details.

Using artificial lights

The secret to using artificial lights in the studio is to have lots of them. Dumping one or two floodlights on the piece is far too limiting. First, try to spill rather a lot of soft light from directly above. Make a frame holding a sheet of translucent plastic and suspend this flat over the sculpture. Now put one or two halogen floodlights above the sheet, shining down through it. Alternatively, you can bounce lights off a white board above the piece. This will be your primary light source, directly overhead.

Next, supply some fill light from the sides, usually both sides. You want this to be secondary to the overhead light, so use smaller lights instead of powerful floods. Move the lights closer and then farther away until they give the effect you want, and watch for shadows on the background. Try to place the sculpture well forward of the background and keep the lights off to the sides to avoid shadows.

Now is a good time to worry about lighting the background. It can be plunged into darkness for contrast, or it can glow with a well-placed light. You can even spill a colored light on the background. Just don't ignore it—it's an important part of the picture.

After that, model the form using smaller lights. One photographer I know uses small flashlights placed here and there to bring out this line, or fill in that shadow. (He tells me that if you use a lot of flashlights you'll need to invest in a battery factory. Or you can buy rechargeable batteries.) This is the stage when you have to become as much an artist with light as you were with form when you made the sculpture. Look through the camera at the scene and slowly run your eye from its very top point down the right side, looking at everything. Then look down the left side. Notice where the form disappears, where it appears too bright, where there are deep inky shadows, where there are glaring spots of light, where it blends with the background. At each of these points you can fix things.

If the form disappears, perhaps a small flashlight off to the side will just lay a line of light on the edge. If the form is too bright, try putting a piece of tracing paper in front of the light shining on that part. (But be careful, lights get very hot and you don't want a fire.) If there is a deep shadow, fill it in with a small flashlight, or perhaps light bounced off a white card. And if the form blends in with the background, change the value contrast. Perhaps you can shine a light on the background at that point so the background becomes light while the sculpture stays dark. Or you can do the reverse, aiming a light away from the background and hitting that edge of the sculpture with a small light.

Finally, take a long, slow look at the whole thing and ask yourself: Is that my sculpture? If it's only a clever photograph, start over. You should be able to describe your work with light and have it still be your work. I know these seem like vague generalities, but ask yourself these questions anyway. They'll help.

Shooting

Exposure is crucial. Set your exposure by using the meter first on the gray card, then on the sculpture itself. If there is a big difference, shoot both readings and some in between. You want to *bracket* your shots—shoot pictures one and two stops on either side of the meter reading—so you have a range of exposures to choose from. Remember, color print film is rather forgiving on exposure, but slide film is not. You need to be right on with slide film, so shoot plenty of pictures, bracketing at half-stops if you can. When the slides come back, you pick the best ones and have duplicates made from those.

This next part sounds so simple, but *focus*. Learn how the focus system on your camera works, and be very careful. Look hard to be sure it is pinpoint sharp.

You should also understand *depth of field*. Depth of field is a measure of what is in focus in the picture. For example, if you take a close-up of a person's face and her nose is sharp while her ears are blurry, that's *shallow* depth of field. If, however, not only are her nose and ears sharp, but also the plant on the windowsill behind her, and even a house across the street seen through a window, that's *deep* depth of field. You control depth of field by opening and closing the lens, which is measured in units called *f-stops*. When the lens is wide open (small f-stop numbers), you get shallow depth of field. When the lens is smaller (large f-stop numbers), you get deep depth of field. For correct exposure, change the shutter speed one notch for each f-stop change, making the shutter faster for larger apertures, and slower for smaller ones.

To understand exposure and the further intricacies of photography, buy and study a good how-to photography book or take an introductory class at your local college or art center. You can also learn from your own experience. Every time you set up and shoot, make careful notes. Write down what the meter says, then what you do. Write down the aperture, the shutter speed, and any bracketing you do. Write down what film and filters you use, and how your lights are set up. If you're shooting outdoors, write down the date, the time of day, and a note about the quality of the light. And remember this: keep things as simple as possible. If you are experimenting, change only one variable at a time, never more. Every photo you take will be a step in your education as a photographer. Keep good notes and be your own teacher.

Labeling and Storing Your Images

Once you have your images, you will want to keep them organized and ready to send out. There is some controversy about how to label images, but the following appears to be more and more a standard:

■ *For slides:* Each slide should be labeled with your name, the title of the work, the material, size, and (optional) date and location. The writing goes on the front of the slide as you look at it, oriented so that the slide is held the correct way, right side

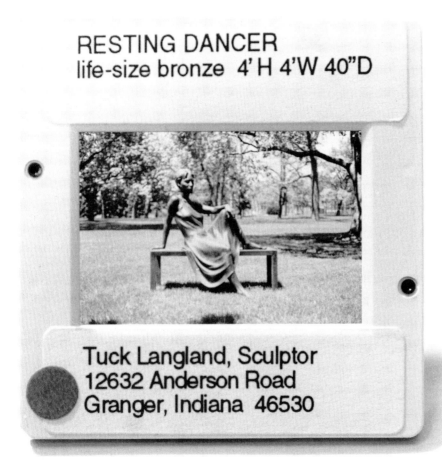

RESTING DANCER
life-size bronze 4' H 4'W 40"D

Tuck Langland, Sculptor
12632 Anderson Road
Granger, Indiana 46530

Proper labeling of a slide. All information is clear, the printing is professional, and the red dot is in the lower left-hand corner. Note that this slide does not give the date of the piece, which is optional.

up and left to right. For horizontal slides, put the major information on the wide band at the top. If it doesn't all fit, you can spill over onto the bottom wide band. For vertical slides, give the slide one quarter-turn to the right, and continue as described above. In general, nothing is written on the back.

For both vertical and horizontal slides, hold the image so that it is correct as you look at it, then place a red dot in the *lower left-hand* corner. This is to allow easy orientation when placing in a carousel for projecting. The illustration above shows an example of a correctly-labeled slide.

■ *For prints:* Never write on the back of a print with a pen or pencil; it will show through on the front. *Always* write (or type, or print on your own fancy laser printer) the information detailed above onto a stick-on label and place that on the back.

■ *For large-format negatives and transparencies:* These will come in glassine envelopes; all labels should go on those envelopes. The envelopes should then be placed, by category, into larger opaque envelopes for further protection.

File your images where they will be protected from light, dust, and physical wear, such as in a file cabinet. Slides are best kept in a purpose-built slide cabinet with several drawers. Avoid the kind with a little slot for each slide, since if you want to add a new one near the front you'll have to move every dagblasted slide; better are the kind with sections that each hold several slides loosely. Another good way to store slides is in transparent, plastic slide sleeves placed in a three-ring binder.

Now you're ready to send out images of your work when called for. Remember, be professional. Don't skimp on this part. When people evaluate you as an artist, all they will have is your photographic material and they will do a lot of judging on what they hold in their hands. If the images are badly shot, poorly lit, and/or scribbled on instead of neatly labeled, what will they think?

EDITIONS AND PRICING

Pricing your work is crucial for sales. Price it too high and nothing sells. Price it too low and you lose money. What to do?

Editions

We'll get to pricing in just a moment, but first we must discuss editions. Except for modeled wax originals, bronzes are, by their nature, reproductions of a clay original. If you can cast one bronze, you can cast many. For this reason, most sculptors working in bronze create works in limited editions. This way, the large costs of the original modeling and mold are spread out over several casts, bringing the cost of each cast down and ultimately making more money for the artist.

How many casts should your edition include? The French have a law that states that a bronze can be called an original if it is part of an edition of ten or fewer. Most sculptors like to keep editions somewhere near that number; I am person-

ally fond of seven. However, if a sculpture is popular and is sure of selling well, edition numbers can go up to twenty-five, fifty, one hundred, or even more. As the edition size increases the rarity decreases, which means the value goes down some. But likewise, the price decreases because the original cost of creation is proportionately spread out.

Interestingly enough, in nineteenth-century France, it was the sculptures in very large editions—sometimes more than 1,000—that were most sought after, rather than those in the small editions. The thinking was exactly like that surrounding our best-selling books today—the larger the edition, the more popular the work, and thus, it is thought, the better the work. But if you put a large edition number on your early works, you are committed to creating and selling that number, which may or may not happen. It's better, in my view, to begin your career with small edition numbers—under ten. Then when you begin to sell out regularly, you can consider enlarging the editions. (See page 128 for instruction on marking each cast in an edition.)

There is also the question of an *artist's proof* and a *foundry proof*. If you have hired a foundry to cast an entire edition, you should do a foundry proof. This is the first cast, which you personally supervise. The foundry proof then stays in the foundry as a guide so the remaining casts can be done without your supervision. The artist's proof is a little different—it's for you. Most artists cast only one artist's proof, but some cast as many as 10 percent of the edition. These can be used for sale or gifts.

When you establish an edition size, don't cheat if it is selling well by casting and selling more. Be honest. People paid you good money and expect fair practice. When the entire edition has been cast, destroy the mold.

TIP

Some galleries will ask for a certificate of authenticity to pass on to the customer. You can buy fancy forms for this, or make one up yourself. It ought to include your name, the title of the piece, the date of the casting, the number and edition of the casting, and the foundry that cast it.

Pricing

Here is the tricky one. None of us likes this part of the business, but it is not only necessary, it is delicate and extremely important. You can base your prices on several factors. Here are a few:

■ *Foundry cost.* Even if you have cast the work yourself, send a photo to a foundry for a quote to help you figure your pricing. Foundry costs will include any of three items: enlarging, molding, and/or casting. Enlarging (if necessary) and molding are one-time costs for the entire edition, but the casting must be paid for each cast. If you are cautious about selling out an edition, you should get the enlarging and molding costs back with sales of only half the edition. So take

those two numbers, add them together, and divide by half the edition number. Add that number to the casting cost, and there is your foundry cost for a small edition. A good rule of thumb is to then charge three times that number. As your reputation and sales increase, you can charge more, like four or even five times foundry cost.

■ *The size of the work, the complexity of the work, and the quality of the work.* Each piece you create will have variables of these three elements, and they should all affect the price. You can combine the more quantifiable measures of size and complexity with the elusive one of quality, and bump the foundry price accordingly.

■ *Comparison with other works on the market.* Here's the most important rule in pricing, and it's one that just about negates any other. Your work should be priced about the same as work of similar size, complexity, and quality by *artists of a similar reputation.* A dealer once told me that when you buy a painting done by one of the old masters, you're buying an autograph. We all know that a simple sketch by Rembrandt is worth far more than a life-sized bronze by an unknown. So in the end, the price is based on your reputation and what the market will bear, not what you believe you need to survive.

There is only one way to establish prices by this rule: visit commercial galleries and look at their sculptures. Find artists with reputations similar to yours—beginners, those getting established, or those already well established—and look at their prices. That's what you should be charging.

Whatever method you use, if you are selling your work through a gallery, you should of course also consult with the gallery owner about price.

Pricing editions

It is common practice to raise the price of each casting in an edition as the edition sells. For small editions, usually the first two or three casts remain at the same price and then subsequent casts are each raised by about 10 percent. This is an encouragement to buy early, and it reflects the increasing rarity of the works as the edition sells. For large editions, the price may increase in plateaus, so that numbers ten through twenty are one price, twenty through thirty a slightly higher price, and so on.

Another common practice is to offer a *precasting price.* Many sculptors will take a good photo of the work while still in clay and publish it, either through a gallery, in magazine ads, or on the Internet, and offer casts for a reduced price—usually between 10 and 25 percent less—to encourage sales before having to pay the initial costs of casting. This brings in money up front and allows collectors to get a bargain.

Honesty

Sculpture is a long-term business. Your reputation is everything. Trying to cut someone out of a deal to make a quick buck is stupid and will kill you in the long run. If your work is shown in a gallery, I can just about guarantee that sooner

or later someone will pull you aside and ask to buy a piece at the artist's price, thereby cutting out the gallery. Don't do it.

It takes work to make a sculpture and it takes work to sell a sculpture. Someone has to be paid for each of these jobs. If a gallery sells your work, it deserves a cut. After all, the gallery owners pay for the space, the renovation, the lights, the personnel, and the advertising. They put in their time, and their only pay is a slice of what they sell. Without that slice they'd have to close.

If someone comes to your house to buy sculpture, you are taking time away from working. You have to run around picking up the newspapers and old socks, and maybe even spring for a bottle of wine to schmooze them—now *you* are doing the work of selling. When this happens, you deserve the commission. If a person sees your work in a gallery or show, however, and comes to your house later to buy, here is what I strongly recommend. First, sell at the gallery price—never cut that price. There should only be one price for each sculpture, and it should never depend on who is selling it. The only exception is if a collector has already bought several of your works; it's not uncommon to cut some kind of deal as a thank you.

If you do sell a piece from your home, mail the gallery a check for its percentage, on the grounds that it was the gallery's investment that brought the buyer to you and the gallery deserves its cut. If you do that, they will find you an honest businessperson and will be willing to continue working with you. If, on the other hand, you cut them out of deals, they will cut you out, period, and word will get around. Honesty is *smarter* than greed.

EXHIBITING

There are five major ways of exhibiting, and a lot of other minor ones. The five major ways are competitive shows, invitational shows, art fairs and weekend shows, solo shows, and in galleries.

Competitive Shows

For most artists starting out, this is the door into the world of exhibiting. There are hundreds of shows every year, in all corners of the country and around the world. The rules are usually very similar: You find out about the show (more on that in a moment); you send in either slides, photos, or the work itself; a jury selects work; you send the work itself; the jury selects prizewinners; the show stays up for about a month; and you collect your work and move on. There are occasional sales from these shows, but not very many. The main benefits are that it helps you to build a resume, get your work seen, maybe win some prizes, and simply become part of the art scene.

Most of these shows have an entry fee that is not refunded if you are rejected. Shows that request slides have a second level of elimination when the accepted works arrive; if they aren't as shown in the slides, they can be rejected. That is also when the awards are given.

Competitive shows are local, regional, or national. Naturally the competition gets stiffer at each level, but so does the prestige. You usually start with local shows, which are not difficult to enter. After a few of those you graduate to the regional, multistate shows. With some success there you can move on to national shows, and eventually international shows. Each time the stakes are higher, the competition more intense, the odds of being rejected greater, and the rewards of acceptance even higher.

Since these are competitions, you have to be ready to lose. And you will lose. You will have a piece slung out of a minor show and then have the same piece win a prize in a bigger show. You will get into shows your teachers are rejected from, and later, if you become a teacher, your students will get into shows that reject you. Learn to accept rejection. Even Babe Ruth was out six of every ten at-bats. I once heard of an insurance salesman who figured he sold one $100 policy for every ten calls. So each time a door slammed in his face he figured he'd made ten dollars. After all, without making calls he couldn't sell anything. Think of these shows the same way.

How do you find out about competitive shows? The best way is a magazine called *Art Calendar* (see Further Reading). This monthly publication lists nearly every show going, as well as commissions, galleries looking for work, workshops, retreats, grants, and more. A very valuable part of the magazine is its exposés of fraudulent shows and rip-off schemes. There are other publications that list shows as well. Keep your eyes open for them, subscribe, and you'll have more shows than you can ever enter.

Invitational Shows

These are more of a sure thing. You are invited to show with a few other artists who may be sculptors like you or may work in other media. There is no competition to get in, nor are there any prizes. An invitational show is generally more prestigious than a competitive show, unless the competitive show is a national show and/or you win a prize.

One way to get invited into a show is to ask. Find lists of small museums, municipal galleries, and university and college galleries. Write to them with slides of your work and ask for a show. You'll be surprised how easy it is to be invited.

Art Fairs and Weekend Shows

These shows are directed at selling. There may or may not be awards, and if so they are usually very small. The shows are often held outdoors in tents, or in spaces where you bring your own shelter. You set up your work in a small space and stay there throughout the show, while crowds of people file past and wrinkle their noses at your prized masterpieces. You'll find lots of whistling gophers. These are people who ask "What's that go fer?" and when you tell them the price, they let out a low whistle.

These shows can be a real test of character, but they can also sell work—often faster than any other way. There is sometimes a commission from each sale that must be paid to the show's organizers; the other standard practice is to pay a fee up front and keep all money from sales.

The advantages of these shows are that the publicity is done for you, the crowds are more or less guaranteed, and you just have to be there. The disadvantages are the immense competition from all those other artists, and the fact that you have to be there usually two long days, or perhaps more, trying to smile and remain cheerful, hoping that the rich-looking couple coming along next might buy something.

Another important advantage of these shows is that you can assemble a mailing list of interested people. Have a paper or notebook handy and ask people to write their names and addresses if they like your work. You can keep them informed of upcoming exhibitions and begin to build a clientele.

Solo Shows

Solo shows are quite prestigious, and are sometimes the best sellers of all because there are no other artists around. They usually last a month or so, allowing a long time for potential buyers to make their way in to see the work, and you only have to be there on opening night. So the solo show is something to shoot for.

There are lots of places that give solo shows, including private sales galleries, college and university galleries, small art centers, municipal museums, and sometimes banks, theaters, and other businesses. Very often an institution doesn't know it can give a solo show until you show up and give them the idea, offering to be the first. It never hurts to ask.

With a solo show you are usually responsible for much of the work. You supply all the art, of course, and often the pedestals, unless you are dealing with a museum or gallery that gives lots of sculpture shows. Sometimes the publicity is done by the gallery, sometimes by you, and sometimes it's split, as is the cost of the opening reception. It is almost universal that a percentage of any sales goes to the museum or gallery. More on percentages in a moment.

A strong list of solo shows is the single most important element in a resume, so they are good things to seek out. There is also another very strong advantage to the solo show: the opportunity to see your work collected en masse, in a gallery setting, with the right lights and walls, and people standing around admiringly. You really see your work differently in the solo show setting, and I recommend it most highly for personal artistic development, as well as career advancement and sales.

Galleries

Sooner or later you will want to work with a gallery. There are hundreds of articles and book chapters on approaching galleries and getting them to accept you as one of their stable of artists. All the advice is good, but remember that nearly anything can work. I was once in London, feeling very angry at the way a gallery had treated me, when I saw another gallery with work in the window that fit well with mine. The gallery was closed and the owner was vacuuming the carpet inside. I banged on the door and he waved me away. I kept banging until he angrily opened the door to tell me he was closed and I yelled over the vacuum cleaner "I want to show you my work!" Now this was definitely the wrong way to go about it. But more than twenty years later, I am still showing with that dealer.

In general, however, you should be a professional. First, look at the galleries you are interested in. Be sure they take your kind of work and artists at your career stage. Don't trot into a major New York gallery, fresh with an MFA in hand. You're wasting everyone's time. Do your homework.

Next, write or call to see if the gallery is looking at artists. Get the name of the person you should see. If he or she is willing to look at your work, set up an appointment. Arrive on time, looking neat and with your work well presented, and don't say too much. They know what they are looking for and they are choosing art, not talk.

If a gallery says yes, don't feel that you've arrived and the cover of *Art News* is next. Most smaller and newer galleries are eager to take work on consignment because it is free inventory. It costs them nothing to take a chance on you, and who knows, your work might sell. But they may not try to sell it very hard, concentrating instead on their old regulars. So don't be surprised if a gallery takes you on, then a year later has sold nothing and says goodbye. This is standard. Go get another one.

If a gallery does take you on, you need to talk business. First is commission. Many galleries take 50 percent commission for paintings, drawings, and the like. It is fairly standard, however, for galleries dealing with bronze sculpture to take less—between 33 and 40 percent—because of the high cost of casting. Another factor is how much work you'll deliver, and how much the gallery promises to show. You don't want your work tied up in some gallery's basement. And a third factor is any costs you are expected to pay, such as for ads run in magazines or any other fees. In general, galleries don't charge the artist (except for a percentage on sales), and some will do a cooperative advertising deal. You should always be asked and consent to any charge first. If a gallery slaps you with an unannounced bill, start looking somewhere else. See if you can find one that's closed and the owner is vacuuming the carpet.

If you get a good gallery, and it sells your work with some regularity for a year or two, feel free to discuss the possibility of a solo show. A solo show puts you on the map with the gallery's collectors, makes you a real part of its stable (rather than just inventory filling), and calls for a financial commitment from the gallery owners, which will make them more eager to recoup that commitment by selling your work.

But before agreeing to work with any gallery, it is important to protect yourself. Here are three very important words of warning:

1. Before going with a gallery, call some of the artists showing there to see how happy they are. If the gallery is legit you shouldn't have any trouble getting the artists' names and numbers.
2. Always have a contract. A contract is simply a piece of paper that states what each party says it will do. It avoids confusion later if there is a disagreement and you start the "I said/you

said" stuff. It needn't be filled with a lot of legalese; just state what each party agrees to, sign two copies, and keep yours.

3. Watch out for funny business. For example, a gallery can sell your work and then keep the money to pay bills, planning to pay you from the sales of some other artist's work. A gallery can tell you they discounted the price of your work, and give you less. And a gallery can go out of business and you can lose all your work.

Keep an eye on the gallery. Visit often, checking to see how much is selling. Look for extravagant costs beyond those that sales might logically support. If you suspect anything imminent, get your work out fast. Don't hang around until you lose it. There are lots more galleries. You got one, you'll get another.

Other Venues

People have always found ways to show art if the official art community seems closed to them. One way is to arrange your own show in your studio. Another is to rent space at a regional motel or similar place. One artist I know phones major hotels to find out about conventions being held there, then books a table in the lobby. He sells more at doctors' conventions than at art fairs, partly because there is no competition. Be as creative when looking for places to show as you are in your work.

COMMISSIONS

One of the most important ways a sculptor can make a living off art is by completing commissions. First you have to get one, then you have to price it, write the contract, and do the work. You have to be sure to collect the money, and lastly, you have to stand behind your work. Commissions can be risky, but they can also be among the most lucrative of all forms of selling sculpture.

How do you get a commission? Reading ads in sculpture and art magazines is one way, but they are usually for national competitions and are a little like winning the lottery. Someone wins, but do you? Better is to look out for possibilities in your region. New buildings going up, new housing developments, hospitals, schools, parks, churches, and the like

would often benefit greatly by having a public sculpture, and sometimes don't know it. Making a presentation can sometimes create a commission where there wasn't one before. A good gallery dealer will also find commissions, so that is an important question to ask a potential gallery.

Assuming you've got someone interested, you need to design and present something. This can often be a simple sketch, a very small clay model or the like. Then the client will ask that all-important, two-word question: "How much?" To answer that well, you have to do some homework.

Here's a basic rule: the first figure you blurt out will be the one the client will want to hold you to, so be careful. If you blurt out a number way too high, they're gone. If you make up a price that is way too small, they'll expect you to keep it, and you'll lose money. One way around this is by giving a "window" price, saying "I doubt it will cost more than x, and it almost certainly won't cost less than y." But an even better practice is to say, "Let me work on that and get back to you." Then do your homework carefully and quote a price that is realistic. They'll probably hold you to it.

Once you have some interest, get on the phone and send drawings to relevant foundries—if you are contemplating a large work—and start getting prices. Here's a good plan for estimating the price of a piece before it's made:

1. Call a foundry and ask them the price for casting a life-sized, six-foot-tall figure of a simple standing man in a suit. You should be able to get a pretty accurate price. Now ask the foundry how much to enlarge and mold the piece. Those two numbers together will usually just about double the cost of the casting.

2. Let's assume that the foundry gave you a price of $9,000 to cast, plus $5,000 to enlarge and $4,000 to mold. That totals $18,000. Now divide by 36. Why 36? Because that is the height of the figure in feet (6 feet), squared. In this case, the answer is $500. This tells you that, with this particular foundry, the cost is $500 per foot of height squared.

Now that you've calculated the price per foot squared for that particular foundry, you can figure out how much any size figure would cost. Say you want to do a figure 9 feet tall, which is 81 when squared (9×9). Multiply 81 by the cost per foot squared ($500). It would cost $40,500 to enlarge, mold, and cast a 9-foot figure at that foundry. Or at least that's close enough. This way you won't have to call the foundry every time someone asks, "I wonder what a figure such-and-such size would cost?"

The next question is how much *you* charge for that figure. Most sculptors will take the foundry price and either double, triple, or quadruple it according to their reputation. Notice that it doesn't matter if you do the enlarging or the foundry does, if you make the mold or the foundry does, because whoever does it has to be paid. And if you do it, you get paid.

Don't forget to account for all the other expenses involved. For example, will you have to travel to the foundry to work on the enlargement, the wax, the final bronze? Will you need to get a motel room and eat in restaurants while you're there?

What about shipping the final work? And of course you need to consider the installation very carefully. You'll usually be required to insure the work during shipping and installation, and take out liability insurance so if it falls from the crane and hurts someone you're covered. These policies aren't very expensive, but they must be quoted for and factored in.

Before you agree to any commission, make sure the client isn't expecting you to install sidewalks and benches, while you're thinking you only need to dump the piece on his lawn. Again, a contract here is absolutely crucial. Be sure to spell out exactly who pays for what, how long production will take, payment schedules (see below), what happens in case of delays (you didn't work fast enough, the client didn't come up with the money on time, the site wasn't ready for installation, and so on), and how either side can break the contract. Another important point is who owns the copyright and has to approve any reproductions of the work. Don't give up your right to control reproductions or you might see posters of your piece with Mickey Mouse ears.

You should also consider the idea of an edition. Often a client wants a unique piece. This means it must cost more, since the high cost of the original creation and modeling is passed on to the client in full. If you can get the client to agree that the piece will be part of an edition, you can cut the cost. You might agree not to place another cast within a certain radius (50 miles? 100 miles?) of the client's piece, but this must be agreed to in the contract.

A good payment schedule is one that pays commitment money up front for initial concepts, say 10 percent of the total price, and then pays enough money so you can pay the foundry—usually 30 percent to begin the enlargement, 30 percent to begin casting, and 30 percent on delivery. The specific schedule should depend on your situation.

Finally, get a lawyer to look over the contract and advise you. Let me repeat that: *get a lawyer to look the contract over and advise you.* You can be badly hurt by a single tiny clause.

Competitions for Commissions

Now you have to make the final presentation to get that contract signed. Many commission competitions work this way: You send in slides of your work and a resume, and a committee selects semifinalists from that information, choosing people they feel have the experience they want and work in a style that matches what they're looking for. Semifinalists are then often asked to produce a specific design for the commission, usually in the form of a drawing. The artists are often paid a small fee for this. From those drawings, a still-smaller list of finalists is chosen and asked to make maquettes, or working models, of their proposals. Again, there is usually a small fee for this as well. In many cases the finalists are invited to present their maquettes at an interview. The winner is chosen from those final presentations.

So how do you do all this effectively? First, you need a packet of slides and a resume that shows the breadth of your work and experience. This is why it's often a good idea to get some kind of commission—any kind of commission—and complete it well, even if you don't make money on it, just to have the slides and that line on your resume. Failing that, make smaller sculptures that could be enlarged, and photograph them in such a way that they look large. You're not telling lies

Resting Dancer, *Tuck Langland, 1996. Bronze, 4' (1.2 m) high, 4' (1.2 m) wide, 40" (102 cm) deep.*

here, you're just letting people see that you think big. Take small works outside and shoot them against buildings and other backgrounds, holding the camera at a low level to give the effect of the piece as enlarged and in place. Or use a digital camera and place the sculpture on another site at another scale by manipulating the image on the computer. Whatever you do, never lie. Always label such photos clearly as computer alterations. Any falsehoods on your resume or slide labels will come back to haunt you. As I said earlier, the sculpture business is a long-term business, not a quick kill. Your career will only be as good as your reputation, and the cornerstone of your reputation is honesty.

If you are selected for the semifinals, work out your idea carefully. Consider all the factors. How big can you go for the money offered? Be careful here, and don't promise something you can't deliver. Make the design fit the space. Look at the real space, walk around in it, close your eyes, and envisage what would be ideal there.

You can present a drawing at this stage, or a small model. You should take photos of the real space, and you can even sketch a silhouette of your piece in the correct scale right on a photo, or do it digitally on the computer. You should also have a clear drawing of the piece, with a good indication of dimensions, materials, and so on. At this stage you want to catch their eyes and excite their imaginations, not cover every technical issue.

If you're lucky enough to become a finalist, you work that much harder on the next stage. First, you need to make a decent model of your idea. No matter what the scale, the model ought to be about 18 to 24 inches tall. Much smaller than that is too fussy, too much like a tiny doll, and much larger is unwieldy and clumsy. To do the very best job, consider using a three-pronged attack:

1. *The maquette itself.* This ought to be well worked out with a reasonable amount of detail, though still a sketch. It can be cast in plaster or any of the superplasters discussed, and it ought to be colored the way the final piece will be. This model can be on a simple base.

2. *The piece in situ.* Make a much smaller replica of the maquette, perhaps only 3 inches tall, but place it in the context of the site, with the surrounding sidewalks, benches, plantings, and so on. Get a nice board, figure where the sculpture will be, and then contour the board to reproduce any hills or changes of grade. This can be done with either plaster or a superplaster, being sure to key it to the board with nails pounded in beforehand.

Create a convincing landscape model on the board by adding grass, paving, model trees, and so on (all available in the model train department of your local hobby shop). If you make such a model to show the piece in place, it can be a big help in the competition.

3. *A digital image.* The third tactic is to take your finished large maquette to the site, place it about where it goes, and take a slide or digital image of it. Then move the piece aside and get a good image of the site itself. Now scan or download both images into a computer (get a friend if you can't do this yourself), and have them superimposed. (By taking both images on the same day, you'll ensure similar lighting.) Add shadows on the lawn where the piece now sits and print a nice color shot, showing your piece at full size in place.

When you've done all that, take everything to the interview, be yourself, be honest, and you've given yourself the best chance you can.

Let's hope all goes well. Let's hope you designed your piece well, got a good contract from an enlightened and fair client, created the work without problems, and installed the piece on time and on budget. Congratulations. Now unveil it, pop the champagne, and you're a sculptor. A real live sculptor.

METRIC CONVERSIONS

Most measurements used in this book are in English standard, which means inches, feet, and pounds. A chart of metric equivalents is provided here for those working in metric-standard countries. Unfortunately, metric conversions are not so simple when it comes to hardware, plumbing parts, and lumber. For these types of equipment and supplies, please note the following:

■ *Hardware:* In the United States, nuts and screws are sized at ¼ inch, ⁵⁄₁₆ inch, and so on. Although ¼ inch converts to 6.4 mm in metric, there is no such screw manufactured—they are instead made in the 6 mm size. Below is a table showing common US hardware sizes and the roughly equivalent metric sizes. Note that the first number for each size is the diameter and the second is the thread pitch. In metric, thread pitch is the measure (in millimeters) between the peaks of two threads.

US screw size	Metric screw size
10–24	5 mm × 0.8
¼ × 20	6 mm × 1
⁵⁄₁₆ × 18	8 mm × 1.25
⅜ × 16	10 mm × 1.5
½ × 13	12 mm × 1.75

■ *Plumbing parts:* Until recently, all plumbing parts have used standard English sizes, even in metric-standard countries. This may be changing. I encourage you to visit plumbing supply stores with a good idea of how large inch sizes are and look for equivalents.

■ *Lumber:* In countries using the metric system, lumber is cut to even metric sizes. The standard board thickness in the United States is ¾ inch, which converts to 1.9 cm, so the equivalent board would be 2 cm thick. Again, I encourage you to select lumber that is the closest equivalent to the English sizes mentioned in the book.

The chart below offers some standard US measures and their metric equivalents. You should be able to use these to calculate metric measures throughout the book, except for the items just noted. Please note that all metric measures (except millimeters and milliliters) are rounded off to the nearest tenth.

CONVERSION CHART

	English	Metric
Length		
	¹⁄₃₂ in	0.8 mm
	¹⁄₁₆ in	2 mm
	⅛ in	3 mm
	¼ in	6 mm
	½ in	13 mm
	¾ in	19 mm
	1 in	25 mm
	6 in (or ½ ft)	15.2 cm
	1 ft	30.5 cm
Weight/Mass		
	1 oz	28.4 g
	1 lb	0.5 kg
Fluid Volume		
	1 tsp	5 ml
	1 c	240 ml

GLOSSARY

air-dried: any material that hardens by drying in the air, as opposed to setting by chemical means

armature: a framework used to support clay during the modeling process

artist's proof: a bronze casting created at the beginning of an edition to allow the artist to see the finished product (*see also* foundry proof)

back iron: an external support for a figure or animal armature

base: any form used to support the finished sculpture; usually made of wood or stone

baseboard: the board to which the armature is attached and on which the clay sculpture is created

beads: small beads of bronze on a casting, caused by bubbles in the initial layer of investment

bronze: an alloy of copper used for casting sculpture, traditionally composed of approximately 85 percent copper and 15 percent tin (*see also* Everdur and Herculoy)

building up: rapid adding of clay to an armature to build up the form

burn out: the process of heating the investment mold to remove the wax pattern inside prior to pouring in the bronze (*see also* dewaxing and firing)

burn-out kiln: the kiln in which molds are burned out

bushings: plumbing parts that allow pipes of different sizes to be connected

butterflies: two short wood sticks bound into a cross with wire, used to help support the clay

calipers: compass-like dividers used for measuring

casting: the process of creating a form by pouring a liquid that will harden into a mold or form

ceramic shell: a method of lost wax or investment casting using colloidal silica and a refractory stucco; the most common method used in commercial sculpture foundries today

chase: to clean up and remove flaws from a casting, whether plaster, wax, or metal

cire perdue: the French term for lost wax casting

clay wall: a wall made of clay, used to divide a mold into sections

close nipple: a piece of pipe, threaded on both ends, that is so short the threads meet with no unthreaded pipe remaining

concept model: a very small, quick model of the concept for a sculpture that can be easily manipulated to try different designs

contrapposto: a standing pose in which the weight is primarily on one leg, thus tipping the hips and imparting a gentle curve to the body

core: the investment material that is poured into a hollow wax sculpture to keep the bronze casting hollow

core pins: small metal pins that support the core inside the cavity once the wax sculpture has been burned out

core rods: steel rods that support the core once the wax has been burned out

crucible: a heatproof pot or container in which metal is melted in the furnace

devesting: the process of removing the metal cast from the investment

dewaxing: the process of initially removing wax from a ceramic shell mold prior to firing

die: a machine tool used to create threads on the outside of a rod

die mold: a rigid mold made of metal for casting large numbers of parts

disclosing wax: a soft white wax used to reveal and fill very small holes in wax casts

dross: the collected impurities skimmed off the surface of molten metal before pouring; sometimes called *slag*

ecorché course: a course of anatomy study in which the human body is built up in clay from the skeleton through the various muscle layers

edition: a number of castings of a particular sculpture, with the number set by the artist

enlarging: the process of making a small model or maquette into a large sculpture

Everdur: a bronze alloy consisting of 95 percent copper, 4 percent silicon, and 1 percent manganese; the most common sculpture alloy used today

filler: any material used to take up space inside a large clay sculpture

firing: heating a ceramic shell mold to harden the material and remove the last traces of wax; also, heating a dried water clay object to harden it

flange: a plumbing part used to mount a pipe to a board so it stands perpendicular to the board

flashing: a thin fin of metal that has flowed into a small crack in the mold

flask: a cylinder of expanded steel lath wrapped with tar paper to hold the liquid investment material as it is poured around the wax sculpture

flexible mold: any mold made of a flexible material, such as latex, polyurethane, or silicone

floor flange: *see* flange

foundry: a shop in which metal is cast

foundry proof: a casting, finished to the artist's specifications, that remains in the foundry as a guide to finishing the remaining casts of the edition (*see also* artist's proof)

full service foundry: a foundry that can enlarge, fabricate, and perform many other tasks besides simple casting

fumed patina: a patina that is applied by placing the bronze in a closed container filled with various chemical fumes

gas hole: a hole in a casting caused by a bubble of gas

gates: channels that carry molten metal from the main sprue to the sculpture

grog: fired clay ground into granules or powder

head peg: a common form of armature for modeling a portrait head

Herculoy: a common casting alloy of bronze that consists of 92 percent copper, 4 percent silicon, and 4 percent zinc

high relief: a sculpture in which the figures are fully round, though placed against a background

horizontal member: the part of a figure armature that extends from the back iron to the figure

induction furnace: a metal-melting furnace heated by electricity

ingot: the brick-like bar of metal sold by suppliers

ingot mold: a heavy steel or iron mold into which excess metal is poured at the conclusion of a pouring

invest (*v*): the process of coating the wax sculpture with investment material

investment (*n*): the complete mold of fireproof material with the wax sculpture inside

J-gating: a system of feeding metal into the investment; the main sprue carries the metal to the bottom of the cavity, from which it then rises to the top

jewelry investment: a manufactured gypsum product used to create very fine, and usually small, investments

lost wax: the predominant method for casting metal sculpture; the object to be cast is created in wax and then invested, the wax is removed with heat, and metal is then poured into the resulting cavity

low relief: a relief sculpture in which the figures are extremely flat, as on a coin; sometimes called *bas* relief

maquette: a model for a larger sculpture

medium relief: a relief sculpture in which the figures are flattened only about halfway; sometimes called *mezzo relievo*

melting furnace: the furnace in which metal is melted, usually heated by gas

mis-run: a flaw in metal casting caused when metal fails to fill the cavity

model: the person who poses for a sculpture

mold: any form that is a negative of the sculpture and is intended to be filled to make a casting of the sculpture

mother mold: a rigid shell created around a flexible mold to prevent it from distorting

negative: a mold, or negative shape, of a form

nipple: a short length of pipe threaded on both ends

oil clay: a modeling medium made of clay mixed with an oil/wax mixture that never dries or hardens

one-piece mold: a mold created in one piece, such as a relief

open-face mold: a mold in which the top surface is open, such as a relief mold

parting line: the small ridge left on a casting from the seam between two mold pieces

patching wax: a very soft wax used to patch small holes in a wax cast

patina: the final coloring on a bronze sculpture, usually achieved by applying various chemicals to the surface

piece mold: a rigid mold made in several pieces, each of which will pull off the casting without catching

plasticity: the quality in clay of elasticity, as opposed to shortness (*see also* shortness)

positive: a form in its normal state, as opposed to a mold (or negative) of the form

pouring: the process of pouring molten metal into a mold

pouring cup: the cup placed at the top of the main sprue into which the molten metal is poured

press casting: the process of casting soft water clay into a mold by pressing in small pieces or large sheets

pyrometer: a thermometer used to indicate the temperature of kilns, furnaces, or molten metal

ramping up/down: the process of heating/cooling a burn-out kiln at a controlled rate

refractory: any heatproof material

release agents: materials that prevent one material from sticking to another; commonly used in molds to prevent the cast from sticking

relievo secco: an extremely flat relief, usually little more than a drawing; literally translates as "dry relief"

riffler: a file with spoon-shaped ends

rigid mold: a mold made of rigid materials, such as plaster, or a die mold

sand casting: a method of casting metal in which the sculpture is first made in a hard material and pressed into large

sand molds, then removed, and the metal is poured into the molds; a common method for casting large works

scab: a thin piece of metal that has peeled loose from a metal casting, caused by delamination of the initial layer in the investment

shank: a device used to pick up a crucible of metal for pouring

shell: *see* ceramic shell

shim: a very thin sheet of metal, often brass, used to divide pieces of a mold

shortness: the quality of clay that breaks easily when pulled; the opposite of plasticity

slip: water-based clay that has been mixed with extra water until it has the consistency of cream

slip casting: the process of casting clay by pouring liquid clay slip into a plaster mold and then pouring it out again, leaving a layer of clay

slurry: the colloidal silica mixture used for ceramic shell casting

slush casting: any casting in which a liquid (slip, plaster, wax, and so on) is poured into a mold and then poured out again, leaving a layer of material

solid investment: a bronze casting investment made of a solid mass of plaster-based refractory material (*see also* traditional investment)

sprue: the main feed that runs from the pouring cup to the gate system to channel molten metal into the investment mold

sprue system: the entire system of pouring cup, sprue, gates, and vent; sometimes called the *gating* system

sticky wax: a rosin-filled wax used to glue the sprue system together

stirring rod: any strong steel rod used to reach into the crucible of molten metal to feel for lumps and determine readiness for pouring

superplaster: any of a number of gypsum and resin gypsum systems for casting that are considerably harder than regular plaster

tap: a machine tool used to create screw threads inside a hole (*see also* die)

thread: the spiral grooves that make screws and nuts

tipping furnace: a metal-melting furnace that can be tipped to pour the metal into a waiting crucible; usually used for large quantities of metal

tongs: tools used to reach into a melting furnace to remove the crucible; also, any long-handled pinchers used for handling ingots or scraps of metal

top-hat kiln: a kiln in which the main body of the kiln can be raised to reveal the items inside

traditional investment: the traditional method of casting in lost wax, using solid molds of plaster-based refractory materials (*see also* solid investment)

undercut: any part of a sculpture beneath which a mold will catch, preventing it from pulling off cleanly

vent: a channel designed to allow air to escape from the cavity inside an investment

waste mold: a plaster mold used only once, in which undercuts are ignored as the clay is destroyed in removing the mold, and then the mold is destroyed (wasted) when removing the cast

water clay: clay in which water is the lubricant, such as pottery clay

working model: a model of a sculpture for enlarging

FURTHER READING

Since you're reading a book now, you must have some faith in learning through reading. Scores of books have been written about sculpture, and many of them are invaluable. The following is a compilation of some very important books that expand ideas covered here but take them much further, and/or are written by true experts in various techniques. This list is, of course, by no means exhaustive or complete, but it is a good start. Books are listed alphabetically by author's last name, with publisher information and ISBN numbers included wherever possible to help you locate the book. The dates provided represent the most recent editions.

Please note that some of the books listed are no longer in print (indicated with an asterisk *), but are such classics that you should keep your eyes open for them in used bookstores and grab a copy if you find one.

Andrews, Oliver. *Living Materials: A Sculptor's Handbook*. Berkeley: University of California Press, 1983. ISBN: 0-520-06452-6
This excellent general sculpture technique book covers just about every process.

Clark, Nancy, et al. *Ventilation: A Practical Guide for Artists, Craftspeople, and Others in the Arts*. New York: The Lyons Press, 1987. ISBN: 0-941130-44-0
A good book to own and study. Your lungs are worth it.

*Clarke, Geoffrey and Stroud Cornock. *A Sculptor's Manual*. New York: Reinhold Book Corporation, 1968. ISBN: 2-89-37020-5
This excellent old book mainly covers full mold casting, which involves replacing Styrofoam with hot aluminum.

Edge, Michael S. *The Art of Patinas for Bronze*. Springfield, OR: Artesia Press, 1990. ISBN: 1-879257-00-9
A very good basic patina book, but watch out for recipes that use potassium ferrocyanide. Also, be alert to the inconsistent use of metric (liters and cc) versus English (gallons and pints) systems. (And note that it's Johnson's Paste Wax, not Johnson & Johnson.)

Gault, Rosette. *Paper Clay*. Philadelphia: University of Pennsylvania Press, 1998. ISBN: 0-8122-1642-3

Goldfinger, Eliot. *Human Anatomy for Artists: The Elements of Form*. New York: Oxford University Press, 1991. ISBN: 0-19-505206-4

Gregory, Ian. *Kilnbuilding*. Gentle Br., 1995. ISBN: 1-889250-02-3

Grubbs, Daisy. *Modeling a Likeness in Clay*. New York: Watson-Guptill Publications, 1982. ISBN: 0-8230-3094-6
This is the book for the measuring technique used to create portrait heads.

Harmsen, W. D., ed. *Sculpture to Bronze*. Denver: Harmsen Publishing Co., 1981. ISBN: 0-9601322-3-6

*Hoffman, Malvina. *Sculpture Inside and Out*. New York: W.W. Norton, 1939. No ISBN available.
If you can find a copy, this is a wonderful book. The techniques are very dated, but there is an enthusiasm and joy in the writing. Ms. Hoffman has also written two other books: Heads and Tails, *which describes her commission to create bronzes of the seventy-odd races of mankind for Chicago's Field Museum, and* Yesterday Is Tomorrow, *an account of her extraordinary life. All three are great reading.*

Kipper, Patrick V. *The Care of Bronze Sculpture: Recommended Maintenance Programs for the Collector*. Loveland, CO: Path Publications, 1996. ISBN 0-9647269-1-2
Patrick Kipper is a master patineur (see next entry), but this small book is about the care of bronze. It's worth having, although it doesn't offer many new revelations.

Kipper, Patrick V. *Patinas for Silicon Bronze*. Loveland, CO: Path Publications, 1996. ISBN: 0-9647269-0-4
This is one of the "big three" books for patinas, along with those by Ron Young and Michael Edge, and is the most elegant of the three. It's a must-have if you're doing your own patinas.

*Langland, Tuck. *Practical Sculpture*. Englewood Cliffs, NJ: Prentice-Hall, 1988. ISBN: 0-13-692179-5 01
My first book covers the whole range of sculpture techniques. It's now out of print, but copies can still occasionally be found.

Lanteri, Edouard. *Modelling and Sculpting the Human Figure*. New York: Dover Publications, 1985. ISBN: 0-486-25006-7
Some things never go out of style, and this book (originally published in the early 1900s) is one of them. I would also recommend Lanteri's Modelling and Sculpting Animals, *published by Dover Publications in 1985 (ISBN: 0-486-25007-5).*

Lucchesi, Bruno and Margit Malmstrom. *Modeling the Figure in Clay*. New York: Watson-Guptill Publications, 1996. ISBN: 0-8230-3096-2

Lucchesi, Bruno and Margit Malmstrom. *Modeling the Head in Clay*. New York: Watson-Guptill Publications, 1996. ISBN: 0-8230-3099-7

Lucchesi, Bruno and Margit Malmstrom. *Terracotta: The Technique of Fired Clay Sculpture*. New York: Watson-Guptill Publications, 1996. ISBN: 0-8230-5321-0
These three Lucchesi books are priceless and should be on every sculptor's bookshelf. He teaches by doing with clear, sequential photographs. They are a joy to study.

Mazzone, Domenico. *Sculpturing*. Laguna Hills, CA: W. Foster Publications, 1994. ISBN: 1-56010-124-5

Miller, Richard M. *Figure Sculpture in Wax and Plaster*. New York: Dover Publications, 1987. ISBN: 0-486-25354-6
A fine book that shows how to create small studies without armatures, and without even using clay.

*Mills, John. *The Encyclopedia of Sculpture Techniques*. New York: Watson-Guptill Publications, 1990. ISBN: 0-8230-1609-9
This very handy reference book is, unfortunately, out of print.

*Mills, John. *The Technique of Sculpture*. New York: Reinhold, 1965. Library of Congress Catalog Card No. 65-14037.
An old but excellent book. It's a treasure if you can find it.

Nigrosh, Leon. *Sculpting Clay.* Worcester, MA: Davis Publications, Inc., 1991. ISBN: 0-87192-236-3

Olsen, Frederick. *The Kiln Book.* Iola, WI: Krause Publications, 1983. ISBN: 0-8019-7071-7

Olson, Lynn. *Sculpting with Cement: Direct Modeling in a Permanent Medium.* Valparaiso, IN: Steelstone Press, 1995. ISBN: 0-9605678-0-1
This is a very good book for using cement. See also Schwanke, below.

Penny, Nicholas. *The Materials of Sculpture.* New Haven: Yale University Press, 1994. ISBN: 0-300-05556-0

Plowman, John. *Encyclopedia of Sculpting Techniques: A Unique Visual Directory, With Step-by-Step Instructions and a Gallery of Finished Works.* Philadelphia: Running Press, 1995. ISBN: 1-56138-532-8

Power, Dale. *Sculpting in Clay with Dale Power.* Atglen, PA: Schiffler Publications Ltd., 1998. ISBN: 0-7643-0113-6

Rich, Jack C. *The Materials and Methods of Sculpture.* New York: Dover Publications. ISBN: 0-486-25742-8

Rossol, Monona. *The Artist's Complete Health and Safety Guide.* New York: Allworth Press, 1994. ISBN: 1-88059-18-8
This is a good book to have and study.

Rubino, Peter. *The Portrait in Clay.* New York: Watson-Guptill Publications, 1997. ISBN: 0-8230-4102-6

Schwanke, Dik and Jean Lahti-Wagner. *Cement Sculpture: A Studio Handbook.* Lanham, MD: University Press of America, 1985. ISBN: 0-8191-4625-0

Slobodkin, Louis. *Sculpture: Principles and Practice.* New York: Dover Publications, 1973. ISBN: 0-486-22960-2
This book has long been a standard, even when there were only a few. It is now very dated but is an interesting addition to any sculptor's library.

Speight, Charlotte F. *Images in Clay Sculpture: Historical and Contemporary Techniques.* New York: Harper Collins, 1983. ISBN: 0-06-430127-3

Thomas, Guy. *Bronze Casting: A Manual of Techniques.* Marlborough: Crowood Press, 1996. Distributed by Trafalgar, P.O. Box 257, N. Pomfret, VT 05053. Tel: (800) 423-4525. ISBN 1-85223-938-7

Vasari, Giorgio. *Vasari on Technique.* New York: Dover Publications, 1960. ISBN: 0-486-20717-X
Vasari wrote about art during the Renaissance, and was most famous for his book Lives of the Artists. *This book provides good insight into Renaissance techniques.*

Verhelst, Wilbert. *Sculpture: Tools, Materials, and Techniques.* Englewood Cliffs, NJ: Prentice-Hall, 1973. ISBN: 0-13-796615-6
A good general-purpose book.

Williams, Arthur. *Sculpture: Technique, Form, Content.* Worcester, MA: Davis Publications, Inc., 1995. ISBN: 0-87192-277-0
This very fine book covers a whole range of sculpture techniques.

Young, Ronald D. *Contemporary Patination.* San Rafael, CA: Sculpt Nouveau, 1994. ISBN: 0-9603744-1-8
This book, along with those by Patrick Kipper and Michael Edge, pretty well covers the patination process. Young's book goes more into buried, wrapped, and fumed patinas than the other books.

Young, Ronald D. and Robert A. Fennell. *Methods for Modern Sculptors.* San Rafael, CA: Sculpt Nouveau, 1994 ISBN: 0-9603744-0-X
This is the best book I know on ceramic shell casting. It's a must if that's your direction.

Zorach, William. *Zorach Explains Sculpture: What It Means and How It Is Made.* New York: Dover Publications, 1996. ISBN: 0-486-29048-4
A somewhat dated book, but interesting.

You might also consider subscribing to the following periodicals:

Art Calendar, P.O. Box 199, Upper Fairmount, MD 21867-0199. Tel: (410) 651-9150.
This monthly magazine lists shows, commissions, galleries looking for work, workshops, retreats, grants, and more.

Art Foundry Journal, P.O. Box 448, Welches, OR 97067. Tel: (503) 622-3828.
A very good magazine devoted to art casting.

Medallic Sculpture, American Medallic Association, 56 N. Plank Road, Suite 1-685, Newburgh, NY 12550. Tel: (718) 274-2221.
This is a great magazine for those interested in medals and small reliefs.

Sculpture, 1529 18th Street, NW, Washington, DC 20036. Tel: (202) 234-0555.
The biggest and glossiest sculpture magazine available. Sculpture *covers almost exclusively the very contemporary avant-garde and includes a great many useful ads.*

Sculpture Review, c/o The National Sculpture Society, 1177 Avenue of the Americas, New York, NY 10035. Tel: (212) 764-5645.
The magazine for figurative sculpture.

Woman's Art Journal, 1711 Harris Road, Laverock, PA 19038. Tel: (215) 233-0639.

Lastly, the following are publications that list foundries. Addresses and phone numbers for each can be found in the listings above.

Art Foundry Journal publishes an issue called *The North American Foundry Guide and Product Directory,* which lists loads of supplies and tools of all kinds, plus 375 foundries.

The National Sculpture Society published the *1997 Sculptor's Supply Index,* which also lists many kinds of supplies, tools, and services, plus 131 foundries.

The Directory of Art Bronze Foundries, by Michael S. Edge, was published in 1990 by Artesia Press. It lists 240 foundries, and includes a good description of what a foundry does as well as a listing of suppliers for the many tools and materials used. ISBN: 1-879257-01-7

LIST OF SUPPLIERS

Finding the supplies and tools you need is often a hassle, especially if you live outside a major city. Modern communications, however, are making it a whole lot easier than it used to be. Usually a phone call (often toll free) and a credit card number will bring a package to your door in about four days, no matter where you live. So don't limit your shopping to local sources. The whole country is at your command.

With that said, a great deal of the ordinary stuff can be easily found through local suppliers. The first places to shop are hardware stores and mega-hardware stores, such as Home Depot and HQ. They will have tons of tools and materials, such as power tools, hand tools, hardware of all kinds, paints and solvents, abrasives, and on and on. Try them first.

Other good sources are specialty paint stores, plumbing supply stores, electrical supply stores, and industrial suppliers, which will usually have the items hardware stores are missing. Look for industrial suppliers, like Grainger, which stock motors, specialty tools, blowers, thermostats, and all kinds of items. Such suppliers usually have huge catalogs, but may require that you be in business before you can buy from them. In most cases, a printed business card (Jane Smith, Sculptor) will do the job. Also, lumberyards will have plaster, sand, lath, tar paper, and, *duh*, lumber.

Look in the Yellow Pages under "ceramics" to see if there is a supplier in your area. You can usually buy ready-mixed water clay plus some sculpture tools from ceramics suppliers, and many will fire clay for you. They are also a source of catalogs for things like kilns and so on. And don't forget arts and craft stores. They often have a pitiable selection of sculpture tools, but sometimes they have just the tool you need. And they can usually order just about anything for you.

Your best friend is often the Yellow Pages. If you need something, start calling. When the person you call doesn't have what you need, don't hang up without asking "Where do you suggest I try?" Often there will be a suggestion that might lead to another suggestion, and before long, bingo. The Internet is also a wonderful source of information. If you're on-line, dive in and start looking. Be sure to write down any e-mail addresses you find as you can often get supplies and information that way.

The suppliers listed on the following pages handle things more particularly pertinent to sculpture. They are national in scope, and most will send a catalog with a simple phone request. It's a good idea to get several catalogs to familiarize yourself with the many products available. For example, if you want to start making rubber molds, call each of the places listed that supply rubber materials and get their catalogs. The catalogs often include a good deal of technical how-to information, and of course they list all kinds of products too numerous to list here.

Most importantly, these companies bring out new products all the time, newer than can be chased down for a book like this. Call now and then to get yourself on their mailing lists and keep up with the new stuff. Another great source for new product information is magazine ads. Subscribe to the sculpture magazines listed on page 234 and follow the ads carefully. Often, new materials and tools will appear there first. A new product could come out only a month after this book hits the stores and make an entire section obsolete! Be alert for it.

The suppliers listed will be broken down into the following categories:

1. General sculpture supplies (tools and equipment)
2. Clay and modeling materials
3. Casting and direct building materials (plasters, superplasters, and so on)
4. Materials for flexible molds (rubbers and the like)
5. Metal casting supplies and equipment (waxes, ceramic shell materials, melting equipment, metal, chasing tools, and so on)
6. Patina chemicals and related materials
7. Materials for bases
8. Other (miscellaneous materials, classes, and more)

...and supplies. Their

...ue. Call for the one nearest

...67
...220
...ight.com
...general tools, often of serviceable but
...essional quality. Small brushes, small
...d so on. They have a great catalog.

... Enterprises
...st 8th Street
...und, CO 80537
...(970) 663-3247
...: (970) 662-8071
...lyptic modeling tools—very good tools.

Loveland Academy of Fine Arts
205 12th Street SW
Loveland, CO 80537
Tel: (800) 726-5232
Fax: (970) 669-1511
www.lovelandacademy.com
The Loveland Modeling Stand, plus an array of tools, armatures, and some clay. They also run sculpture classes (see page 238).

Montoya/MAS International
435 Southern Boulevard
West Palm Beach, FL 33405
Tel/fax: (561) 833-2722
Tools and supplies, including lots of stone. They also offer classes (see page 238).

Pearl Paint
Many locations nationwide. Call for a catalog or the location nearest you.
Tel: (800) 221-6845
Fax: (212) 274-8290
www.pearlpaint.com
Large stock of general art supplies. A must-have catalog.

Peter Leggieri's Sculpture Supply Co.
415 E. 12th Street
New York, NY 10009
Tel: (888) 671-8003
Fax: (212) 475-1134
General supplies; nice Italian tools.

Sculpture House Casting
155 W. 26th Street
New York, NY 10001
Tel: (888) 374-8665
Fax: (212) 645-3717
www.sculptshop.com
Sculpture tools and good modeling stands.

2. CLAY AND MODELING MATERIALS

American Art Clay Co., Inc.
4717 W. 16th Street
Indianapolis, IN 46222
Tel: (800) 374-1600
Fax: (317) 248-9300
www.amaco.com

Clay, tools, and equipment, primarily for the ceramics trade but also useful for sculpture.

A.R.T. Studio Clay Company, Inc.
9320 Michigan Avenue
Sturtevant, WI 53177-2425
Tel: (877) ART-CLAY; in WI: (414) 884-4ART
Fax: (414) 884-4343
www.artclay.com
Everything imaginable for ceramics and some for sculpture. They have a great catalog.

Castilene
704 Fairhill Drive
Louisville, KY 40207
Tel: (502) 895-7107
Castilene, an oil-based clay that burns out like wax.

Cast-Tech Co., Inc.
346 N. Lindenwood
Olathe, KS 66062
Tel: (800) 473-5944
Fax: (913) 782-5906
Clay, waxes, rubber molding compounds, and more.

Chavant, Inc.,
42 West Street
Red Bank, NJ 07701
Tel: (800) CHAVANT
Fax: (732) 842-3621
www.chavant.com
Oil-based clays of all kinds, plus modeling tools.

Classic Clay
P.O. Box 1871
Cucamonga, CA 91729
Tel: (909) 989-8071
Classic Clay (also available from J. F. McCaughlin Co., listed on page 237).

Nasco
P.O. Box 3837
Modesto, CA 95353-3837
Tel: (800) 558-9595
Fax: (209) 545-1669
www.nascofa.com
Supplies for arts and crafts, ceramics, and some for sculpture.

3. CASTING AND DIRECT BUILDING MATERIALS

Ball Consulting, Ltd.
338 14th Street, Suite 201
Ambridge, PA 15003
Tel: (800) 255-2673
Fax: (412) 266-1504
www.ball-consulting-ltd.com/home.html
Forton MG, a resin/gypsum casting system.

Design Cast
Materials Division
951 Pennsylvania Ave
Trenton, NJ 08638-3985
Tel: (609) 392-1922
Fax: (609) 989-9343
Resin/gypsum casting systems.

Lance Gypsum Products
4225 West Ogden Avenue
Chicago, IL 60623
Tel: (773) 522-1900
Fax: (773) 522-1618
www.lancegypsum.net

Full range of US Gypsum products, such as Hydrocal, plus Perma-Flex rubbers and Sculpture House clay.

USG (US Gypsum)
Industrial Gypsum Division
125 South Franklin Street
Chicago, IL 60606
Tel: (800) USG-4YOU
Fax: (312) 606-4519
www.usg.com
Full range of plasters and gypsum/cement products. Call for a list of distributors and technical information only, not to order.

Van Aken International
9157 Rochester Court
P.O. Box 1680
Rancho Cucamonga, CA 91729
Tel: (909) 980-2001
Fax: (909) 980-2333
www.vanaken.com
Oil clay.

Winterstone USA (a division of J. W. Reynolds Company, Inc.)
2206 S. Harwood
Dallas, TX 75215-1323
Tel: (800) 421-4378
Fax: (214) 421-5726
www.winterstone.com
Winterstone, a multicomponent sculpting medium that sets to a stone-hard material.

4. MATERIALS FOR FLEXIBLE MOLDS

Alumilite Corporation
315 E. North Street
Kalamazoo, MI 49007-3530
Tel: (800) 447-9344
Fax: (616) 488-4000
Dow silicones and rigid casting resins.

Baker & Collinson, Inc.
12000 Mt. Elliot Avenue
Detroit, MI 48212-2534
Tel: (800) 291-2226
Fax: (313) 366-0179
Rubber molding compounds and accessories.

Burman Industries, Inc.
14141 Covello Street, Bldg. 10C
Van Nuys, CA 91405-1491
Tel: (818) 782-9833
Rubbers, clay, and more.

Cementex Latex Corporation
121 Varick Street
New York, NY 10013
Tel: (800) 782-9056 or 212 741-1770
Fax: (212) 627-2770
www.cementex.com
Full range of rubber molding compounds, specializing in latex.

Pink House Studios
35 Bank Street
St. Albans, VT 05478-1601
Tel: (802) 524-7191
Fax: (802) 524-7191
Wide range of molding products with focus on body casting materials, including alginates and rapid-set, skin-friendly silicones.

The Perma-Flex Mold Co., Inc.
1919 E. Livingston Avenue
Columbus, OH 43209
Tel: (800) 736-6653 (MOLD)
Fax: (614) 252-8572
www.perma-flex.com
Urethane and other molding compounds.

Polytek Development Corporation
55 Hilton Street, Dept. INT
Easton, PA 18042
Tel: (610) 559-8620
Fax: (610) 559-8626
www.polytek.com
Wide range of molding compounds in all categories, plus great variety of casting compounds. Must-have catalog that also offers technical advice.

J. W. Reynolds Co., Inc.
2206 S. Harwood Street
Dallas, TX 75215-1323
Tel: (800) 421-4378
Fax: (214) 421-5726
Various rubber compounds and molding supplies.

Silicones, Inc.
211 Woodbine Street
High Point, NC 27282
Tel: (336) 883-5018
Fax: (336) 886-7122
Various molding compounds, specializing in— guess what—silicones.

Smooth-On, Inc.
2000 Saint John Street
Easton, PA 18042
Tel: (800) 762-0744
Fax: (610) 252-6200
www.smooth-on.com
Wide range of molding rubbers and casting materials.

Synair Corporation
P.O. Box 5269
2003 Amnicola Highway
Chattanooga, TN 37406
Tel: (800) 251-7642
Fax: (423) 697-0424
www.synair.com
Wide range of molding materials and casting resins.

5. METAL CASTING SUPPLIES AND EQUIPMENT

AA Abrasives, Inc.
121 N. 3rd Street
Philadelphia, PA 19106-1903
Tel: (215) 925-6367
Fax: (215) 925-4975
Grinding wheels and abrasives of all sorts.

M. Argueso & Co., Inc.
441 Waverly Avenue
Mamaroneck, NY 10543-0554
Tel: (914) 698-8500
Fax: (914) 698-0325
www.argueso.com
Waxes, sprues, and more.

Atlas Metal Sales
1401 Umatilla Street
Denver, CO 80204-2432
Tel: (800) 662-0143 or (303) 623-0143
Fax: (303) 623-3034
Casting ingots, plus bronze plate, tubes, and bars.

B & B Refractories, Inc.
12121 Los Nietos Road
Santa Fe Springs, CA 90670-2907
Tel: (562) 946-4535
Fax: (562) 946-5904
Ceramic shell supplies.

Belmont Metals, Inc.
330 Belmont Avenue
Brooklyn, NY 11207
Tel: (718) 342-4900
Fax: (718) 342-0175
www.belmontmetals.com
Casting metals.

Bondex Metal Co., Inc.
P.O. Box 780127
Maspeth, NY 11378
Tel: (718) 386-7402
Fax: (718) 381-0162
Casting metals.

Enviro-Safety Products
516 E. Modoc Avenue
Visalia, CA 93292
Tel: (800) 637-6606
Fax: (559) 625-5595
www.envirosafetyproducts.com
Very important safety products.

Far West Materials
405 Woodland Avenue
Walla Walla, WA 99362
Tel: (509) 522-0556
Fax: (509) 525-7326
www.farwestmaterials.com
Ceramic shell supplies.

Farmer's Copper and Industrial Supply, Inc.
202 37th Street
Galveston, TX 77553
Tel: (800) 231-9450
Fax: (409) 765-7115
www.farmerscopper.com
Casting metals.

Foundry Systems Engineers, Inc.
P.O. Box 88071
Atlanta, GA 30356
Tel: (404) 256-6500
Fax: (770) 804-0105
Casting and foundry equipment.

H. M. Hillman Brass and Copper, Inc.
2345 Maryland Road
Willow Grove, PA 19090-1708
Tel: (800) 441-5992
Fax: (215) 659-0807
Casting metals.

Johnson Atelier
60 Ward Avenue Extension
Mercerville, NJ 08619
Tel: (609) 890-7777
Fax: (609) 890-1816
www.atelier.org
Just about everything needed for casting in metal. Their catalog is a dream, following the process from beginning to end, with products for every stage. They also give classes and offer apprenticeships.

The Kindt-Collins Company
12651 Elmwood Avenue
Cleveland, OH 44111

Tel: (800) 321-3170
Fax: (216) 252-5639
www.kindt-collins.com
Wide range of casting waxes, sprues, and more.

J. F. McCaughlin Co.
2628 River Avenue
Rosemead, CA 91770
Tel: (626) 573-3000
Fax: (626) 573-8837
Range of products perfect for the sculptor, from Classic Clay to waxes, to shell materials, and foundry supplies. Great catalog.

Melting Pot International, Inc.
1305 Fairlakes Place
Mitchellville, MD 20721
Tel: (301) 333-0316
Fax: (301) 333-0317
www.themeltingpot.org
Small melting furnaces that melt 18 pounds of bronze on a 110-v house current. They work.

McEnglevan Industrial Furnace Company
700 Griggs Street
P.O. Box 31
Danville, IL 61834-0031
Tel: (217) 446-0941, ext. 112
Fax: (217) 446-4535
www.mifco.thomasregister.com/olc/mifco/
Wide range of metal melting furnaces, plus assorted casting equipment and supplies.

Premier Abrasives
1521 6th Avenue N, Suite B
Lewiston, ID 83501
Tel: (208) 743-5263
Fax: (208) 743-5286
www.premierabrasives.com
Cross pads and patina prep pads.

Premier Wax Co., Inc.
3327 Hidden Valley Drive
Little Rock, AR 72212-3027
Tel/fax: (501) 225-2925
Casting waxes.

Ransom and Randolf
3535 Briarfield Boulevard
Maumee, OH 43537
Tel: (800) 800-7496
Fax: (419) 865-9997
Ceramic shell materials.

REMET Corp.
210 Commons Road
Utica, NY 13502
Tel: (800) 445-2424
Fax: (315) 797-4477
www.remet.com
Ceramic shell materials, waxes, and so on.

Ribbon Technology
P.O. Box 30758
Gahanna, Ohio 43230
Tel: (800) 848 0477
Fax: (614) 864 5305
Stainless steel fibers to reinforce both solid and shell investment casting.

Saunders Equipment, Inc.
P.O. Box 265, Route 301
Cold Spring, NY 10516

Tel: (914) 265-3631
Fax: (914) 265-3632
Shell supplies and equipment, rubbers, and more.

Sunnyside Corporation
Consumer Products Division
225 Carpenter Avenue
Wheeling, IL 60090-6095
Tel: (800) 323-8611
Fax: (847) 541-9043
Carbo-Sol, also available from paint stores.

Synthetic Industries
Fiber Reinforced Concrete Division
1220 Central Avenue
Hanover Park, IL 60103
Tel: (800) 424-3340
Fax: (630) 307-7185
Steel fibers for reinforcing investments.

Westech Products, Inc.
1242 Enterprise Court
Corona, CA 91720
Tel: (800) 654-3529; in CA: (909) 279-4496
Fax: (909) 279-3216
www.westechproducts.com
Waxes, shell materials, and more.

REMET-Yates Investment Casting
1615 W. 15th Street
Chicago, IL 60608
Tel: (312) 666-9850
Fax: (312) 666-7502
Just what the name says.

6. PATINA CHEMICALS, ETC.
Birchwood Casey Laboratories, Inc.
a division of Fuller Laboratories, Inc.
7900 Fuller Road
Eden Prairie, MN 55344-2138
Tel: (800) 328-6156
Fax: (612) 937-7979
www.birchwoodcasey.com/birch.html
Ready-made patina solutions.

Bryant Laboratory, Inc.
1101 5th Street
Berkeley, CA 94710-1201
Tel: (800) 367-3141
Fax: (510) 528-2948
Patina chemicals and recipes.

Butcher's
67 Forest Street
Marlboro, MA 01752
Tel: (888) 291-7510
Fax: (800) 786-7337
www.butchers.com
Butcher's Paste Wax.

Copper Coatings, Corp.
3486 Kurtz Street
San Diego, CA 92110-4429
Tel: (800) 882-7004
Fax: (619) 683-7901
Ready-mixed patina solutions.

A&C Distributors
3486 Kurtz Street
San Diego, CA 92110-4429
Tel: (800) 995-9946
Fax: (619) 683-7901
Suppliers of patina solutions.

Sculpt-Nouveau
625 W 10th Avenue
Escondido, CA 92025-4715
Tel: (800) 728-5787
Various metal dyes for patina enhancement.

StanChem, Inc.
401 Berlin Street
East Berlin, CT 06023-1127
Tel: (860) 828-0571
Fax: (860) 828-3297
Incra-Lac, a final coating for bronze.

7. MATERIALS FOR BASES
Baja Onyx and Marble
524 W. Calle Primera, Suite 1004
San Ysidro, CA 92173-2836
Tel: (619) 428-6127
Fax: (619) 428-6129
*Wide range of stone bases, from jet black
to multicolored. Standard and custom sizes.*

Burdoch Marble Co.
757 N. Twin Oaks Valley Road
San Marco, CA 92069
Tel: (800) 783-8738
Fax: (760) 591-3837
Stone bases.

Gilmer Wood Co.
2211 NW St. Helens Road
Portland, OR 97210-2233
Tel: (503) 274-1271
Fax: (503) 274-9839
*Exotic woods of all kinds. (Don't look for oak
or walnut here.)*

L. L. Johnson Lumber Mfg. Co.
P.O. Box 278
563 N. Cochran
Charlotte, MI 48813
Tel: (800) 292-5937
Fax: (888) 258-5914
www.theworkbench.com
*Domestic and exotic woods. They also do
some mill work.*

Montoya/MAS International (see page 236)

Sculpture House (see page 236)

Stonewurks, Inc.
314 Lincoln Avenue
Clay Center, KS 67432
Tel: (785) 632-5687
Fax: (785) 632-6093
*Strata Stone, which is a stone-covered honeycomb
aluminum slab for bases. Great for large bases.*

8. OTHER
Artida Arts, Inc.
56 Ludlow Street
New York, NY 10002
Tel: (212) 777-4323 or (212) 777-4780
Fax: (212) 260-1732
Classes in sculpture.

Avalon Concepts Corp.
1055 Leisz's Bridge Road
Leesport, PA 19533
Tel: (800) 636 8864
Fax: (610) 916-1131
www.avalonconcepts.com
Rigid foam that is used as a sculpting material.

Cyber F/X
615 Ruberta Avenue
Glendale, CA 91201
Tel: (818) 246-2911
Enlargers with the milled foam process.

Johnson Atelier (see page 237)
Classes.

Loveland Academy of Fine Arts (see page 236)
Classes.

Medallic Art Co., Ltd.
80 Airpark Vista Boulevard
Dayton, NV 89403-8303
Tel: (800) 843-9854
Fax: (775) 246-6006
www.medallic.com
*Services for the medallist, such as reducing,
stamping, and more.*

Mitchell Graphics, Inc.
2363 Mitchell Park Drive
Petoskey, MI 49770-9600
Tel: (231) 347-4635
Fax: (231) 347-9255
Color printing of your work.

Montoya (see page 236)
Classes.

National Sculpture Society
1177 Avenue of the Americas
New York, NY 10036-2714
Tel: (212) 764-5645
Fax: (212) 764-5651
www.SculptureReview.com/nss.html
*Sculpture organization that focuses on
figurative work.*

Scott Sign Systems, Inc.
P.O. Box 1047
Tallevast, FL 34270-1047
Tel: (800) 237-9447
Fax: (941) 351-1787
www.scottsigns.com
Plastic sign letters, perfect for lettering on reliefs.

Scottsdale Artists School
3720 N. Marshall Way
Scottsdale, AZ 85251
Tel: (800) 333-5707
Fax: (480) 990-0652
www.scottsdaleartschool.org
Lots of classes.

Signilar Art Videos
P.O. Box 278W
Sanbornton, NH 03269-0278
Tel: (800) 205-4904
Fax: (603) 934-6525
www.signilar.com
*Videos of processes demonstrated by
Bruno Lucchesi.*

Vaugel Sculpture Studios
Tel/fax: (919) 829-9395
www.vaugelsculpture.com
*Classes in classical sculpture modeling, offered in
the United States and France.*

INDEX